# ADVERTISING PHOTOGRAPHY IN JAPAN 2

# ADVERTISING PHOTOGRAPHY IN JAPAN 2

JAPAN ADVERTISING PHOTOGRAPHERS' ASSOCIATION

KODANSHA INTERNATIONAL LTD.
Tokyo, New York & San Francisco

Book Design: Keisuke Nagatomo, member of the Art Directors Club of Tokyo

Layout: Hidetaka Mochizuki, Shigeo Hiratsuka, Tetsuro Igarashi, Hot Art Co., Ltd.

Theme Concept: Naoe Wakita, member of the Tokyo Copywriters Club

Financial assistance for this publication was received
from Nagase & Co., Ltd., a Division of Kodak Products.

The Japan Advertising Photographers' Association (APA) is located at:
3rd Fl., Record Kaikan, 8-9, Tsukiji 2-chome, Chuo-ku, Tokyo 104
Tel. 03-543-3387

Distributed in the United States by Kodansha International/USA Ltd., through
Harper & Row, Publishers, Inc., 10 East 53rd Street, New York, New York 10022.
Published by Kodansha International Ltd., 12-21, Otowa 2-chome, Bunkyo-ku, Tokyo 112,
and Kodansha International/USA Ltd., 10 East 53rd Street, New York, New York 10022
and the Hearst Bldg., 5 Third Street, Suite 430, San Francisco, California 94103.

Printed in Japan.
First edition, 1984

LCC 83-117721
ISBN 0-87011-647-9
ISBN 4-7700-1147-4 (in Japan)

# CONTENTS

# INTRODUCTION
●

Shinichiro Tora
Art Director, Popular Photography, New York

At the dawn of history, primitive man learned to take advantage of his intelligence and his prehensile hands in order to survive, and he invented tools. This invention ultimately transformed man's way of life, for he also learned to use tools for creative expression. On the walls of cliffs or caves, he scratched his impressions of the mysterious, myth-inspiring phenomena of nature or the momentous experiences of man. Later he developed more refined techniques of relief engraving and color, and his pictorial skills improved as his ability to construct forms was recorded in visual expression. Gradually visual expression became one of the most powerful forms of human communication, depicting even human emotions. Man's desire to express what he saw around him grew stronger and stronger, and finally he used his intelligence and his hands to invent the tool we call a camera.

This invention, which took place only about one hundred and fifty years ago, was as revolutionary for man as that which finally enabled him to satisfy his yearning for flight. Not only can the camera record natural phenomena with exact precision, but it can also capture fleeting human emotions, holding the moment in a fixed image. Paintings, as they are being created, gradually become tinged with the powerful emotional sensibilities of the artist, thus becoming, perhaps, more emphatic than the reality they express. The emotional impressions of a photographer are expressed instantaneously in the images brought to life by his camera.

As part of the progress of science and technology, the camera has developed with almost incredible rapidity, so that in this electronic age one needs only to aim the lens and snap the shutter. These developments place new demands on the professional photographer. Creative sensibility is now much more important than the object to be photographed or expertise with the tools of photography. More and more, photographers must move beyond technical competence and play a role previously considered to be part of the repertoire of the art director.

I think it can be said that the creative photography movement enjoyed its golden age during the 60s in New York. It was during this period that Edward Steichen, a leading advocate of the artistic quality of photographs, was planning the dramatic ''Family of Man'' exhibit at the Museum of Modern Art, Robert

Capa's spectacular photojournalism was being featured in *Life*, and Nathan Lyons was producing his new contemporary photographs.

In the field of advertising photography, the powerful "photo army" of Avedon, Hiro, and Penn was working under the famous Alexey Brodovich, producing photographs for *Vogue* and *Bazaar* that firmly established their leadership as photographers in the international fashion and advertising worlds. Even such powerful art directors as Henry Wolf, Otto Storch, and Art Kane became willing slaves to the seductive attractions of photography, and a new vision stirred the world of graphic design. Sam Haskins arrived on the scene from South Africa and won acclaim with his fresh images of adolescent girls, while Pete Turner captured attention with his fresh, original use of color.

It was also during the 60s that documentary film makers and photojournalists began to travel widely in search of spectacular sights and events. Fashion and advertising photographers responded by producing work that displayed a search for new ideas and a greater degree of expressive range through new techniques. At the same time, photographers throughout the world learned a great deal from the creative photography movement in New York, making that city's visual creations a standard against which to compare their own work.

These visual creations owed their spectacular rise to the mammoth American mass communications industry, but the same industry was also responsible for the decline of the creative photography movement in New York. The death of the original *Life* magazine was perhaps the first ominous sign, and the escalation of the Vietnam War brought shifts in public tastes and lifestyles that impeded the continued development of creative photography in the United States.

However, just as American photographers were losing interest in this field, Japanese photographers were beginning to recreate the movement in the unique setting of the Japanese advertising market. This transplant called for profound changes in visual-communication conceptions and modes of expression. The Japanese had to take what they had learned during the golden age of American creative photography and adapt it to the special demands of the Japanese market —and that meant adapting advertising photography to Japanese society at large. These adjustments have been a source of much confusion in discussions between American and Japanese fashion and advertising photographers, and it is worth examining them in some detail.

The often-stated difference between advertising in Japan and in the United States is that American advertisers approach consumers directly while the Japanese favor an indirect approach. Japanese advertising photographers knew that the strategy of "coming on strong" with a direct, impactful image would not be as effective with Japanese consumers as an indirect approach with a softer mood. It is part of the Japanese character that blunt, aggressive, or outspoken communication is distasteful, and the hard-sell approach can lead to disaster. The Japanese have a saying, "That which is hidden should certainly be called a flower." A reserved, indirect style is valued, and with this in mind, Japanese advertising photographers gradually invented a formula that can be called the "visual expression of mood."

For example, when a Japanese advertising photographer attempts to create an image for a luxury item, he rarely includes the product itself in his photographs. Instead, he uses an elegant foreign model and shoots the photograph in a well-known foreign scene. By doing so, he lures the potential consumer into a world of dreams, desires, and unsatisfied appetites, while indulging his fantasy of himself as a member of the elite.

The logic of this indirect approach is, no doubt, incomprehensible to foreigners, but it is an integral part of the unique perspective of the culture created by the Japanese during the Edo period (1603—1868) and still a major influence in 1984. Indeed, the influence of this style of indirect visual expression has increased until today it is the norm not only in advertising, but in mass culture as a whole. The principles underlying this style of expression are revealed in the concept of *ma* in Noh or Kabuki, but more than anything else they reflect the traditional Japanese spirit of subtle play. The following saying, which circulated during the Edo period, illustrates these principles better than any explanation:

''When the wind blows, bucket shops make money.''

Nonsense, right? No, this is what the joke means: When the wind blows, the air is full of dust...dust gets in your eyes and you can't see...you can't see so you can't do any work...you can't do any work, so you might as well go to a teahouse and listen to a shamisen player...shamisen covers are made of cat skin, so a lot of cats are killed...a lot of cats are killed, so the mice multiply...mice like to gnaw on wooden buckets...so, bucket shops make a lot of money.

Japanese of the Edo period would never have bothered to spell out the direct logical links that make the joke work and anyone who demanded an explanation would have been labeled a country bumpkin. The value of indirectness has not been lost in modern Japan. The added refinement of a concept of composition that has much in common with graphics has made it possible for advertising photographers to expand the potential of indirectly expressed imagery even further, but the underlying principles have existed in Japan for centuries.

In 1984, we may say proudly that Japanese fashion and advertising photographers have perfected a mode of visual expression that claims international attention, and many feel that the influence of the Japanese approach now exceeds that of the American creative photography movement at its peak.

A great number of historical precedents for this hugely successful adoption of a foreign medium may be cited. During the ninth and tenth centuries, for example, there was a massive infusion of culture from China into Japan. However, having acknowledged the superiority of this culture, the Japanese proceeded to assimilate it by effecting a complete transformation. In flower arranging and tea ceremony, the Japanese used a base of Chinese philosophy to produce the uniquely Japanese concepts of *wabi* and *sabi*. The most dramatic period of adaptation was the two and a half centuries of the Edo period, during which the Tokugawa shoguns closed Japan off completely from contact with foreign countries. It was during this period that the Japanese, and especially the townsman class, displayed a creativity and cultural genius that gave birth to a new and uniquely Japanese society.

It was this society that produced *ukiyo-e*, a mode of visual expression that greatly influenced modern Japanese advertising photography. With the invention of new techniques of printing, including polychrome prints and the use of mica dust in backgrounds, *ukiyo-e* prints took the sophisticated world of Edo by storm, making it one of the first mass communication societies. In this period before the development of photography, Japanese publishers wedded traditional genres of painting with new techniques of polychrome printing to mass-produce pictures from the fashionable world of Kabuki, portraits of actors or the beautiful women of the Yoshiwara, and scenes of famous areas in the city or countryside. Demand for these swept the country, and mass publishing emerged as an essential part of Japanese society. In these small prints—the actor portraits of Sharaku

and Toyokuni, the beautiful women of Utamaro and Eisen, and the landscapes of Hokusai and Hiroshige—there throbbed a vital creativity.

*Ukiyo-e* became an important medium for advertising, and even a great artist like Utamaro did many series of prints for large kimono dealers. Many of his portraits of beautiful women served to advertise famous tea houses or houses of pleasure in the Yoshiwara, while the popular Kabuki prints were commissioned as advertisements by the theaters. Nevertheless, these mass-produced prints never lost their high quality, and they have become famous in foreign countries as an example of the artistic excellence attained by traditional Japanese culture. Indeed, *ukiyo-e* exerted a profound influence on the Late Impressionists, launching an artistic revolution in Europe.

The creative genius displayed in *ukiyo-e* woodblock prints has been passed down in an unbroken line from generation to generation of artists, and modern Japanese designers and photographers are still experimenting with new concepts in visual expression. It is my sincere hope that in the same way that *ukiyo-e* developed in the unique cultural setting of Japan and had a powerful effect on the rest of the world in the nineteenth century, so Japanese advertising photography may ignite another international visual revolution in a different and exciting medium.

# EDITORIAL COMMITTEE/SELECTION COMMITTEES

# CONTRIBUTING PHOTOGRAPHERS

●

Advertising Production Division
Independent Works

**Yojiro Adachi** ●*235*
*1-19-703, Nishi Azabu 3-chome, Minato-ku, Tokyo 106  Tel.03-478-6769*

**Kosei Aida** ●*123*
*Sasaki Studio, New Sun Bldg., 8-7, Kaji-cho 2-chome, Chiyoda-ku, Tokyo 101  Tel.03-256-3021*

**Yoshinobu Aikawa** ●*8-10·278*
*17-1306, Shibakubo-cho 2-chome, Tanashi-shi, Tokyo 188  Tel.0424-64-7066*

**Yasuhiko Akaishizawa** ●*150*
*951-136, Gomo, Gifu-shi, Gifu 500  Tel.0582-39-6178*

**Shigeru Akimoto** ●*11-13·131·132·289-292*
*30-6-565, Jingumae 4-chome, Shibuya-ku, Tokyo 150  Tel.03-404-6921*

**Minoru Akiyama** ●*248·249*
*15-20, Kugahara 4-chome, Ohta-ku, Tokyo 146  Tel.03-753-1519*

**Shotaro Akiyama** ●*352·353*
*Akiyama Studio, 25-22, Nishi Azabu 2-chome, Minato-ku, Tokyo 106  Tel.03-407-7375*

**Kichisaburo Anzai** ●*59*
*30-6-321, Jingumae 4-chome, Shibuya-ku, Tokyo 150  Tel.03-405-0843*

**Seiichi Aoki** ●*179*
*Nippon Design Center, 13-13, Ginza 1-chome, Chuo-ku, Tokyo 104  Tel.03-567-3231*

**Taku Aramasa** ●*310*
*21-3-101, Nishi Azabu 2-chome, Minato-ku, Tokyo 106  Tel.03-409-6582*

**Katsu Asano** ●*206·207*
*15-28, Minami Tsukushino 4-chome, Machida-shi, Tokyo 194  Tel.0427-96-6165*

**Hiromasa Echigo** ●*110*
*18-11, Funabashi 4-chome, Setagaya-ku, Tokyo 156  Tel.03-483-1703*

**Ryusei Egawa** ●*286*
*Office Lux, Ogiso Bldg., 4-3, Soto Kanda 4-chome, Chiyoda-ku, Tokyo 101  Tel.03-255-5900*

**Masao Kawahara** ●*115·230*
2B, Casa Bianca Mansion, 1-14, Kobai-cho, Kita-ku, Osaka-shi, Osaka 530  Tel.06-353-6802

**Nobuo Kimura** ●*176*
4-8-1202, Takanawa 1-chome, Minato-ku, Tokyo 108  Tel.03-447-7807/7644

**Hideo Kishimoto** ●*233·234·357·358*
Sapporo Commercial Photo, Iwase Bldg., Kita 3-jo Higashi 5-chome, Chuo-ku, Sapporo-shi, Hokkaido 060  Tel.011-222-4655

**Soichiro Kita** ●*101·362*
Kita Office, 17-55-306, Akasaka 2-chome, Minato-ku, Tokyo 107  Tel.03-585-9819

**Saburo Kitai** ●*217·218*
Kitai Studio, 7-17, Roppongi 3-chome, Minato-ku, Tokyo 106  Tel.03-408-8517

**Sunao Kitajima** ●*228*
9-3, Ichizaki 1-chome, Minami-ku, Fukuoka-shi, Fukuoka 815  Tel.092-521-9458

**Kazuhiro Kobayashi** ●*99*
8-4, Minami Azabu 3-chome, Minato-ku, Tokyo 106  Tel.03-442-3328

**Masaaki Kobayashi** ●*133*
Kakusen House-H, 38-5, Jingumae 3-chome, Shibuya-ku, Tokyo 150  Tel.03-408-9090

**Toru Kogure** ●*75-77·89*
Studio White, 6-30-505, Akasaka 9-chome, Minato-ku, Tokyo 107  Tel.03-402-7883

**Yuten Konishi** ●*445·446*
31, Higashi Kota-cho, Iwakura, Sakyo-ku, Kyoto-shi, Kyoto 606  Tel.075-711-4571

**Seiji Koshimiya** ●*125*
14-7-411, Nakanobu 4-chome, Shinagawa-ku, Tokyo 142  Tel.03-785-6815

**Akira Kumagai** ●*253*
Akira Kumagai Studio, 15, Kaitai-machi, Shinjuku-ku, Tokyo 162  Tel.03-268-1862

**Masami Kume** ●*113*
Aoyama Rio Mansion, 13-16, Minami Aoyama 6-chome, Minato-ku, Tokyo 107  Tel.03-409-0894

**Hajime Kunifusa** ●*60·239*
5-11-602, Roppongi 7-chome, Minato-ku, Tokyo 106  Tel.03-401-4043

**Michio Kuroda** ●*57*
Creative Center, Hakuhodo Inc., 22, Kanda Nishiki-cho 3-chome, Chiyoda-ku, Tokyo 101  Tel.03-233-6362

**Sachiko Kuru** ●*323-326*
2-1-702, Udagawa-cho, Shibuya-ku, Tokyo 150  Tel.03-464-8889

**Muneo Maeda** ●*295·296*
Photo Mamu, 3rd Fl., Chisei Bldg., 4-2, Moto Akasaka 1-chome, Minato-ku, Tokyo 107  Tel.03-404-6461

**Mitsuomi Maehara** ●*63*
Sasaki Studio, New Sun Bldg., 8-7, Kaji-cho 2-chome, Chiyoda-ku, Tokyo 101  Tel.03-256-3021

**Ryutaro Masumoto** ●*90*
2-307, Shibazono-cho 2-chome, Kawaguchi-shi, Saitama 333  Tel.0482-69-5750

**Tadashi Matsumoto** ●*56*
Photo United, 31-17, Ookayama 1-chome, Meguro-ku, Tokyo 152  Tel.03-294-7447

**Susumu Matsushima** ●223·224·452-456
19-25-605, Kori Minamino-cho, Neyagawa-shi, Osaka 572  Tel.0720-33-3440

**Masaru Mera** ●61·157·204
8-7-303, Minami Aoyama 6-chome, Minato-ku, Tokyo 107  Tel.03-400-9005

**Takehiro Misaka** ●340-345
3-11, Chiyoda 4-chome, Takaishi-shi, Osaka 592  Tel.0722-61-0729

**Toshiro Miura** ●97·98
Magna Co., Ltd., 13-3, Ginza 6-chome, Chuo-ku, Tokyo 104  Tel.03-543-4341

**Masatsugu Miyai** ●193
231-33, Ozu, Ozu-machi, Kikuchi-gun, Kumamoto 869-12  Tel.0962-93-2280

**Akinori Miyashita** ●124
11-2, Hiroo 2-chome, Shibuya-ku, Tokyo 150  Tel.03-409-1591

**Kazuyoshi Miyoshi** ●21·144·145·203
8-3-902, Minami Aoyama 6-chome, Minato-ku, Tokyo 107  Tel.03-400-3066

**Tsuyoshi Mochizuki** ●365-369
13-9, Higashi Yukigaya 5-chome, Ota-ku, Tokyo 145  Tel.03-728-8228

**Reiko Mori** ●280
Studio Luft, Marutomi Bldg., 35-26, Daikan-cho, Higashi-ku, Nagoya-shi, Aichi 461  Tel.052-932-3410

**Masayuki Motomiya** ●252
14-4-201, Tsukiji 2-chome, Chuo-ku, Tokyo 104  Tel.03-545-9320

**Teruto Nagai** ●309
Studio New Flash, Matsuya Bldg., 8-27, Daido 3-chome, Tennoji-ku, Osaka-shi, Osaka 543  Tel.06-779-0554

**Tetsu Nakagawa** ●321
Light Publicity Ltd., Honshu Bldg., 12-8, Ginza 5-chome, Chuo-ku, Tokyo 104  Tel.03-543-1201

**Yasutoshi Nakajima** ●402-405
Nakajima Pro. Photo, 2166, Hokoshimizu, Nagano-shi, Nagano 380  Tel.0262-35-2277

**Masaya Nakamura** ●272-274
2nd Fl., Kaneko Bldg., 2-9, Nishi Azabu 1-chome, Minato-ku, Tokyo 106  Tel.03-408-7812

**Tomu Nakamura** ●288
30-5, Miyasaka 1-chome, Setagaya-ku, Tokyo 156  Tel.03-425-0835

**Hiroyuki Negishi** ●208-210·282
Takasaki Studio, 10-45-205, Akasaka 6-chome, Minato-ku, Tokyo 107  Tel.03-582-0461

**Junichiro Nishimaki** ●117·354-356
Creative Center, Hakuhodo Inc., 22, Kanda Nishiki-cho 3-chome, Chiyoda-ku, Tokyo 101  Tel.03-233-6362

**Masaaki Nishimiya** ●105-107
Nishimiya Photo Studio, 21-5-504, Akasaka 3-chome, Minato-ku, Tokyo 107  Tel.03-582-7018

**Shinta Nishioka** ●412-416
Nishioka Photo Labo., 8-3, Kusatsu 2-chome, Kusatsu-shi, Shiga 525  Tel.0775-63-6791

**Kazuyoshi Nomachi** ●109
3rd Fl., Murata Bldg., 27-6, Yoyogi 4-chome, Shibuya-ku, Tokyo 151  Tel.03-370-6315

**Kazuyuki Imose** •*156*
*Studio Bon, Kenshu Bldg., Kita 1-jo Nishi 21-chome, Chuo-ku, Sapporo-shi, Hokkaido 064 Tel.011-621-5657*

**Koichi Inakoshi** •*66-68·256*
*14-32-105, Jingumae 1-chome, Shibuya-ku, Tokyo 150 Tel.03-401-0362*

**Issei Isshiki** •*69-71·237·322*
*Isshiki Studio, TBS Shinzaka Bldg., 9-2, Akasaka 8-chome, Minato-ku, Tokyo 107 Tel.03-404-8451*

**Isao Itani** •*359-361*
*Studio Idea, 3, Koraibashi 1-chome, Higashi-ku, Osaka-shi, Osaka 541 Tel.06-203-2981*

**Kazuhito Ito** •*281*
*3-302, Takabari-jutaku, 28-1, Takabari Aza Maeyama, Itaka-cho, Meito-ku, Nagoya-shi, Aichi 465 Tel.052-703-9701*

**Yuji Itsumi** •*200*
*4-18-206, Shibuya 1-chome, Shibuya-ku, Tokyo 150 Tel.03-406-1064*

**Yoichi Iwase** •*118*
*18-5, Nishi Rokugo 2-chome, Ota-ku, Tokyo 144 Tel.03-738-9045*

**Shozo Iwata** •*58*
*Creative Coordination, Dentsu Inc., 11-10, Tsukiji 1-chome, Chuo-ku, Tokyo 104 Tel.03-544-5839*

**Bishin Jumonji** •*78·213*
*12-28, Roppongi 7-chome, Minato-ku, Tokyo 106 Tel.03-408-8285*

**Mitsushisa Kageyama** •*318-320*
*Magna Co., Ltd., 13-3, Ginza 6-chome, Chuo-ku, Tokyo 104 Tel.03-543-4341*

**Eiji Kakuo** •*130·436-441*
*Photo Eiji, 23, Minami Nonin-machi 2-chome, Higashi-ku, Osaka-shi, Osaka 540 Tel.06-942-5087*

**Toshio Kanasaki** •*432-435*
*5-4, Tamade Nishi 1-chome, Nishinari-ku, Osaka-shi, Osaka 557*

**Akio Kanbayashi** •*174·246*
*Studio Gorilla, 4-1, Ginza 6-chome, Chuo-ku, Tokyo 104 Tel.03-573-1785*

**Nobuo Kanemoto** •*406*
*8-1, Naka Sakurazuka 3-chome, Toyonaka-shi, Osaka 560 Tel.06-841-0579*

**Somei Kaneto** •*79·80·225*
*7-8-303, Azabu Juban 1-chome, Minato-ku, Tokyo 106 Tel.03-403-5388*

**Tsuyoshi Kano** •*55*
*Creative Center, Hakuhodo Inc., 22, Kanda Nishiki-cho 3-chome, Chiyoda-ku, Tokyo 101 Tel.03-233-6362*

**Yoshio Kashiwagi** •*216*
*Craetive Center, Hakuhodo Inc., 22, Kanda Nishiki-cho 3-chome, Chiyoda-ku, Tokyo 101 Tel.03-233-6360*

**Muneki Kashiyama** •*18*
*6-30-303, Akasaka 9-chome, Minato-ku, Tokyo 107 Tel.03-423-0337*

**Gisen Katahira** •*14-17*
*3rd Fl., Kobayashi Apt., 8-35, Minami Aoyama 3-chome, Minato-ku, Tokyo 107 Tel.03-405-4095*

**Katsuhiko Kato** •*297·298*
*10-17, Izumi 2-chome, Okegawa-shi, Saitama 363 Tel.0487-86-6706*

**Akiyoshi Serikawa** ●421-427
*Serikawa Creations, 10-12-402, Minami Senba 1-chome, Minami-ku, Osaka-shi, Osaka 542 Tel.06-264-1827*

**Masamitsu Shibano** ●236
*Studio Madison, 13-9, 6-jo Minami 2-chome, Gifu-shi, Gifu 500 Tel.0582-74-5650*

**Atsushi Shiiki** ●240
*1-1-702, Jingumae 1-chome, Shibuya-ku, Tokyo 150 Tel.03-478-2176*

**Yukio Shimosato** ●111·212
*Studio Shim, 12-1-110, Sarugaku-cho, Shibuya-ku, Tokyo 150 Tel.03-461-9687*

**Shuichi Shindo** ●219
*6-14, Higashi 4-chome, Shibuya-ku, Tokyo 150 Tel.03-400-7350*

**Kishin Shinoyama** ●30-34
*3-6, Roppongi 6-chome, Minato-ku, Tokyo 106 Tel.03-402-3458*

**Shintaro Shiratori** ●62·87·88·114·177·178·238·257·258·260·287·373-378
*Creative Center, Hakuhodo Inc., 22, Kanda Nishiki-cho 3-chome, Chiyoda-ku, Tokyo 101 Tel.03-233-6355*

**Masaya Suga** ●314-317
*22-13-401, Okuzawa 6-chome, Setagaya-ku, Tokyo 158 Tel.03-703-7861*

**Takeo Sugai** ●457
*Minami 13-jo Nishi 23-chome, Chuo-ku, Sappora-shi, Hokkaido 064 Tel.011-561-5320*

**Naoya Sugiki** ●254
*2-3, Kakinokizaka 1-chome, Meguro-ku, Tokyo 152 Tel.03-724-0033*

**Mamoru Sugiyama** ●119
*12-18-303, Kami Osaki 1-chome, Shinagawa-ku, Tokyo 141 Tel.03-443-8945*

**Nobutsugu Sugiyama** ●198
*Studio Nobu, 41-1-202, Jingumae 5-chome, Shibuya-ku, Tokyo 150 Tel.03-499-4210*

**Masayoshi Sukita** ●134
*30-6-702, Jingumae 4-chome, Shibuya-ku, Tokyo 150 Tel.03-404-9993*

**Hideo Suzuki** ●54·259
*Creative Center, Hakuhodo Inc., 22, Kanda Nishiki-cho 3-chome, Chiyoda-ku, Tokyo 101 Tel.03-233-6362*

**Kazuo Suzuki** ●300·428-431
*Iima Heights, 6-16, Nakanoshima 1-jo 4-chome, Toyohira-ku, Sapporo-shi, Hokkaido 062 Tel.011-823-4892*

**Koji Suzuki** ●245
*Nippon Design Center, 13-13, Ginza 1-chome, Chuo-ku, Tokyo 104 Tel.03-567-3231*

**Yoshihiro Tatsuki** ●64·65
*Fujii Bldg., 3-6, Roppongi 3-chome, Minato-ku, Tokyo 106 Tel.03-586-5231/4*

**Matsutoshi Takagi** ●294·303-305
*Nippon Design Center, 13-13, Ginza 1-chome, Chuo-ku, Tokyo 104 Tel.03-567-3231*

**Noboru Takahashi** ●108·229
*17-55-309, Akasaka 2-chome, Minato-ku, Tokyo 107 Tel.03-586-0773*

**Sakae Takahashi** ●22·23
*3-15, Higashi Toyonaka-cho 3-chome, Toyonaka-shi, Osaka 560 Tel.06-854-6514*

Tetsuro Takai ●19·20·268
15-19-504, Roppongi 6-chome, Minato-ku, Tokyo 106 Tel.03-479-4279

Katsuji Takasaki ●1-7·35·91·170-172·175·214·215
Takasaki Studio, 10-45-205, Akasaka 6-chome, Minato-ku, Tokyo 107 Tel.03-582-0461/2

Isamu Takei ●151
4-25-102, Roppongi 3-chome, Minato-ku, Tokyo 106 Tel.03-738-3732

Yasunori Takeuchi ●28
6-22, Terasaki-machi 2-chome, Oita-shi, Oita 870-01 Tel.0975-52-2531

Akira Takezaki ●267
4-4, Komone 4-chome, Itabashi-ku, Tokyo 173 Tel.03-956-7911

Ryuhei Taniguchi ●201·202
6-12-503, Higashi Tenman 2-chome, Kita-ku, Osaka-shi, Osaka 530 Tel.06-357-7157

Toshio Tateishi ●181·182
Studio Tateishi, 20-2-203, Roppongi 7-chome, Minato-ku, Tokyo 106 Tel.03-401-4096/6215

Kiyoshi Tatsukawa ●152
18, Shinano-machi, Shinjuku-ku, Tokyo 160 Tel.03-351-6384

Akiyoshi Terashima ●270
3-12, Minami Azabu 5-chome, Minato-ku, Tokyo 106 Tel.03-440-0786

Chikao Todoroki ●311·312
Sasaki Studio, New Sun Bldg., 8-7, Kaji-cho 2-chome, Chiyoda-ku, Tokyo 101 Tel.03-256-3021

Minsei Tominaga ●313
#65, Tokyu Apt., 20-23, Daikanyama, Shibuya-ku, Tokyo 150 Tel.03-463-9558

Masao Torii ●308
13-15-703, Nishi Azabu 2-chome, Minato-ku, Tokyo 106 Tel.03-406-8689

Nobuyasu Toyokuni ●227
Studio Higashi Ginza, 15-15-401, Tsukiji 2-chome, Chuo-ku, Tokyo 104 Tel.03-545-8680

Fumio Tsukamoto ●363·364
16-13, Kami Saginomiya 2-chome, Nakano-ku, Tokyo 165 Tel.03-990-1957

Masaji Tsunoda ●284·285·407-411
Tsunoda Studio, 10-10-602, Minami Aoyama 7-chome, Minato-ku, Tokyo 107 Tel.03-409-2175

Yoshihisa Tsuruta ●148·149·397-400
#203, Royal Shibuya, 5-9, Sakuragaoka-cho, Shibuya-ku, Tokyo 150 Tel.03-461-8807

Kenichi Ura ●271
3-1-410, Some Minamino-machi 3-chome, Toyonaka-shi, Osaka 561 Tel.06-862-5658

Senji Urushibata ●183-192
Suntory Ltd., 2-3, Moto Akasaka 1-chome, Minato-ku, Tokyo 107 Tel.03-470-1131

Makoto Yamada ●195
1-1, Minami Hagiwara, Oita-shi, Oita 870-01 Tel.0975-56-1845

Mitsuo Yamane ●447-451
Ken Studio, 139, Yamazato-cho, Showa-ku, Nagoya-shi, Aichi 466 Tel.052-832-2769

# CONTRIBUTING PHOTOGRAPHERS (Non-members of APA)

●

Open Division

**Shuji Abe** ●602-605
*12-4-104, Jingumae 4-chome, Shibuya-ku, Tokyo 150 Tel.03-470-6218*

**Tetsuzo Akasaka** ●585-588
*Minami 15-jo Nishi 18-chome, Chuo-ku, Sapporo-shi, Hokkaido 064 Tel.011-551-1107*

**Satoru Akinobu** ●595-597
*3-19, Kamata 1-chome, Ota-ku, Tokyo 144 Tel.03-739-3984*

**Eiichi Arai** ●508-511
*4-3-105, Bishoen 1-chome, Abeno-ku, Osaka-shi, Osaka 545 Tel.06-623-5259*

**Junichi Date** ●657-659
*1-1-101, Sukematsu Danchi, Izumiotsu-shi, Osaka 595 Tel.0725-21-5452*

**Issaku Fujita** ●526-531
*5-7, Tamako-cho 4-chome, Higashi Murayama-shi, Tokyo 189 Tel.0423-93-5346*

**Keisuke Furui** ●676-679
*5-1-105, Shinoto 1-chome, Atsuta-ku, Nagoya-shi, Aichi 456 Tel.052-682-2521*

**Akira Furukawa** ●654-656
*17, Yamanouchi Sekisan-cho, Ukyo-ku, Kyoto-shi, Kyoto 615 Tel.075-313-3770*

**Tokuzo Goto** ●689-693
*13-24, Shimoshima-cho, Kadoma-shi, Osaka 571 Tel.0720-83-1484*

**Mitsuru Harakawa** ●543-545
*1-26-1215, Kyodo 2-chome, Setagaya-ku, Tokyo 156 Tel.03-429-4791*

**Katsuhiko Hishinuma** ●505-507
*31-31, Wada 2-chome, Suginami-ku, Tokyo 166 Tel.03-384-1804*

**Naohiko Hoshino** ●495·496
*9-11, Senju Okawa-cho, Adachi-ku, Tokyo 120 Tel.03-888-6080*

**Takahisa Ide** ●470-473
*32, Takayasu-cho Minami 1-chome, Yao-shi, Osaka 581 Tel.0729-22-8472*

**Tokuji Iioka** ●606-608
17-13, Kamiya 1-chome, Kita-ku, Tokyo 115  Tel.03-913-2554

**Masakazu Ikeda** ●492-495
28-10, Ehara-cho 2-chome, Nakano-ku, Tokyo 165  Tel.03-951-9450

**Takashi Imai** ●541
4-16, Ikutamatera-machi, Tennoji-ku, Osaka-shi, Osaka 543  Tel.06-779-8486

**Yoshiyuki Inoue** ●484-486
11-12, Kami Nagoya-cho 4-chome, Nishi-ku, Nagoya-shi, Aichi 451  Tel.052-522-0323

**Ryuzo Ishikawa** ●625-627
1-2-404, Minami Eguchi 3-chome, Higashi Yodogawa-ku, Osaka-shi, Osaka 533  Tel.06-320-2768

**Toru Katsuta** ●518-521
12-41, Nadeshikohara, Hiratsuka-shi, Kanagawa 254  Tel.0463-31-6827

**Yutaka Kawachi** ●554
6th Fl., 920 Broadway, New York, N.Y. 10010  Tel.212-677-1756

**Masahiro Kayano** ●548-550
12-7, Ue-machi 1-chome, Higashi-ku, Osaka-shi, Osaka 540  Tel.06-762-2566

**Hiroshi Koiwai** ●487-491
13-12, Wakabayashi 3-chome, Setagaya-ku, Tokyo 154  Tel.03-414-3526

**Yuki Komatsu** ●664·665
16-31, Wakahama-cho, Sakata-shi, Yamagata 998  Tel.0234-23-5408

**Norimasa Kumamoto** ●546
8-8, Takasuna 2-chome, Chuo-ku, Fukuoka-shi, Fukuoka 810  Tel.092-521-3172

**Masatomo Kuriya** ●564
17-22, Nishi Azabu 4-chome, Minato-ku, Tokyo 106  Tel.03-406-7675

**Katsuo Kuroda** ●547
3-22, Ichiban-cho 2-chome, Sendai-shi, Miyagi 980  Tel.0222-66-3664

**Koji Kuroda** ●478-480
24-4-1008, Nishi Gotanda 1-chome, Shinagawa-ku, Tokyo 141  Tel.03-493-2026

**Takuo Kusama** ●542
22-20-1017, Higashi Shinagawa 3-chome, Shinagawa-ku, Tokyo 140  Tel.03-472-8307

**Masao Machida** ●499-502
3-23-303, Murakami-danchi, Yachiyo-shi, Chiba 276  Tel.0474-84-0635

**Hiroshi Maruyama** ●474·475
1-801, Mansion Gajoen, 8-39, Shimo Meguro 1-chome, Meguro-ku, Tokyo 153  Tel.03-493-1154

**Takashi Matsuda** ●592·593
6-6-105, Ebisu 2-chome, Shibuya-ku, Tokyo 150  Tel.03-444-5522

**Tomohisa Matsushita** ●594
7-11, Hozan-cho, Toyonaka-shi, Osaka 560  Tel.06-843-9068

**Mamoru Minamiura** ●616-618
8-6, Ebisu 2-chome, Shibuya-ku, Tokyo 150  Tel.03-442-4896

**Tadayuki Minamoto** •580-584
23-20-101, Kita Shinjuku 1-chome, Shinjuku-ku, Tokyo 160 Tel.03-361-7348

**Kazuo Murase** •652·653
1-4, Kasumigaoka 4-chome, Tarumi-ku, Kobe-shi, Hyogo 655 Tel.078-708-7465

**Kazumi Nagasawa** •503
19-2, Rokkakubashi 1-chome, Kanagawa-ku, Yokohama-shi, Kanagawa 221 Tel.045-432-0516

**Shinichi Nagashima** •515-517
2F-13, Yoneyama-so, 2-7, Nishi Oizumi 1-chome, Nerima-ku, Tokyo 177 Tel.03-923-1606

**Yoichi Nagata** •555·556
60-11-302, Komazawa 2-chome, Setagaya-ku, Tokyo 154 Tel.03-424-4948

**Toshiaki Nakajima** •660-663
7-11, Kami Takada 1-chome, Nakano-ku, Tokyo 164

**Hiroshi Nakano** •576-579
6-20-207, Udagawa-cho, Shibuya-ku, Tokyo 150 Tel.03-462-5506

**Kenji Nakayama** •498
33-8-301, Nerima 2-chome, Nerima-ku, Tokyo 176 Tel.03-948-8087

**Chiharu Nishioka** •619-624
8-3, Kusatsu 2-chome, Kusatsu-shi, Shiga 525 Tel.0775-63-6791

**Yoshiaki Ochiai** •570-572
7-7, Shoman-cho 2-chome, Owariasahi-shi, Aichi 488 Tel.052-774-1324

**Shinji Okada** •666-671
Kamishinnyu Wada, Nogata-shi, Fukuoka 822 Tel.09492-3-2346

**Junichi Okuda** •613-615
787-60, Shibumi-cho, Tsu-shi, Mie 514 Tel.0592-27-3885

**Masatoshi Okumura** •680·681
5-A25-303, Satakedai 1-chome, Suita-shi, Osaka 565 Tel.06-871-7324

**Kiyokazu Onishi** •672-675
91, Oharano Ueba-cho, Nishigyo-ku, Kyoto-shi, Kyoto 610-11 Tel.075-331-0291

**Yasuyoshi Ono** •631-647
19, Oguchi-dori, Kanagawa-ku, Yokohama-shi, Kanagawa 221 Tel.045-421-1895

**Hisayoshi Osawa** •466-468
3-3-201, Minami Azabu 2-chome, Minato-ku, Tokyo 106 Tel.03-456-6909

**Hiroaki Oshima** •523
25-1-207, Sasazuka 2-chome, Shibuya-ku, Tokyo 151 Tel.03-375-4294

**Takashi Sakai** •504
7-6, Minami Aoyama 2-chome, Minato-ku, Tokyo 107 Tel.03-402-0607

**Shinichiro Sawano** •628-630
40-23, Narita Higashi 1-chome, Suginami-ku, Tokyo 166 Tel.03-315-5989

**Taizo Shimoda** •524
7-3-637, Shinmori 1-chome, Asahi-ku, Osaka-shi, Osaka 535 Tel.06-955-0793

**Yoshihide Shojima** ●562·563
67-9-201, Yoyogi 5-chome, Shibuya-ku, Tokyo 151  Tel.03-469-5763

**Masanobu Sugiyama** ●512-514
5th Fl., Alex, 16, Fukuzumi-cho 1-chome, Gifu-shi, Gifu 500  Tel.0582-53-1117

**Hideo Suzuki** ●469·525
5-10-106, Hayamiya 2-chome, Nerima-ku, Tokyo 176  Tel.03-935-3219

**Kunihiro Tachibana** ●567-569
6-7, Fukazawa 5-chome, Setagaya-ku, Tokyo 158  Tel.03-704-0982

**Tsutomu Tai** ●551-553
Nippon Commercial Photo, 14-1, Shibaura 3-chome, Minato-ku, Tokyo 108  Tel.03-455-6001

**Yoshihiro Takada** ●522
110-10, Rokuro-cho, Matsubara-dori Yamato Oji Higashi Iru 2-chome, Higashiyama-ku, Kyoto-shi, Kyoto 605  Tel.075-531-5528

**Izumi Takahashi** ●565·566
3-43-102, Kami Takada 2-chome, Nakano-ku, Tokyo 164  Tel.03-389-9828

**Kunihiro Takuma** ●601
Jingumae Office, 2-19-202, Jingumae 3-chome, Shibuya-ku, Tokyo 150  Tel.03-404-9661

**Hiromitsu Tanaka** ●573-575
6, Nopporo Yoyogi-cho 3-chome, Ebetsu-shi, Hokkaido 069-01  Tel.01138-4-3989

**Yuko Tanaka** ●589-591
10-11, Kami Saginomiya 3-chome, Nakano-ku, Tokyo 165  Tel.03-999-2484

**Chonosuke Teraoka** ●537-540
13-3-201, Miyazaki 1-chome, Miyamae-ku, Kawasaki-shi, Kanagawa 213  Tel.044-852-2505

**Mishiro Tokunaga** ●534-536
#202, Seiyu Heights, 506, Kizuki, Nakahara-ku, Kawasaki-shi, Kanagawa 211  Tel.044-433-5945

**Makoto Toyota** ●682-684
5-10, Shinoro 8-jo 2-chome, Kita-ku, Sapporo-shi, Hokkaido 002  Tel.011-771-9307

**Kunihiro Uehara** ●497
49-4, Chuo 4-chome, Nakano-ku, Tokyo 164  Tel.03-380-0910

**Kei Uesugi** ●559-561
Miura-so, 38-4, Saginomiya 3-chome, Nakano-ku, Tokyo 165  Tel.03-336-0924

**Jushi Watanabe** ●557·558
Studio Champ, 19-3-417, Dogenzaka 2-chome, Shibuya-ku, Tokyo 150  Tel.03-462-2729

**Hiroyuki Yagyu** ●481-483
12-3, Hanman-cho 2-chome, Abeno-ku, Osaka-shi, Osaka 545  Tel.06-623-2424

**Yasuko Yamamoto** ●476·477
13-11, Hatsudai 2-chome, Shibuya-ku, Tokyo 151  Tel.03-379-1168

**Naoko Yamashita** ●609-612
194-25, Takazukashinden, Matsudo-shi, Chiba 271  Tel.0473-91-5841

**Michiko Yanagioka** ●648-651
13-34, Tamai-cho 2-chome, Toyonaka-shi, Osaka 560  Tel.06-855-9666

**Takashi Yanoma** ●532·533
2-15-1122, Minami Aoyama 2-chome, Minato-ku, Tokyo 107  Tel.03-702-0098

**Shoichi Yokota** ●598-600
892, Tatsuno-machi, Nerima-ku, Tokyo 177  Tel.03-928-9302

**Muneyoshi Yoshida** ●685-688
#601, Ushimaki Bldg., 16, Horita Dori 6-chome, Mizuho-ku, Nagoya-shi, Aichi 467  Tel.052-881-4160

# ADVERTISING PRODUCTION DIVISION

This category is designed to promote a new social awareness of the communicative power of photographs in advertising, and clearly shows current trends and the high technical level of photographic expression in Japan. The works cover a broad range of advertising material, including posters, magazines, calendars, and direct mail items, published between October 1, 1981, and September 30, 1983. Of the 3,248 submissions, 332 were selected for inclusion. They include a few works by non-Japanese photographers for Japanese enterprises.

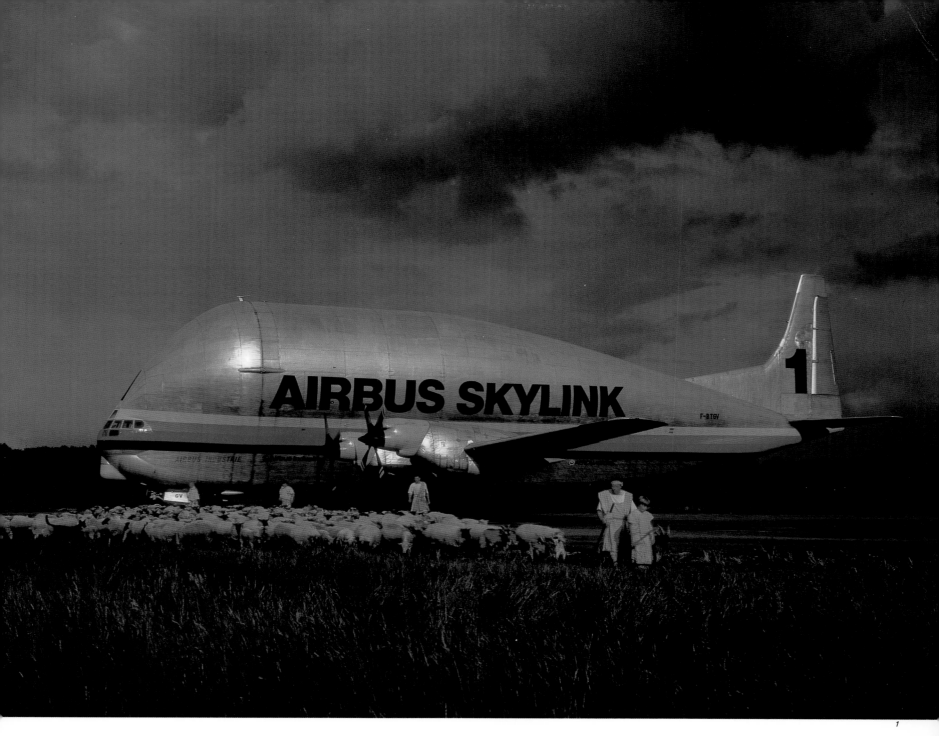

## APA Prize

●1-3 ●poster
camera film

| | |
|---|---|
| photographer | 高崎勝二 katsuji takasaki |
| ● | ● |
| art director | 宮崎晋 susumu miyazaki |
| designer | 小柳英治 eiji koyanagi |
| | 千葉篤 atsushi chiba |
| | 大貫卓也 takuya onuki |
| copywriter | 笠原伸介 shinsuke kasahara |
| | 藤浦圭一郎 keiichiro fujiura |
| production | ㈱博報堂 hakuhodo |
| advertiser | 小西六写真工業㈱ |
| | konishiroku photo ind. |

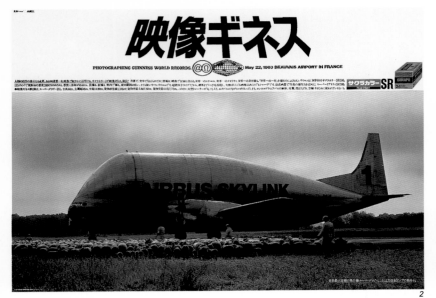

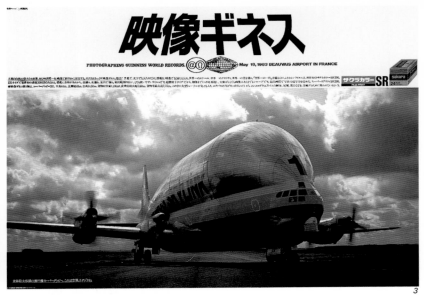

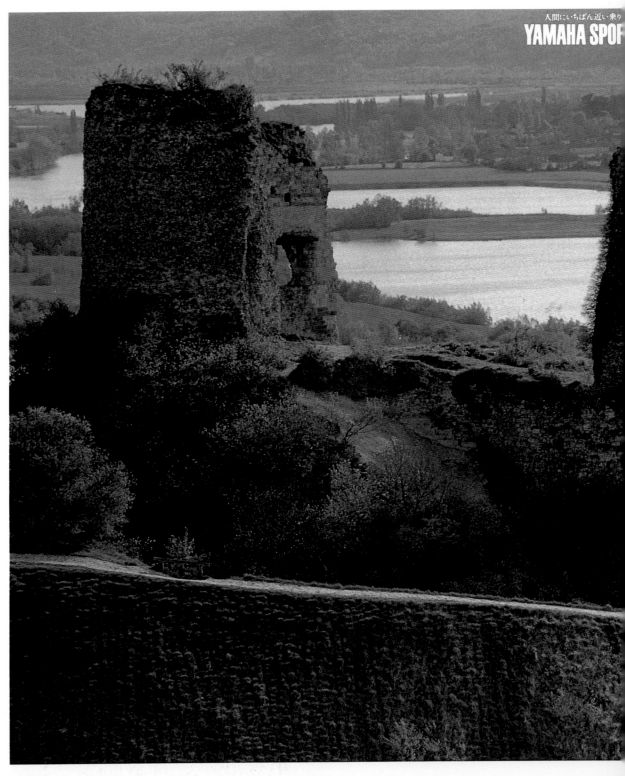

## APA Prize

● 4-7    ● calendar
         motorbikes

| | | |
|---|---|---|
| photographer | 高崎勝二 | katsuji takasaki |
| art director | 田中康之 | yasuyuki tanaka |
| designer | 田中康之 | yasuyuki tanaka |
| copywriter | 渡辺悦男 | etsuo watanabe |
| agency | ㈱電通 | dentsu |
| production | ㈱電通 | dentsu |
| advertiser | ヤマハ発動機㈱ | yamaha motor |

**8** *AUGUST*

| mon | tue | wed | thu | fri | sat | sun | mon | tue | wed | thu | fri | sat | sun |
|---|---|---|---|---|---|---|---|---|---|---|---|---|---|
| 1 | 2 | 3 | 4 | 5 | 6 | 7 | 8 | 9 | 10 | 11 | 12 | 13 | 14 |

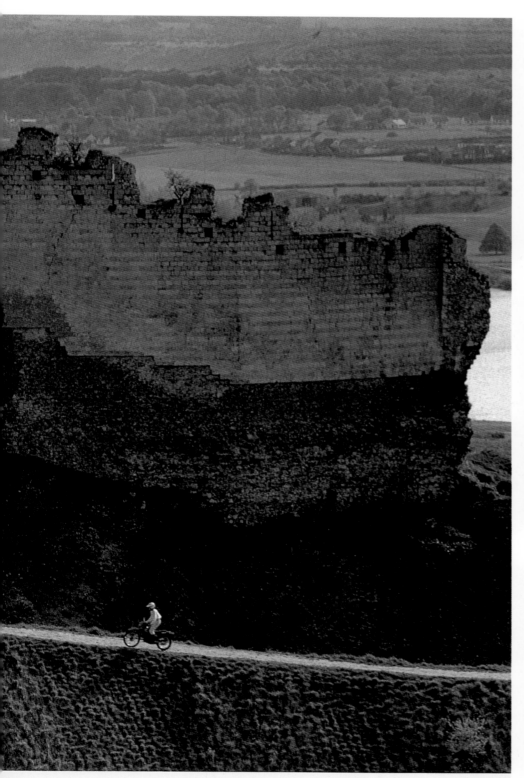

YAMAHA SPORTS BIKE

YAMAHA SPORTS BIKE

CREPERIE RESTAURANT

YAMAHA SPORTS BIKE

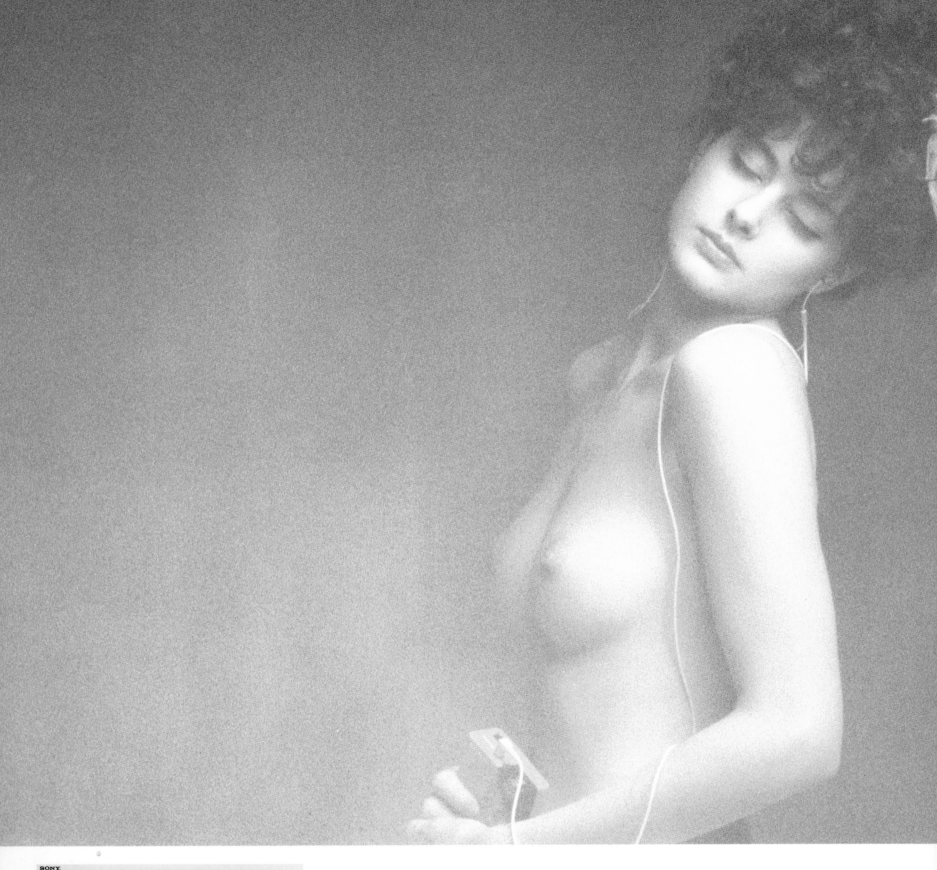

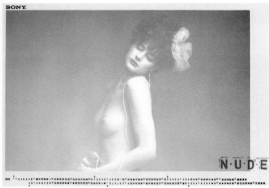

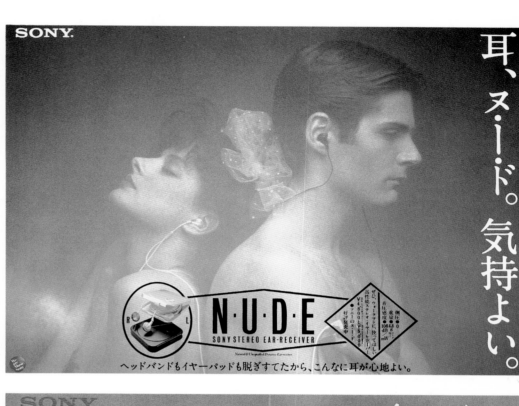

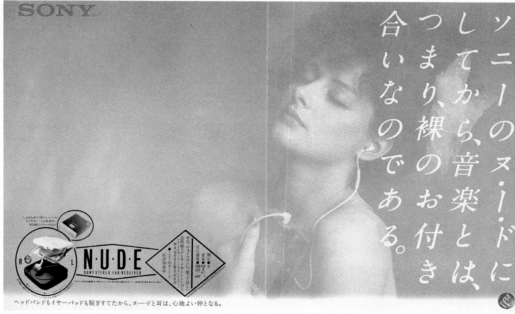

## APA Prize

●8　●calendar
●9　●magazine
●10　●poster
　　　audio equipment

photographer　相川喜伸 yoshinobu aikawa
●
art director　葛西薫 kaoru kasai
designer　鈴木司 tsukasa suzuki
　　　西川哲生 tetsuo nishikawa
copywriter　山之内慎一 shinichi yamanouchi
agency　㈱サン・アド sun-ad
production　㈱サン・アド sun-ad
advertiser　ソニー㈱ sony

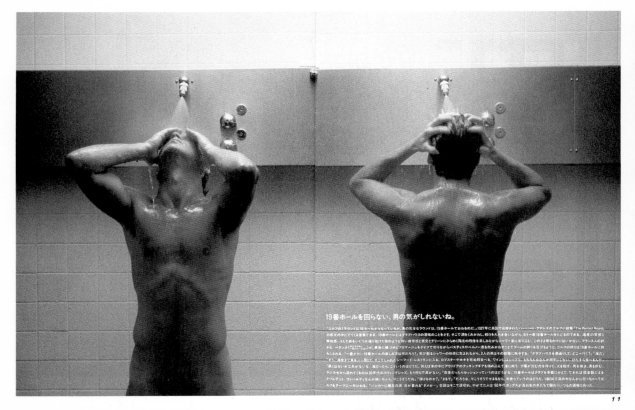

19番ホールを回らない、男の気がしれないね。

11

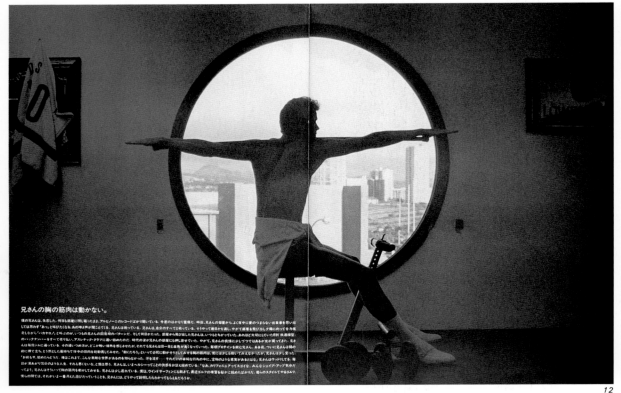

兄さんの胸の筋肉は動かない。

12

## APA Prize

● 11-13　　　● pamphlet
　　　　　　　 sportswear

photographer　秋元茂 shigeru akimoto
●　　　　　　　●

art director　宮原鉄生 tetsuo miyahara
designer　　　安福慧至 satoshi yasufuku
copywriter　　長倉添一 kyoichi nagakura
production　　㈱デルタモンド deltamonde
advertiser　　㈱デサント descente

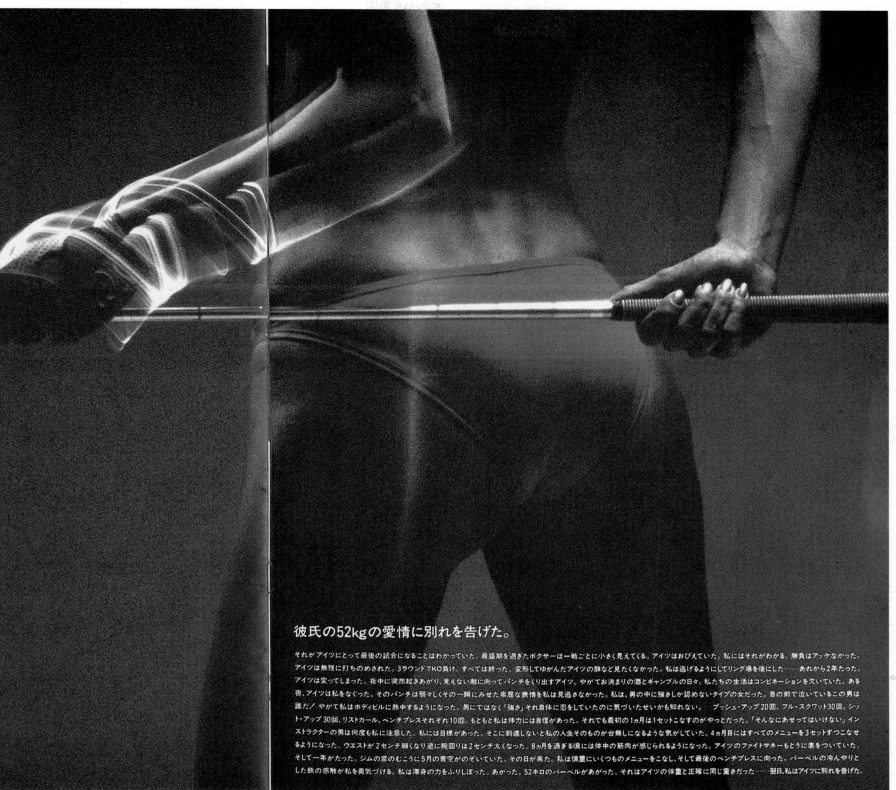

## 彼氏の52kgの愛情に別れを告げた。

それがアイツにとって最後の試合になることはわかっていた。最盛期を過ぎたボクサーは一戦ごとに小さく見えてくる。アイツはおびえていた。私にはそれがわかる。勝負はアッケなかった。アイツは無残に打ちのめされた。3ラウンドTKO負け。すべては終った。変形してゆがんだアイツの顔など見たくなかった。私は逃げるようにしてリング場を後にした……あれから2年たった。アイツは変ってしまった。夜中に突然起きあがり、見えない敵に向ってパンチをくり出すアイツ。やがてお決まりの酒とギャンブルの日々。私たちの生活はコンビネーションを欠いていた。ある夜、アイツは私をなぐった。そのパンチは弱々しくその一瞬にみせた卑屈な表情を私は見逃さなかった。私は、男の中に強さしか認めないタイプの女だった。目の前で泣いているこの男は誰だ！　やがて私はボディビルに熱中するようになった。男にではなく「強さ」それ自体に恋をしていたのに気づいたせいかも知れない。　プッシュ・アップ20回。フル・スクワット30回。シット・アップ30回、リストカール、ベンチプレスそれぞれ10回。もともと私は体力には自信があった。それでも最初の1ヵ月は1セットこなすのがやっとだった。「そんなにあせってはいけない」インストラクターの男は何度も私に注意した。私には目標があった。そこに到達しないと私の人生そのものが台無しになるような気がしていた。4ヵ月目にはすべてのメニューを3セットずつこなせるようになった。ウエストが2センチ細くなり逆に腕回りは2センチ太くなった。8ヵ月を過ぎる頃には体中の筋肉が感じられるようになった。アイツのファイトマネーもとうに底をついていた。そして一年がたった。ジムの窓のむこうに5月の青空がのぞいていた。その日が来た。私は慎重にいくつものメニューをこなし、そして最後のベンチプレスに向った。バーベルの冷んやりとした鉄の感触が私を勇気づける。私は渾身の力をふりしぼった。あがった。52キロのバーベルがあがった。それはアイツの体重と正確に同じ重さだった……翌日、私はアイツに別れを告げた。

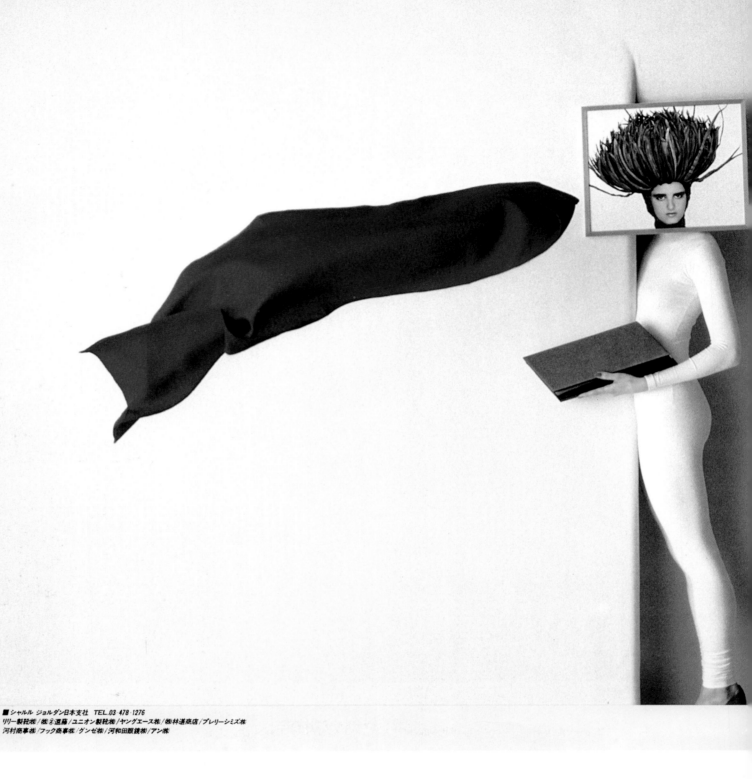

SCARF 011001 ¥10,000
HANDBAG No.75 ¥31,000

■シャルル ジョルダン日本支社　TEL.03・478・1276
リリー製靴㈱/㈱遠藤/ユニオン製靴㈱/ヤングエース㈱/㈱林道商店/プレリーシミズ㈱
河村商事㈱/フック商事㈱/グンゼ㈱/河和田眼鏡㈱/アン㈱

## APA Prize

● 14・17　　●magazine
● 15・16　　●poster
　　　　　　　fashion(14・16)
　　　　　　　shoes(15・17)

photographer　片平義宣 gisen katahira
●
art director　福田毅 tsuyoshi fukuda
designer　戸田伸二 shinji toda
agency　スタンダード通信社
　　　　standard advertising (14・16・17)
　　　　信和広告㈱ shinwa kokoku (15)
production　クリエイティブスタジオ・カメレオン
　　　　　　chameleon
advertiser　シャルル・ジョルダン日本支社
　　　　　　charles jourdan japan

● 18　　●poster
　　　　　fashion

photographer　樫山宗己 muneki kashiyama
●
art director　福田毅 tsuyoshi fukuda
designer　戸田伸二 shinji toda
agency　スタンダード通信社
　　　　standard advertising
production　クリエイティブ・スタジオ・カメレオン
　　　　　　chameleom
advertiser　シャルル・ジョルダン日本支社
　　　　　　charles jourdan japan

CHARLES JOURDAN

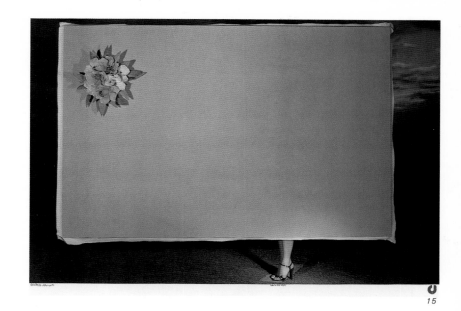

15

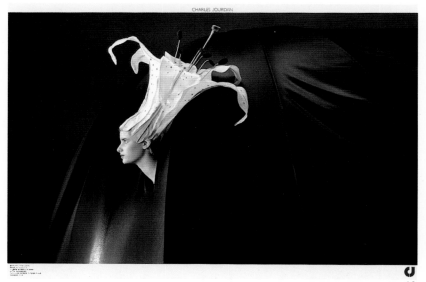

16

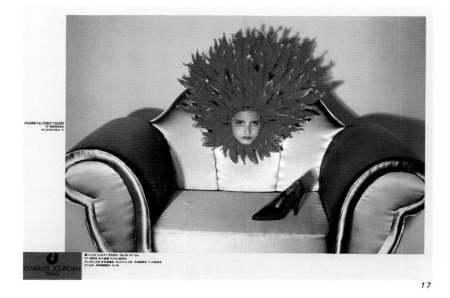

17

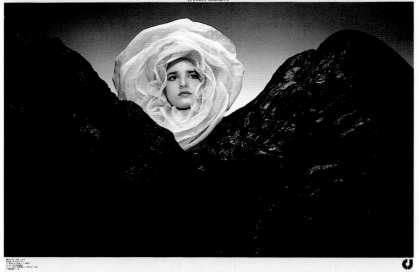

18

14

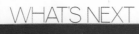

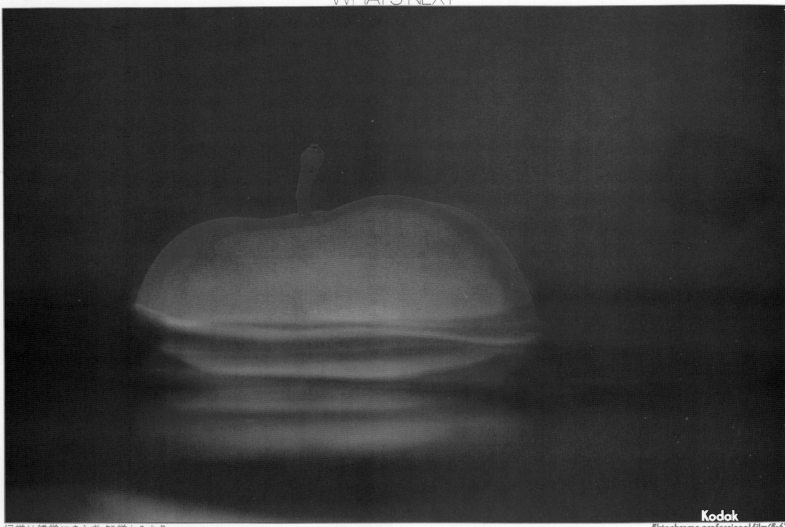

幻覚は錯覚にあらず、知覚とみたり。

Kodak
Ektachrome professional film〈E-6〉

*19*

WHAT'S NEXT

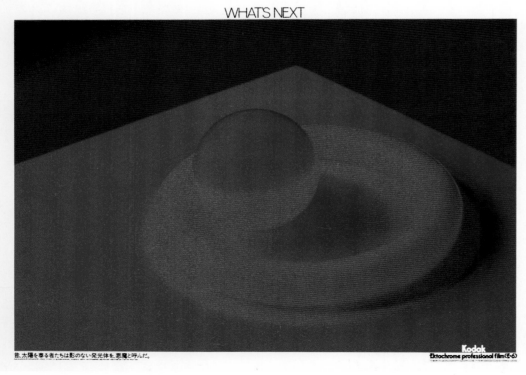

昔、太陽を奪る者たちは影のない発光体を悪魔と呼んだ。

Kodak
Ektachrome professional film〈E-6〉

## APA Prize

●*19·20*　　●*poster*
　　　　　　　　camera film

| | | |
|---|---|---|
| *photographer* | 高井哲朗 | tetsuro takai |
| ● | | |
| *art director* | 森田純一郎 | junichiro morita |
| *designer* | 森田純一郎 | junichiro morita |
| *copywriter* | 関橋英作 | eisaku sekihashi |
| *agency* | J.W.トンプソン | j.w. thompson |
| *production* | J.W.トンプソン | j.w. thompson |
| *advertiser* | 長瀬産業㈱ | nagase |

Kodak Ektachrome professional film (E-6)

## *Tokyo-region Prize*

●21　　　●*poster*
　　　　　　*camera film*
*photographer*　三好和義 kazuyoshi miyoshi
●
*art director*　森田純一郎 junichiro morita
*designer*　森田純一郎 junichiro morita
*copywriter*　関橋英作 eisaku sekihashi
*agency*　J.W.トンプソン j.w.thompson
*production*　J.W.トンプソン j.w.thompson
*advertiser*　長瀬産業㈱ nagase

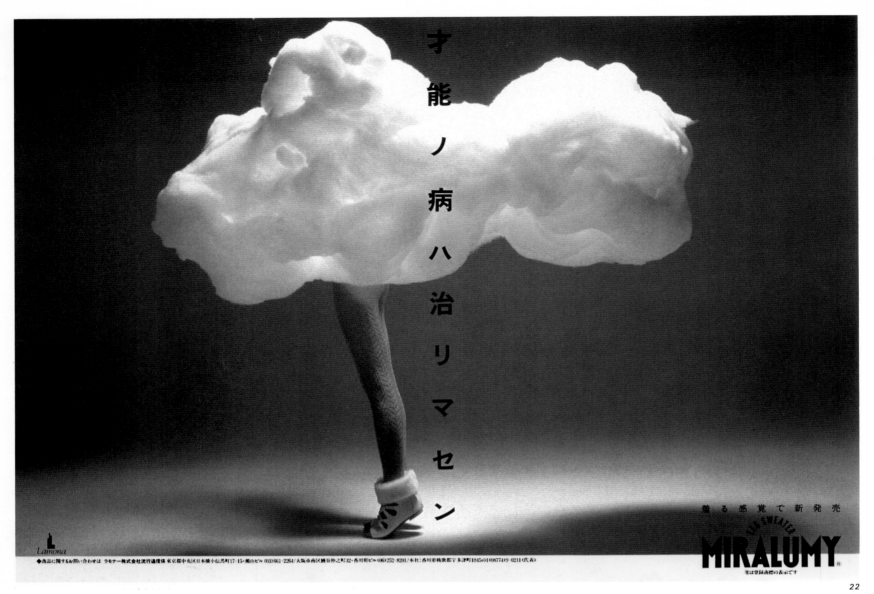

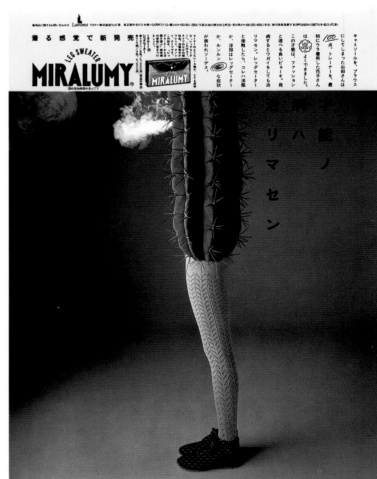

## Kansai-region Prize

●22·23 ●*magazine*
 *hosiery*

| | | |
|---|---|---|
| photographer | 高橋榮 | sakae takahashi |
| ● | | |
| art director | 小山禎朋 | teiho koyama |
| designer | 大島光二 | koji oshima |
| copywriter | 田岡久子 | hisako taoka |
| production | a.c. | |
| advertiser | lamona | |

第31回サファリ・ラリーは、我がスバル、そして初陣である4WD・RXにとどまらず、日本車と日本のラリーストにとって記念すべき「サファリ」となった。その5日間はドライコンディションで、いつになく高速かつ苛酷。4WD・RXは高岡祥郎/砂原茂雄のドライブ/ナビを得て、日本人として初の史上最高総合5位でゴールしたのである。さらに、高橋嘉信も昨年に続き総合7位でフィニッシュ。快挙である。これは日本の純血チームが到達できる、最初にして最後の総合5位という見方もある。これに、栄光のマシン4WD・RXがドライバーたる高岡らの手によって開発された量販車であることも付け加えておきたい。サファリ・ラリー 史上、及び、車の開発史上注目すべき事実として…。

# THE SAFARI 5

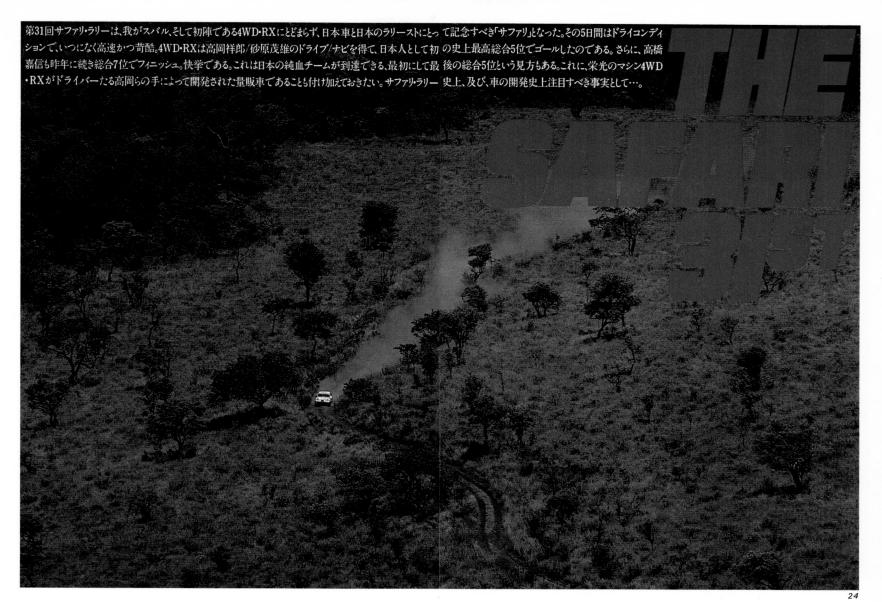

24

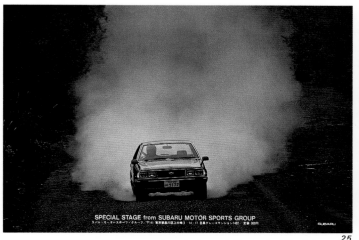

SPECIAL STAGE from SUBARU MOTOR SPORTS GROUP

25

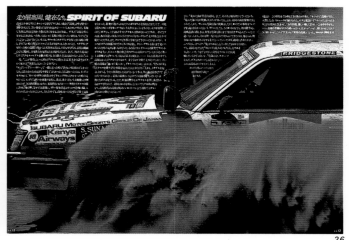

SPIRIT OF SUBARU

26

Competitive 4WD RX

27

## Chubu-region Prize

●24・26 ●pamphlet
motorcars

photographer 尾関一 hajime ozeki

●
art director 天野弘史 hiroshi amano
copywriter 天野弘史 hiroshi amano
production スバル・インターナショナル
subaru international
advertiser subaru motor sports group

●25 ●pamphlet
●27 ●magazine
motorcars

photographer 尾関一 hajime ozeki

●
art director 富士重工㈱宣伝課 fuji heavy ind.
designer 富士重工㈱宣伝課 fuji heavy ind.
copywriter 富士重工㈱宣伝課 fuji heavy ind.
advertiser subaru motor sports group (25)
富士重工㈱ fuji heavy ind. (27)

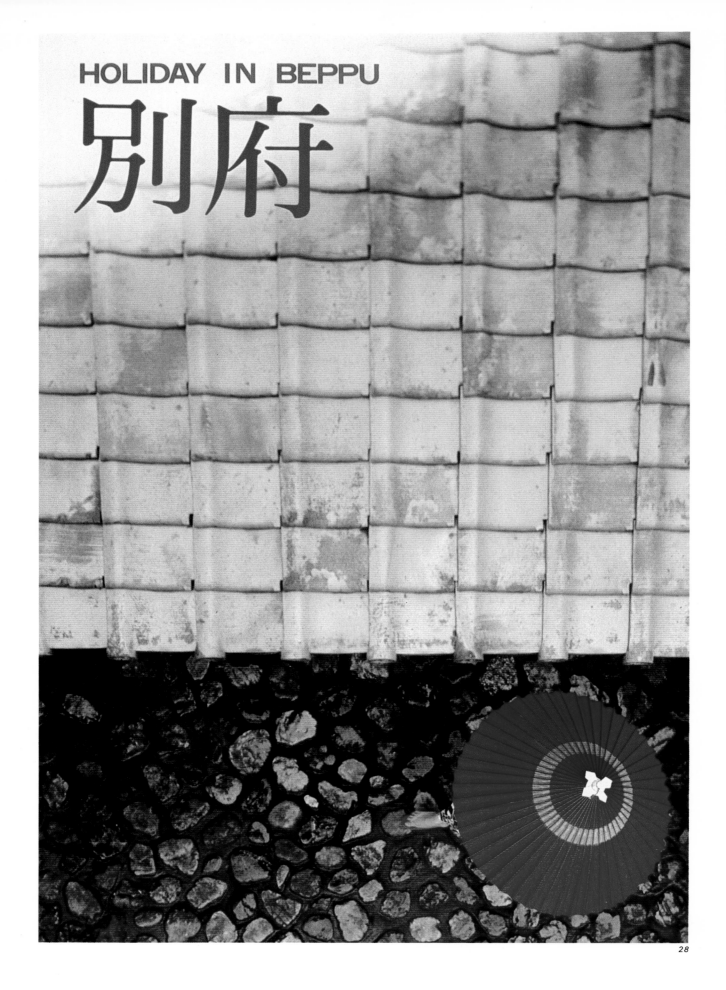

HOLIDAY IN BEPPU

別府

### *Kyushu-region Prize*

●28            ●*pamphlet*
                *tourist promotion*
*photographer* 竹内康訓 yasunori takeuchi
●              ●
*art director*  菅瞭三 ryozo kan
*designer*      江崎義博 yoshihiro ezaki
*copywriter*    丹後正通 masamichi tango
*agency*        ㈱電通大分 dentsu oita
*production*     ㈱アド・パスカル ad pasukaru
*advertiser*    別府市 beppu city

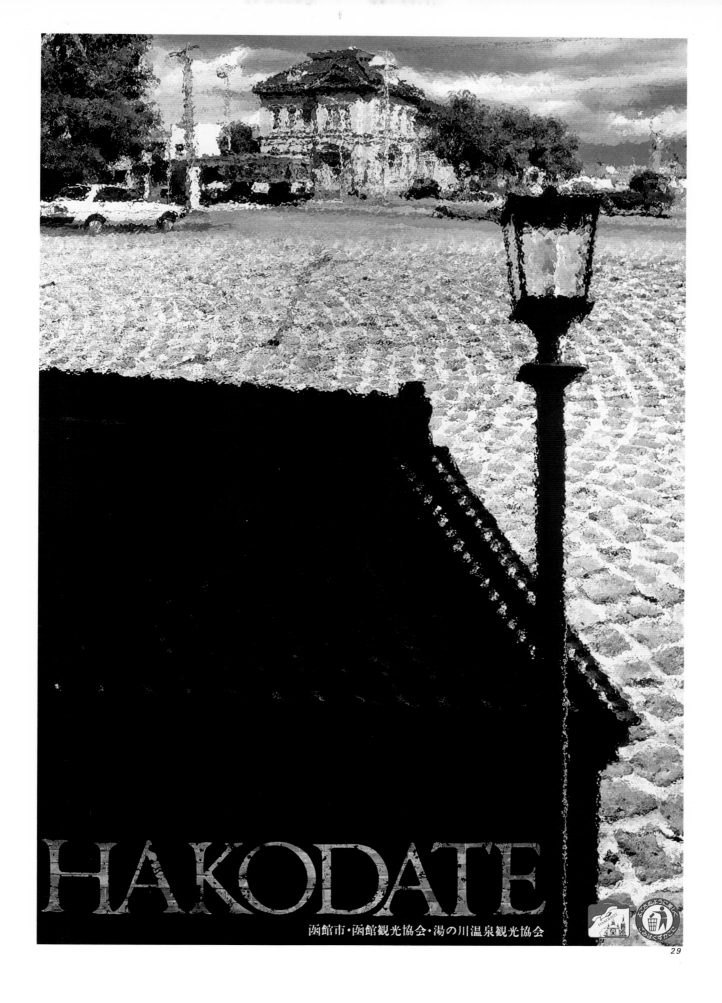

HAKODATE

函館市・函館観光協会・湯の川温泉観光協会

### Hokkaido-region Prize

●29　　　●poster
　　　　　 tourist promotion

photographer　吉村博道 hiromichi yoshimura
　　　　　　　　●
art director　　吉村博道 hiromichi yoshimura
designer　　　 小畠昭一 shoichi obata
production　　　有道映写真 dohei
advertiser　　　函館市 hakodate city

31

32

33

34

30

30

●30-34　　●magazine cover

photographer　篠山紀信 kishin shinoyama
●
art director　長友啓典 keisuke nagatomo
advertiser　朝日新聞社 asahi shinbun publish.

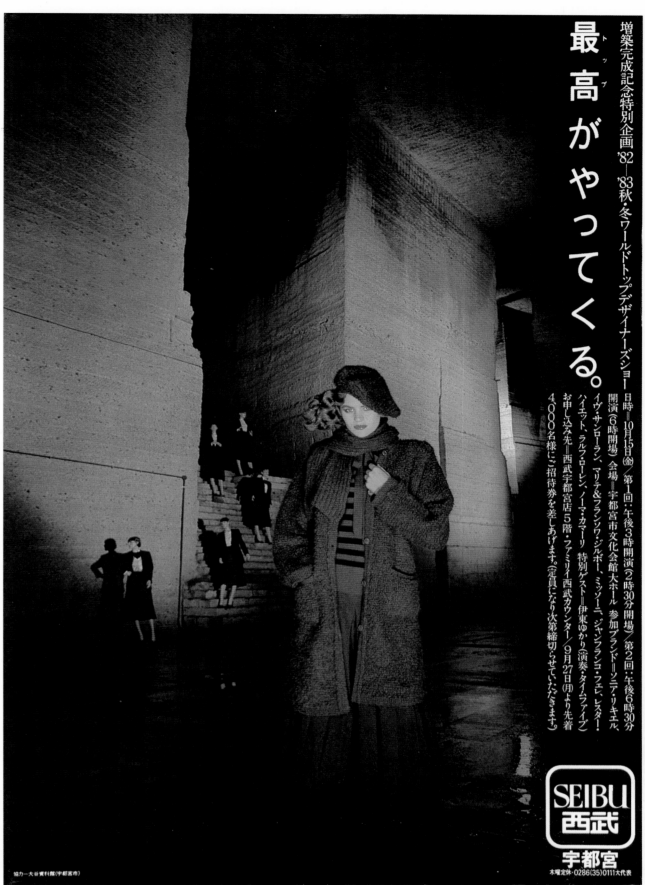

最高がやってくる。

おもしろい人しか、つまらない。

●35  ●poster
          fashion
photographer  高崎勝二 katsuji takasaki
●
art director  吉田臣 shin yoshida
designer     本間久 hisashi honma
copywriter   岩崎俊一 shunichi iwasaki
production   コミュニケーション・アーツ・R
             communication arts r
advertiser   ㈱西武百貨店 seibu dept.

●36  ●poster
          department store
photographer  半田也寸志 yasushi handa
●
art director  吉田臣 shin yoshida
designer     本間久 hisashi honma
copywriter   糸井重里 shigesato itoi (36)
             岩崎俊一 shunichi iwasaki (37)
production   コミュニケーション・アーツ・R
             communication arts r
advertiser   ㈱西武百貨店 seibu dept.

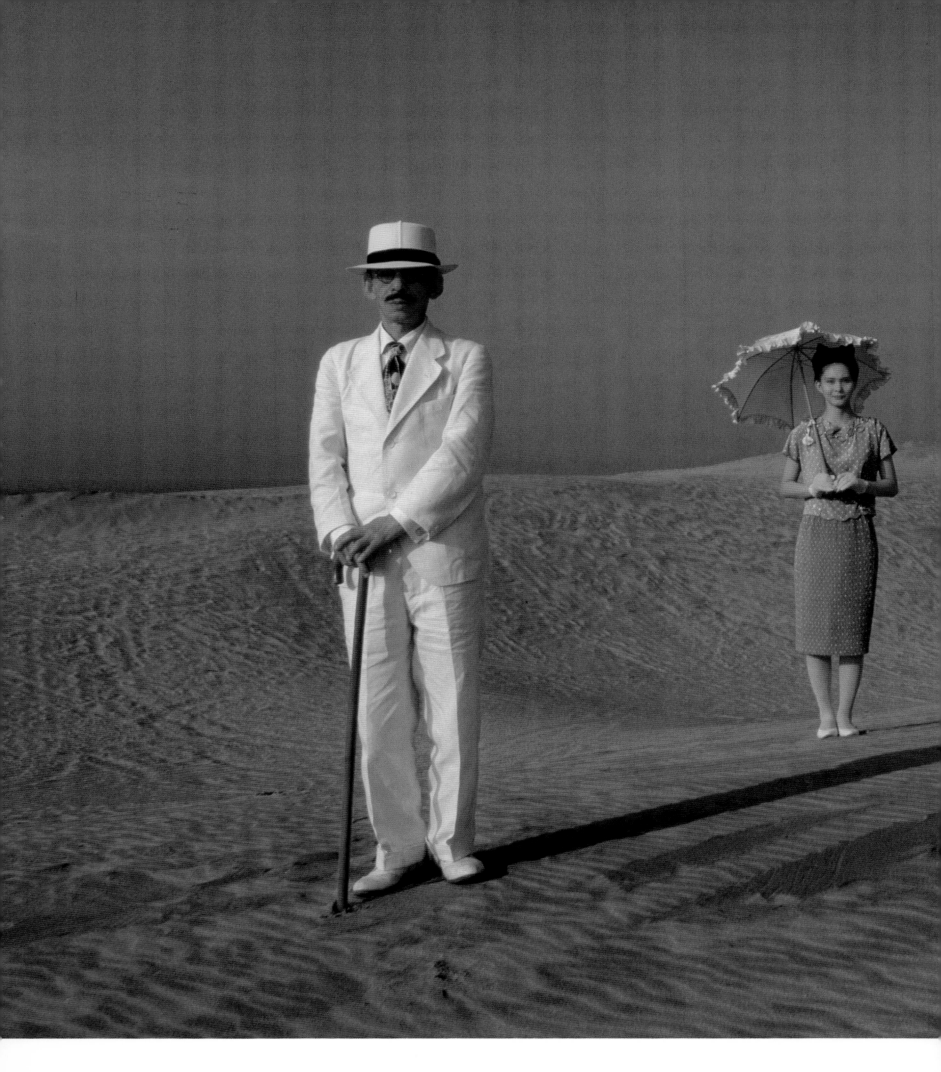

●37    ●*poster*
        *department store*
photographer   半田也寸志 yasushi hando
●              ●
art director   吉田臣 shin yoshida
designer       本間久 hisashi honma
copywriter     糸井重里 shigesato itoi
               岩崎俊一 shunichi iwasaki
production     コミュニケーション・アーツ・R
               communication arts r
advertiser     ㈱西武百貨店 seibu dept.

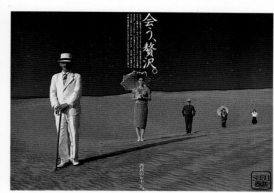

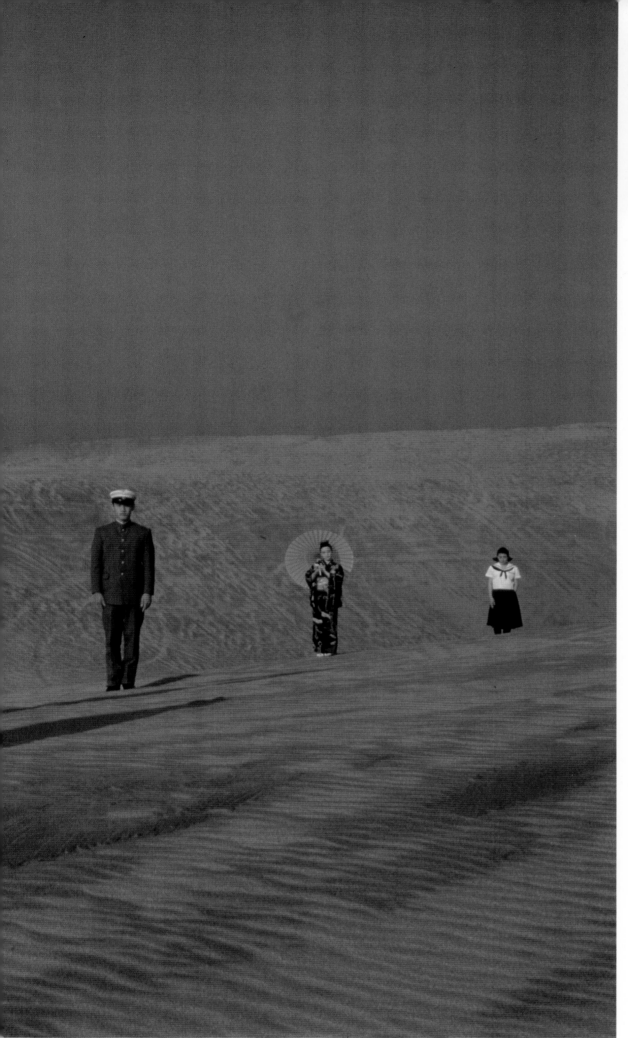

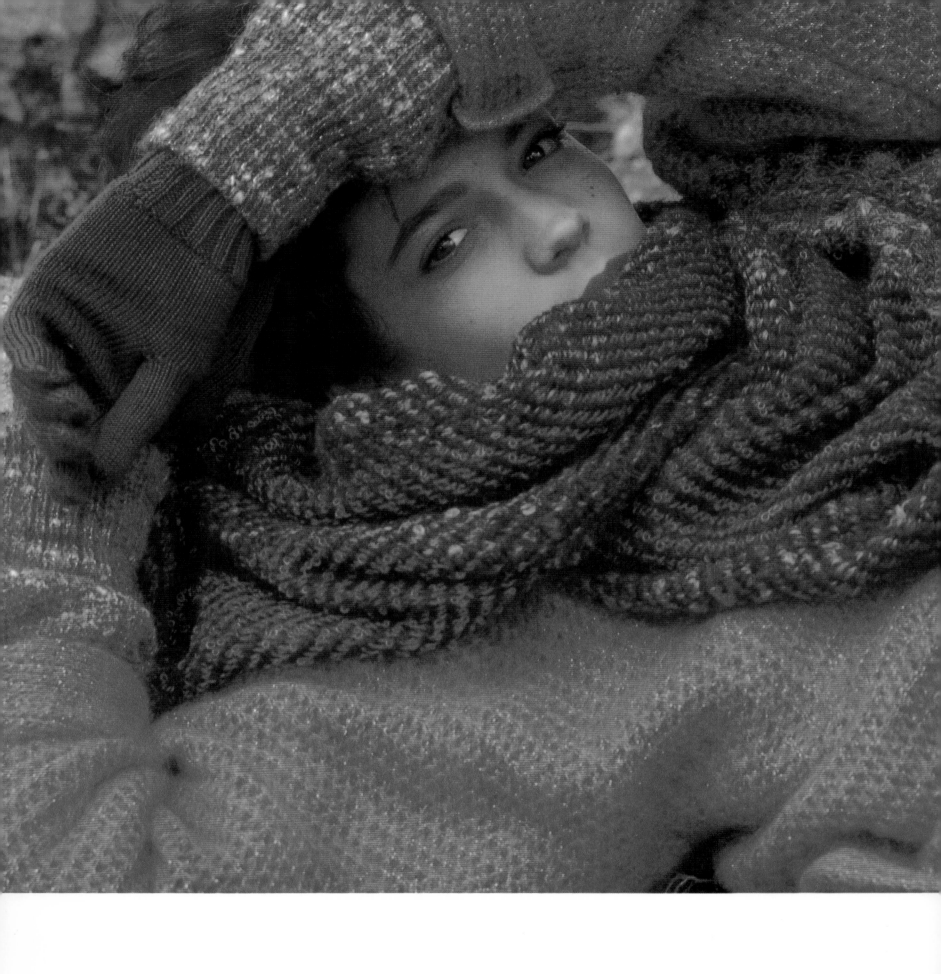

枯れ葉色のコートを作ろうと思い立ったのは、
親愛なるサガン、あなたひとりじゃないわ。

38

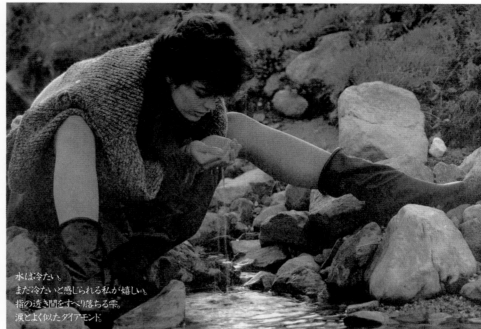

水は冷たい。
まだ冷たいと感じられる私が嬉しい。
指の透き間をすべり落ちる雫。
涙とよく似たダイアモンド。

39

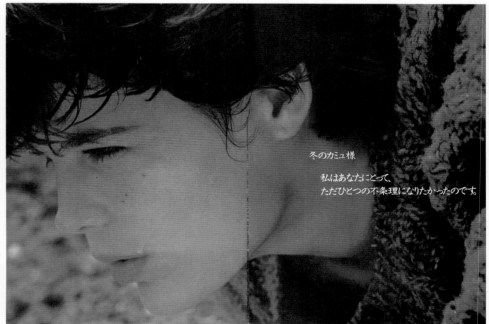

冬のカミュ様

私はあなたにとって、
ただひとつの不条理になりたかったのです。

38

40

●38-40　●pamphlet
　　　　　　fashion
photographer　半田也寸志 yasushi handa
●
art director　原田尚子 naoko harada
designer　　　田中俊紀 toshiki tanaka
copywriter　　森下泰幸 yasuyuki morishita
production　　マックスA.A. max a.a.
advertiser　　㈱三陽商会 sanyo shokai

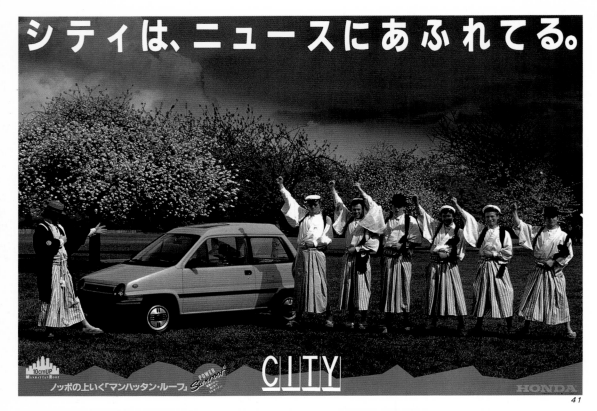

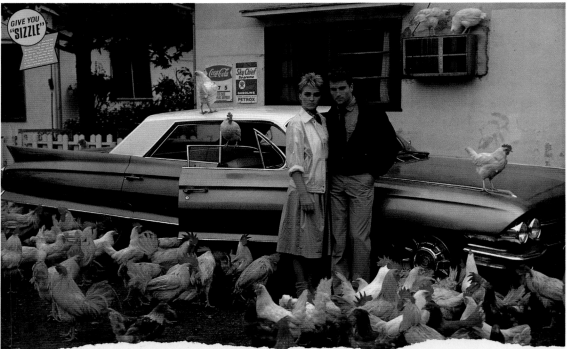

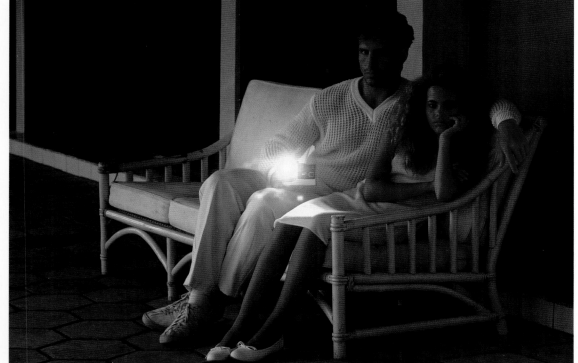

41

42

43

43

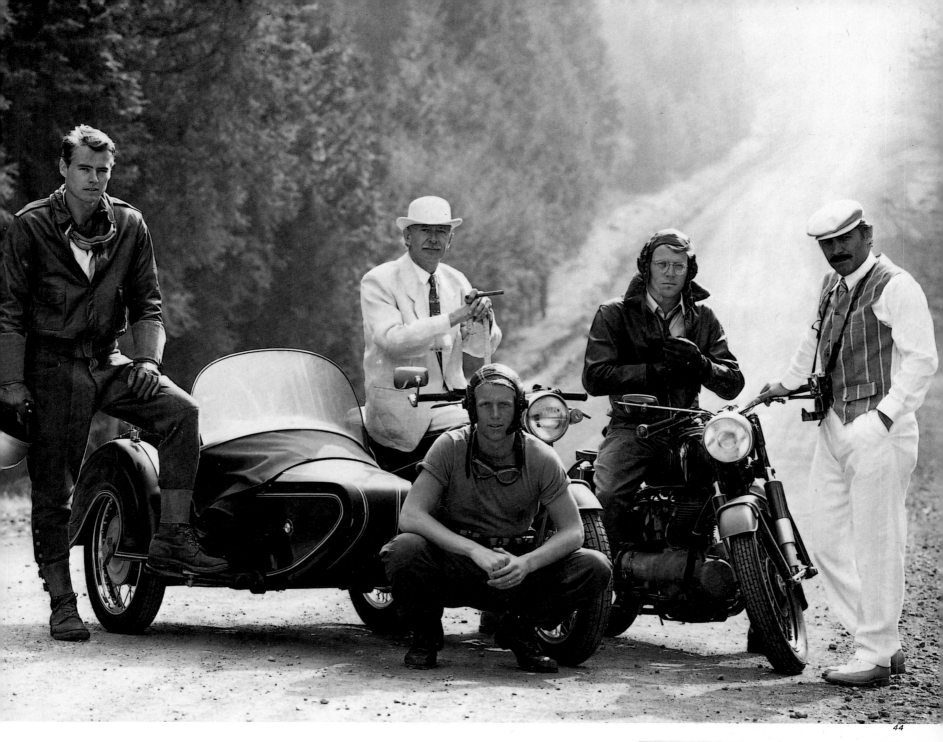

In the century since its invention, the motorcycle has given a new dimension to adventure. The great outdoors has become the bike rider's best friend.

44

44

AUSTRALIA
A BIKE RIDER'S PARADISE

45

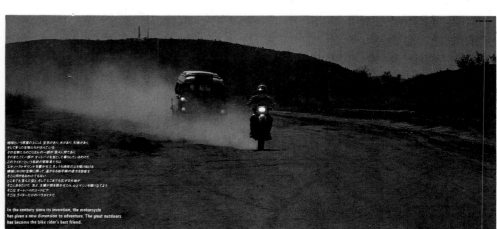

In the century since its invention, the motorcycle has given a new dimension to adventure. The great outdoors has become the bike rider's best friend.

46

47

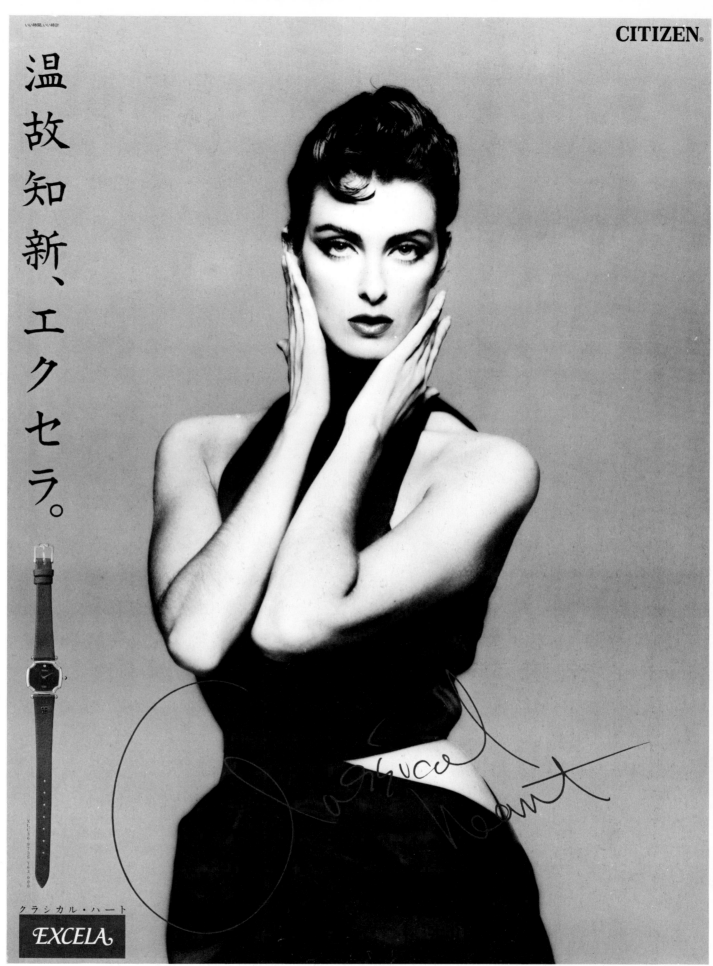

●47·48　　●poster
　　　　　　　wristwatches
*photographer*　横須賀功光 noriaki yokosuka
*　*
*art director*　山口誠 makoto yamaguchi
　　　　　　　三枝幸友 yukitomo saegusa
*designer*　鶴川和彦 kazuhiko tsurukawa
　　　　　　　杉山啓子 keiko sugiyama
*copywriter*　秋場良一 ryoichi akiba
*agency*　㈱博報堂 hakuhodo
*production*　㈱スタジオコム studio com
*advertiser*　シチズン商事㈱ citizen

PENTAX

君がオトナになる頃、僕はプロになっているかもしれない。

●49        ●poster                    ●50-52       ●magazine
            cameras                                 camera film

photographer  藤井英男 hideo fujii      photographer  藤井保 tamotsu fujii
●                                     ●
art director  副田高行 takayuki soeda    art director  龍山悠一 yuichi tatsuyama
designer      副田高行 takayuki soeda    designer      龍山悠一 yuichi tatsuyama
copywriter    喜多嶋隆夫 takao kitajima   copywriter    越前昭彦 akihiko koshimae
production    ㈱サン・アド sun-ad         production    ㈱クリエイティブハウスCA
advertiser    旭光学商事㈱ asahi optical                creative house ca
                                      advertiser    富士写真フィルム㈱ fuji photo film

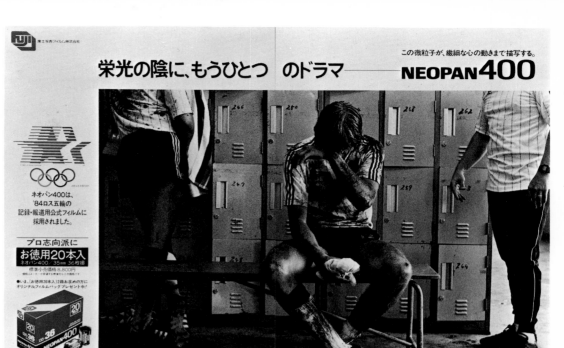

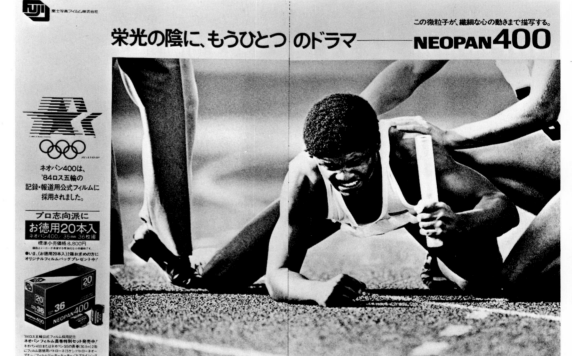

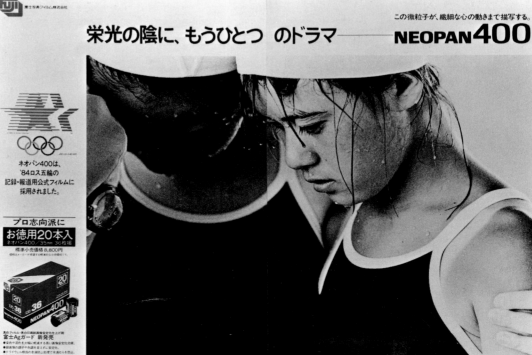

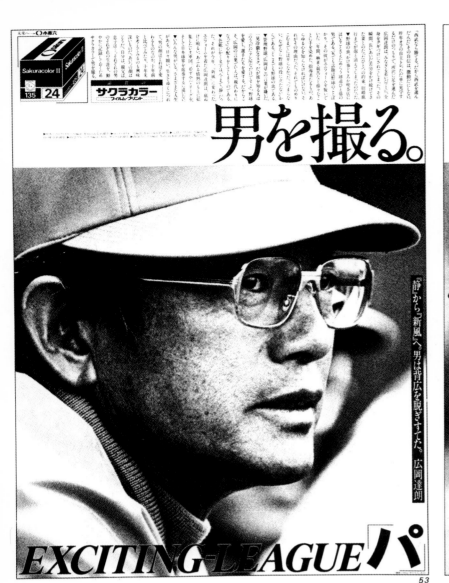
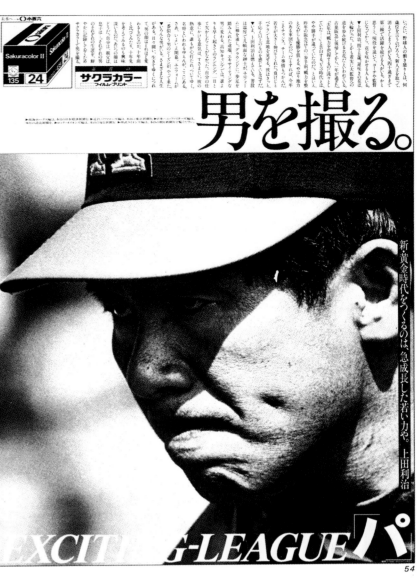
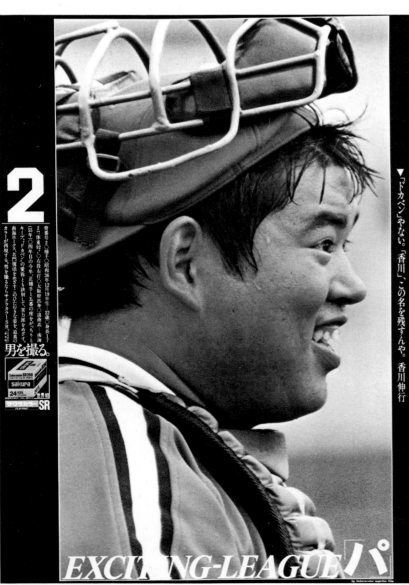
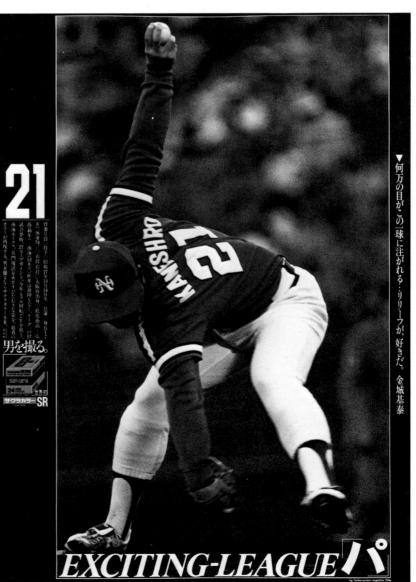

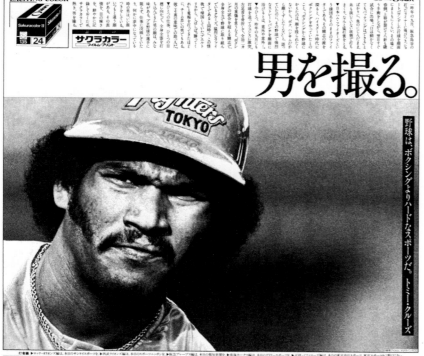

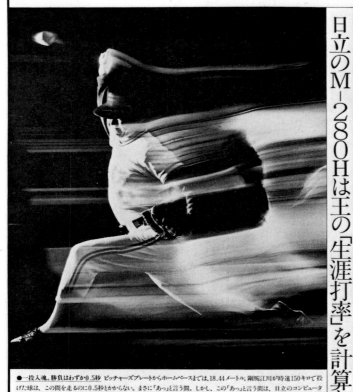

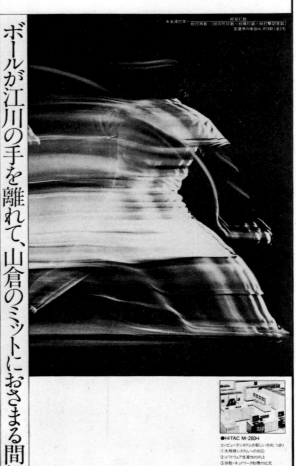

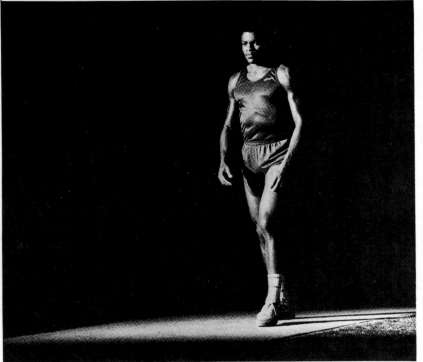

ゼロックスの決意。

精神集中
Carl Lewis
カール・ルイス Carl Lewis
"コンピューターに回転がかったサラブレッド"
押せばUICAC24たC大でで、100メートル走を制覇すた
2種目混じり、世界記録保持。世界記録目をめざして
などの、100メートルの世界記録行の手前かくなってからG0世界
自然に、史本組合すがすメートル76万を記念の世界最保持。
ゼロックスはわたしがとピッぞとデリフリーニーひきります。
●100通走メタルが自保証されている。22歳。

1983年、わたしたちは、全力をこめたスタート・ダッシュで走り出し
ます。内に秘め、貯えたものをいっ気に爆発させるスパートです。より、
速くあるために。一瞬のうちにすべてを後にできる、独走の脚力を
お見せします。より、美しくあるために。可能性にむかって、すべての力を
こめて飛躍します。つねに新しく、比類ない存在であるために。無人の
地平にむかって、大きなストライドで力走します。ゼロックスは、ゼロックス。
それを実証するために、卓越にむかって、ひたすら走り続けます。

**XEROX**

59

挑む。

Carl Lewis
カール・ルイス Carl Lewis
挑む、ヘッジングまであることからめの
世界最速と瞬で疾て、100メートル走を制覇
46秒トータレーニーに2種目でなを制ゆの、「超えんの世界記録
「超えんの世界記録」をめざす。
グルズの夢、22歳。

理想を高く掲げ
ここまで自動化した。
ゼロックス1075RFタイプ
新発売。

新製品、ゼロックス107SRFタイプは、
速さ、美しさをはじめ、縮小コピー、
両面コピーなど、さまざまな機能を高め、
みがきあげたうえで、いっさいすべてを、
自動化しました。必要事項をボタンで指示し、
原稿を重ねたままセット、スタートボタンを
押せば、あとは、すべて自動。1分間70枚の
高速で両面原稿からそのまま自動的に
両面コピーし、必要な部数を正しい
ページ順に、1部1部、互い違いにトレイに出し、
必要にあわせて、ソーテックスもします。
原稿をボタン装てるだけで、あなたなものが必要な
だけ、綴じられたかたちで手にできる、これは、
いま世にある複写機技術の数員の集合体、
高速・高性能複写機の理想に、限りなく近い
（東京・大阪地区で発売開始）。

富士ゼロックス株式会社
〒107 東京都港区赤坂3-2-5 電話(583)3211
XEROXは登録商標です。

**XEROX**

60

精神力だけでは、テープを切れない。

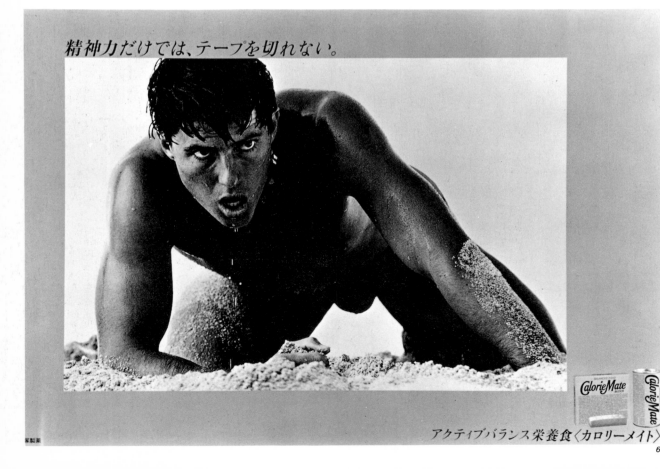

CalorieMate
アクティブバランス栄養食〈カロリーメイト〉

●59 ●newspaper
photocopy machines

photographer 安斉吉三郎 kichisaburo anzai
art director 柳町恒彦 tsunehiko yanagimachi
designer 柳町恒彦 tsunehiko yanagimachi
copywriter 桝田弘司 koji masuda
agency ㈱電通 dentsu
production ㈱電通 dentsu
advertiser 富士ゼロックス㈱ fuji xerox

●60 ●newspaper
photocopy machines

photographer 國房魁 hajime kunifusa
art director 柳町恒彦 tsunehiko yanagimachi
designer 河合薫 kaoru kawai
copywriter 桝田弘司 koji masuda
production ㈱電通 dentsu
advertiser 富士ゼロックス㈱ fuji xerox

●61 ●poster
soft drinks

photographer 目羅勝 masaru mera
art director 細谷巌 gan hosoya
designer 関勲 isao seki
copywriter 秋山晶 sho akiyama
agency ㈱ライトパブリシティ light publicity
production ㈱ライトパブリシティ light publicity
advertiser 大塚製薬㈱ otsuka pharmaceutical

61

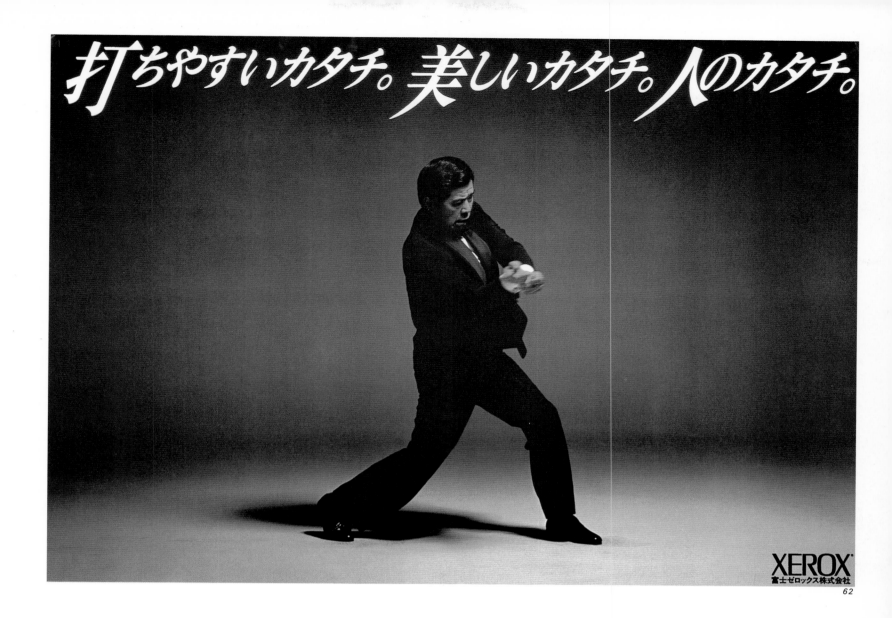

打ちやすいカタチ。美しいカタチ。人のカタチ。

**XEROX**
富士ゼロックス株式会社
62

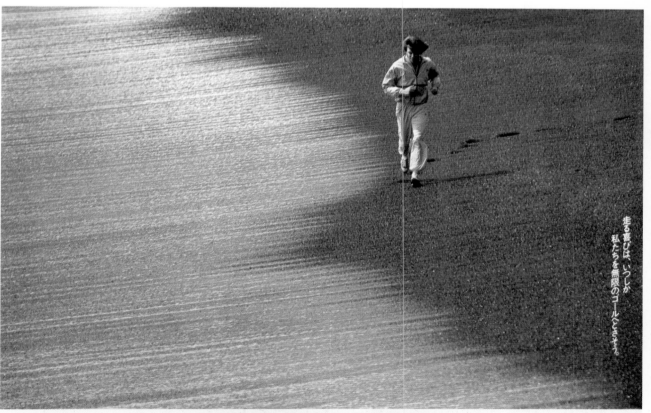

走る喜びは、いつしか私たちを無限のゴールへとさそう。

**THERE IS NO FINISH LINE.**

63

●62　●poster
　　　photocopy machines

photographer　白鳥真太郎 shintaro shiratori
●
art director　長谷川幸興 yukioki hasegawa
　　　　　　　祖父江将浩 masahiro sobue
designer　　　佐藤ヒロム hiromu sato
copywriter　　若山憲二 kenji wakayama
agency　　　　㈱博報堂 hakuhodo
production　　 ㈱博報堂 hakuhodo
advertiser　　 富士ゼロックス㈱ fuji xerox

●63　●poster
　　　sports shoes

photographer　前原光臣 mitsuomi maehara
●
art director　㈱マイル・ポスト mile post
designer　　　甲賀友章 tomoaki koga
copywriter　　樋口和彦 kazuhiko higuchi
production　　 ㈱マイル・ポスト mile post
advertiser　　 ナイキ・ジャパン nike japan

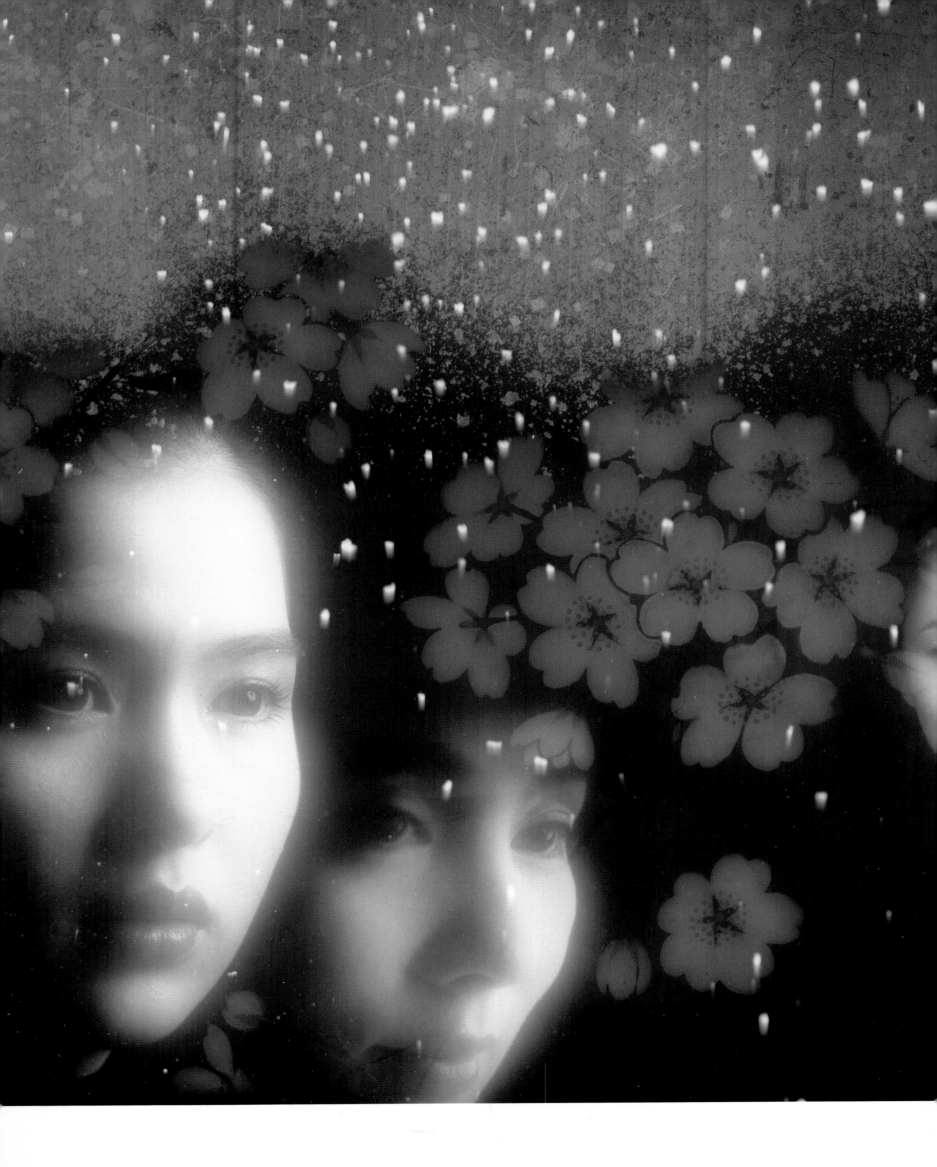

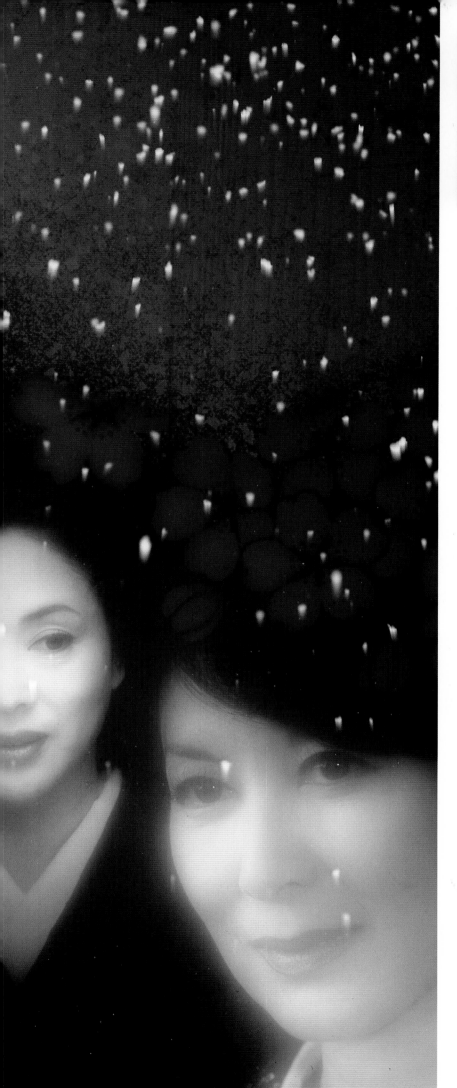

●64　　　　　●book cover
photographer　立木義浩 yoshihiro tatsuki
●
art director　　江島任 tamotsu ejirna
publisher　　　新潮社 shinchosha

●65　　　　　●poster
　　　　　　　 shopping center
photographer　立木義浩 yoshihiro tatsuki
art director　　松葉孝夫 takao matsuba
copywriter　　 岩永嘉弘 yoshihiro iwanaga
advertiser　　　天神コア tenjin core

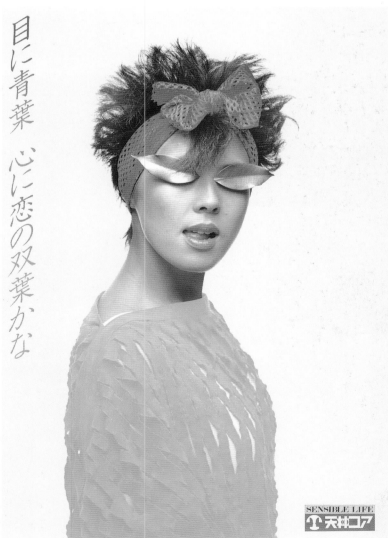

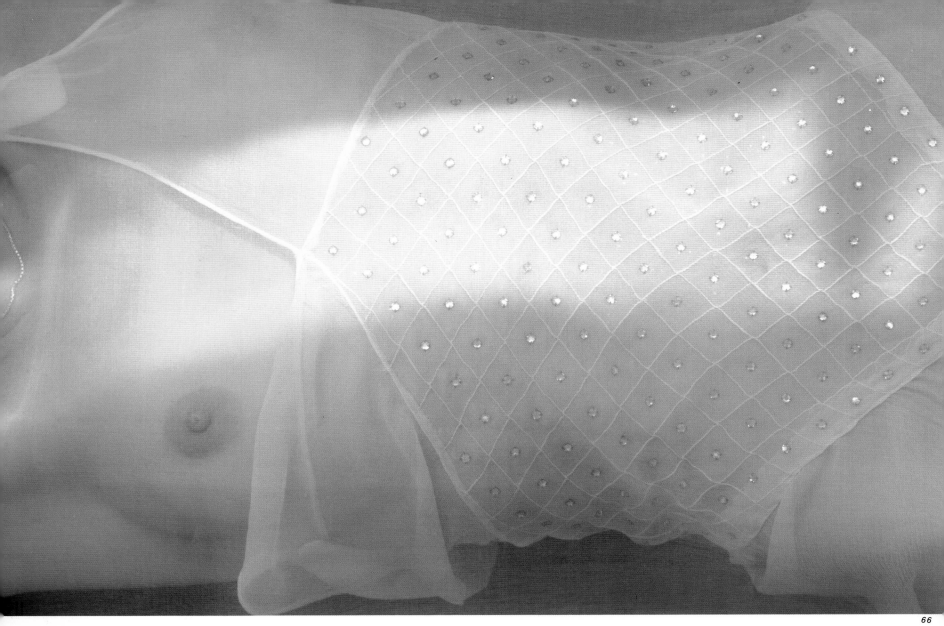

KASUGAI

KASUGAI

KASUGAI

● 66-68          ● poster
                 advertising company
photographer     稲越功一 koichi inakoshi
●
art director     村瀬省三 shozo murase
designer         村瀬省三 shozo murase
copywriter       村瀬省三 shozo murase
agency           ㈱カスガイ kasugai
production       村瀬省三デザイン事務所
                 shozo murase design office
advertiser       ㈱カスガイ kasugai

69

9 SEPTEMBER

THU FRI SAT SUN MON TUE WED THU FRI SAT SUN MON TUE WED THU FRI SAT SUN MON TUE WED THU FRI SAT SUN MON TUE WED THU FRI
1 2 3 4 5 6 7 8 9 10 11 12 13 14 15 16 17 18 19 20 21 22 23 24 25 26 27 28 29 30

8 AUGUST

69

70

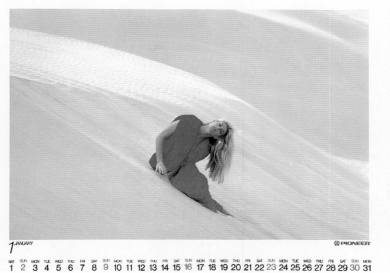

1 JANUARY

SAT SUN MON TUE WED THU FRI SAT SUN MON TUE WED THU FRI SAT SUN MON TUE WED THU FRI SAT SUN MON TUE WED THU FRI SAT SUN MON
1 2 3 4 5 6 7 8 9 10 11 12 13 14 15 16 17 18 19 20 21 22 23 24 25 26 27 28 29 30 31

●69-71　●calendar
　　　　　general electronics manufacturing
photographer　一色一成 issei isshiki
　　　　●
art director　宮地毅 takeshi miyaji
designer　津田徹 toru tsuda
agency　㈱コンセプトコミュニケーターズ
　　　　　concept communicators
production　㈱コンセプトコミュニケーターズ
　　　　　concept communicators
advertiser　パイオニア㈱ pioneer electric

71

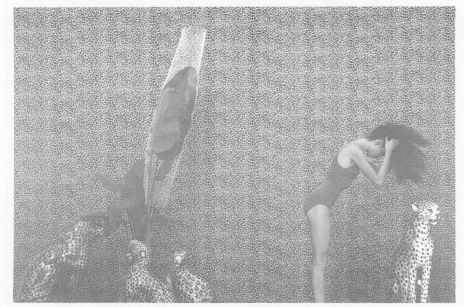

2 | MON 1 | WED 2 | THU 3 | FRI 4 | SAT 5 | SUN 6 | MON 7 | TUE 8 | WED 9 | THU 10 | FRI 11 | SAT 12 | SUN 13 | MON 14 | TUE 15 | WED 16 | THU 17 | FRI 18 | SAT 19 | SUN 20 | MON 21 | TUE 22 | WED 23 | THU 24 | FRI 25 | SAT 26 | SUN 27 | MON 28 | · | · | ·

 Wacoal

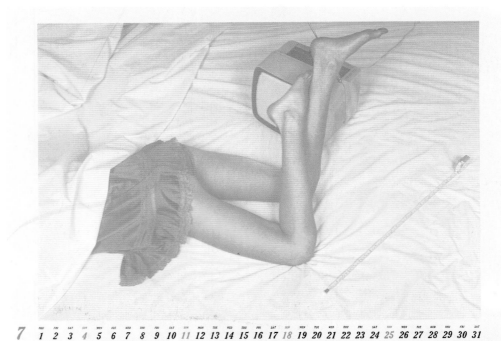

4 | FRI 1 | SAT 2 | SUN 3 | MON 4 | TUE 5 | WED 6 | THU 7 | FRI 8 | SAT 9 | SUN 10 | MON 11 | TUE 12 | WED 13 | THU 14 | FRI 15 | SAT 16 | SUN 17 | MON 18 | TUE 19 | WED 20 | THU 21 | FRI 22 | SAT 23 | SUN 24 | MON 25 | TUE 26 | WED 27 | THU 28 | FRI 29 | SAT 30 | ·

 Wacoal

●72-74　●calendar
　　　　　women's underwear

photographer　与田弘志 hiroshi yoda
●　　　　　●
creative　　　粟野牧夫 makio awano
　director
art director　水谷孝次 koji mizutani
designer　　　北谷茂久 shigehisa kitatani
production　　㈱日本デザインセンター
　　　　　　　nippon design center
advertiser　　㈱ワコール wacoal

7 | THU 1 | FRI 2 | SAT 3 | SUN 4 | MON 5 | TUE 6 | WED 7 | THU 8 | FRI 9 | SAT 10 | SUN 11 | MON 12 | TUE 13 | WED 14 | THU 15 | FRI 16 | SAT 17 | SUN 18 | MON 19 | TUE 20 | WED 21 | THU 22 | FRI 23 | SAT 24 | SUN 25 | MON 26 | TUE 27 | WED 28 | THU 29 | FRI 30 | SAT 31

Wacoal

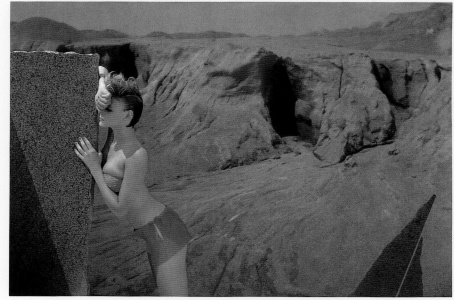

5 | 1 2 3 4 5 6 7 8 9 10 11 12 13 14 15 16 17 18 19 20 21 22 23 24 25 26 27 28 29 30 31

Wacoal

75

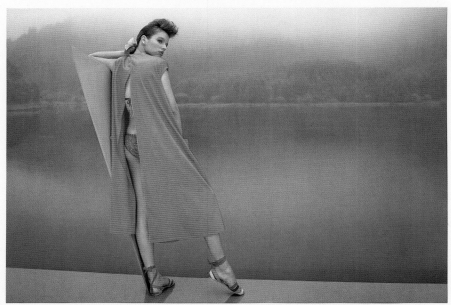

3 | 1 2 3 4 5 6 7 8 9 10 11 12 13 14 15 16 17 18 19 20 21 22 23 24 25 26 27 28 29 30 31

Wacoal

76

11 | 1 2 3 4 5 6 7 8 9 10 11 12 13 14 15 16 17 18 19 20 21 22 23 24 25 26 27 28 29 30

Wacoal

●75-77　　●calendar
　　　　　　women's underwear

photographer　小暮徹 toru kogure
●
creative
　director　粟野牧夫 makio awano
art director　水谷孝次 koji mizutani
　　　　　　北谷茂久 shigehisa kitatani
designer　　水谷孝次 koji mizutani
　　　　　　北谷茂久 shigehisa kitatani
production　㈱日本デザインセンター
　　　　　　nippon design center
advertiser　㈱ワコール wacoal

77

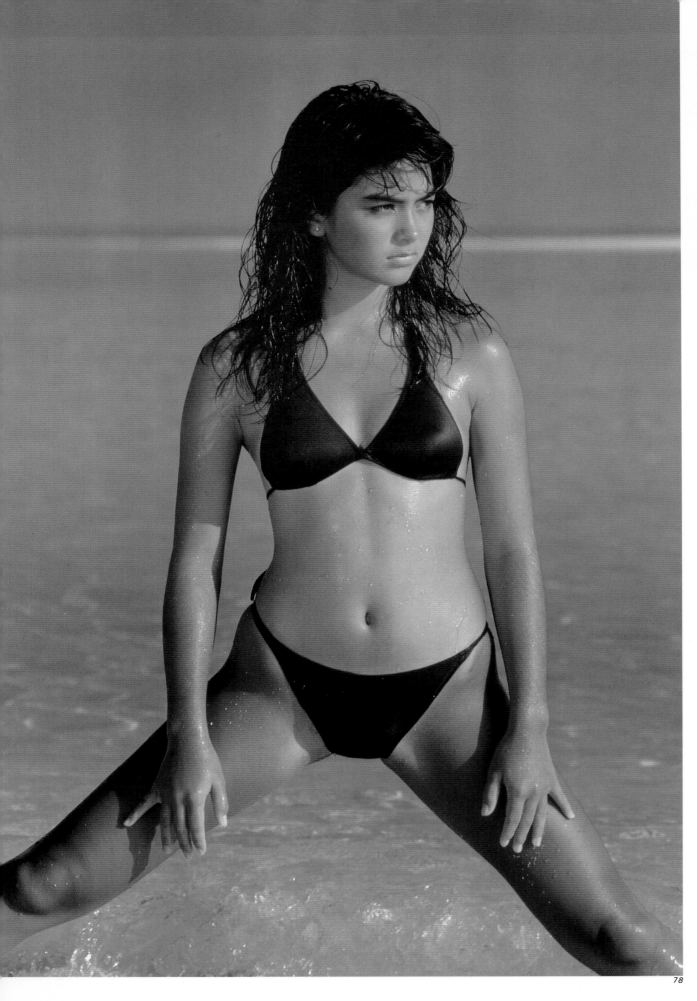

78

78

| ●78 | ●poster airline | ●79 | ●poster cosmetics | ●80 | ●poster cosmetics |
|---|---|---|---|---|---|
| photographer | 十文字美信 bishin jumonji | photographer | 金戸聰明 toshiaki kaneto | photographer | 金戸聰明 toshiaki kaneto |
| art director | 島倉孝次 koji shimakura | copywriter | 小野田隆雄 takao onoda | art director | 中山禮吉 reikichi nakayama |
| | 土屋亘 wataru tsuchiya | advertiser | ㈱資生堂 shiseido | designer | 川崎修司 shuji kawasaki |
| designer | 山本幸司 koji yamamoto | | | | 伊藤満 mitsuru lto |
| copywriter | 眞木準 jun maki | | | | 渋谷克彦 katsuhiko shibuya |
| | 青田光章 mitsuaki aota | | | copywriter | 小野田隆雄 takao onoda |
| agency | ㈱博報堂 hakuhodo | | | advertiser | ㈱資生堂 shiseido |
| production | ㈱博報堂 hakuhodo | | | | |
| advertiser | 全日空㈱ all nippon airways | | | | |

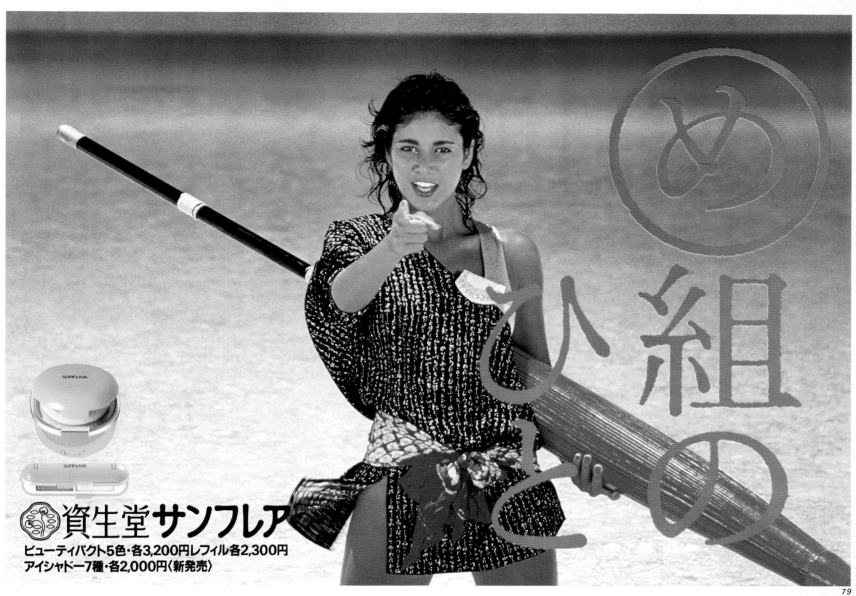

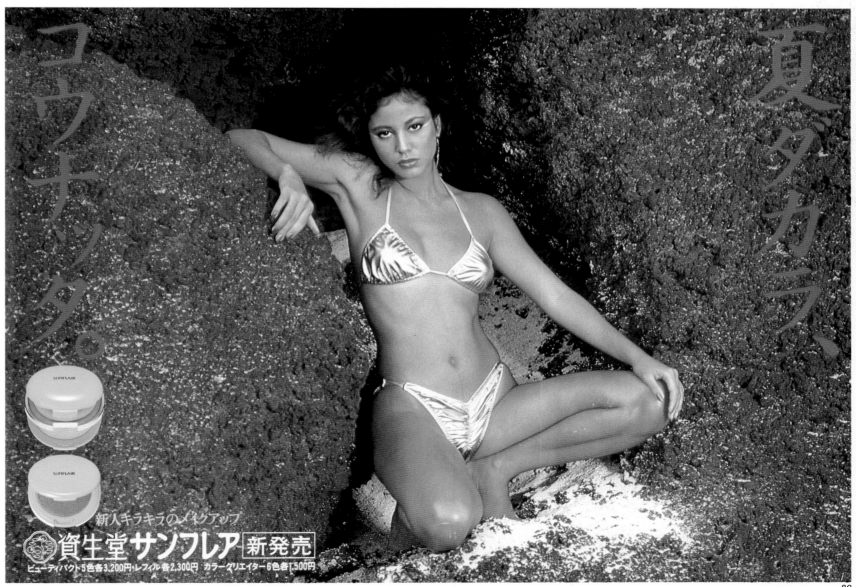

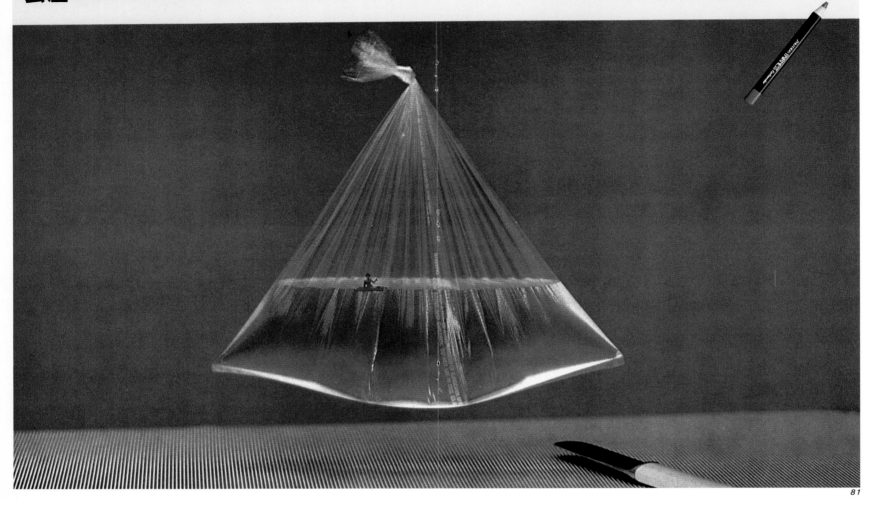

81

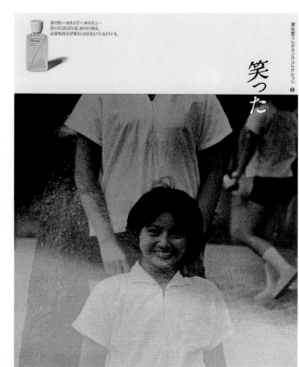

●81・82　●magazine
　　　　　 cosmetics
photographer　与田弘志 hiroshi yoda
●　　　　　　 ●
art director　太田和彦 kazuhiko ota
designer　　　太田和彦 kazuhiko ota
copywriter　　佐藤芳文 yoshifumi sato
production　　㈱資生堂宣伝制作部 shiseido
advertiser　　㈱資生堂 shiseido

●83-86　●magazine
　　　　　 cosmetics
photographer　坂野豊 yutaka sakano
●　　　　　　 ●
art director　太田和彦 kazuhiko ota
designer　　　太田和彦 kazuhiko ota
copywriter　　佐藤芳文 yoshifumi sato
production　　㈱資生堂 shiseido
advertiser　　㈱資生堂 shiseido

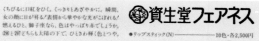

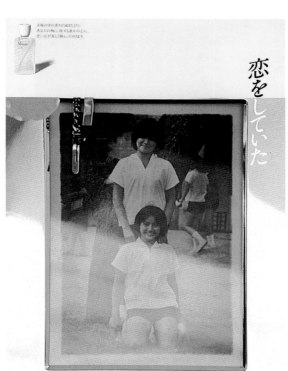

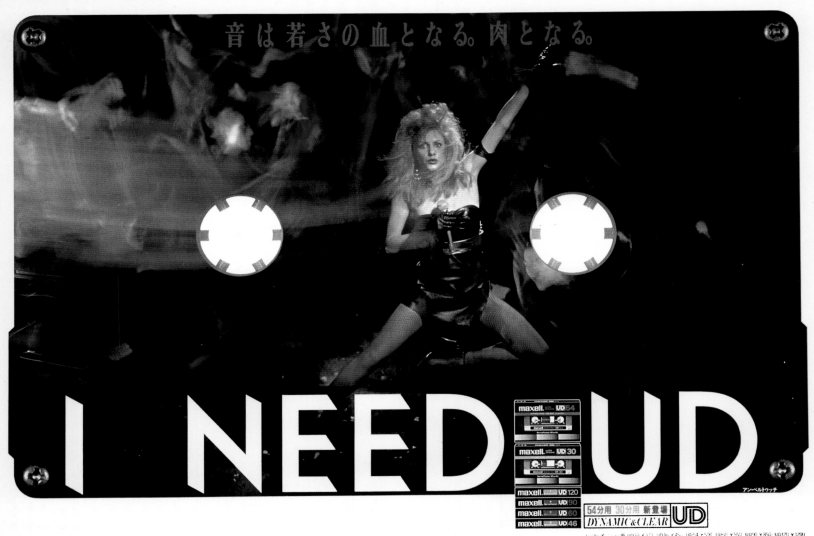

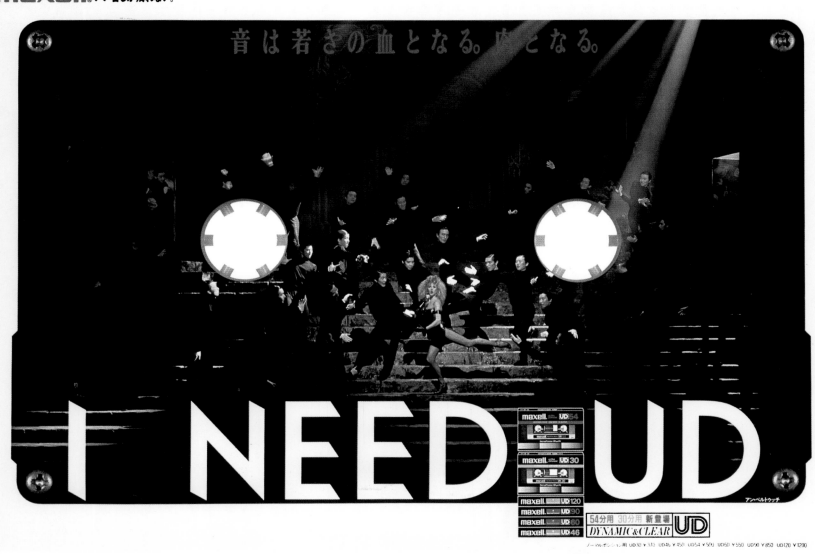

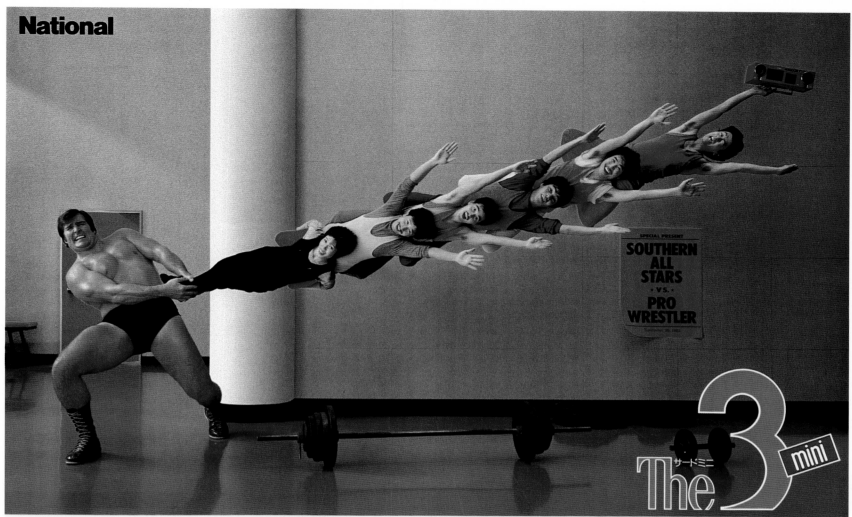

ジャイアントがなんじゃ。**ザ・サード** ミニが勝つ。

●87・88　●poster
cassette tapes

photographer　白鳥真太郎 shintaro shiratori
●
art director　祖父江将浩 masahiro sobue
designer　佐藤ヒロム hiromu sato
copywriter　若山憲二 kenji wakayama
agency　㈱博報堂 hakuhodo
production　㈱博報堂 hakuhodo
advertiser　日立マクセル㈱ hitachi maxell

●89　●poster
audio equipment

photographer　小暮徹 toru kogure
●
art director　金岩秀和 hidekazu kanaiwa
designer　高田務 tsutomu takada
copywriter　瀬木康夫 yasuo seki
copywriter　植村潤吉 junkichi uemura
agency　㈱博報堂 hakuhodo
production　松下電器産業㈱宣伝事業部
matsushita electric
㈱博報堂 hakuhodo
advertiser　松下電器産業㈱
matsushita electric

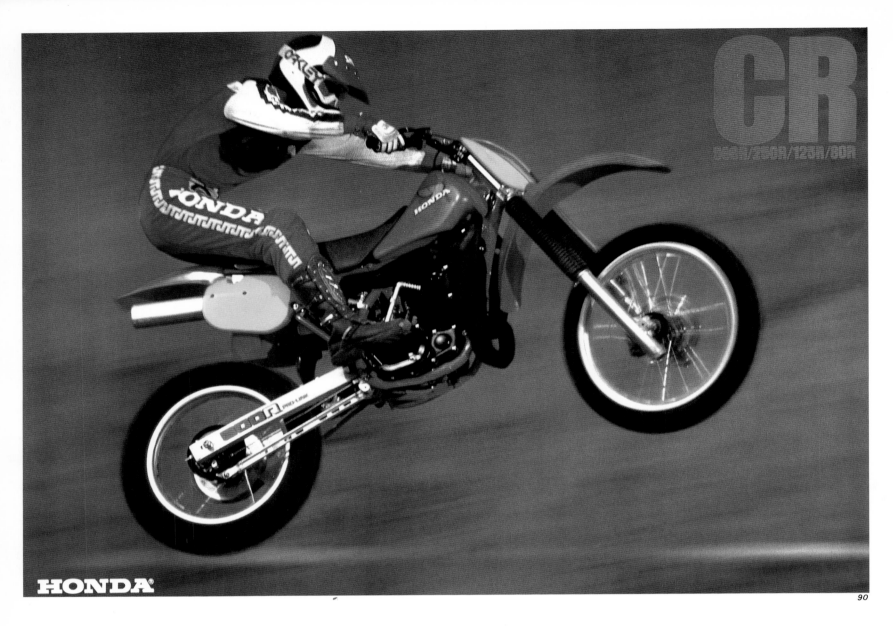

**CR**
250R/250R/125R/80R

HONDA®

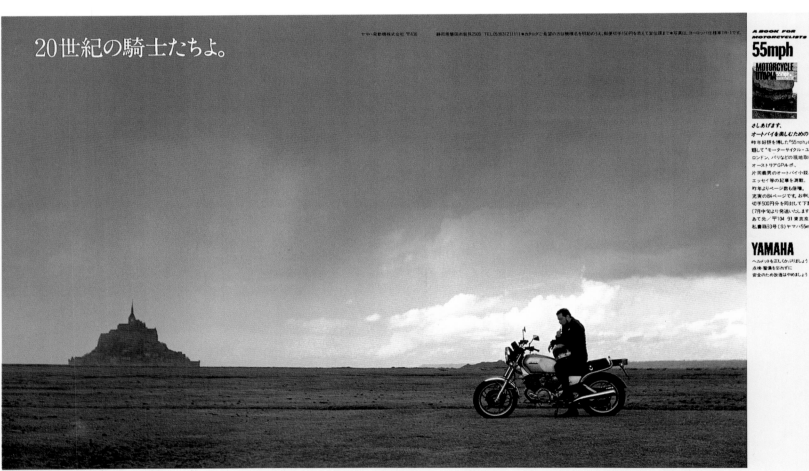

20世紀の騎士たちよ。

ヤマハ発動機株式会社 〒436　静岡県磐田市新貝2500　TEL.0538(32)1111●カタログご希望の方は車種名を明記のうえ、郵便切手150円を添えて宣伝課まで●写真は、ヨーロッパ仕様車18-1です。

オートバイの母なる大地、ヨーロッパ。ここで、オートバイに乗るという行為は、決して異端ではない。単なるファッションでもない。ごく普通の紳士が、ごく自然にオートバイに乗る。これが、ヨーロッパだ。そこに、ひとつの乗りものと人間の関わりあいの深さを感じる。思えば、ここはかつて騎士たちが駆け巡った大地。彼らが馬を大切にした歴史が、オートバイを育てたのかも知れない。そう考えても、あながちオーバーではない。とすれば、オートバイに跨ったライダーたちこそ、現代の騎士。オートバイという鉄の馬を操ることは、騎士道に通じる。男子たるもの、オートバイに乗れてこそ一人前なのである。

人間にいちばん近い乗りものなんだ。
**YAMAHA SPORTS BIKE** XV750E
Vツインエンジンを搭載したグランド・スポーツ・ツアラーXV750E。ヨーロッパのライダーたちを魅了したVツインの無類にパワフルな動力性能が、あなたを高速クルージングの世界へ誘ってくれるだろう。標準現金価格￥620,000

# GOOD SCENE, GOOD MACHINE.

その予感を秘めた排気音の中で、
心はすでに迫りくる坂を登りつめていた。

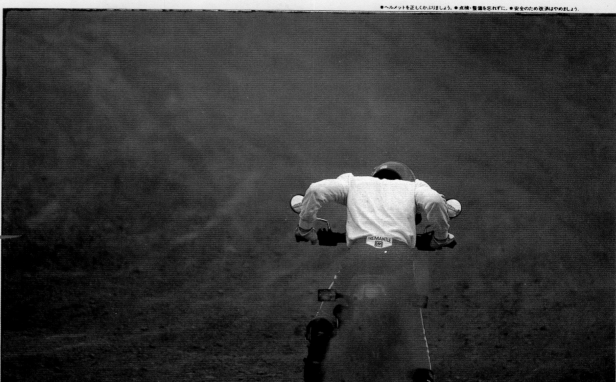

●ヘルメットを正しくかぶりましょう。●点検・整備を忘れずに。●安全のため改造はやめましょう。

ひとしきり走ってゴーグルを外すと、うっすらとかいた汗が風に当たって心地よい。しばしの間、休息すると、相棒は元気よく排気音を響かせ、僕はふたたびゴーグルを降ろした。

●水冷2ストロークエンジン搭載。スーパー・トレールDT125。軽量97kgの乾燥重量、16psのハイパワー。十分に鍛えられた足まわりとロング・ホイールトラベル。オフローダー達

から"公道を走れるモトクロッサー"と呼ばれるのも、あながちオーバーではありません。名車DTの名を冠したDT125。きっと、あなたの熱い血をかきたてることでしょう。

## DT125

●2サイクル・水冷・単気筒・123cc ●Y.E.I.S. ●最高出力16ps/7,000r.p.m ●最大トルク1.6kg・m/7,000r.p.m. ●リターン式6段 ●ボディカラー/ホワイト。

サンシャインレッド、スカイブルー ●標準現金価格¥235,000 ●カタログご希望

望の方は機種名を明記のうえ、郵便切手150円をそえて、宣伝課まで。

## GOOD SCENE, GOOD MACHINE.

ひとつとして同じことのないコーナーの連続を、
僕は魚のように走り抜けた。

ネガティブな挙動をもつのが憎いワインディングロード。右へ、左へ、時々やかなエグゾーストノート。次のコーナーを攻める。僕は、しなやかに泳ぐ魚のようだった。

●DOHC/パラレルツインを積んだスーパー・パフォーマーXS250。パワフルな走りは、スリムなライディングポジション。ひとことで言えば、きわめて乗りやすく、スポーツ

ライクな走りを楽しめるマシン、といえるでしょう。新しいヨーロピアン・スタンダードとも言うべきスタイリング。ああ、あなたはどこかへ旅がしてみたくなる。

## XS250.

●4サイクル・DOHC・水冷2気筒 ●YICSそえて多量の気持のいい250cm。●標準現金価格¥360,000 ●カタログご希望 ●ボディカラー/レーシングブルー ●リターン式6段

### PURE SPECIAL
### XV400

なんてセクシーなのだろう。

●90 ●poster
        motorbikes
photographer 桝本隆太郎 ryutaro masumoto
●
art director 大島満雄 mitsuo oshima
designer 大島満雄 mitsuo oshima
agency 東京グラフィックデザイナーズ
        tokyo graphic designers
production 東京グラフィックデザイナーズ
        tokyo graphic designers
advertiser 本田技研工業㈱ honda motor

●91 ●magazine
        motorbikes
photographer 高崎勝二 katsuji takasaki
●
art director 田中康之 yasuyuki tanaka
copywriter 渡辺悦男 etsuo watanabe
agency ㈱電通 dentsu
advertiser ヤマハ発動機 yamaha motor

●92-94 ●magazine
        motorbikes
photographer 江口友一 yuichi eguchi
●
art director 福井政弘 masahiro fukui
designer 田中康之 yasuyuki tanaka
copywriter 渡辺悦男 etsuo watanabe
agency ㈱電通 dentsu
production ㈱電通 dentsu
advertiser ヤマハ発動機㈱ yamaha motor

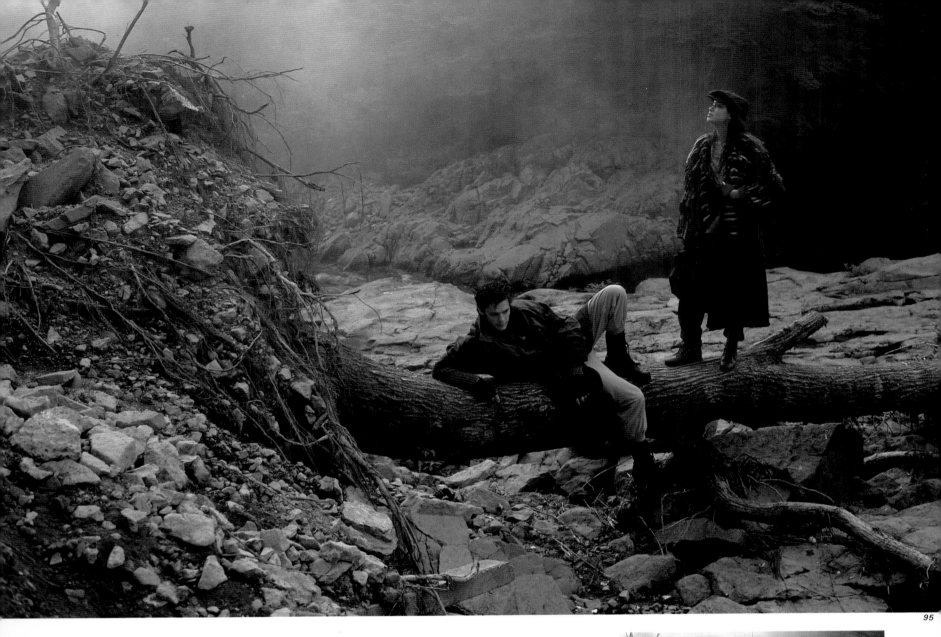

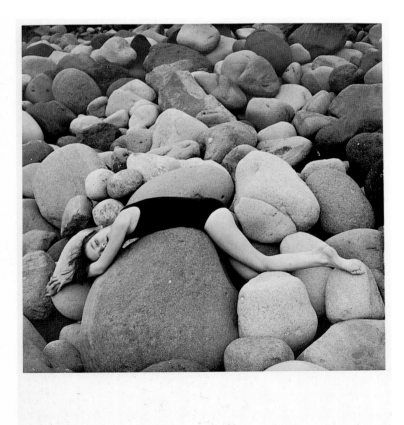

*Chris*

*Toshikazu Okuno Photo Show. May 31st to June 5th, 1982. Nagase Photo Salon 4-3-13, Ginza, Chuo-ku, Tokyo, Japan.*

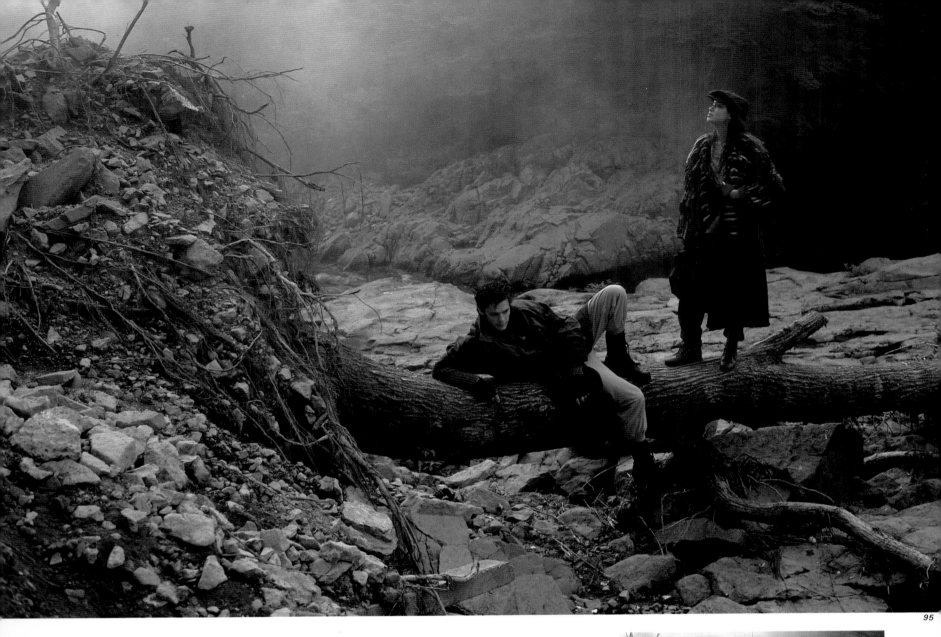

●95      ●*magazine*
             hosiery

photographer   奥野敏一 toshikazu okuno
●
art director   仲條正義 masayoshi nakajo
designer   仲條正義 masayoshi nakajo
copywriter   内田今朝雄 kesao uchida
agency   ㈱資生堂 shiseido
production   ㈱資生堂 shiseido
advertiser   ㈱資生堂 shiseido

●96      ●*poster*
             photo exhibition

photographer   奥野敏一 toshikazu okuno
art director   平塚重雄 shigeo hiratsuka
designer   平塚重雄 shigeo hiratsuka
copywriter   田口道明 michiaki taguchi
advertiser   ナガセフォトサロン
             nagase photo salon

●97・98      ●*catalog*
             fashion

photographer   三浦俊郎 toshiro miura
●
art director   三浦俊郎 toshiro miura
designer   佐藤功 isao sato
copywriter   影山光久 mitsuhisa kageyama
production   ㈱マグナ magna
advertiser   ㈱ジュン jun

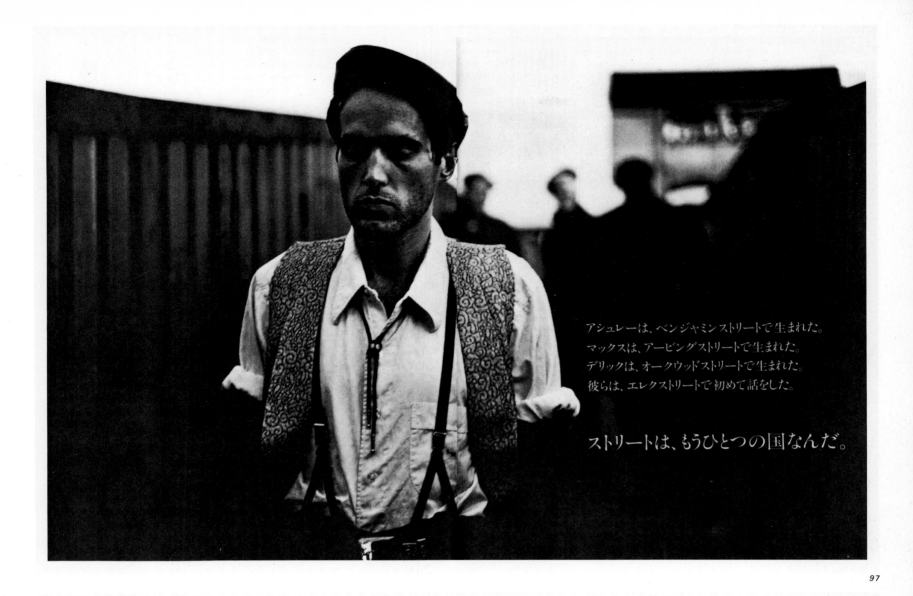

アシュレーは、ベンジャミンストリートで生まれた。
マックスは、アービングストリートで生まれた。
デリックは、オークウッドストリートで生まれた。
彼らは、エレクストリートで初めて話をした。

ストリートは、もうひとつの国なんだ。

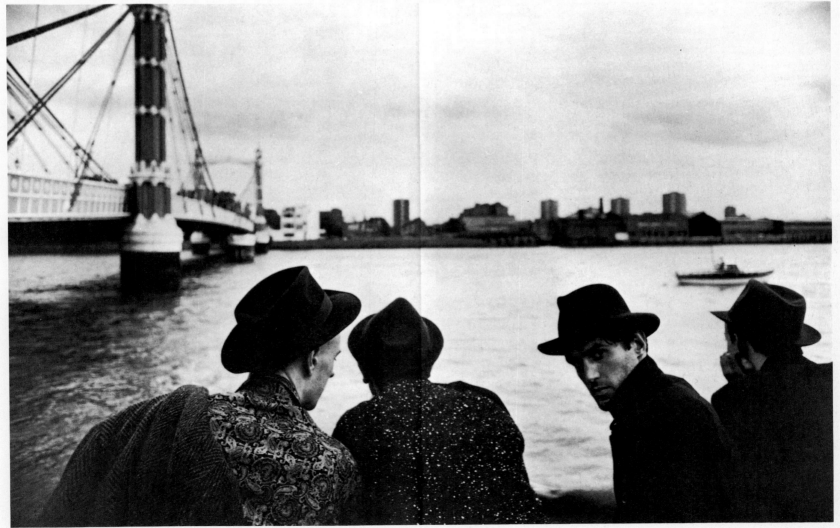

From Left: Hat 14,000yen  Hat 18,000yen  Hat 15,000yen  Hat 14,000yen

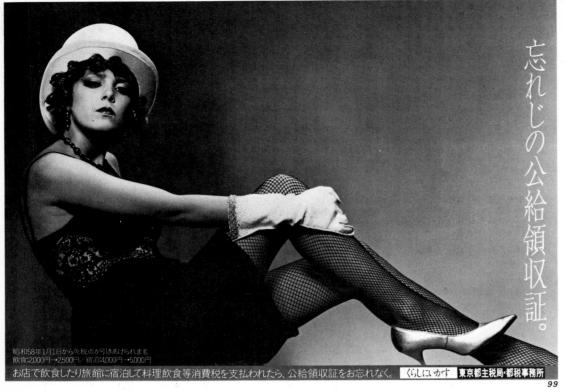

忘れじの公給領収証。

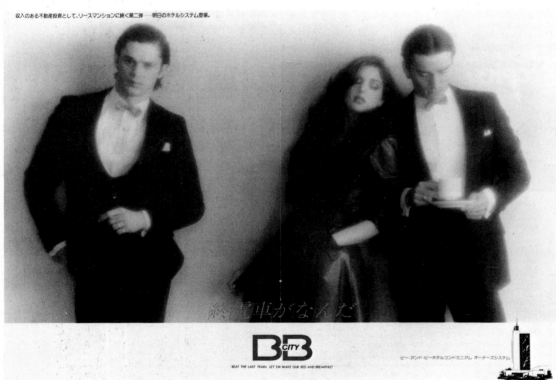

BCITY

YAMAHA GS1

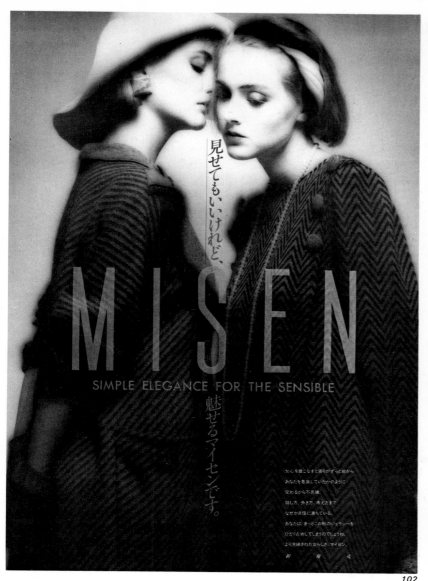

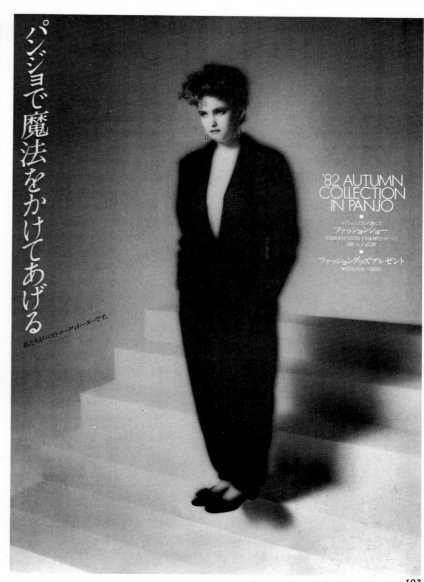

# MISEN

SIMPLE ELEGANCE FOR THE SENSIBLE

魅せるマイセンです。

見せてもいいけれど、

女心を着こなすと誇りがずっと前から
あなたを意識していたかのように
変わるから不思議。
話し方、歩き方、考え方まで
なぜか自信に満ちている。
あなたは、きっとこの秋のジェラシーを
ひとり占めしてしまうのでしょうね。
より洗練された女らしさ・マイセン。
所属愛

パンジョで魔法をかけてあげる

私たちがベストコーディネーターです。

'82 AUTUMN
COLLECTION
IN PANJO

ファッションショー

ファッショングッズプレゼント

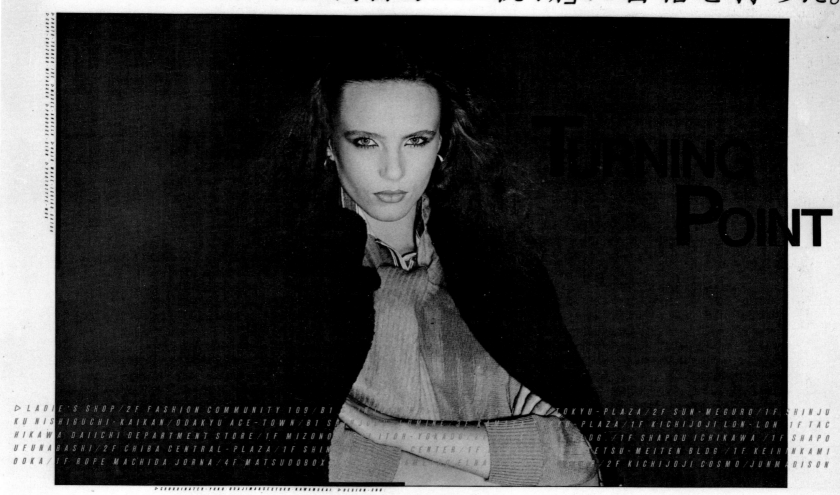

ターニング・ポイント、自分の「軌跡」に自信を持った。

TURNING POINT

▷LADIE'S SHOP/2F FASHION COMMUNITY 109/B1 ... TOKYU-PLAZA/2F SUN-MEGURO/1F SHINJU
KU NISHIGUCHI-KAIKAN/ODAKYU ACE-TOWN/B1 SH ... PLAZA/1F KICHIJOJI LON-LON 1F TAC
HIKAWA DAIICHI DEPARTMENT STORE/1F MIZONO ... ITOH-YOKADO/2 ... BLDG/1F SHAPOU ICHIKAWA/1F SHAPO
UFUNABASHI/2F CHIBA CENTRAL-PLAZA/1F SHIN ... CENTER/1F ... ETSU-MEITEN BLDG/1F KEIHANKAMI
OOKA/1F ROPE MACHIDA JORNA/4F MATSUDOBOX ... 2F KICHIJOJI COSMO/JUNMADISON

▷COORDINATER-YOKO OBAJIMA▷STYLED-KAWAMUKAI ▷DESIGN-ENO

*Joset Makino*

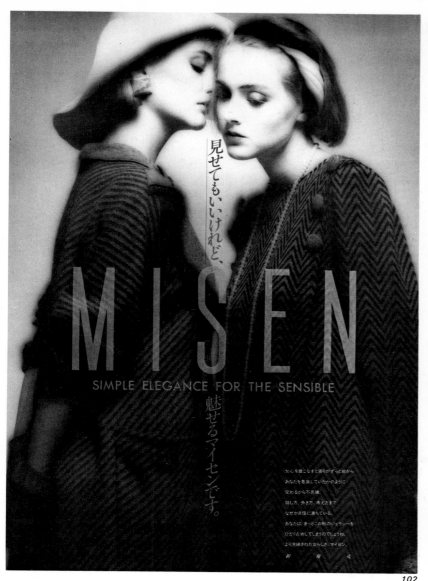

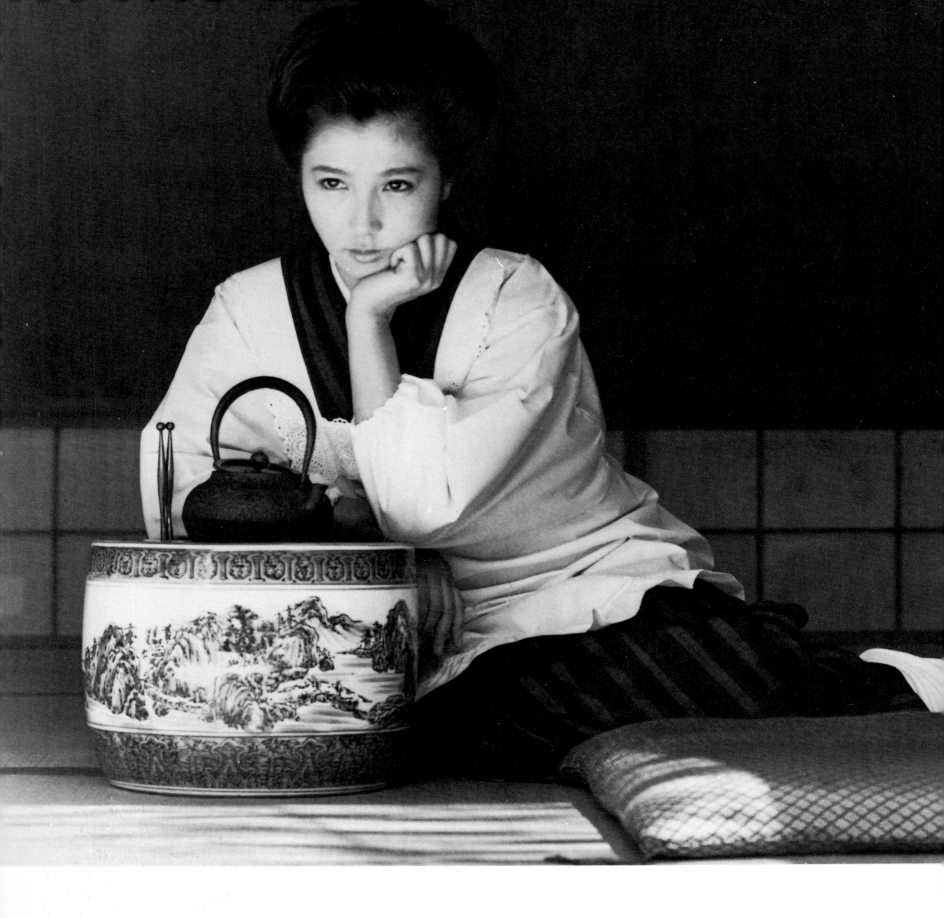

きみは僕の
ホットウイスキーさ

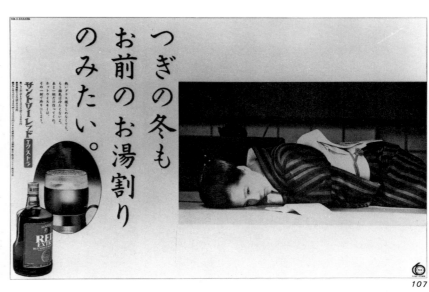

つぎの冬も
お前の お湯割り
のみたい。

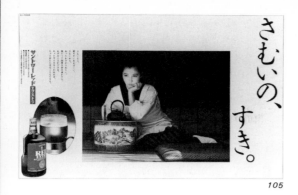

さむいの、すき。

105

●105-107　●newspaper
　　　　　　whisky

photographer　西宮正明 masaaki nishimiya
●
art director　鈴木利志夫 toshio suzuki
designer　鈴木利志夫 toshio suzuki
copywriter　安藤隆 takashi ando
agency　㈱サン・アド sun-ad
production　㈱サン・アド sun-ad
advertiser　サントリー㈱ suntory

●108　●newspaper
　　　　whisky

photographer　高橋昇 noboru takahashi
●
art director　佐藤浩 hiroshi sato
copywriter　開高健 takashi kaiko
production　㈱サン・アド sun-ad
advertiser　サントリー㈱ suntory

105

男は
けっして
孤独になれない
これが
あるかぎり。

乾杯！一九八三年。サントリーオールド

MAN CAN NEVER BE ALONE AS LONG AS HE HAS THIS.

108

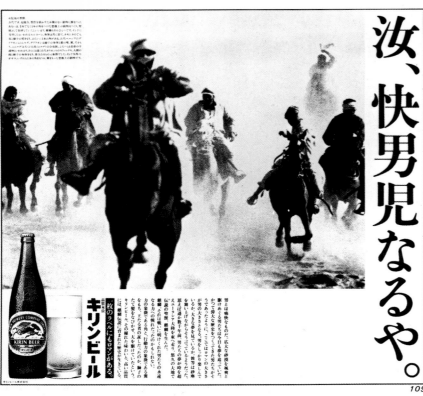

汝、快男児なるや。

キリンビール

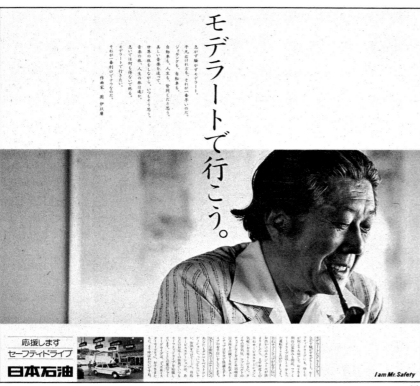

モデラートで行こう。

応援します
セーフティドライブ
日本石油

I am Mr. Safety

110

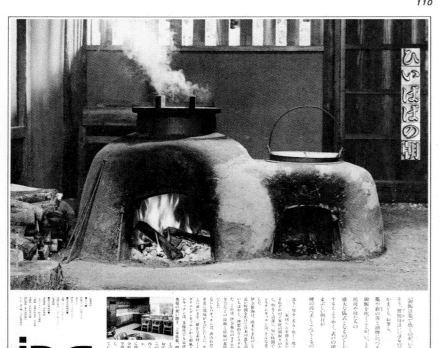

ひいばばの竈

ina
伊奈製陶

111

きょうから、僕は新しい
ポール・アンカ。

私もアデランス Paul Anka

アデランス
札幌相談室
☎011(231)9696
苫小牧相談室
☎0144(33)9696

112

●109　　　●newspaper
　　　　　　　beer
photographer　野町和嘉 kazuyoshi nomachi
●
art director　武川耕一 koichi takekawa
　　　　　　　東本三郎 saburo tomoto
designer　　　鈴木智暢 tomonobu suzuki
　　　　　　　大場弘 hiroshi oba
copywriter　　東本三郎 saburo tomoto
agency　　　　㈱第一企画 dai-ichi kikaku
production　　アドビジョン ad vision
advertiser　　麒麟麦酒㈱ kirin brewery

●110　　　●newspaper
　　　　　　　car gasoline
photographer　越後広正 hiromasa echigo
●
art director　安田次郎 jiro yasuda
designer　　　山本裕 hiroshi yamamoto
copywriter　　雨宮夏夫 natsuo amamiya
agency　　　　㈱電通 dentsu
production　　㈱電通 dentsu
advertiser　　日本石油㈱ nippon oil

●111　　　●newspaper
　　　　　　　kitchen components
photographer　下里幸夫 yukio shimosato
●
art director　早川良雄 yoshio hayakawa
designer　　　小濱正道 masamichi obama
copywriter　　滝来敏行 toshiyuki takirai
production　　早川デザイン事務所
　　　　　　　hayakawa design office
advertiser　　伊奈製陶㈱ ina seito

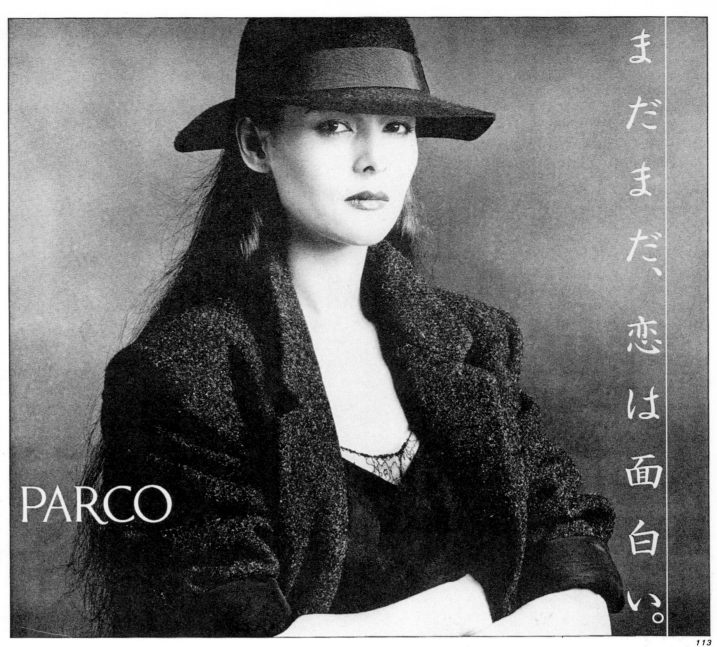

まだまだ、恋は面白い。

PARCO

112

113

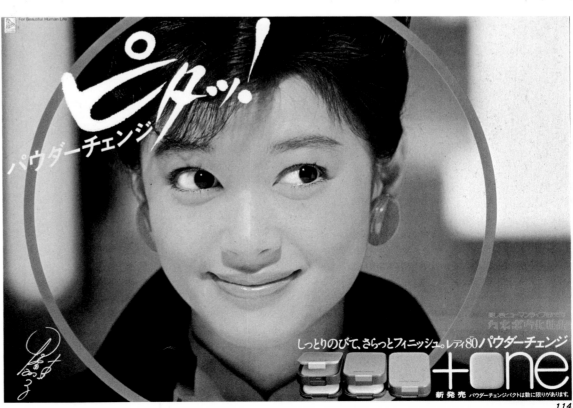

●112　●newspaper
　　　　　men's hairpieces
photographer　小川嘉範 kahan ogawa
●
art director　㈱アデランス宣伝部 aderans
production　読売広告社㈱ yomiuri advertising
advertiser　㈱アデランス aderans

●113　●newspaper
　　　　　shopping center
photographer　久米正美 masami kume
●　　　　　●
art director　大道康央 yasuo omichi
designer　大道康央 yasuo omichi
　　　　　吉田絹代 kinuyo yoshida
copywriter　菊地加蔵 kazo kikuchi
production　㈱大道康央デザイン事務所
　　　　　yasuo omichi design office
advertiser　㈱パルコ parco

●114　●poster
　　　　　cosmetics
photographer　白鳥真太郎 shintaro shiratori
●
art director　砂沢正昭 masaaki sunazawa
designer　松原茂明 shigeaki matsubara
　　　　　浜崎淳子 junko hamazaki
　　　　　林理枝 rie hayashi
copywriter　若山憲二 kenji wakayama
agency　㈱博報堂 hakuhodo
production　㈱博報堂 hakuhodo
advertiser　鐘紡㈱ kanebo

114

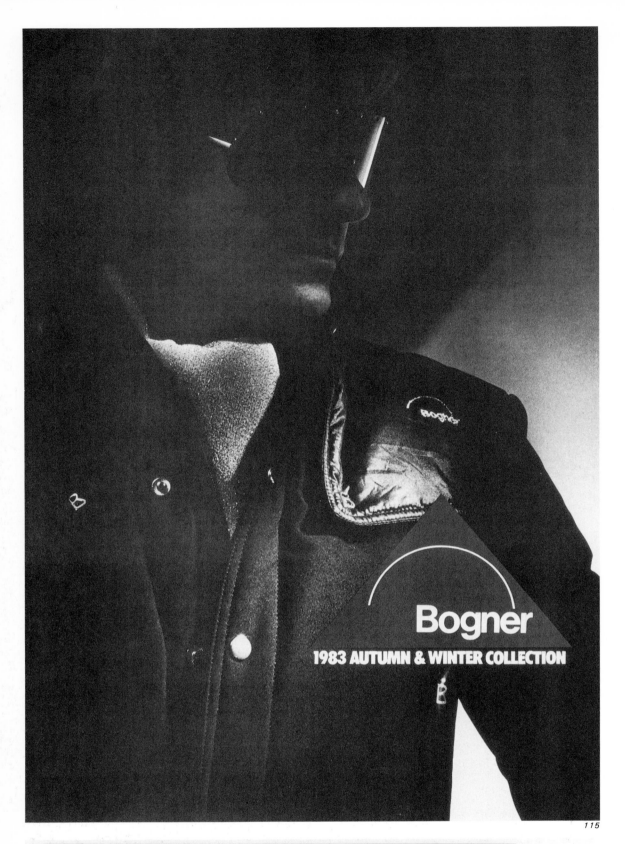

Bogner
**1983 AUTUMN & WINTER COLLECTION**

115

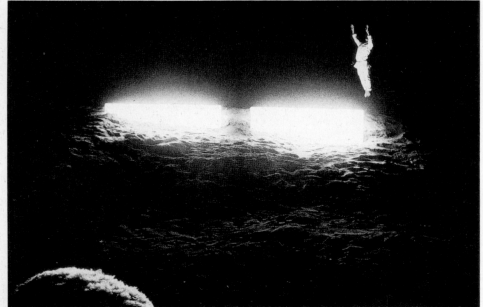

**HIDEHARU SATO** 3-4-301 NANPEIDAI SHIBUYA-KU TOKYO, JAPAN TEL : 03(496)6350

116

●115　　　●planning
　　　　　　sports equipment

photographer　河原雅夫 masao kawahara
●
art director　米谷敏司 toshiji maitani
designer　　後藤泰男 yasuo goto
production　g & o
advertiser　美津濃㈱ mizuno

●116　　　●direct mail
　　　　　　photographer's portforio

photographer　佐藤秀春 hideharu sato
●
advertiser　　佐藤秀春 hideharu sato

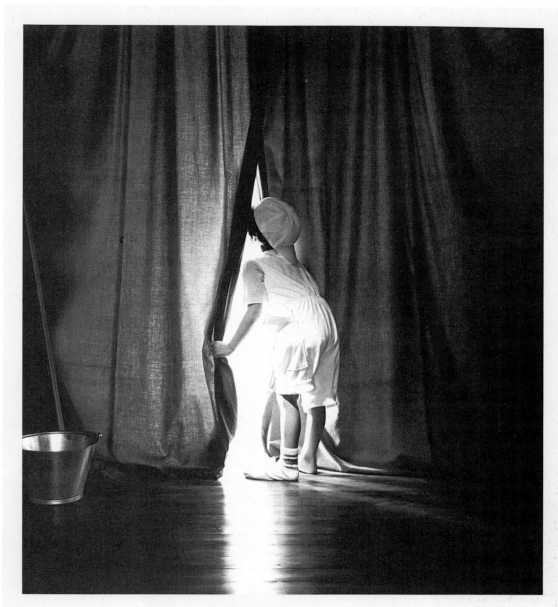

1983
BROTHER
CALENDAR

B O N S A I

●117　●calendar
　　　　machine manufacturing
photographer　西巻順一郎 junichiro nishimaki
●
art director　砂沢正昭 masaaki sunazawa
designer　松原茂明 shigeaki matsubara
　　　　浜崎淳子 junko hamazaki
　　　　福田マユリ mayuri fukuda
agency　㈱博報堂 hakuhodo
production　㈱博報堂 hakuhodo
advertiser　ブラザー工業㈱ brother ind.

●118　●newspaper
　　　　bonsai trees
photographer　岩瀬陽一 yoichi iwase
●
designer　高木和雄 kazuo takagi
advertiser　八雲蔓青園 yakumo manseien

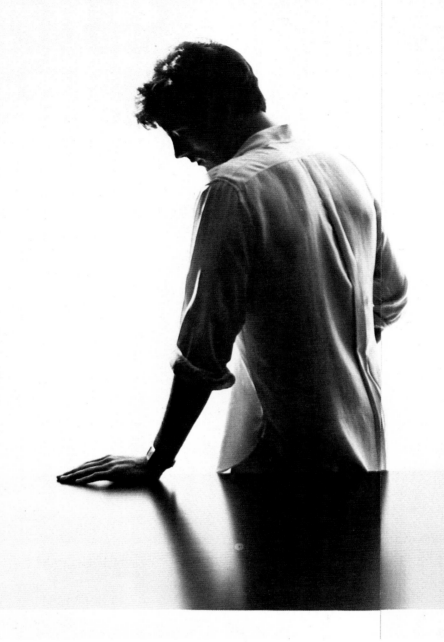

BRITISH SPIRIT

●119　●catalog
wristwatches

photographer 杉山守 mamoru sugiyama
●
creative 粟野牧夫 makio awano
director
art director サイトウ・マコト makoto saito
designer 駿東宏 hiroshi sunto
copywriter 吉田薫 kaoru yoshida
production ㈱日本デザインセンター
nippon design center
advertiser 服部セイコー hattori seiko

●120　●magazine
fashion

photographer 佐藤秀春 hideharu sato
●
art director 高田文世 fumiyo takada
designer 高田文世 fumiyo takada
agency ニック nick
production ニック nick
advertiser ビビド vivid

●121・122　●magazine
fashion

photographer 佐藤秀春 hideharu sato
●
designer 高原ヒロシ hiroshi takahara
agency アーストン ボラージュ
arrston volaju
production アーストン ボラージュ
arrston volaju
advertiser アーストン ボラージュ
arrston volaju

大人的であることに、使われがちな言葉あくまで今のいいだがもっとも大切なキーになってくること、新なたい意味で、今なお永遠に生きつづけることにあたいする。

119

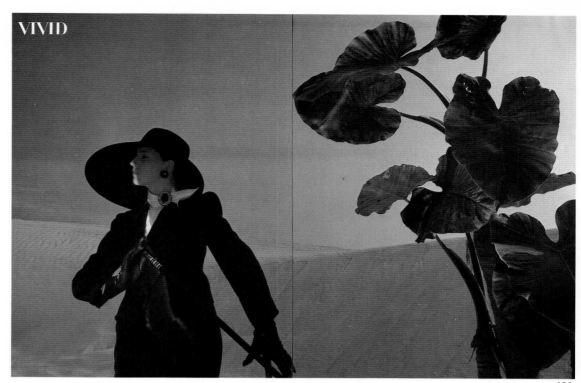

VIVID

arrston volaju

120

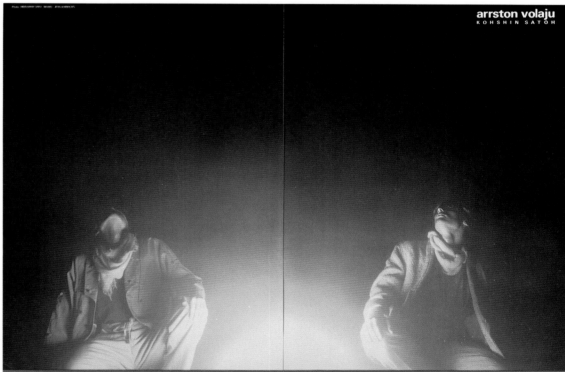

arrston volaju
KOHSHIN SATOH

121

VIVID

arrston volaju
KOHSHIN SATOH

122

# WINTER SALE ►12.26 ⓈⓊⓃ

渇いた風が、街を、人を、寒さでふるわせる。そんな季節、人は愛なくして生きられない、と思う。
だから、男は女の夢で、女は男の胸で、北風をふせいでいる。181の専門店ロンロンのウインターセール。
ハワイ30名様ご招待をはじめとした素敵なプレミアムが、夢を咲かせます。男と女の心あたためます。

吉祥寺 | *Lon Lon*

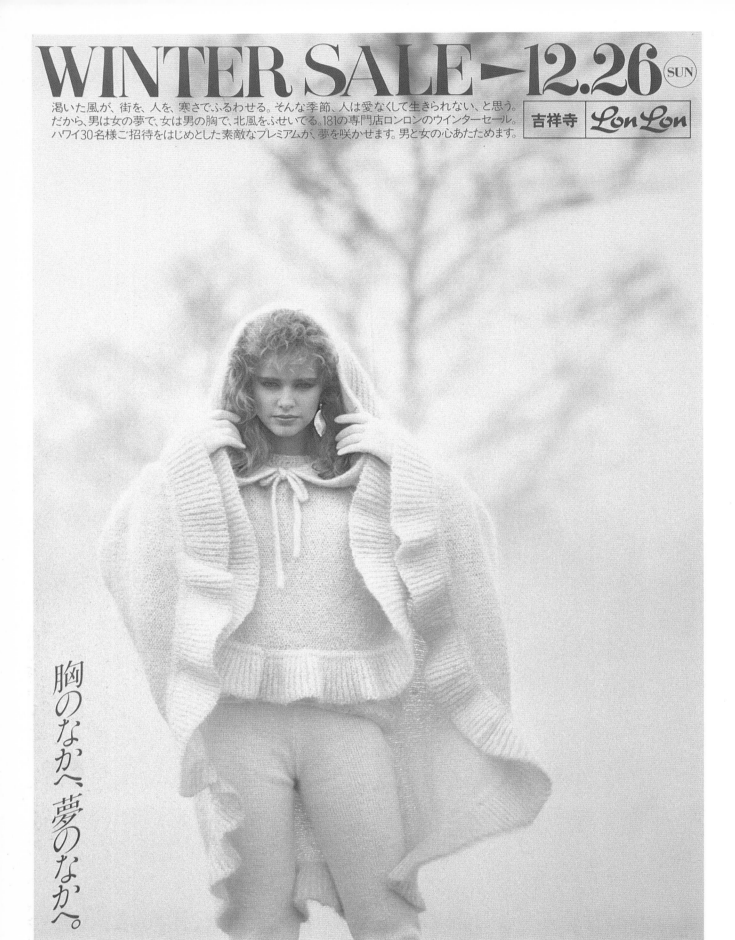

胸のなかへ、夢のなかへ。

123

●123     ●poster
            shopping center
photographer   会田好生 kosei aida
●              ●
art director   加藤順 jun kato
designer       加藤順 jun kato
copywriter     宮崎富士雄 fujio miyazaki
agency         ㈱オリコミ orikomi advertising
production     ㈱オリコミ orikomi advertising
advertiser     吉祥寺ステーションセンターロンロン
               kichijoji station center lonlon

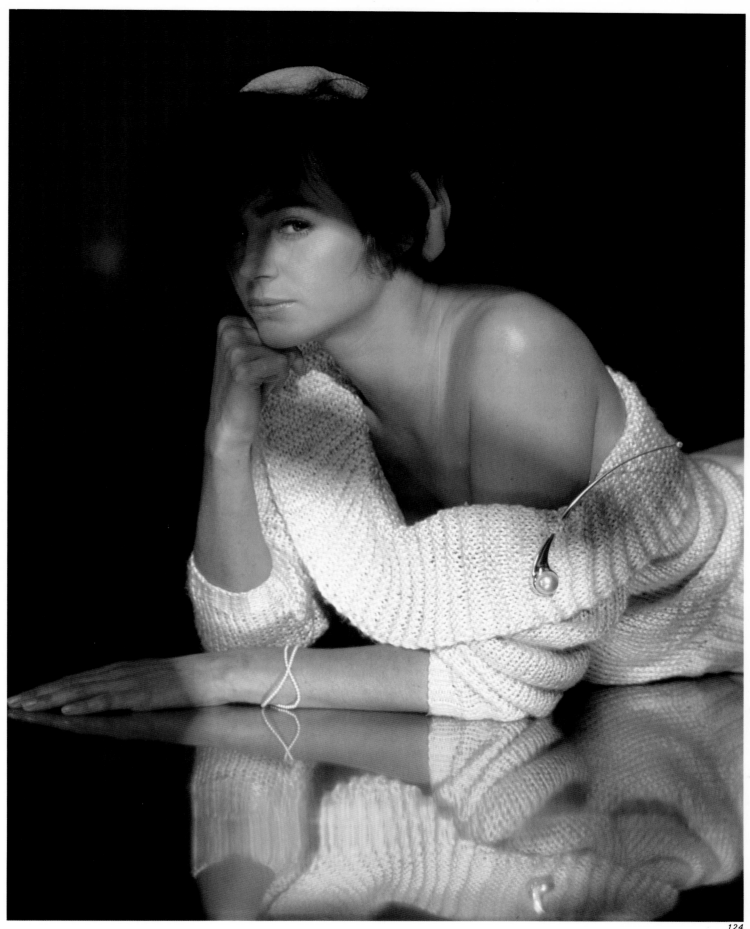

124

●124  ●calendar
        *jewelry*

photographer  宮下昭徳 akinori miyashita
●
art director  赤堀秀樹 hideki akabori
designer      日比野勲 isao hibino
agency        大日本印刷㈱ dai nippon printing
production    大日本印刷㈱ dai nippon printing
advertiser    日本真珠小売店協会
              japan pearl retailers' assoc.

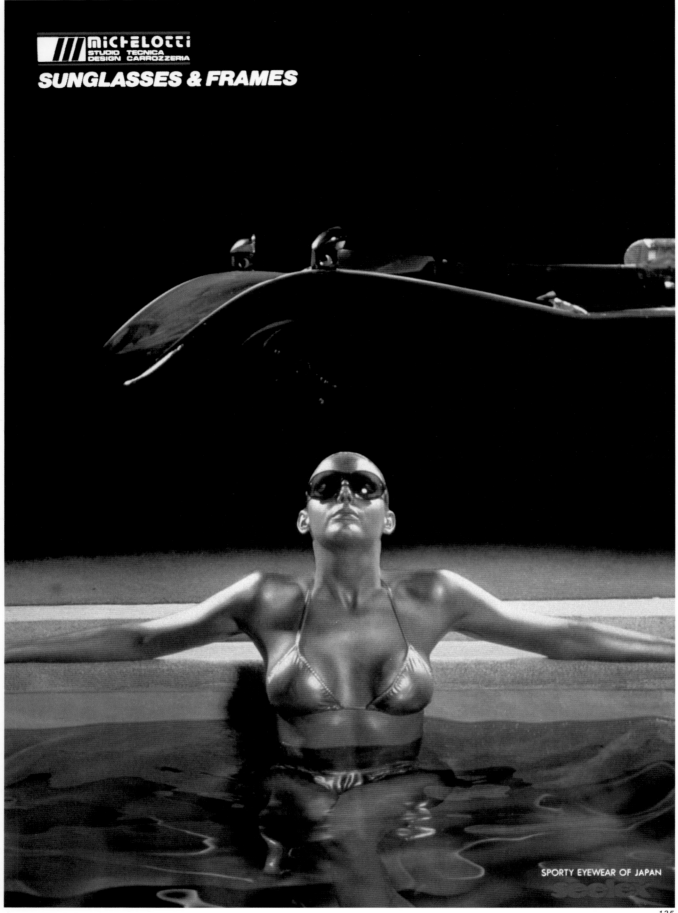

SPORTY EYEWEAR OF JAPAN

●125 ●poster
sunglasses
photographer 越宮誠二 seiji koshimiya
●
art director 松本和之 kazuyuki matsumoto
designer 平田邦夫 kunio hirata
copywriter 平田邦夫 kunio hirata
agency ㈱日本交通事業社
nihon kotsu jigyosha
production creative ad center
advertiser seelex

●126 ●poster
photo exhibition
photographer 藤井秀樹 hideki fujii
●
advertiser オリンパス光学工業㈱ olympus

# Hideki Fujii KOMPOSITIONEN

Fotoausstellung
26.1. - 7.3. '82

**OLYMPUS**
GALERIE

Montag bis Freitag 9–18 Uhr,   Samstag 10–14 Uhr      Große Bleichen 31, »Kaufmannshaus«, 2000 Hamburg 36

| ●127 | ●magazine<br>fashion | ●128 | ●magazine<br>fashion | ●129 | ●poster<br>fashion | ●130 | ●poster<br>soap |
|---|---|---|---|---|---|---|---|
| photographer | 大竹正明 masaaki otake | photographer | 江面俊夫 toshio ezura | photographer | 大竹正明 masaaki otake | photographer | 角尾栄治 eiji kakuo |
| art director | 永井裕子 yuko nagai | art director | 米山功 isao yoneyama | art director | 筒井良太郎 ryotaro tsutsui | art director | 桝井耕一郎 koichiro masui |
| designer | 永井裕子 yuko nagai | designer | 蔵本彩樹 saiki kuramoto | designer | 筒井良太郎 ryotaro tsutsui | designer | 柴田 誠 makoto shibata |
| copywriter | 横山弘美 hiromi yokoyama | copywriter | 藤島康 yasushi fujishima | copywriter | 東海林高夫 takao shoji | copywriter | 桝井耕一郎 koichiro masui |
| agency | 三越 mitsukoshi dept. | agency | ㈱博報堂 hakuhodo | agency | 三愛 san-ai | production | 大日本印刷㈱<br>dai nippon printing |
| production | 三越 mitsukoshi dept. | production | ㈱博報堂 hakuhodo | production | スタジオV studio v | | |
| advertiser | 三越 mitsukoshi dept. | advertiser | コスギ産業㈱<br>kosugi sangyo | advertiser | 三愛 san-ai | advertiser | 花王石鹸㈱ kao soap |

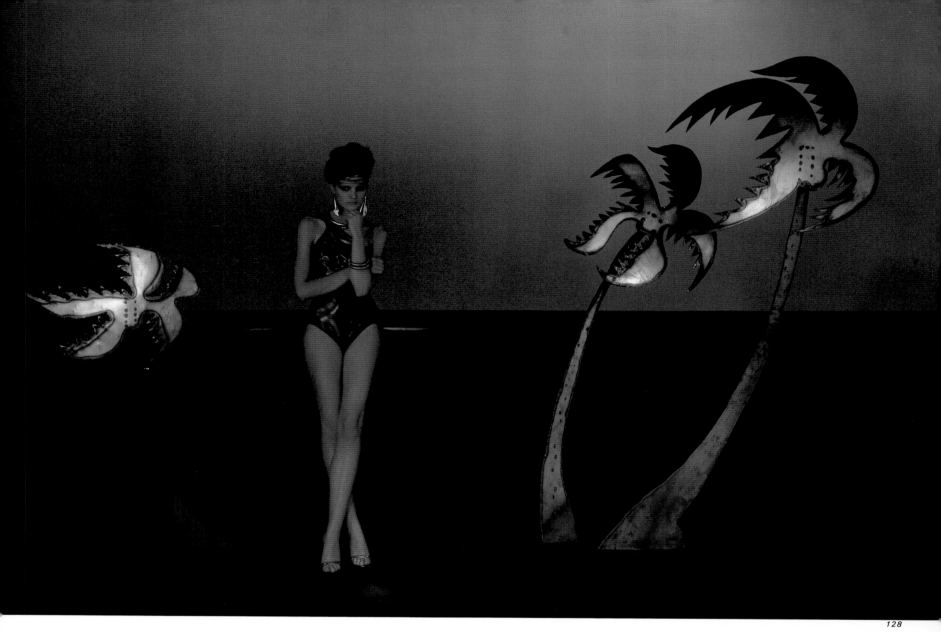

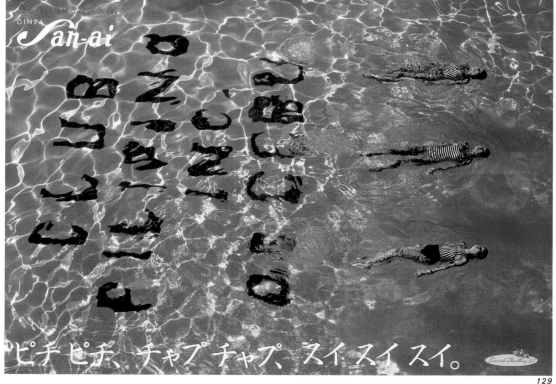

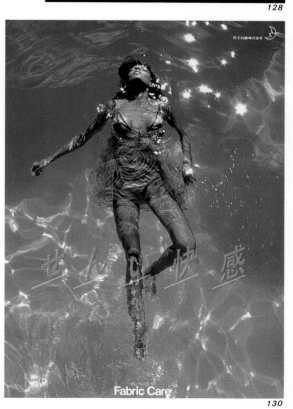

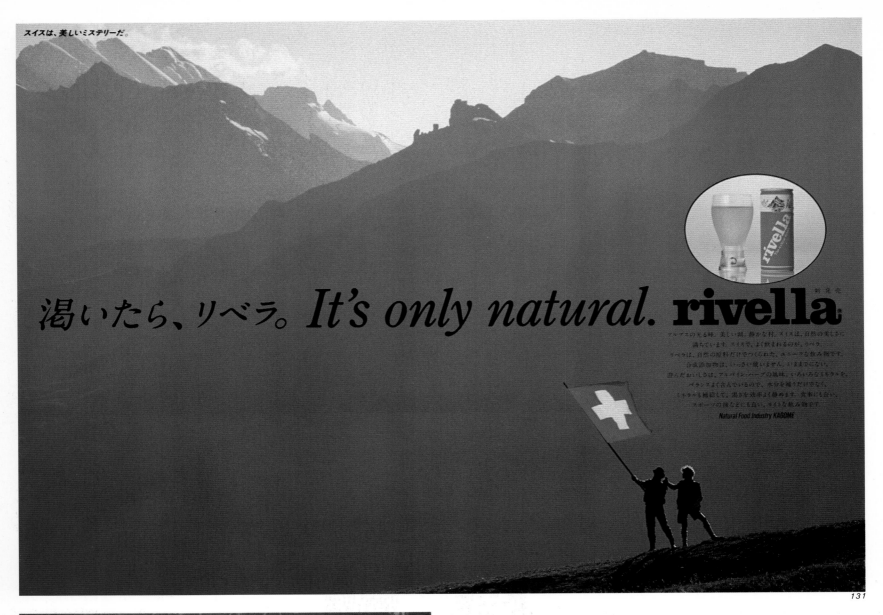

スイスは、美しいミステリーだ。

渇いたら、リベラ。 *It's only natural.* **rivella**

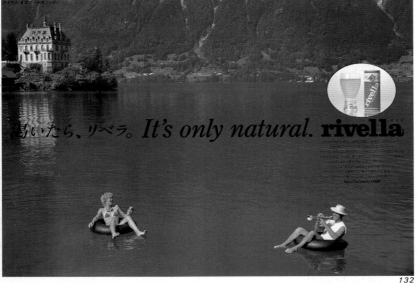

131

132

●131・132　　●poster
　　　　　　　soft drinks

photographer　秋元茂 shigeru akimoto
●
art director　清水啓一郎 keiichiro shimizu
designer　　　柿木栄 sakae kakigi
copywriter　　竹内基臣 kishin takeuchi
production　　エージー az advertising
advertiser　　カゴメ㈱ kagome

●133　　　　　●poster
　　　　　　　whisky

photographer　小林正昭 masaaki kobayashi
●
creative　　　福岡彰夫 akio fukuoka
　director
art director　金森周一 shuichi kanamori
designer　　　小出正義 masayoshi koide
copywriter　　池田雅俊 masatoshi ikeda
agency　　　　㈱電通 dentsu
production　　㈱電通 dentsu
advertiser　　ニッカウヰスキー㈱ nikka whisky

●134　　　　　●poster
　　　　　　　beer

photographer　鋤田正義 masayoshi sukita
●
art director　松田英世 hideyo matsuda
designer　　　酒井賢司 kenji sakai
copywriter　　井川澄夫 sumio igawa
production　　㈱日本デザインセンター
　　　　　　　nipoon design center
advertiser　　朝日麦酒㈱ asahi breweries

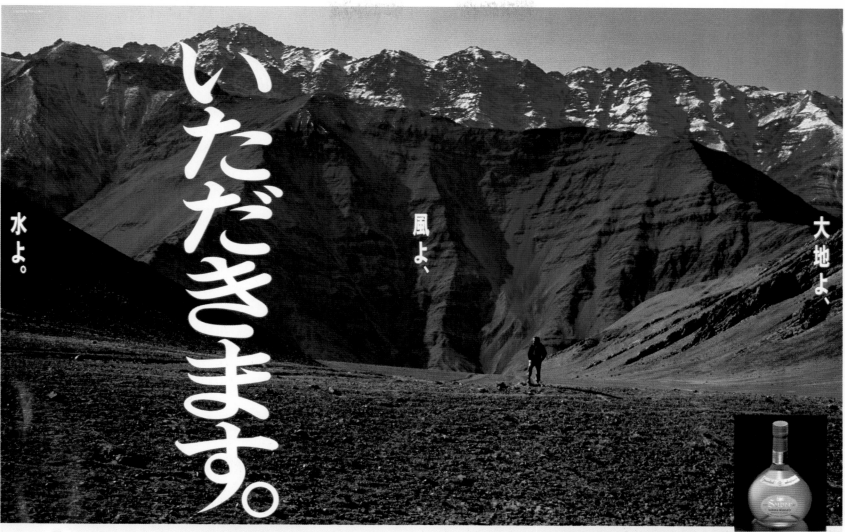

水よ。 風よ、 いただきます。 大地よ、

大地、風、水。その大いなる恵みで私達を育んでくれる自然。自然は、地球誕生
46億年の悠久の時の流れのなかでつくりあげられた、かけがえのないもの。
かつて日本人は、そんな自然の恵みに感謝して、"いただきます"という、素晴らし
い表現を発明した。今いち度、この言葉のもつ深い意味を考えたい、と思う。

自然の恵みに感謝。
SUPER NIKKA
スーパーニッカ

ビール人よ。

LÖWENBRÄU

いま、バイエルンブルー。 （ドイツが生んだ世界のビール）レーベンブロイ
生で新登場

photo grapher shoji yoshida

SHOJI YOSHIDA (1)

SHOJI YOSHIDA (2)

135

SHOJI YOSHIDA (3)

SHOJI YOSHIDA (4)

136

●135・136　●pamphlet
　　　　　　photographic book

photographer　吉田昭二　shoji yoshida
●　　　　　　　●
designer　　　高橋祐二　yuji takahashi
production　　㈱近代精版　kindai seihan
advertiser　　㈱近代精版　kindai seihan

●137·138   ●calendar
          dairy products

| | | |
|---|---|---|
| photographer | 横井隆和 | takakazu yokoi |
| ● | ● | |
| art director | 箕浦昇一 | shoichi minoura |
| designer | 北浜忍 | shinobu kitahama |
| agency | ㈱電通 | dentsu |
| production | バーズ | birds |
| advertiser | グリコ協同乳業㈱ | glico dairy |

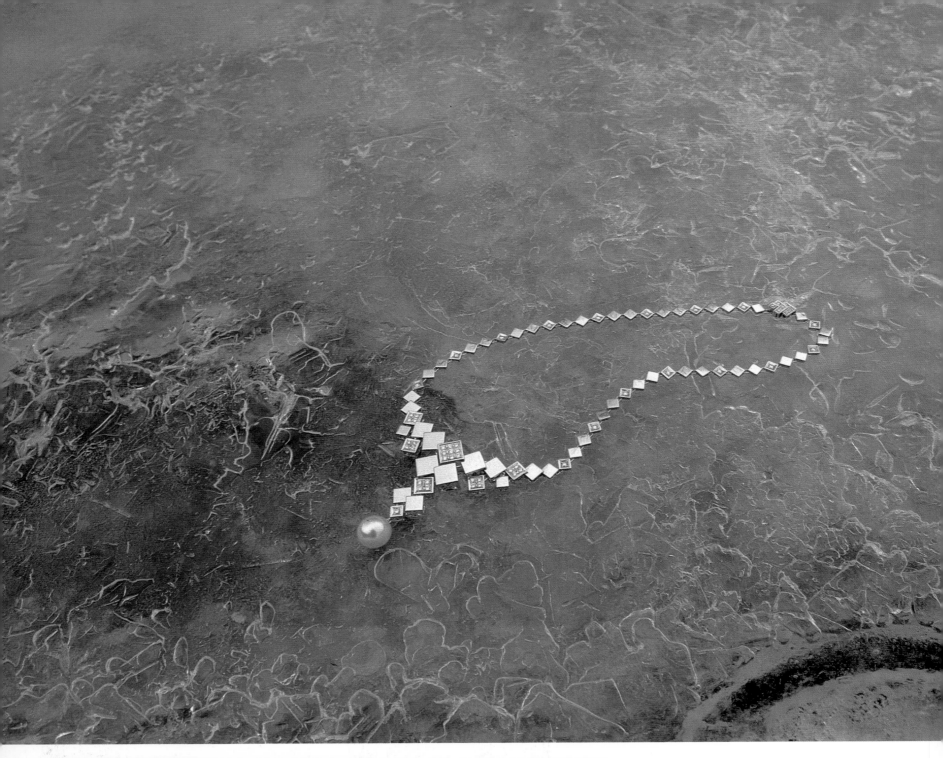

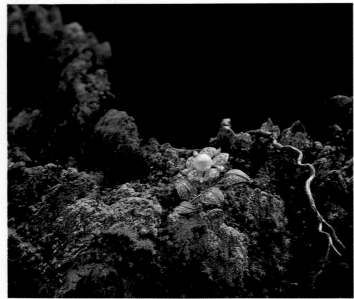

そっと摘んで、胸に飾ります。

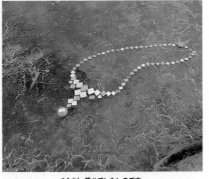

もう少し、眺めていたいのです。

●139·140 ●magazine
jewelry
● ●
photographer 飯塚康弘 yasuhiro iizuka

art director 増渕邦治 kuniharu masubuchi
designer 増渕邦治 kuniharu masubuchi
copywriter 石丸淳一 junichi ishimaru
production ㈱ミキモト mikimoto
advertiser ㈱ミキモト mikimoto

●141-143　●direct mail
　　　　　　jewelry
photographer　遊佐光明 mitsuaki yusa
●
art director　近藤勝 masaru kondo
copywriter　泉山忠彦 tadahiko izumiyama
production　㈱プロジェクト・ワイ project y
advertiser　㈱西武百貨店 seibu dept.

144

145

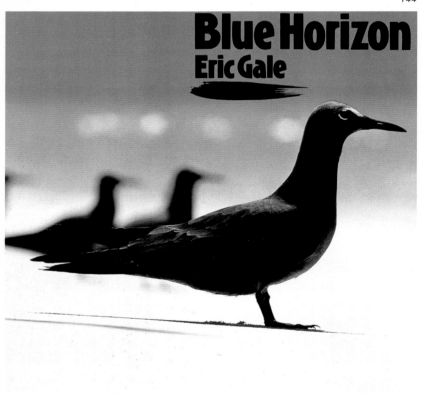

146

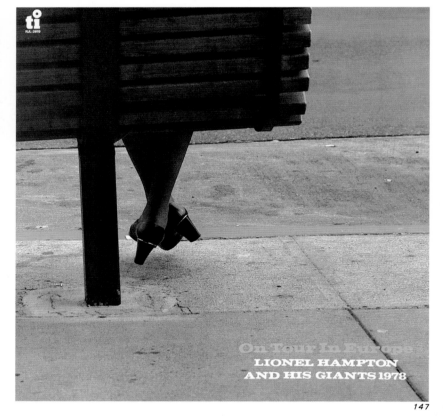

147

●144·145 　　●record jacket
photographer 三好和義 kazuyoshi miyoshi
●
art director 佐村憲一 kenichi samura
designer 佐村憲一 kenichi samura
production ナンバーワン・デザイン・オフィス
no. 1 design office
advertiser ビクター音楽産業㈱
victor musical ind.

●146
photographer 大塚佳男 yoshio otsuka
●
designer 熊野明 akira kumano
production p.c.c.
advertiser ポリドール・レコード
polydor record

●record jacket

●147
photographer 小川弘之 hiroyuki ogawa
●
art director 小林平九郎 heikuro kobayashi
designer 小林平九郎 heikuro kobayashi
agency スタジオ ホーン studio hrn
production スタジオ ホーン studio hrn
advertiser rvc

●record jacket

TOKUMA MUSICAL INDUSTRIES CO., LTD. BMD-1020 ¥2,800 ●このレコードを賃貸業に使用することは禁じます。無断複製することは法律で禁じられております。℗1982

SIDE A
愛してごめんなさい
自由の女神が化粧落して
弾痕
ダンシング・ママ
もの想いブルース NHKみんなのうた
あなたの面影

SIDE B
居酒屋 ＆木ひろしとデュエット
夜のパントマイム
砂の城
LET'S MAKE LOVE
人生哲学
わが胸の底の湖

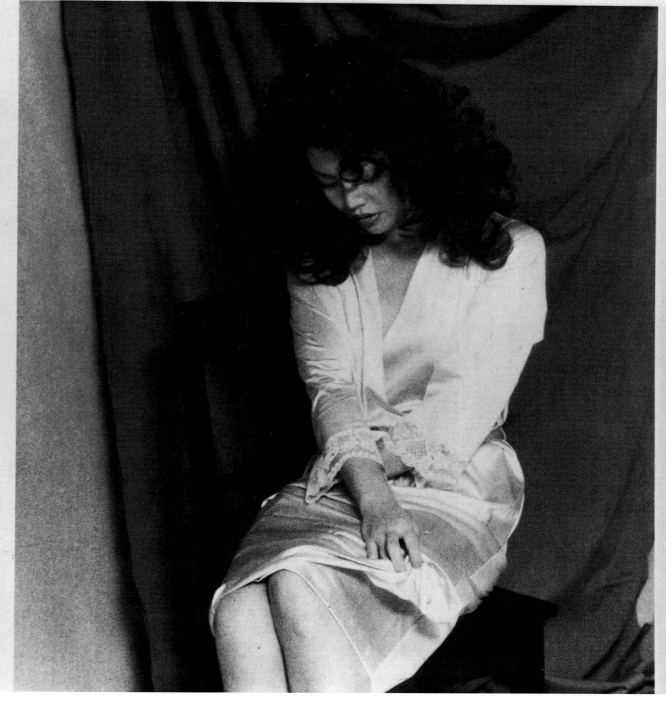

148

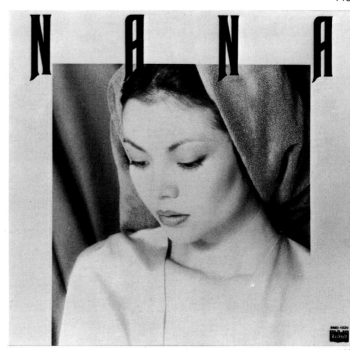

●148・149　●record jacket
photographer　鶴田義久 yoshihisa tsuruta
●
art director　戸田正寿 masatoshi toda
designer　水島正則 masanori mizushima
advertiser　徳間ジャパン tokuma japan

149

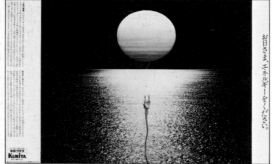

151

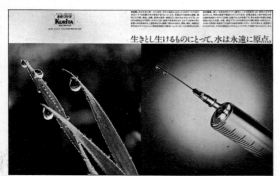

150

●150 ●newspaper
water industry

photographer 桜井和行 kazuyuki sakurai
赤石沢康彦 yasuhiko akaishizawa
●
art director 新見志郎 shiro shinmi
designer 山川厚夫 atsuo yamakawa
copywriter 新見志郎 shiro shinmi
agency ㈱オリコミ orikomi advertising
production ㈱ユー・ピィ・アール u.p.r
advertiser 栗田工業㈱ kurita water ind.

●151 ●newspaper
water industry
●
photographer 武井勇 isamu takei
art director 新見志郎 shiro shinmi
designer 山川厚夫 atsuo yamakawa
copywriter 新見志郎 shiro shinmi
agency ㈱オリコミ orikomi advertising
production ㈱ユー・ピィ・アール u.p.r.
advertiser 栗田工業㈱ kurita water ind.

●152 ●magazine
camera film

photographer 達川清 kiyoshi tatsukawa
●
art director 渡部和夫 kazuo watanabe
designer 渡部和夫 kazuo watanabe
copywriter 西堀博久 hirohisa nishibori
agency J.W.トンプソン j.w.thompson
production J.W.トンプソン j.w.thompson
advertiser 長瀬産業㈱ nagase

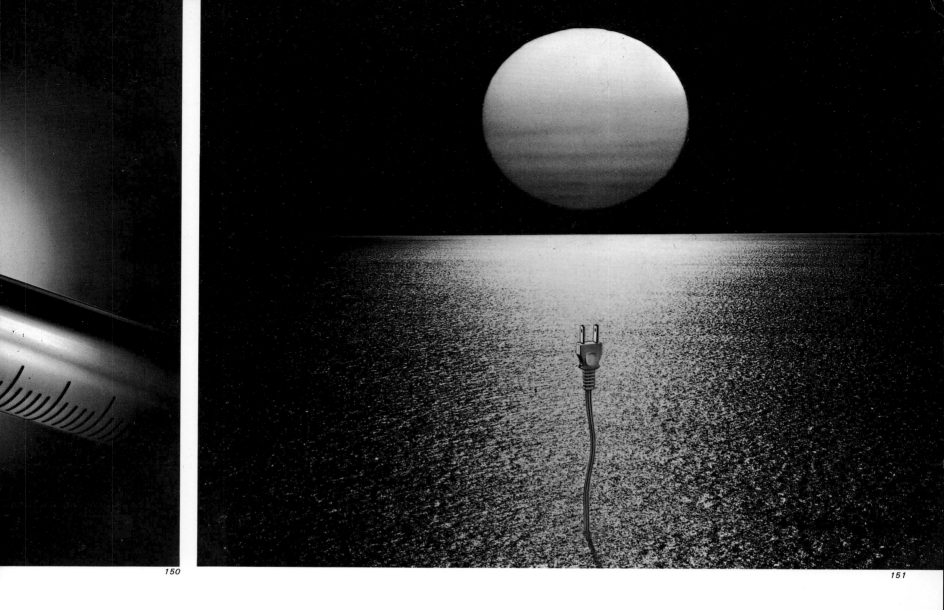

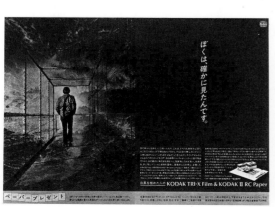

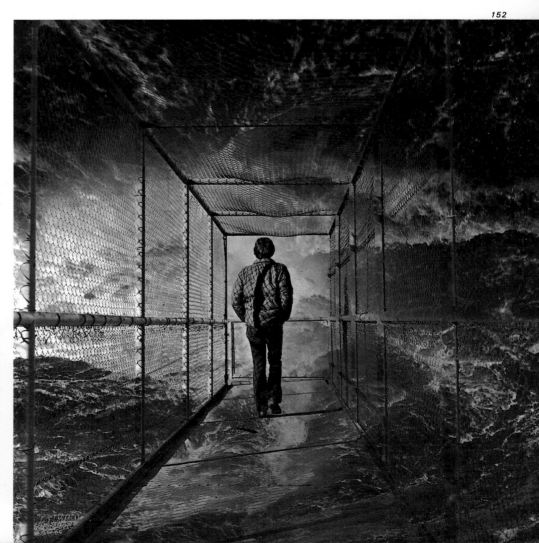

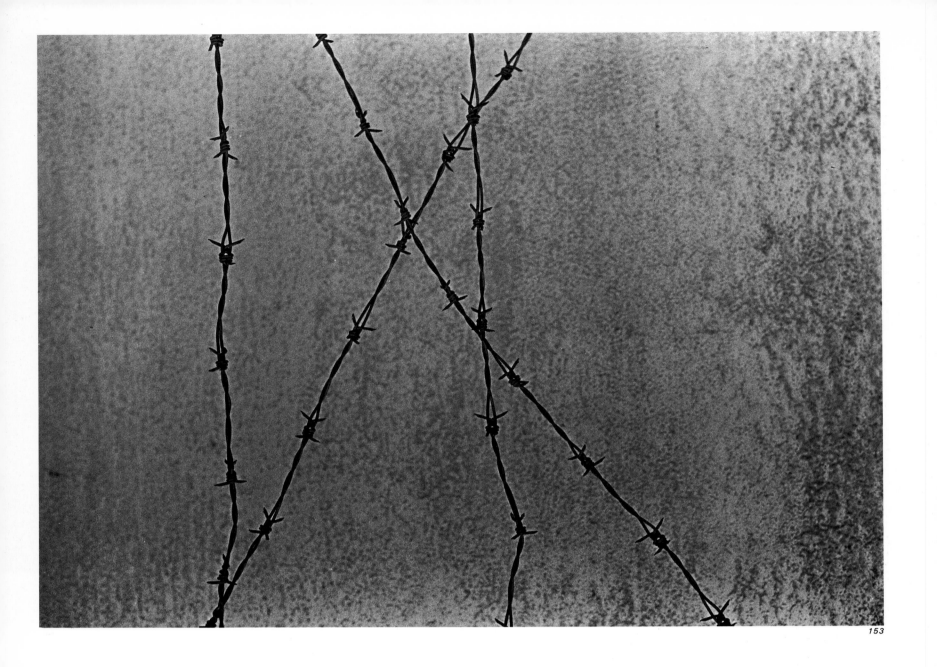

153

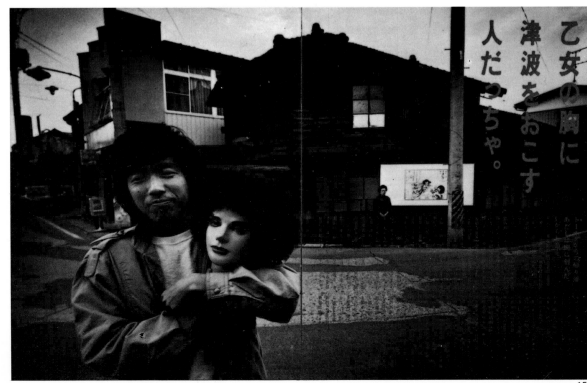

●153・154　●poster
　　　　　　　fashion company
photographer　井出貴久 takahisa ide
●
art director　平田剛 tsuyoshi hirata
designer　井出貴久 takahisa ide
advertiser　バレンザボー valenzapo

155

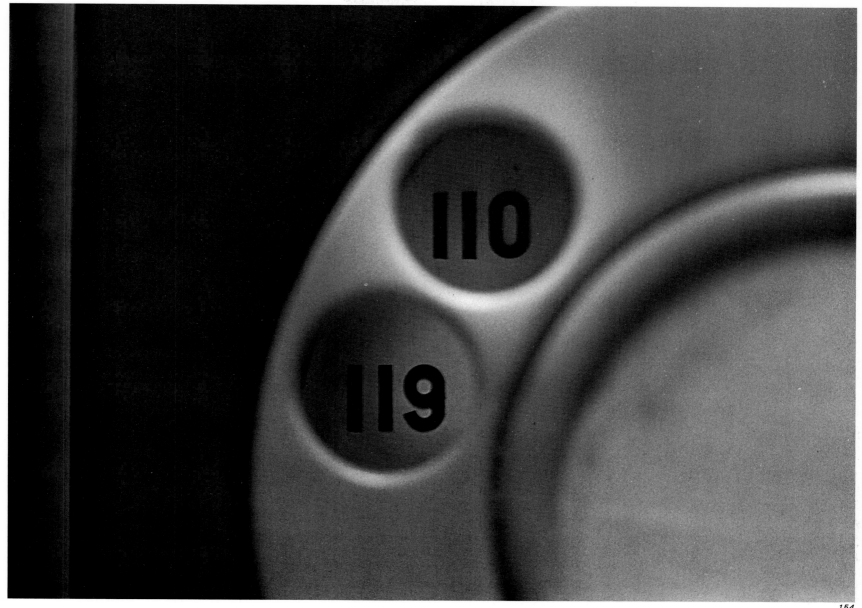

154

156

●155　　●magazine
　　　　　men's cosmetics

photographer　横木安良夫 arao yokogi
●　　　　　　●
art director　瀬口誠一 seiichi seguchi
designer　　瀬口誠一 seiichi seguchi
copywriter　斉藤春樹 haruki saito
　　　　　　小玉フカニ fukani kodama
　　　　　　御倉直文 naofumi onkura
　　　　　　中沢万里子 mariko nakazawa
　　　　　　義田雅之 masayuki minoda
　　　　　　五十嵐みきお mikio igarashi
agency　　　㈱資生堂 hakuhodo
production　㈱博報堂 hakuhodo
advertiser　㈱資生堂 shiseido

●156　　●poster
　　　　　hotel entertainment

photographer　妹背和行 kazuyuki imose
●　　　　　　●
art director　桜井雅章 masaaki sakurai
designer　　桜井雅章 masaaki sakurai
copywriter　桜井雅章 masaaki sakurai
agency　　　クライ・アント cry-ant
production　クライ・アント cry-ant
advertiser　札幌国際ホテル
　　　　　　sapporo international hotel

# LIGHT PUBLICITY LTD.
# A DIRECTORS' COMPANY
# SINCE 1951

*Photograph: Masaru Mera Cocktail: Rokuro Furukawa(KOOL)*

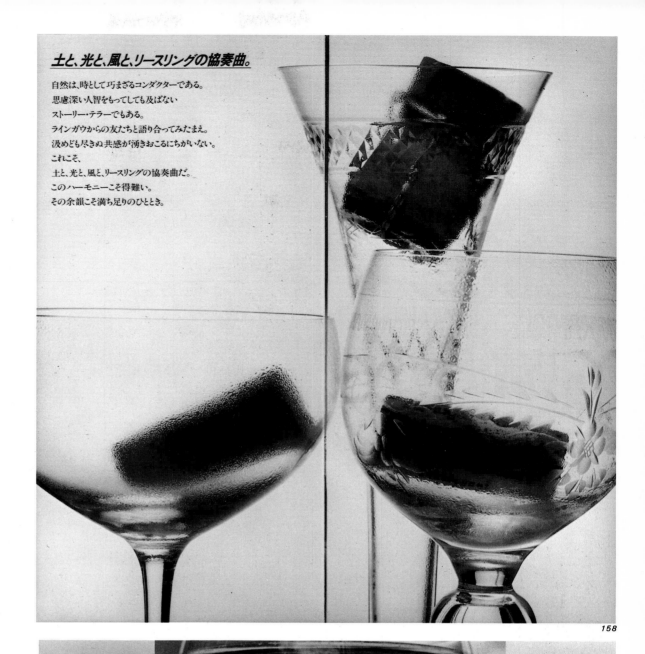

土と、光と、風と、リースリングの協奏曲。

自然は、時として巧まざるコンダクターである。
思慮深い人智をもってしても及ばない
ストーリー・テラーでもある。
ラインガウからの友だちと語り合ってみたまえ。
汲めども尽きぬ共感が湧きおこるにちがいない。
これこそ、
土と、光と、風と、リースリングの協奏曲だ。
このハーモニーこそ得難い。
その余韻こそ満ち足りのひととき。

158

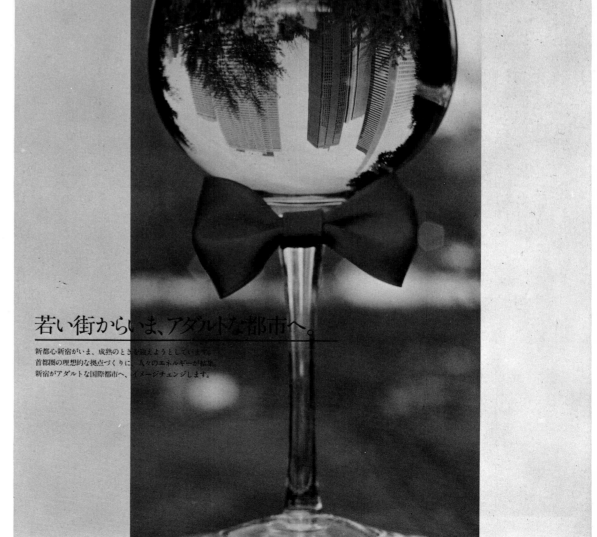

若い街からいま、アダルトな都市へ。

新都心・新宿がいま、成熟のときを迎えようとしています。
首都圏の理想的な拠点づくりに、人々のエネルギーが結集。
新宿がアダルトな国際都市へ、イメージチェンジします。

159

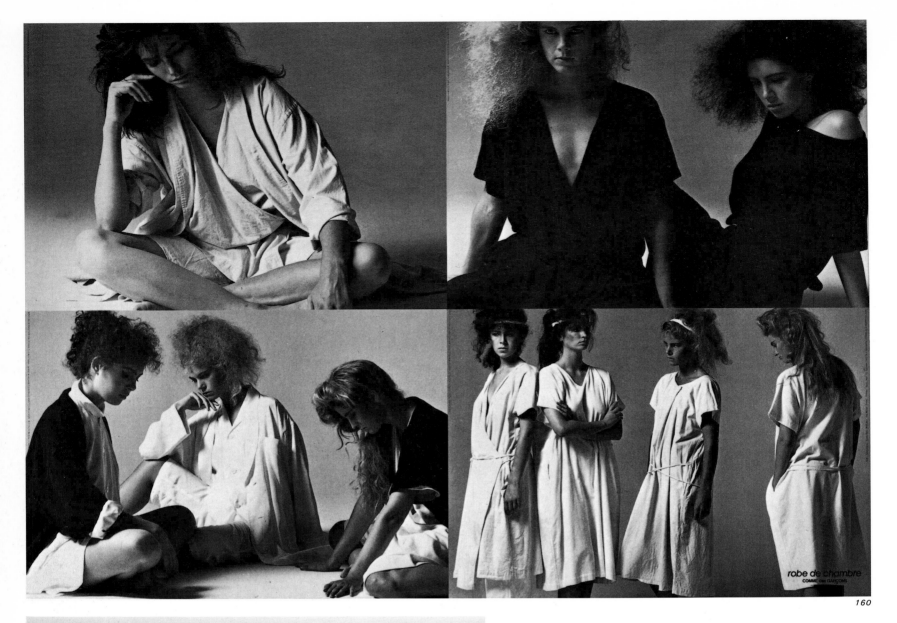

robe de chambre
COMME des GARÇONS

160

161

●160　●poster
　　　　fashion

photographer　坂野豊 yutaka sakano
●
art director　村田東治 toji murata
designer　　　村田東治 toji murata
production　　ストロベリーフィールズ
　　　　　　 strawberry fields
advertiser　　コムデギャルソン
　　　　　　 comme des garçons

●161　●pamphlet
　　　　fashion

photographer　坂野豊 yutaka sakano
●
art director　吉田康一 koichi yoshida
designer　　　吉田康一 koichi yoshida
production　　吉田康一 koichi yoshida
advertiser　　㈱ニコル nicole

●162　●pamphlet
　　　　fashion

photographer　坂野豊 yutaka sakano
●
art director　村田東治 toji murata
designer　　　村田東治 toji murata
production　　ストロベリーフィールズ
　　　　　　 strawberry fields
advertiser　　㈱東京エル tokyo elle

セットアップを着る人のための、人間って、何でしょ。構串ーその4。裸ばかりじゃ何も起らない。という意味が、最近、それもあなたに逢って、4週間目だった。ホントにわかっ

セットアップを着る人のための、人間って、何でしょ。構串ーその5。異常も、日々続くと、平常になってしまう。平常って気分がなくなっちゃったら、アラ、ま、なんてこと、イヤセンって気分がなくなっちゃったら、スカみたい。

163

164

167

●163・164　　●pamphlet
167　　　　　fashion
photographer　坂野豊 yutaka sakano
●
copywriter　仲畑貴志 takashi nakahata
production　㈱メルローズ melrose
advertiser　㈱メルローズ melrose

●165　　　●magazine
　　　　　fashion
photographer　坂野豊 yutaka sakano
●
advertiser　イッセイミヤケインターナショナル
　　　　　issey miyake international

●166　　　●pamphlet
　　　　　fashion
photographer　坂野豊 yutaka sakano
●
art director　二宮浩 hiroshi ninomiya
designer　二宮浩 hiroshi ninomiya
production　㈱ライフグラフィック life graphic
advertiser　日本ハーフ nippon half

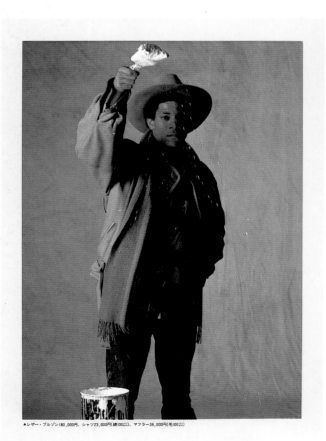

▲レザー・ブルゾン180,000円、シャツ23,000円(綿100%)、マフラー36,000円(毛100%)

165

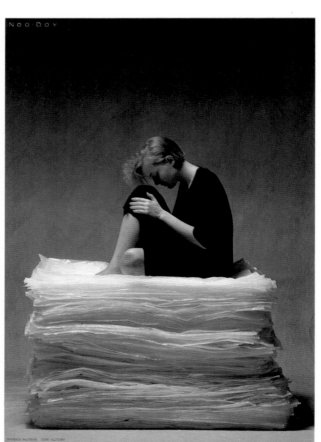

NOO-BOY

166

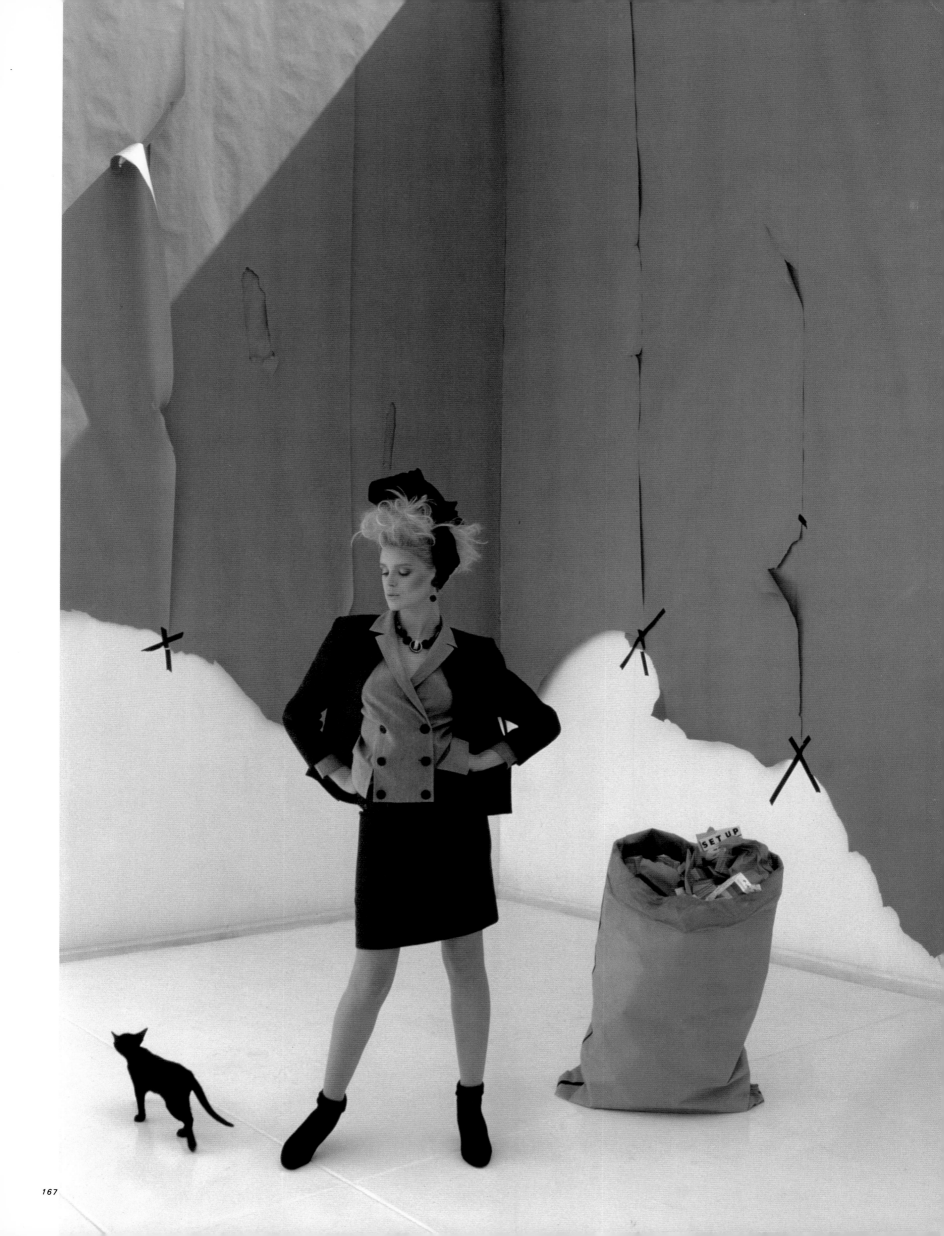

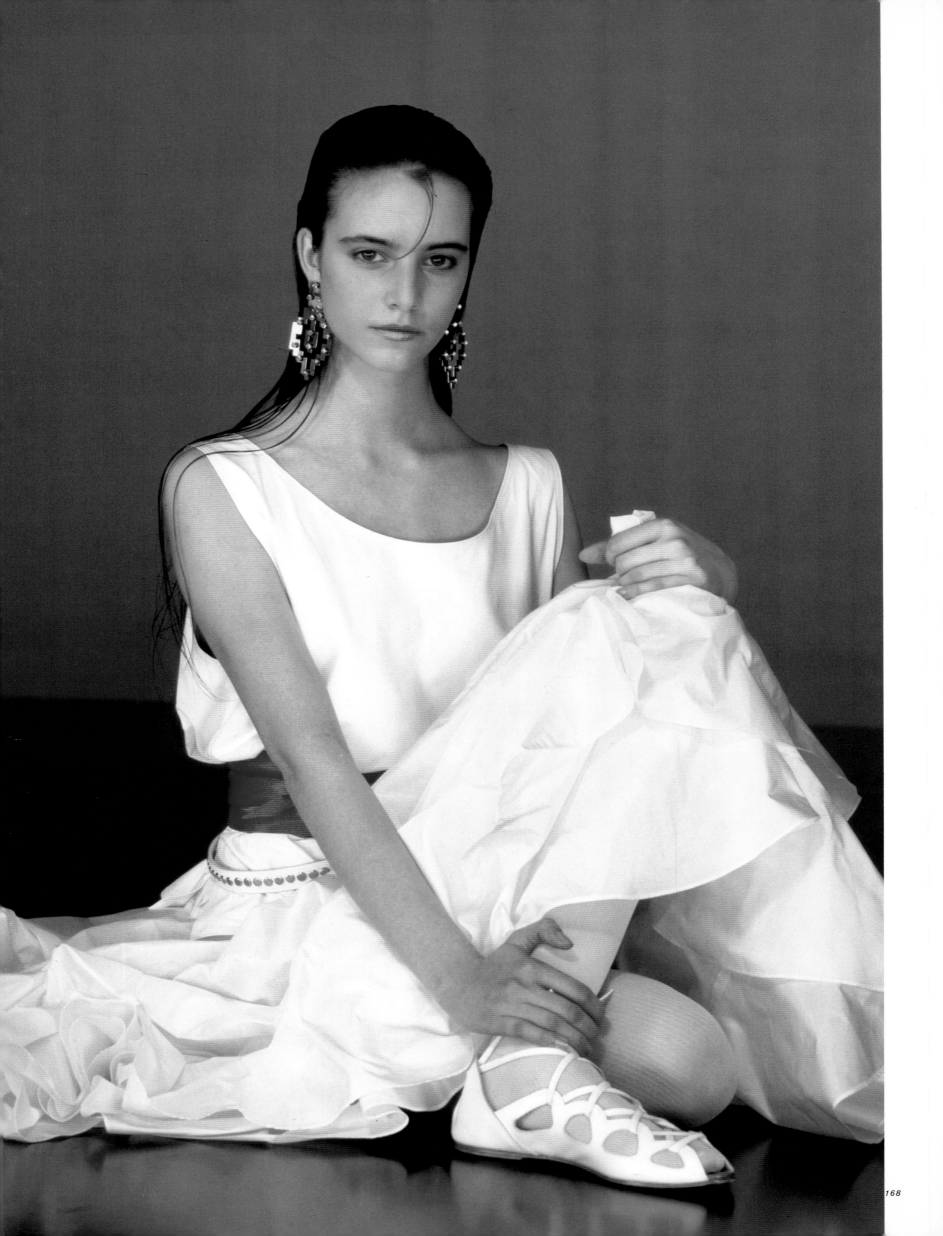

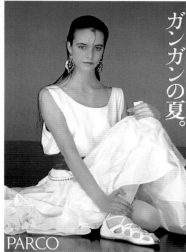

ガンガンの夏。

PARCO

168

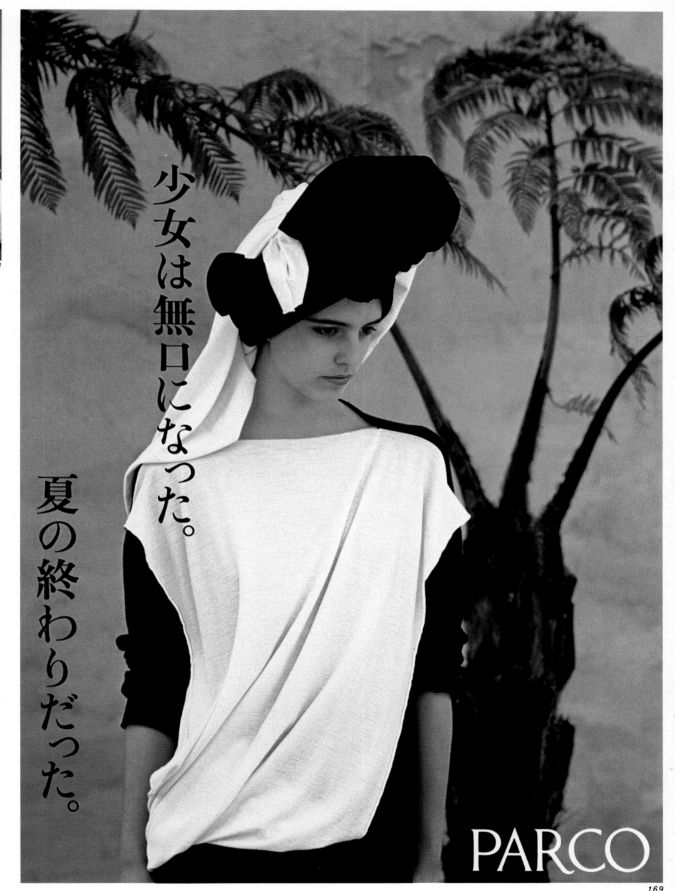

少女は無口になった。
夏の終わりだった。

PARCO

169

●168・169   ●poster
             shopping center
photographer  横須賀功光 noriaki yokosuka
●
art director  大道康央 yasuo omichi
designer      大道康央 yasuo omichi
             山口勇 isamu yamaguchi
copywriter    田旗浩一 koichi tabata (168)
             岩崎俊一 shunichi iwasaki (169)
production    ㈱大道康央デザイン事務所
             yasuo omichi design office
advertiser    ㈱パルコ parco

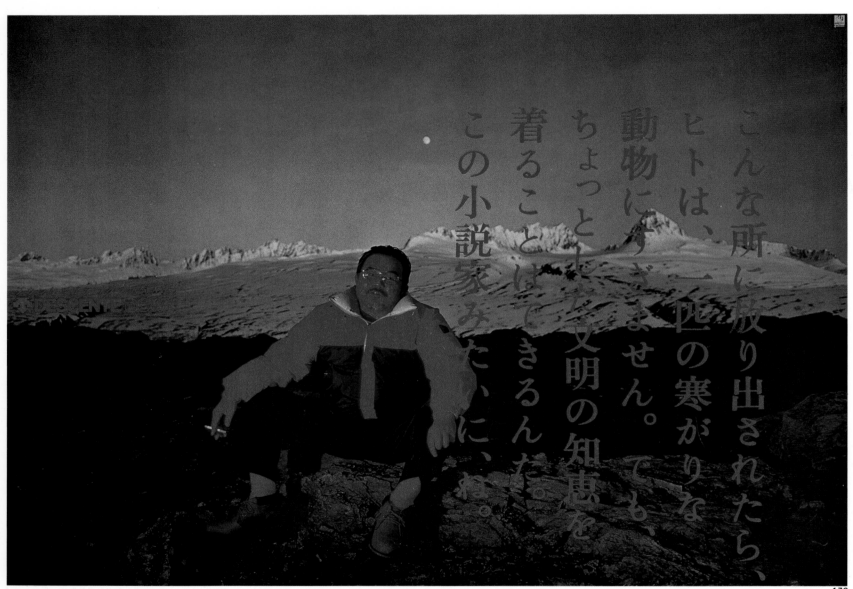

こんな所に放り出されたら、ヒトは、一匹の寒がりな動物にすぎません。でも、ちょっとした文明の知恵を着ることはできるんだ。この小説家みたいに、ね。

170

●170　　　　●poster
●171·172　●magazine
　　　　　　ski wear

photographer　高崎勝二 katsuji takasaki
●
art director　副田高行 takayuki soeda
designer　　　副田高行 takayuki soeda
copywriter　　喜多嶋隆夫 takao kitajima
agency　　　　㈱サン・アド sun-ad
production　　㈱サン・アド sun-ad
advertiser　　㈱デサント descente

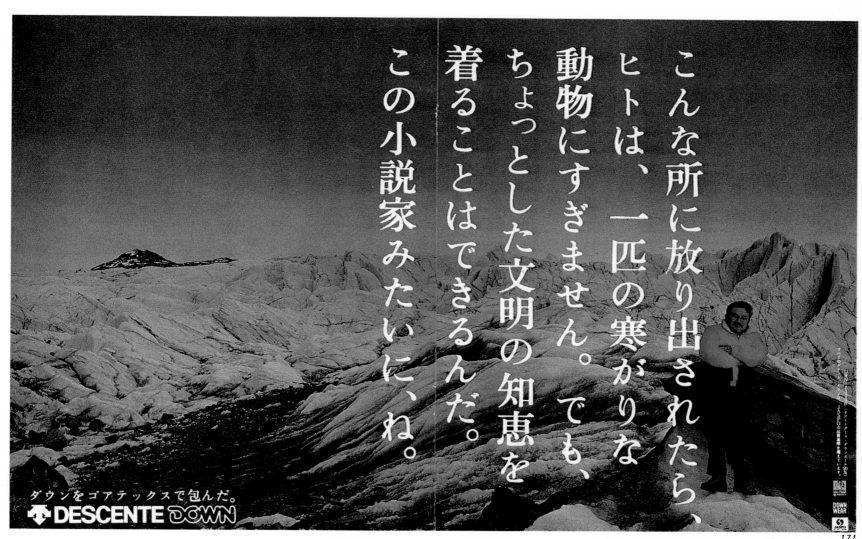

ダウンをゴアテックスで包んだ。
△ DESCENTE DOWN

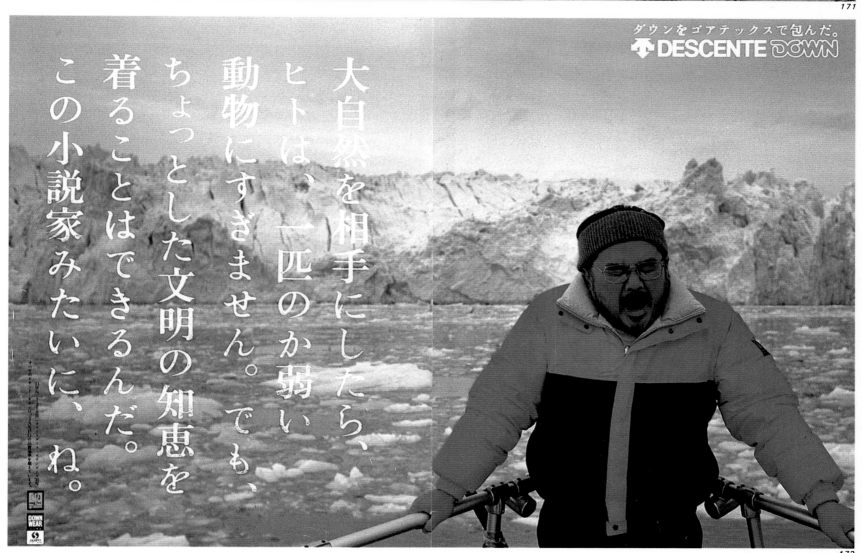

ダウンをゴアテックスで包んだ。
△ DESCENTE DOWN

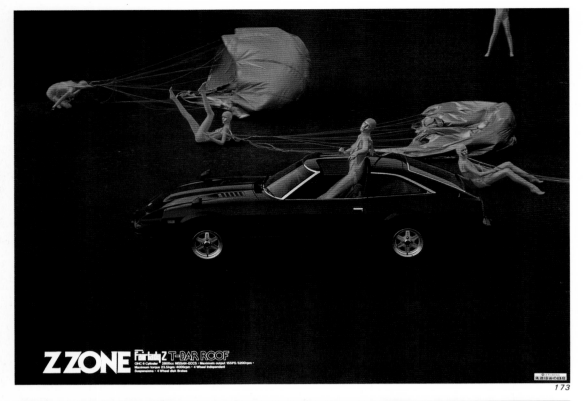

**Z ZONE** Fairlady Z T-BAR ROOF
OHC 6 Cylinder · 2800cc NISSAN-ECCS · Maximum output 155PS/5200rpm
Maximum torque 23.5kgm/4000rpm · 4 Wheel Independent
Suspensions · 4 Wheel disk Brakes

*173*

**Chicago**
JAPAN AIR LINES

*176*

## DATSUN 280ZX 2+2 TURBO

*Type: L28ET  Bore × stroke: 86 × 79mm (3.39 × 3.11in).  Displacement: 2753cc (168.2cu in).*
*Max. power: 204hp at 5600rpm (DIN).  Max. torque: 30.3kg-m at 4400rpm (DIN).*
*Digital electric fuel injection with knock control device.*

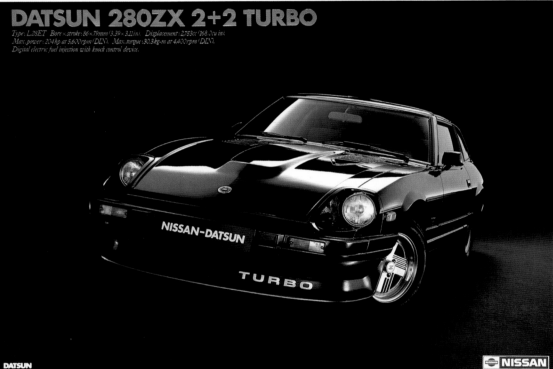

NISSAN-DATSUN

TURBO

DATSUN                                          **NISSAN**

*174*

Z ZONE Fairlady Z
POWER & SAVE

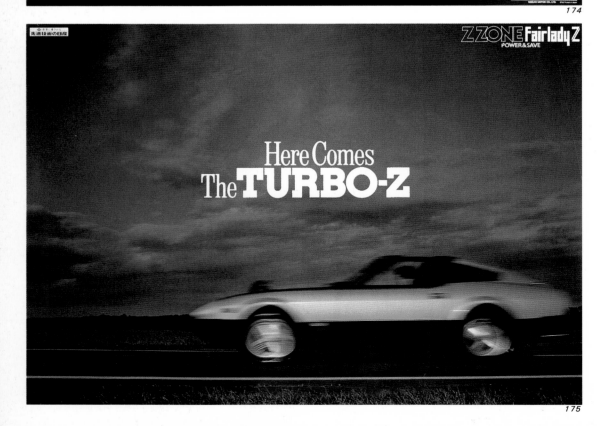

Here Comes
The **TURBO-Z**

*175*

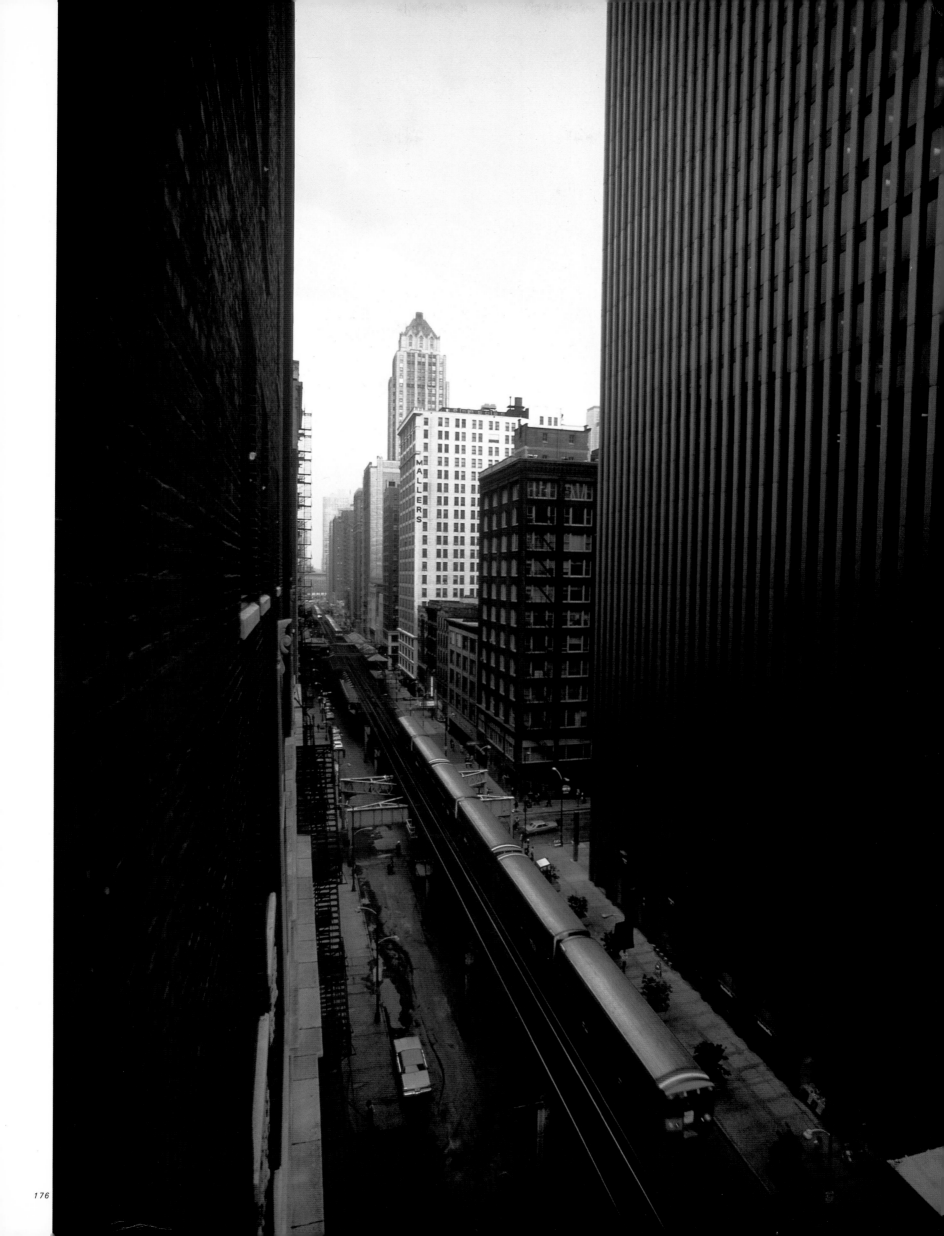

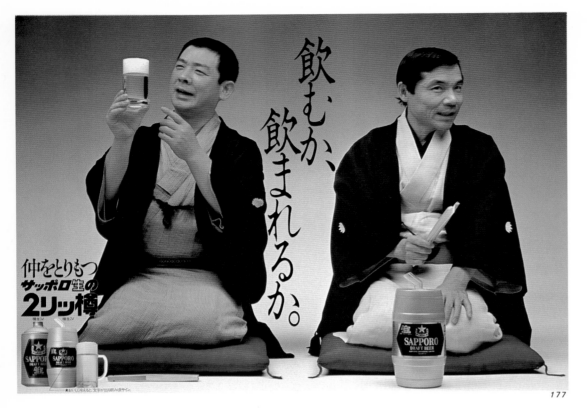

飲むか、飲まれるか。

仲をとりもつ
サッポロ生の
2リッ樽

177

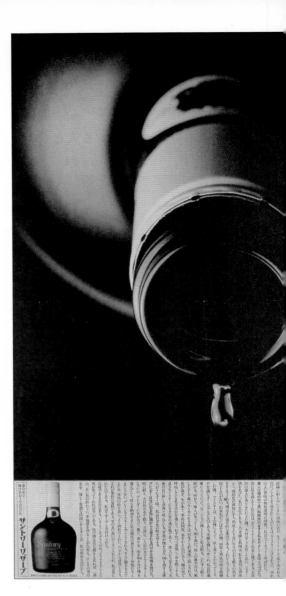

サントリーリザーブ

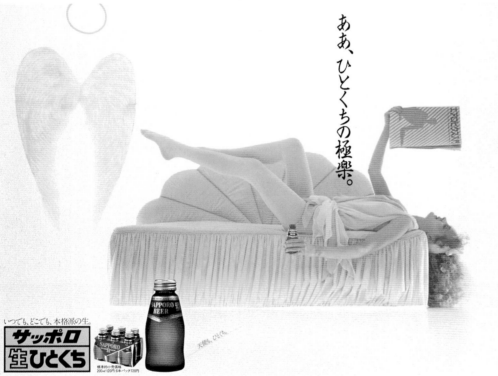

ああ、ひとくちの極楽。

いつでも、どこでも、本格派の生

サッポロ
生ひとくち

178

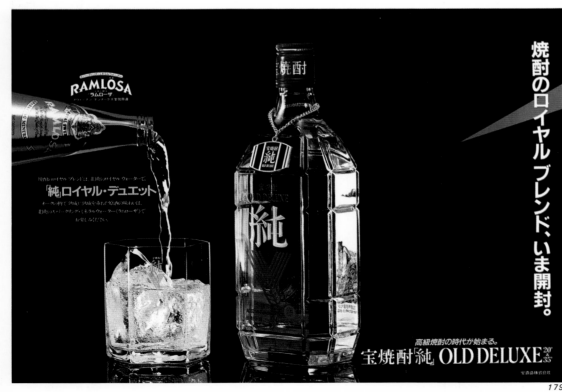

RAMLOSA
ラムローサ

「純」ロイヤル・デュエット

焼酎のロイヤルブレンド、いま開封。

高級焼酎の時代が始まる。
宝焼酎「純」OLD DELUXE

宝酒造株式会社

179

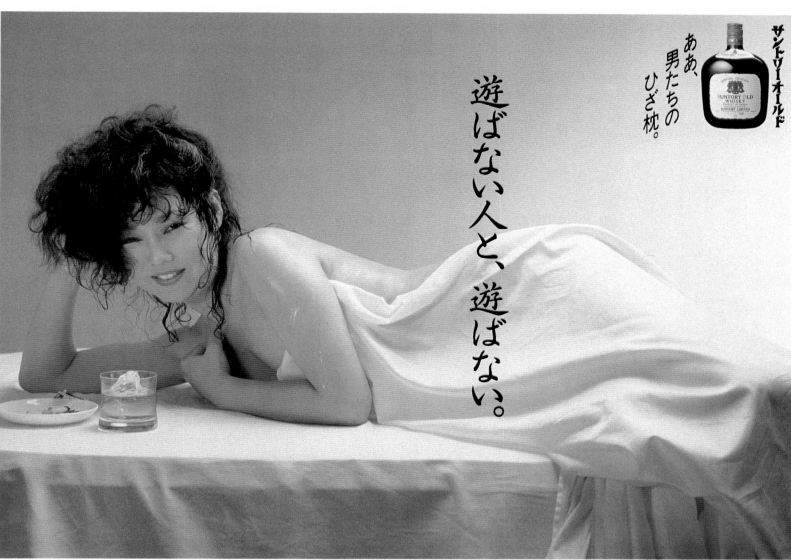

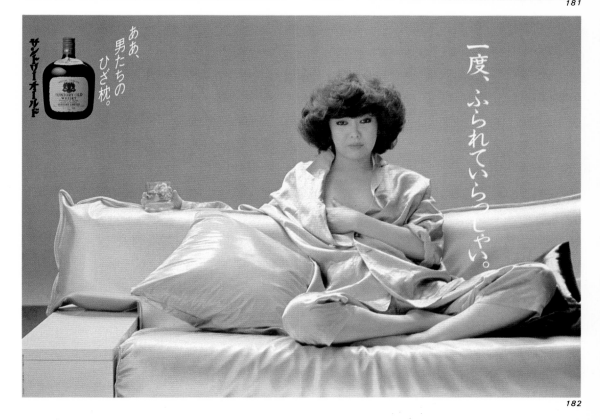

180

181

182

| | | | | | | | |
|---|---|---|---|---|---|---|---|
| **●177·178** | **●poster** beer | **●179** | **●poster** sake | **●180** | **●newspaper** whisky | **●181·182** | **●poster** whisky |
| photographer | 白鳥真太郎 shintaro shiratori | photographer | 青木誠一 seiichi aoki | photographer | 佐藤弘 hiroshi sato | photographer | 立石敏雄 toshio tateishi |
| art director | 原稔 minoru hara | art director | 溝口實 minoru mizoguchi | art director | 八木正仁 masahiro yagi | art director | 大道康央 yasuo omichi |
| | 大栗隆 takashi oguri (178) | designer | 熊川俊喜 toshiki kumakawa | designer | 八木正仁 masahiro yagi | designer | 大道康央 yasuo omichi |
| designer | 大栗隆 takashi oguri (177) | copywriter | 渡辺雅代 masayo watanabe | copywriter | 村山孝文 takafumi murayama | copywriter | 岩崎俊一 shunichi iwasaki |
| | 川崎擴 hiroshi kawasaki | production | ㈱日本デザインセンター nippon design center | agency | ㈱電通 dentsu | agency | ㈱東急エージェンシー tokyu agency |
| copywriter | 土井徳秋 noriaki doi | advertiser | 宝酒造㈱ takara shuzo | production | ㈱電通 dentsu | production | ㈱大道康央デザイン事務所 yasuo omichi design office |
| agency | ㈱博報堂 hakuhodo | | | advertiser | サントリー㈱ suntory | advertiser | サントリー㈱ suntory |
| production | ㈱博報堂 hakuhodo | | | | | | |
| advertiser | サッポロビール㈱ sapporo breweries | | | | | | |

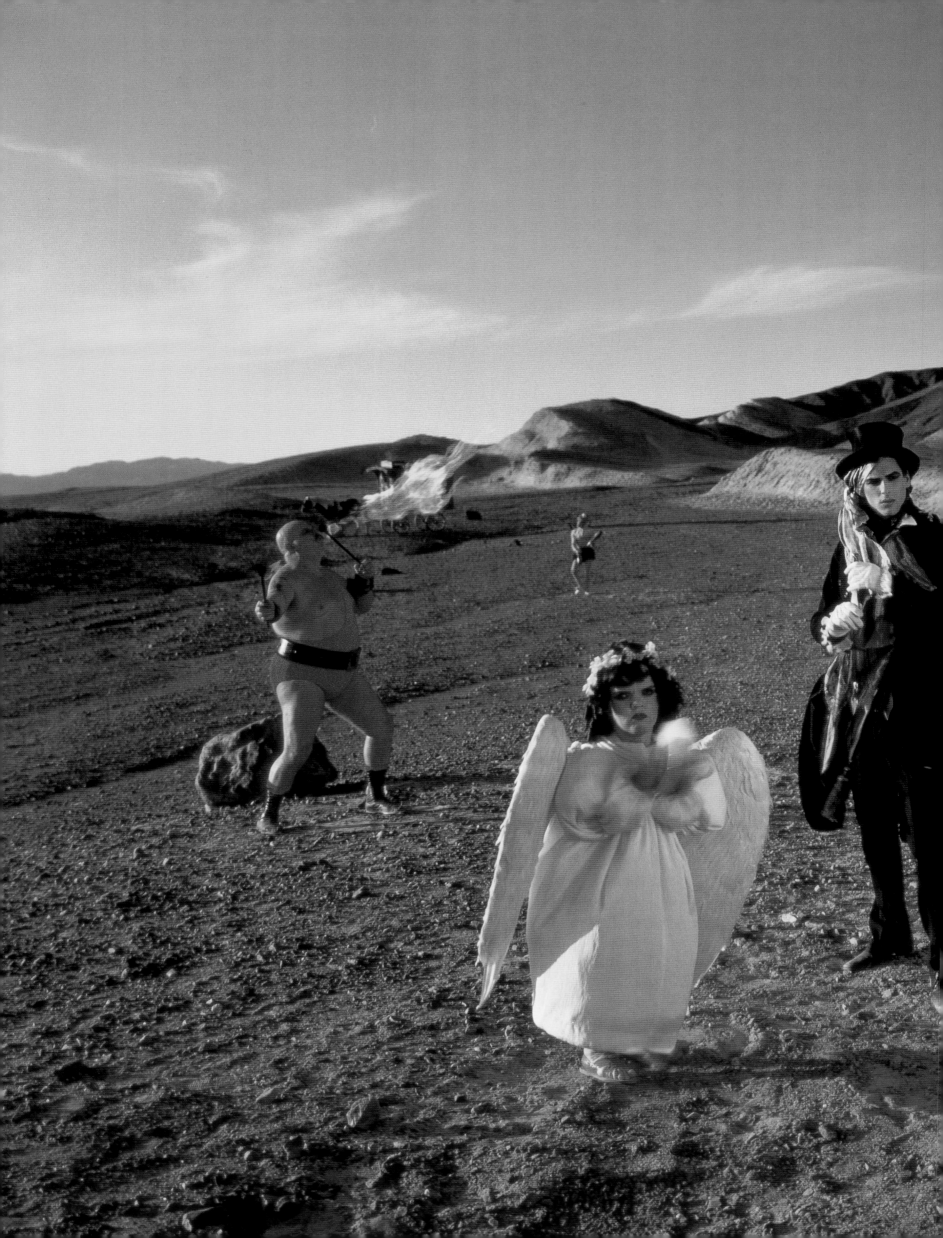

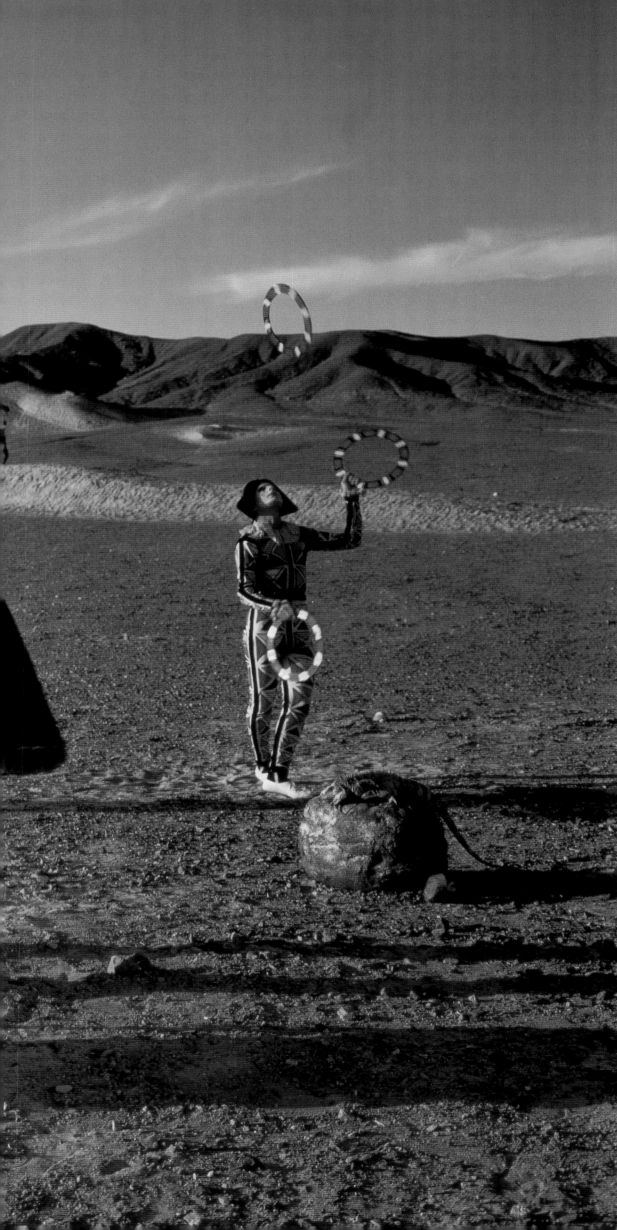

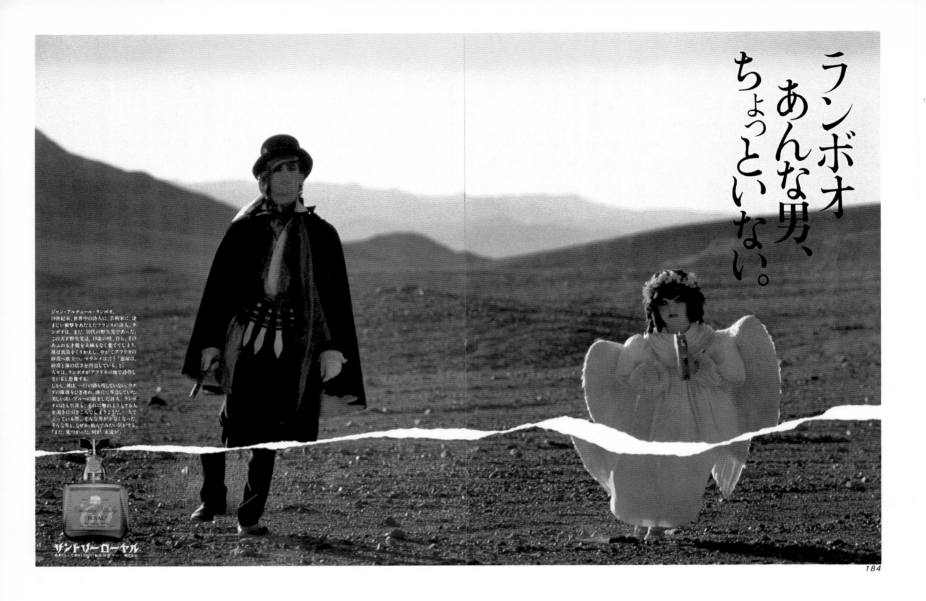

ランボオ
あんな男、
ちょっといない。

ジャン・アルチュール・ランボオ。
19世紀末、世界中の詩人に、芸術家に、凄
まじい衝撃をあたえたフランスの詩人。ラン
ボオは、まだ、10代の野生児だった。
この天才野生児は、19歳の時、自ら、その
あふれる才能を未練なく棄ててしまう。
彼は放浪をくりかえし、やがてアフリカの
砂漠の旅立つ。マラルメは言う「遠сре方は、
砂漠と海の広さを内蔵している。」
人々は、ランボオがアフリカの地を這はして
いるのを想像する。
しかし、彼は、一片の詩も残していない。ラク
ダの隊商をひきつれ、商売に専念していた。
美しい青い、ブルーの瞳をした詩人。ランボ
オの詩も生涯も、それに触れようとする人
を過りに引きこんでしまうようだ。一人で
立っている男、そんな男がすくなくなった。
そんな男を、なぜか、飲んでみたい気がする。
「また、見つかった、何が?、永遠が。」

サントリーローヤル

●183-185  ●magazine
●186  ●newspaper
         whisky
photographer  漆畑銃治 senji urushibata
●
art director  戸田正寿 masatoshi toda
copywriter  長沢岳夫 takeo nagasawa
advertiser  サントリー㈱ suntory

●187・188  ●magazine
            video software
photographer  漆畑銃治 senji urushibata
art director  宮田識 satoru miyata
copywriter  梅本洋一 yoichi umemoto
advertiser  ワンダーキッド wonder kid's

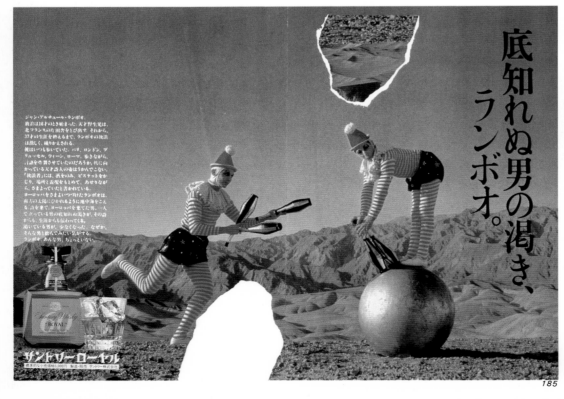

底知れぬ男の渇き、
ランボオ。

ジャン・アルチュール・ランボオ。
放浪は16才のときはじまった。天才野生児は、
北フランスの田舎をとび出す。それから、
37才で生涯を終わるまで、ランボオの放浪
は烈しく、細かされる。

サントリーローヤル

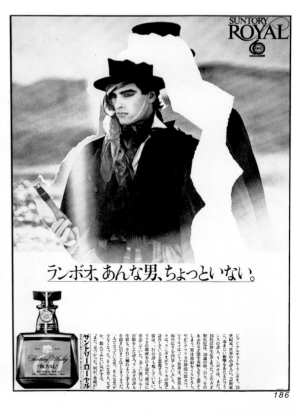

SUNTORY
ROYAL

ランボオ、あんな男、ちょっといない。

サントリーローヤル

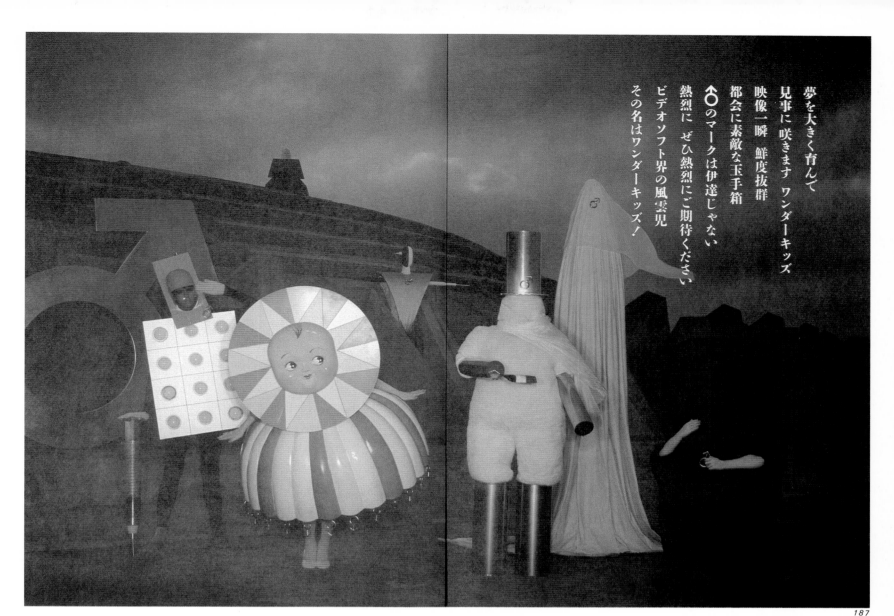

夢を大きく育んで
見事に咲きます ワンダーキッズ
映像一瞬 鮮度抜群
都会に素敵な玉手箱
↑◯のマークは伊達じゃない
熱烈に ぜひ熱烈にご期待ください
ビデオソフト界の風雲児
その名はワンダーキッズ！

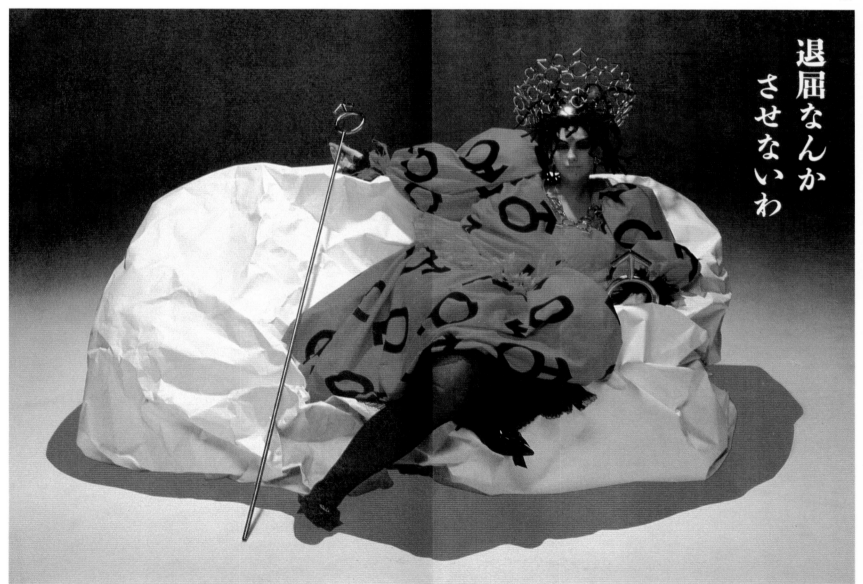

退屈なんか
させないわ

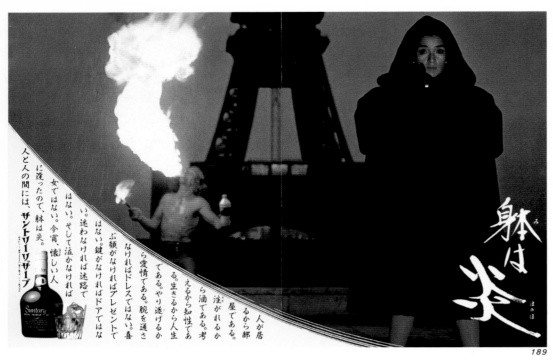

人と人の間には、躰は炎。今宵、懐しい人に逢ったので、躰は炎。人と人の間には、サントリーリリザーブ

女ではない。男ではない。そして泣かなければ迷わなければ道路はない。逃わなければ迷路ない。迷わなければ道路はない。そしてぶ頬がなければドアではなけれなければドレスではない。ら通れる。なり遂げるから人生である。やり遂げるから知性である。喜生きるから人生であ注がれるか。腕を通って、考える。

人が居るから部屋である。

躰は炎

189

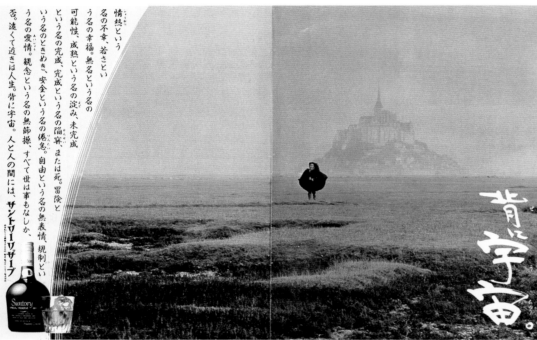

否、遠くて近きは人生。背に宇宙。人と人の間には、サントリーリリザーブ

情熱という名の不幸。若さという名の完成、完成という名の可能性、成熟という名の淀み、未完成という名のときめき、安全という名の油断、未完という名の停息と自由という名の倦怠。観念という名の無節操、すべて世は事もなしか。否、遠くて近きは人生。背に宇宙。人と人の間には、サントリーリリザーブ

背に宇宙。

190

●189·190　●magazine
　　　　　　　whisky
photographer　漆畑銃治 senji urushibata
●
art director　泉屋政昭 masaaki izumiya
copywriter　三浦徳子 yoshiko miura
advertiser　サントリー㈱ suntory

●191　●calendar
●192　●newspaper
　　　　　cognac
photographer　漆畑銃治 senji urushibata
●
art director　宮田識 satoru miyata
copywriter　一倉宏 hiroshi ichikura
advertiser　サントリー㈱ suntory

191

マーテル・コニャックを贈られた夜は、貴族的な夜である。かのナポレオン皇帝栄華の時代に先ずること1世紀、1715年より、マーテルは王朝人寵愛の美酒であった。けだしマーテルこそ嫡流のコニャック。コニャックの源氏。たち昇る薫香は、おのずからその歴史を語る。コニャックを知る男にとって、これぞ正統といえる贈り物。マーテルをおいて他にはない。

**マーテル・コニャック**
V.S.O.P 700㎖ 12,000円（標準的な小売価格です。）

# MARTELL
# COGNAC
## LARGEST SELLING COGNAC IN FRANCE

この起こりは、マーテル。

192

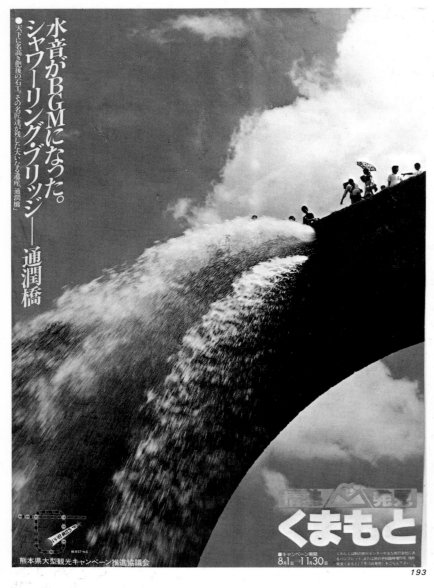

194

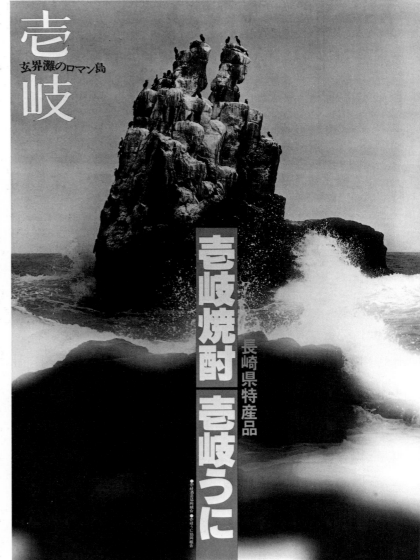

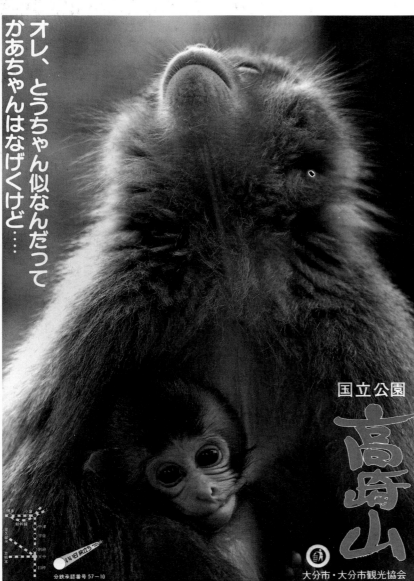

195

●193　　　●poster
　　　　　　tourist promotion

photographer　宮井政次 masatsugu miyai
●
art director　佐伯正繁 masashige saeki
copywriter　立川かず子 kazuko tachikawa
production　秀巧社印刷㈱ shukosha printing
advertiser　熊本県 kumamoto-prefectural, office

●194　　　●poster
　　　　　　tourist promotion

photographer　大久保康三 kozo okubo
●
designer　田河和弘 kazuhiro tagawa
production　秀巧社印刷㈱ shukosha printing
advertiser　壱岐酒造組合 iki shuzo assoc.

●195　　　●poster
　　　　　　tourist promotion

photographer　山田実 makoto yamada
●
art director　丸山譲二 joji maruyama
designer　後藤俊文 toshibumi goto
copywriter　足立高行 takayuki adachi
agency　㈱atb
production　㈱atb
advertiser　大分市 oita city

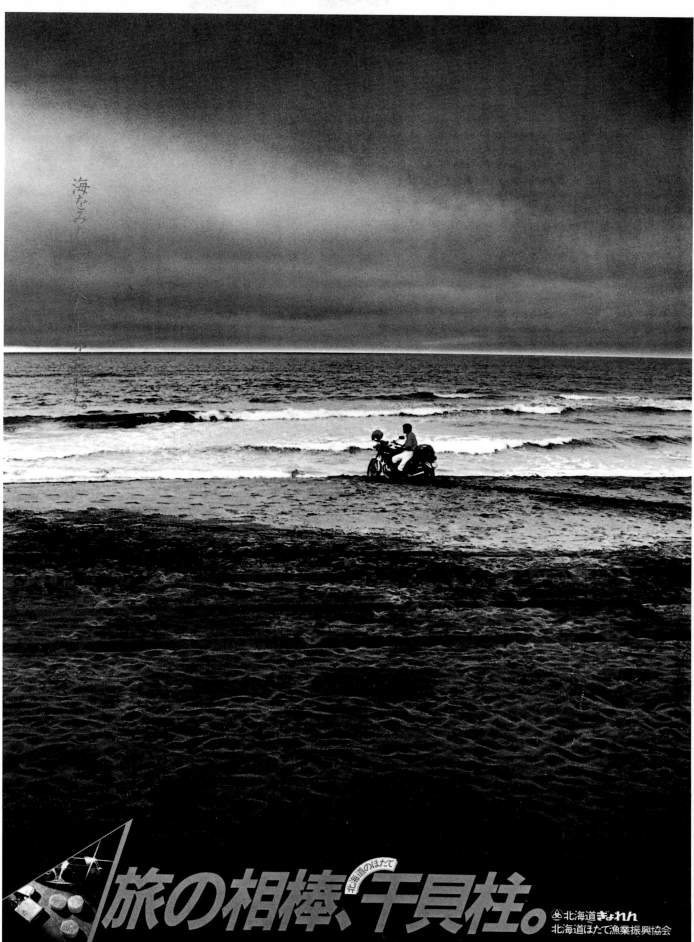

●196　　●poster
　　　　　seafood promotion
photographer　藤倉孝幸 takayuki fujikura
●
creative　　蘇武紘 hiromi sobu
　director
art director　梶間敬一 keiichi kajima
designer　　加藤譲 yuzuru kato
copywriter　和泉卓夫 takuo izumi
agency　　　㈱博報堂札幌支社
　　　　　　hakuhodo sapporo
production　㈲オレンジ・スタジオ orange studio
advertiser　北海道ほたて漁業振興協会
　　　　　　hokkaido hotate gyogyo shinko
　　　　　　kyokai

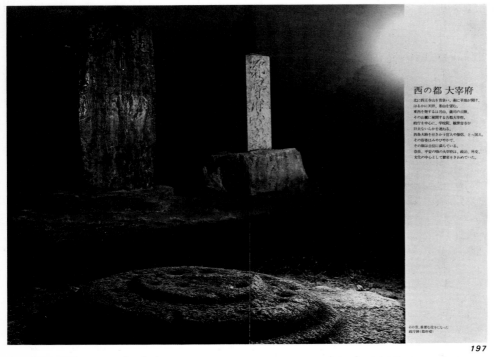

197

198

199

200

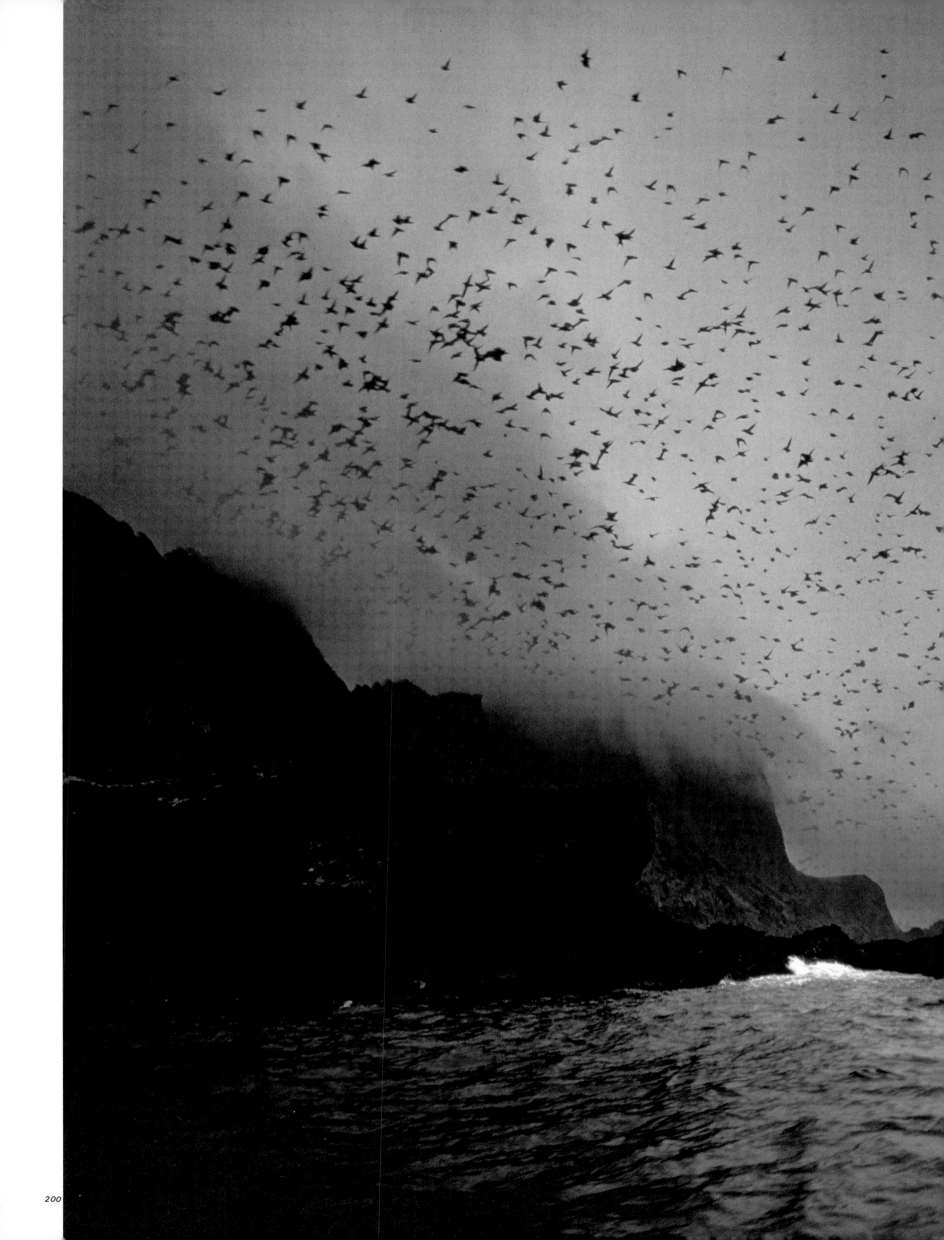

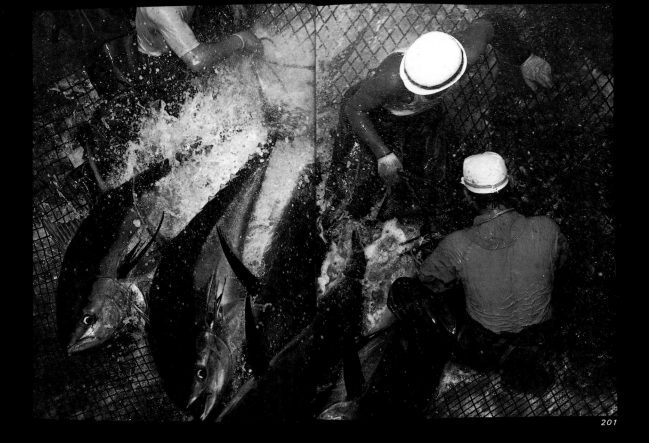

201

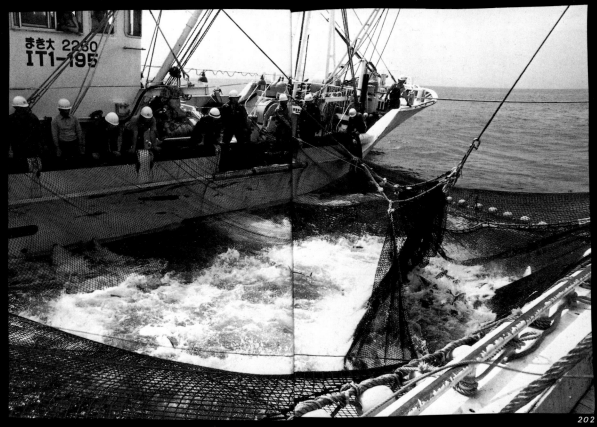

202

●201・202 ●company profile
diesel engines

photographer 谷口龍平 ryuhei taniguchi
●
production ㈱ダイヤモンド社 diamond-sha
㈱グランツ grants
advertiser ㈱ヤンマーディーゼル yamner diesel
yanmer diesel

●203 ●direct mail
photographer's portforio

photographer 三好和義 kazuyoshi miyoshi
●
art director 中村政久 masahisa nakamura
designer 中村政久 masahisa nakamura
production 楽園 rakuen
advertiser 三好和義 kazuyoshi miyoshi

●204 ●magazine
cameras

photographer 目羅勝 masaru mera
●
art director 関勲 isao seki
designer 関勲 isao seki
copywriter 田村定 sadamu tamura
production ㈱ライトパブリシティ light publicity
advertiser キヤノン canon

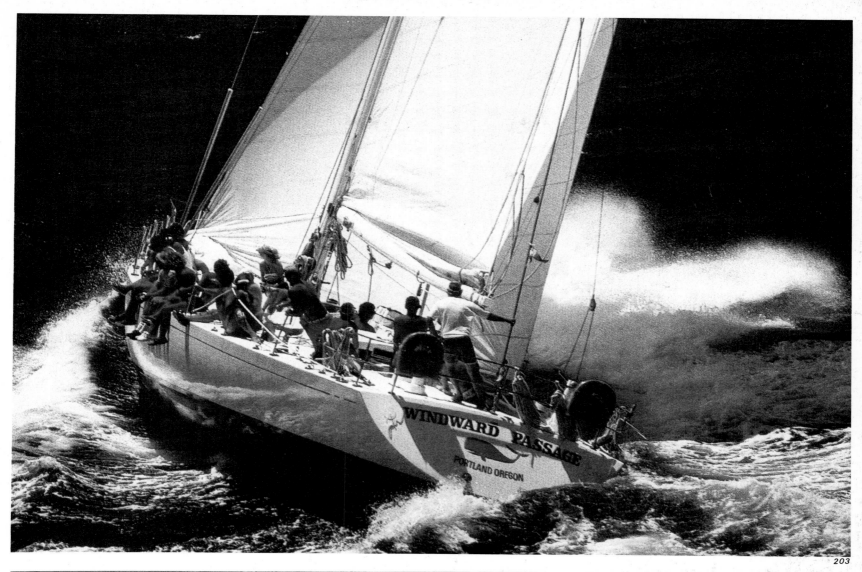

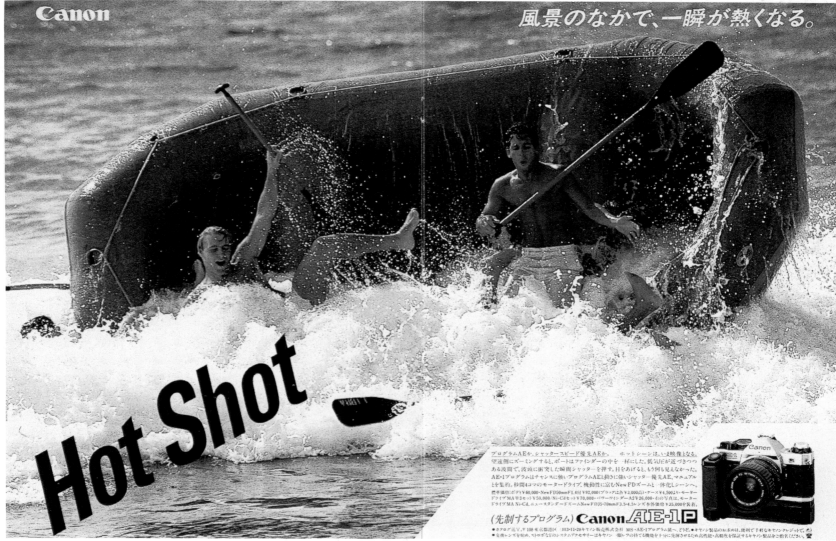

Canon

風景のなかで、一瞬が熱くなる。

Hot Shot

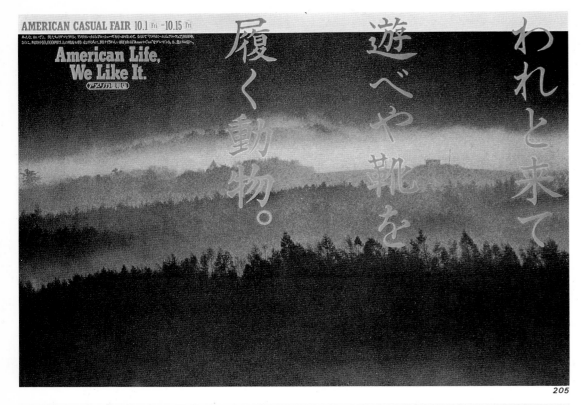

205

206

207

●205　　●poster
　　　　　shoes
photographer　藤井秀男 hideo fujii
●　　　　　●
art director　浅埜勝 katsu asano
designer　　松本和夫 kazuo matsumoto
　　　　　米澤絹江 kinue yonezawa
copywriter　古森暁 satoru komori
agency　　㈱オリコミ orikomi advertising
production　㈱オリコミ orikomi advertising
advertiser　㈱アメリカ屋靴店 americaya shoe

●206　　●pop
　　　　　shoes
photographer　浅埜勝 katsu asano
●　　　　　●
art director　浅埜勝 katsu asano
designer　　松本和夫 kazuo matsumoto
　　　　　米澤絹江 kinue yonezawa
copywriter　古森暁 satoru komori
agency　　㈱オリコミ orikomi advertising
production　㈱オリコミ orikomi advertising
advertiser　㈱アメリカ屋靴店 americaya shoe

●207　　●poster
　　　　　shoes
photographer　浅埜勝 katsu asano
●　　　　　●
art director　浅埜勝 katsu asano
designer　　松本和夫 kazuo matsumoto
　　　　　米澤絹江 kinue yonezawa
copywriter　古森暁 satoru komori
agency　　㈱オリコミ orikomi advertising
production　㈱オリコミ orikomi advertising
advertiser　㈱アメリカ屋靴店 americaya shoe

●208-210　　●poster
　　　　　airline
photographer　根岸広行 hiroyuki negishi
●　　　　　●
art director　柚川祐一 yuichi yukawa
designer　　柚川祐一 yuichi yukawa
copywriter　泉登 noboru izumi
agency　　㈱マッキャンエリクソン博報堂
　　　　　mccann erickson hakuhodo
production　㈱マッキャンエリクソン博報堂
　　　　　mccann erikson hakuhodo
advertiser　ノースウェストオリエント
　　　　　northwest orient

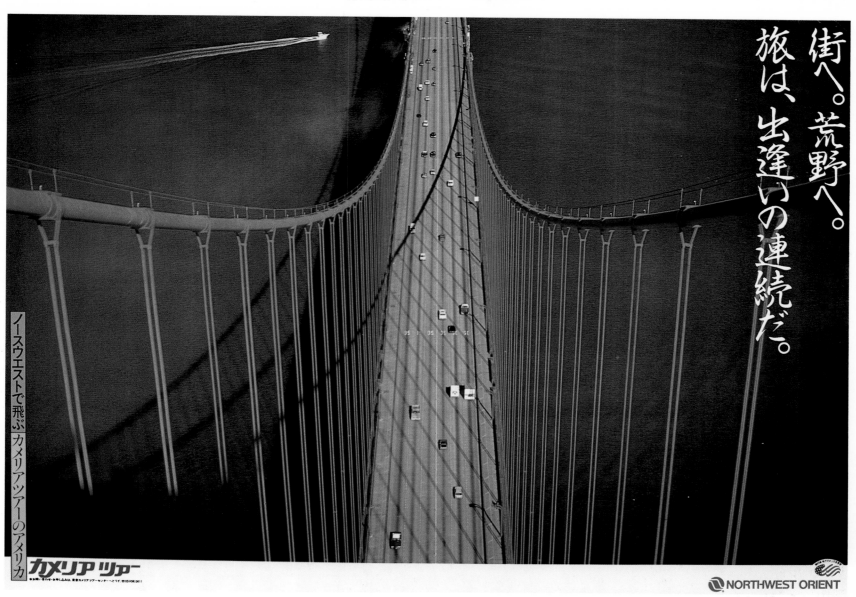

街へ。荒野へ。旅は、出逢いの連続だ。

天に。地に。旅は、胸いっぱいの感動を吸い込む。

The Beverly Hills

旅は、独立の精神を育てる。

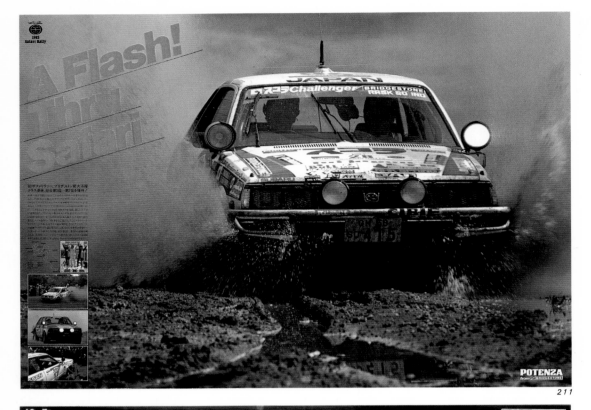

211

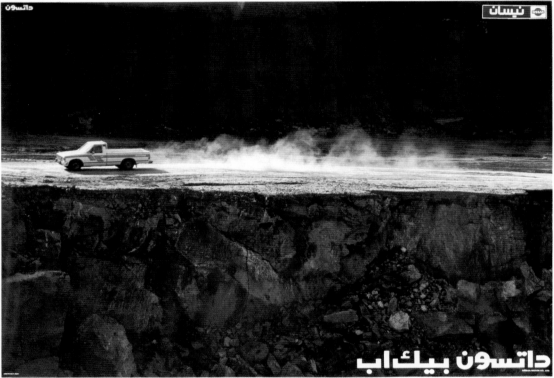

212

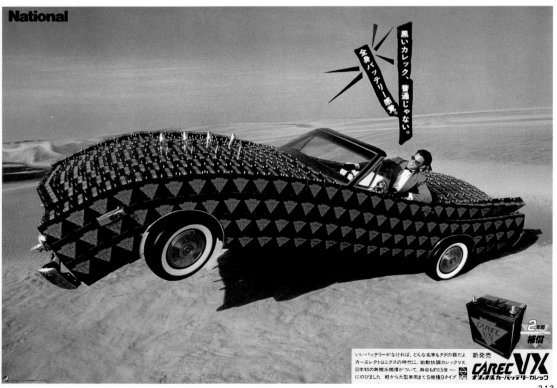

213

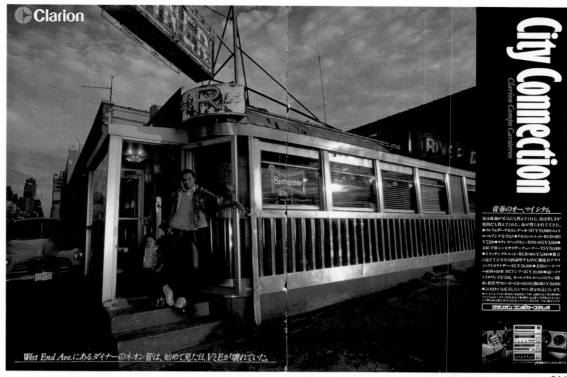

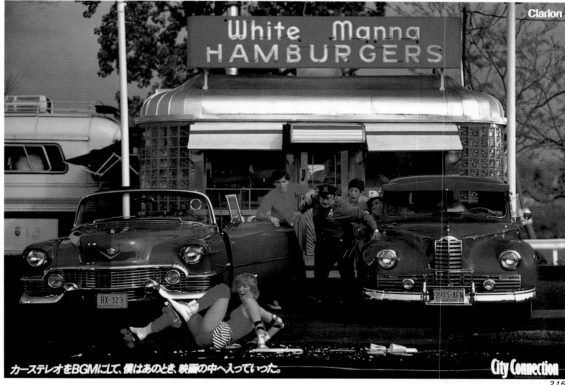

●214　●magazine
●215　●poster
　　　　car stereo system

photographer　高崎勝二 katsuji takasaki
art director　竹村勝博 katsuhiro takemura
designer　竹村勝博 katsuhiro takemura
copywriter　田中清美 kiyomi tanaka
　　　　　岩永嘉弘 yoshihiro iwanaga
agency　㈱10 Ban企画 10 ban kikaku
production　㈱10 Ban企画 10 ban kikaku
advertiser　㈱クラリオン cralion

●216　●poster
　　　　motorcars

photographer　柏木喜郎 yoshio kashiwagi
art director　松尾昌介 shosuke matsuo
designer　渡辺謙治 kenji watanabe
copywriter　大隅剛 takashi osumi
agency　㈱博報堂 hakuhodo
production　㈱博報堂 hakuhodo
advertiser　トヨタ自動車㈱ toyota motor

214

215

216

●217・218　●poster
　　　　　　　tourist promotion
photographer　北井三郎 saburo kitai
●
art director　亀倉雄策 yusaku kamekura
designer　　　亀倉雄策 yusaku kamekura
production　　西武鉄道㈱ seibu railway
advertiser　　国土計画㈱ kokudo keikaku

# みつまた高原

●918mのロープウェー混雑時は連絡リフトがご利用になれます・チェアリフト6・ナイターゲレンデ・駐車場1,000台
●初滑りから春スキーまでシーズンの長い・スキー場
●レストラン=レストランみつまたほか3
●交通=国鉄／上越新幹線越後湯沢駅から10km
　車＝関越自動車道前橋I.C.から国道17号で88km・六日町I.C.から国道17号で28km
●東京から西武観光の直通バス毎日運行
●営業所=みつまた高原スキー場TEL.(0257)88-9221
●お問合せ=西武観光／東京TEL.(03)985-8181・高崎TEL.(0273)25-8181・新潟TEL.(0252)45-8141

●219          ●poster
                national railway

photographer    新藤修一 shuichi shindo
●               ●
art director    鈴木八朗 hachiro suzuki
designer        鈴木八朗 hachiro suzuki
copywriter      鈴木八朗 hachiro suzuki
agency          ㈱電通 dentsu
production       ㈱電通 dentsu
advertiser      国鉄 national railway
                219

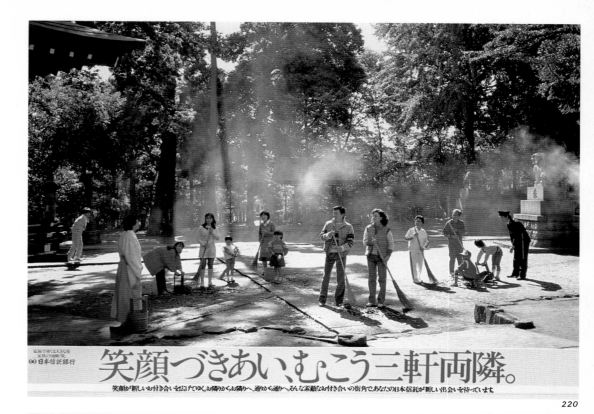

笑顔づきあい、むこう三軒両隣。

笑顔が新しいお付き合いを広げてゆく。お隣りからお隣へ、通りから通りへ。そんな素敵なお付き合いの街角で、あなたの日本信託が新しい出会いを待っています。

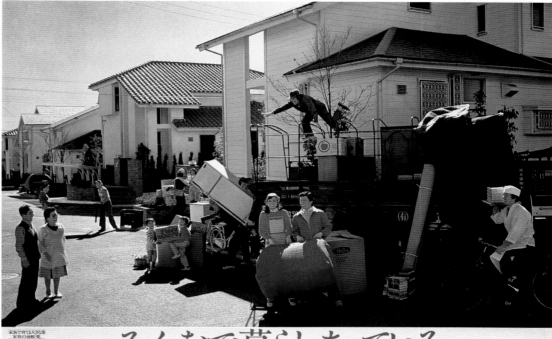

みんなで暮らしあっている。

笑顔があふれている。街ぜんたいが活き活きしている。きっと住んでる人たちが、暮らしを愛しているからなのでしょうね。お近くの日本信託も、そんな街の一員になりたいと思っています。

●220-222　　●poster
　　　　　　　　bank
photographer　江面俊夫 toshio ezura
●　　　　　　　●
art director　金田敏夫 toshio kaneda
designer　　　東海林信 makoto shoji
copywriter　　日比野太郎 taro hibino
agency　　　　㈱博報堂 hakuhodo
production　　㈱博報堂 hakuhodo
advertiser　　日本信託銀行 nihon shintaku bank

ひとつ、ひとつが暮らしの街かど。

暮らしが街かどごとに広がってゆく。街かどが集まって、みんなの街になる。暮らしの匂いがある街、日本信託は、そんな街づくりのお手伝いをしたいと考えています。

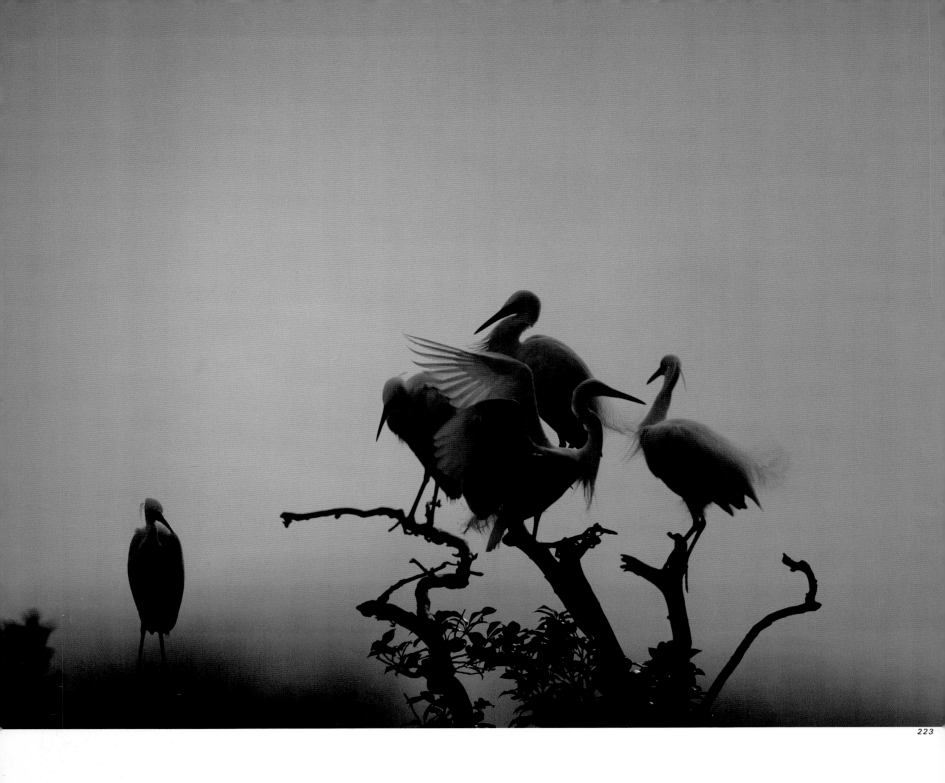

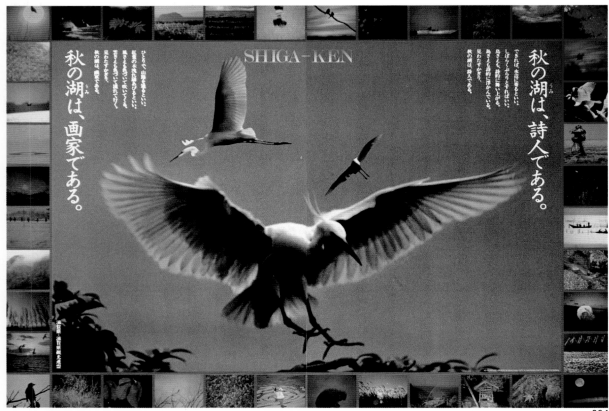

SHIGA-KEN

秋の湖は、詩人である。

秋の湖は、画家である。

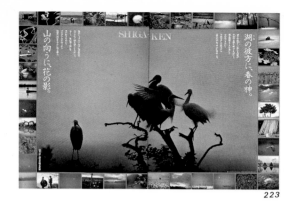

223

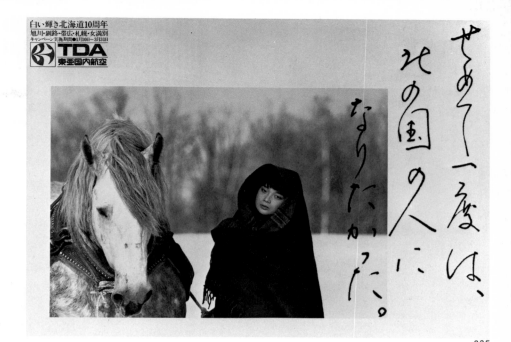

225

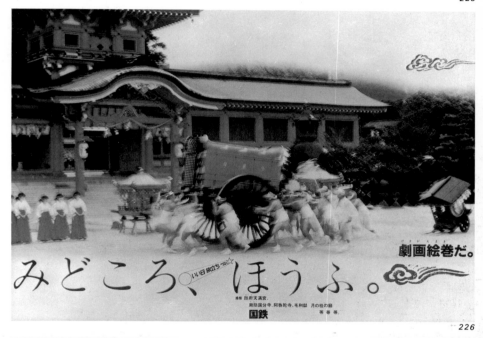

226

227

228

●223・224　　●poster
　　　　　　　tourist promotion
photographer　マツシマススム susumu matsushima
　●
art director　粟津潔 kiyoshi awazu
designer　　　久谷政樹 masaki hisatani
production　　㈱シーデーアイ c.d.i.
advertiser　　滋賀県観光連盟
　　　　　　　shiga prefectural, tourist office

●225　　　　●poster
　　　　　　　airline
photographer　金戸聰明 toshiaki kaneto
　●
art director　船尾夲 susumu funao
　　　　　　　東本三郎 saburo tomoto
designer　　　鈴木智暢 tomonobu suzuki
copywriter　　東本三郎 saburo tomoto
agency　　　　東急エージェンシー tokyu agency
production　　アドビジョン advision
advertiser　　東亜国内航空 toa domestic airlines

●226　　　　●poster
　　　　　　　national railway
photographer　瀬口哲夫 tetsuo seguchi

art director　鈴木八朗 hachiro suzuki
designer　　　鈴木八朗 hachiro suzuki
copywriter　　鈴木八朗 hachiro suzuki
agency　　　　㈱電通 dentsu
production　　㈱電通 dentsu
advertiser　　国鉄 national railway

●227　　　　●poster
　　　　　　　national railway
photographer　豊国順康 nobuyasu toyokuni

art director　鈴木八郎 hachiro suzuki
designer　　　鈴木八郎 hachiro suzuki
copywriter　　鈴木八郎 hachiro suzuki
agency　　　　㈱電通 dentsu
production　　㈱電通 dentsu
advertiser　　国鉄 national railway

●228　　　　●poster
　　　　　　　sake
photographer　北島直 sunao kitajima
　●
art director　森秀幸 hideyuki mori
designer　　　金子真三 shinzo kaneko
copywriter　　矢野寛二 kanji yano
production　　㈱博報堂九州支社
　　　　　　　hakuhodo, kyushu
advertiser　　㈱霧島酒造 kirishima shuzo

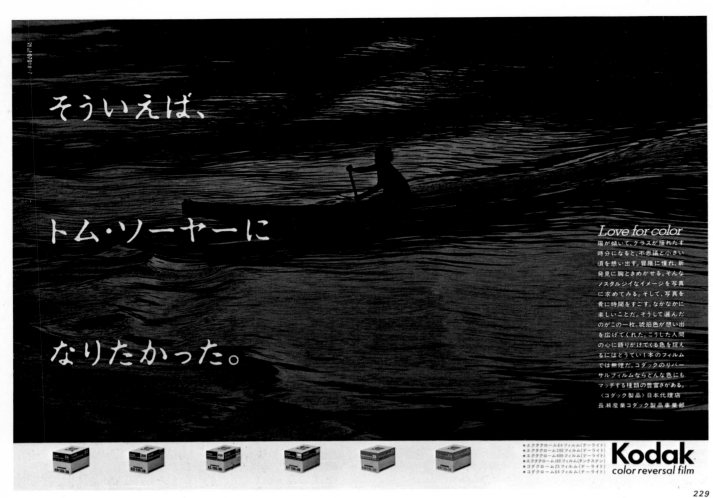

そういえば、

トム・ソーヤーに

なりたかった。

*Love for color*

陽が傾いて、グラスが揺れた夕
時分になると、不思議と小さい
頃を想い出す。冒険に憧れ、新
発見に胸ときめかせる。そんな
ノスタルジイなイメージを写真
に求めてみる。そして、写真を
肴に時間をすごす。なかなかに
楽しいことだ。そうして選んだ
のがこの一枚、琥珀色が想い出
を広げてくれた。こうした人間
の心に語りかけてくる色を捉え
るにはとうてい1本のフィルム
では無理だ。コダックのリバー
サルフィルムならどんな色にも
マッチする種類の豊富さがある。
〈コダック製品〉日本代理店
長瀬産業コダック製品事業部

■エクタクローム64フィルム（デーライト）
■エクタクローム200フィルム（デーライト）
■エクタクローム400フィルム（デーライト）
■エクタクローム160フィルム（タングステン）
■コダクローム25フィルム（デーライト）
■コダクローム64フィルム（デーライト）

**Kodak** color reversal film

229

無垢の自然では、よく訓練された体と気力。そして科学の粋をつくした
装備だけが、弱い人間を強くしてくれる。
'82美津濃山用品。山に学び、内外各地の遠征による実績に支えられ
た確かな品質。あらゆる状況、あらゆる登山形態を想定した多彩な品
揃え。大いなる山々にふさわしい装備を、充実の商品群からお選びください。

# Big Mountain

230

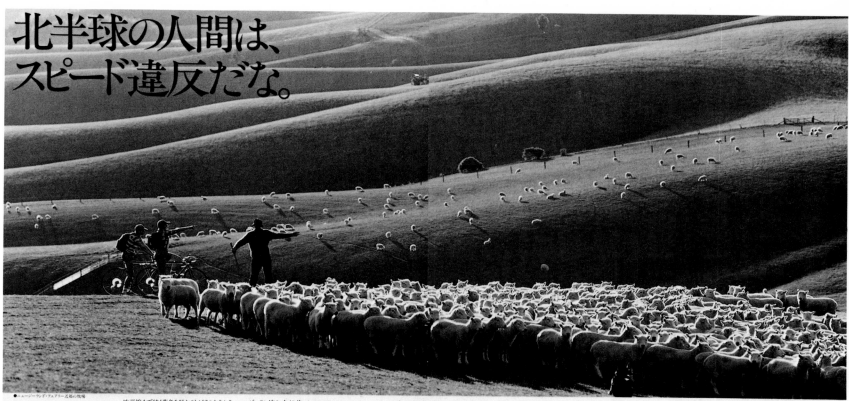

## 北半球の人間は、スピード違反だな。

地平線まで続く草色を見たことがありますか？ニュージーランドは、人々より羊や草が主役の国。人々が、羊のリズムでゆっくり生きています。オーストラリアでは、世界三大美港の一つ・シドニーや英国風の街並も素敵。南半球だから、季節が日本と逆なのも不思議な面白さです。さあ、ジャルパックで南へ。素顔の地球が待っています。どの旅で感動するか。ジャルパック厳選、14コース。

●ニュージーランド・フェアリー近郊の牧場

**地球は素顔が美しい。**
## オセアニア
ニュージーランド／オーストラリア

南回帰線を越えて
**OCEANIA**

エクセル・マイプラン・ニュージーランド7日間 ……………388,000円より
エクセル・フリータイム・ニュージーランド7日間 …………480,000円より
エクセル・フリータイム・シドニーとニュージーランド8日間 …470,000円より
スイート・ニュージーランド7日間 …………………………533,000円より
スイート・オーストラリア7日間 ……………………………488,000円より

---

## 人間やめた。

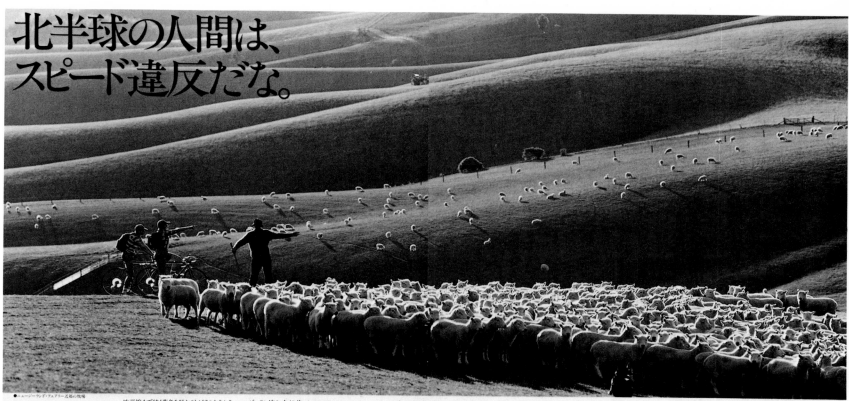

南の氷河を見に行きませんか？息が止まりそうなほど荘厳な光景の連続です。ニュージーランドは、手つかずの自然が美しさを競うあう国です。オーストラリアでは、世界三大美港の一つ・シドニーや英国風の街並も素敵。南半球だから、季節が日本と逆なのも不思議な面白さです。さあ、ジャルパックで南へ。素顔の地球が待っています。どの旅で感動するか。ジャルパック厳選、14コース。

●ニュージーランド・ミルフォード・サウンド

**地球は素顔が美しい。**
## オセアニア
ニュージーランド／オーストラリア

南回帰線を越えて
**OCEANIA**

エクセル・マイプラン・ニュージーランド7日間 ……………388,000円より
エクセル・フリータイム・ニュージーランド7日間 …………480,000円より
エクセル・フリータイム・シドニーとニュージーランド8日間 …470,000円より
スイート・ニュージーランド7日間 …………………………533,000円より
スイート・オーストラリア7日間 ……………………………488,000円より

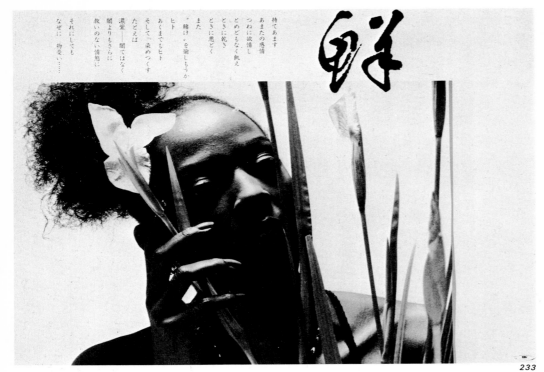

鮮

あなたの感情に酔う。

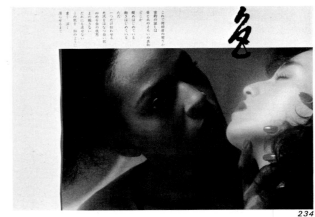

亀

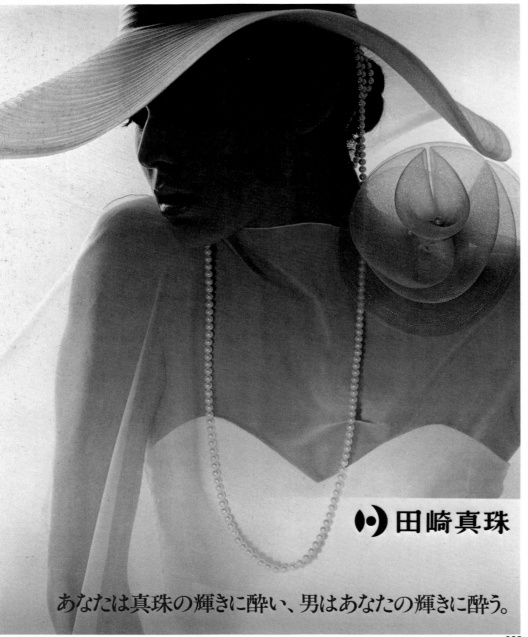

川 田崎真珠

あなたは真珠の輝きに酔い、男はあなたの輝きに酔う。

233

234

235

●233・234　●poster
　　　　　　　photo laboratory
photographer　岸本日出雄 hideo kishimoto
●
art director　仲経晴 tsuneharu naka
designer　　　仲経晴 tsuneharu naka
copywriter　　熊谷政江 masae kumagaya
production　　アドアーツ ad arts
advertiser　　㈱ビッグカラーサービス
　　　　　　　big professional lab.

●235　●magazine
　　　　jewelry
photographer　安達洋次郎 yojiro adachi
●
art director　水野鐸偲 takushi mizuno
designer　　　水野鐸偲 takushi mizuno
copywriter　　糟谷憲一 kenichi kasuya
agency　　　　㈱電通 dentsu
production　　㈱クリムソン crimson
advertiser　　田崎真珠㈱ tazaki pearl

●236　●poster
　　　　printing services
photographer　芝野将光 masamitsu shibano
●
art director　安藤富士夫 fujio ando
designer　　　安藤富士夫 fujio ando
copywriter　　安藤富士夫 fujio ando
agency　　　　㈱慶進社 keishinsha
production　　企画室バード planning office bird
advertiser　　㈱慶進社 keishinsha

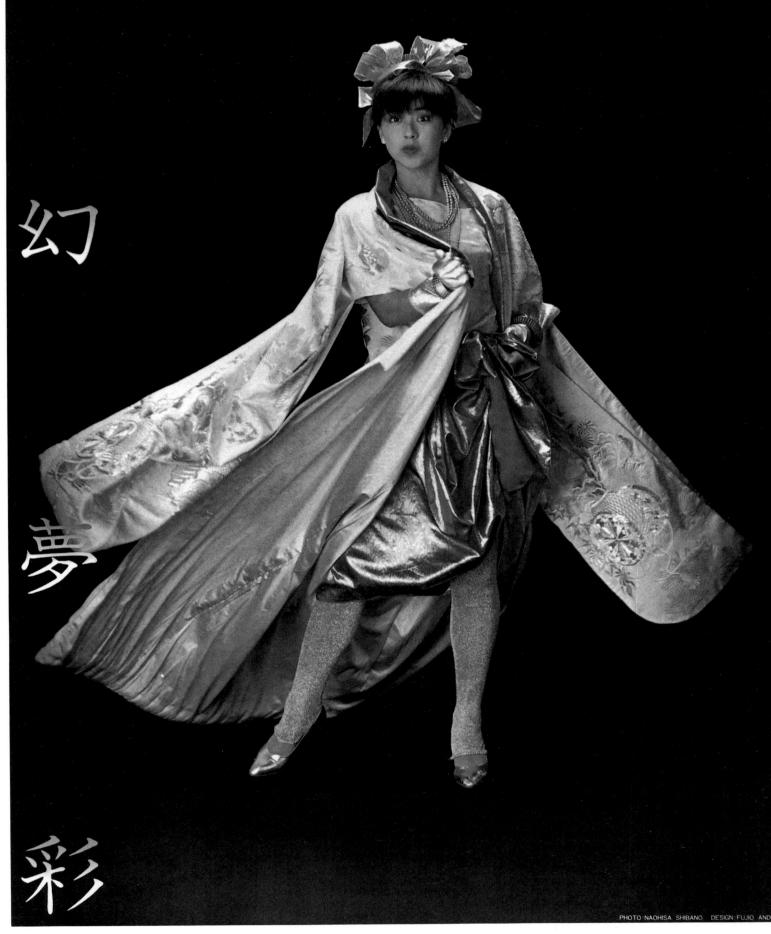

幻

夢

彩

## 1983 CALENDAR

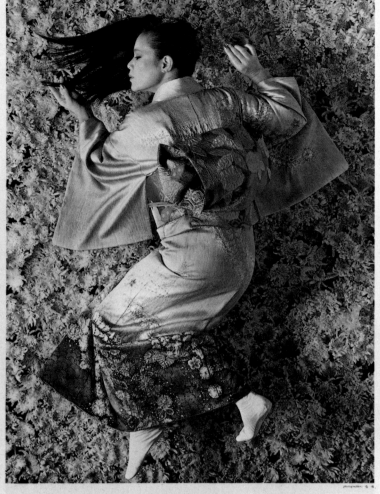

| sun | mon | tue | wed | thu | fri | sat |
|-----|-----|-----|-----|-----|-----|-----|
| | | | | | 1 | 2 |
| 3 | 4 | 5 | 6 | 7 | 8 | 9 |
| 10 | 11 | 12 | 13 | 14 | 15 | 16 |
| 17 | 18 | 19 | 20 | 21 | 22 | 23 |
| 24 | 25 | 26 | 27 | 28 | 29 | 30 |

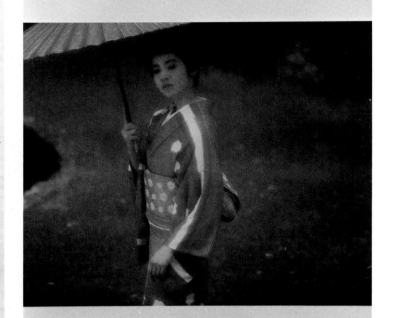

### 5 May

| sun | mon | tue | wed | thu | fri | sat |
|-----|-----|-----|-----|-----|-----|-----|
| | | 1 | 2 | 3 | 4 | 5 |
| 6 | 7 | 8 | 9 | 10 | 11 | 12 |
| 13 | 14 | 15 | 16 | 17 | 18 | 19 |
| 20 | 21 | 22 | 23 | 24 | 25 | 26 |
| 27 | 28 | 29 | 30 | 31 | | |

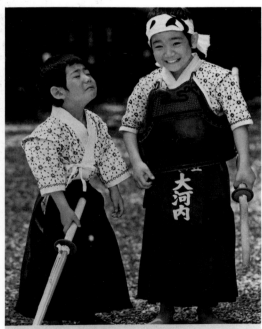

| | | **9** | | | | | | | **10** | | | |
|---|---|---|---|---|---|---|---|---|---|---|---|---|
| | | | 1 | 2 | 3 | | | | | | | 1 |
| 4 | 5 | 6 | 7 | 8 | 9 | 10 | 2 | 3 | 4 | 5 | 6 | 7 | 8 |
| 11 | 12 | 13 | 14 | 15 | 16 | 17 | 9 | 10 | 11 | 12 | 13 | 14 | 15 |
| 18 | 19 | 20 | 21 | 22 | 23 | 24 | 16 | 17 | 18 | 19 | 20 | 21 | 22 |
| 25 | 26 | 27 | 28 | 29 | 30 | | 23/30 | 24/31 | 25 | 26 | 27 | 28 | 29 |

明日の幸せを設計する
明治生命

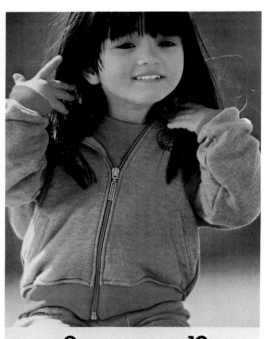

| | | **9** | | | | | | | **10** | | | |
|---|---|---|---|---|---|---|---|---|---|---|---|---|
| | | | 1 | 2 | 3 | 4 | | | | | | 1 | 2 |
| 5 | 6 | 7 | 8 | 9 | 10 | 11 | 3 | 4 | 5 | 6 | 7 | 8 | 9 |
| 12 | 13 | 14 | 15 | 16 | 17 | 18 | 10 | 11 | 12 | 13 | 14 | 15 | 16 |
| 19 | 20 | 21 | 22 | 23 | 24 | 25 | 17 | 18 | 19 | 20 | 21 | 22 | 23 |
| 26 | 27 | 28 | 29 | 30 | | | 24/31 | 25 | 26 | 27 | 28 | 29 | 30 |

ダイヤモンド保険コ
明治生命

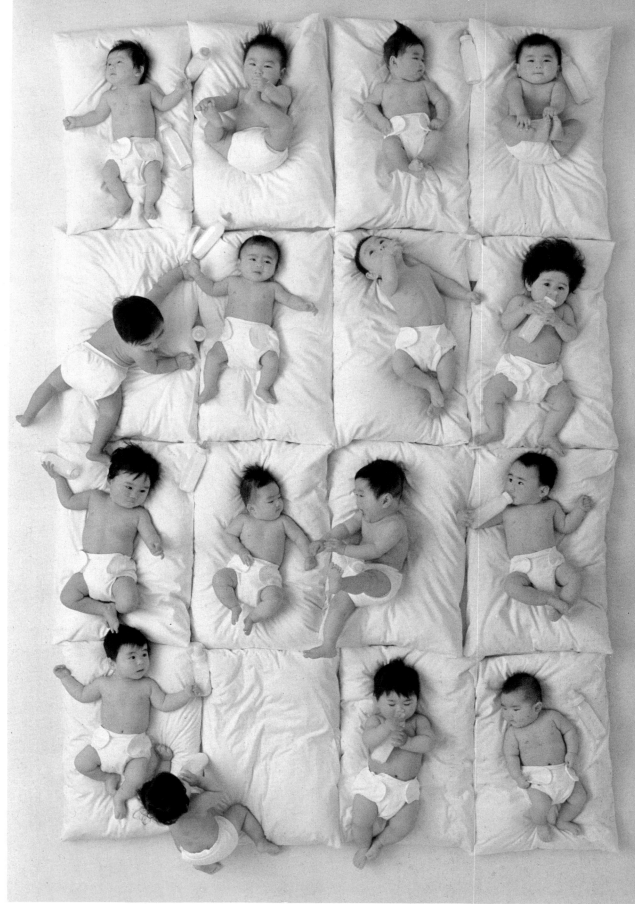

●237　●calendar
　　　　　kimono store

photographer　一色一成 issei isshiki
●
art director　佐藤靖 yasushi sato
designer　中沢利謙 toshiaki nakazawa
agency　日放㈱ nippo marketing & advertising
production　佐藤靖デザイン室
　　　　　yasushi sato design room
advertiser　㈱さが美 sagami

●238　●calendar
　　　　　kimono store

photographer　白鳥真太郎 shintaro shiratori
●
art director　中田賢 masaru nakada
designer　中田賢 masaru nakada
agency　㈱博報堂 hakuhodo
production　㈱博報堂 hakuhodo
advertiser　丹羽幸 niwako

●239　●calendar
　　　　　insurance company

photographer　國房魁 hajime kunifusa
●
art director　皿田啓一 keiichi sarada
designer　野間卓克 takayoshi noma
copywriter　関谷竹生 takeo sekiya
agency　㈱大日本印刷 dai nippon printing
production　㈱大日本印刷 dai nippon printing
advertiser　㈱明治生命保険相互会社
　　　　　meiji mutual life insurance

●240　●calendar
　　　　　insurance company

photographer　椎木厚 atsushi shiiki
●
art director　本橋信二 shinji motohashi
designer　野間卓克 takayoshi noma
copywriter　関谷竹生 takeo sekiya
agency　㈱大日本印刷 dai nippon printing
production　㈱大日本印刷 dai nippon printing
advertiser　㈱明治生命保険相互会社
　　　　　meiji mutual life insurance

●241　●magazine
　　　　　mineral water

photographer　広川泰士 taishi hirokawa
●
art director　鈴木利志夫 toshio suzuki
designer　鈴木利志夫 toshio suzuki
copywriter　安藤隆 takashi ando
production　㈱サン・アド sun-ad
advertiser　サントリー㈱ suntory

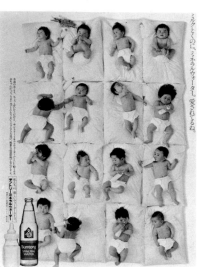

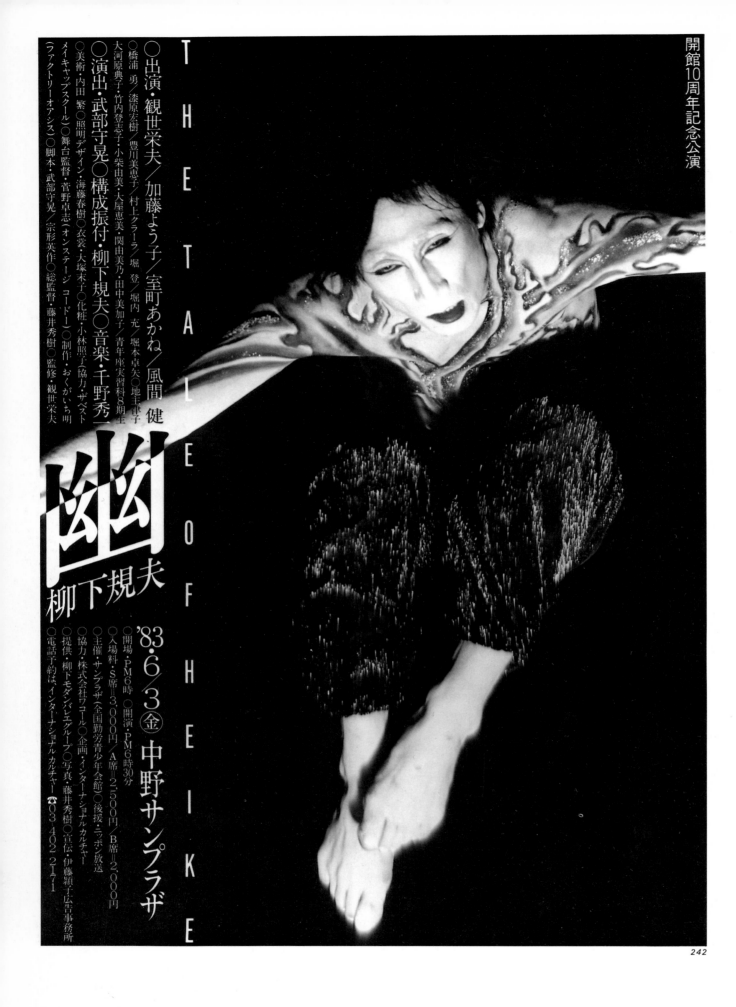

●242　●poster
　　　　stage play
photographer　藤井秀樹 hideki fujii
●
designer　伊藤頴子 eiko ito
advertiser　中野サンプラザ nakano sun plaza

●243　●poster
　　　　kimono exhibition
photographer　藤井秀樹 hideki fujii
●
art director　江橋洋 hiroshi ehashi
　　　　　　　井上謙次 kenji inoue
designer　江橋洋 hiroshi ehashi
　　　　　井上謙次 kenji inoue
advertiser　松屋 matsuya dept.

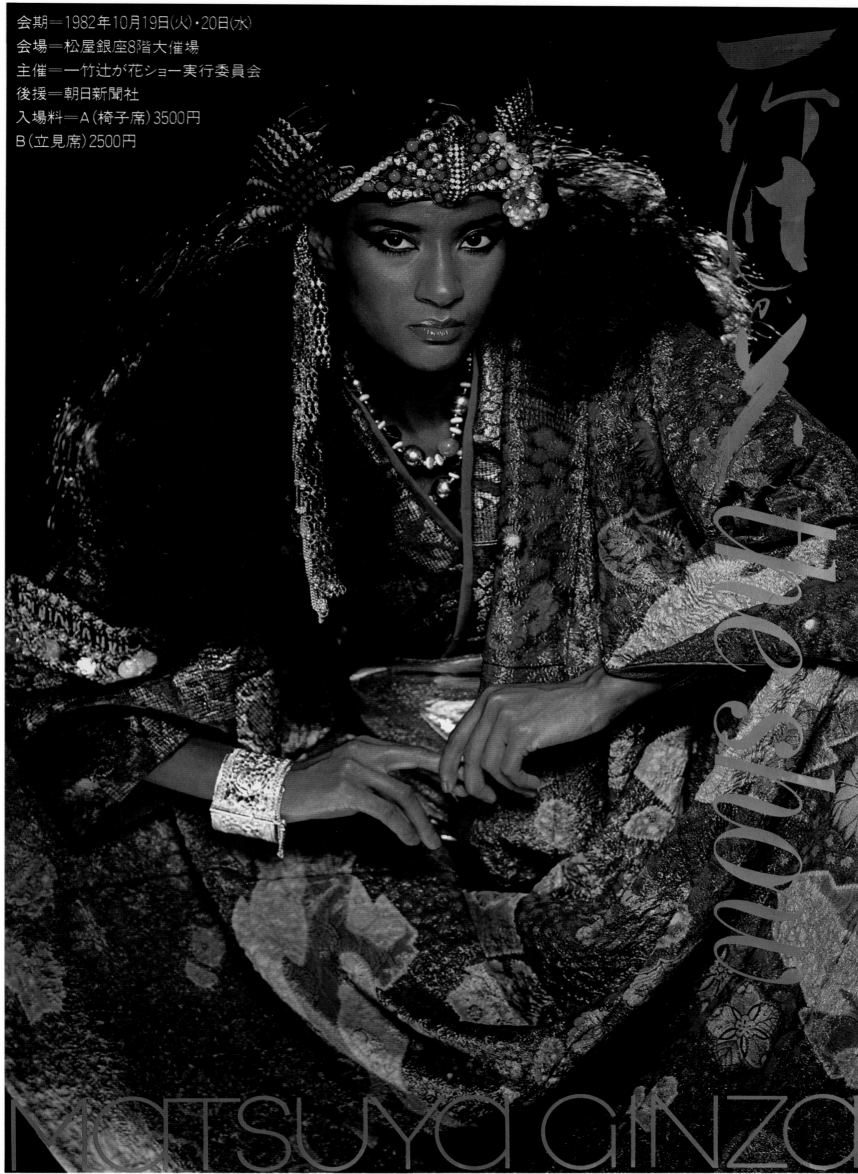

会期＝1982年10月19日(火)・20日(水)
会場＝松屋銀座8階大催場
主催＝一竹辻が花ショー実行委員会
後援＝朝日新聞社
入場料＝A(椅子席)3500円
B(立見席)2500円

matsuya ginza

243

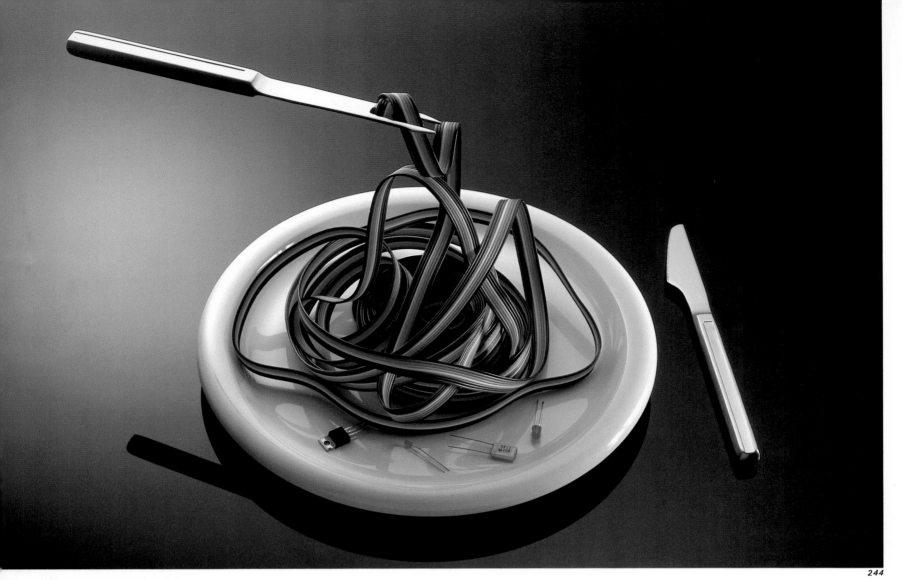

244

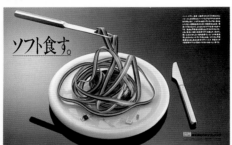

244

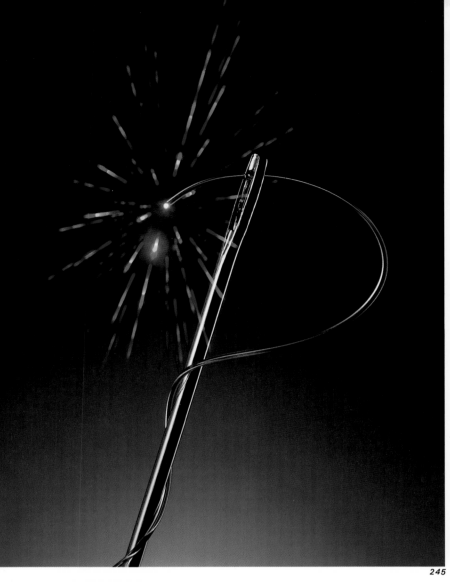

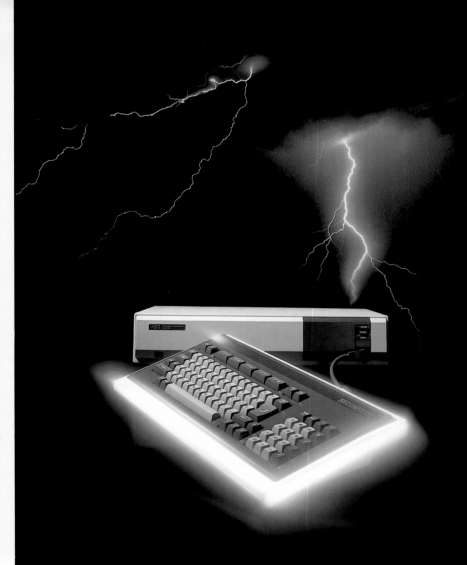

245

246

光のホットライン

通信

245

SYSTEMS BANK

アスキー・システム・バンク（PC88＝1）

PC88＝1

PC-8801 BASIC入門

工藤丈豪・屋敷誠二・横溝和宏共著

アスキー出版

246

器

247

歯車から歯車へ力が伝わるように、
わたしたちも情報をお届けします。
歯車と歯車が噛合うように、
人間と機械を繋ぎ、
人間と機械の調和を求めて。
テクノメーション。
これが「MMT」のテーマです。

248

GAS AGE.25

249

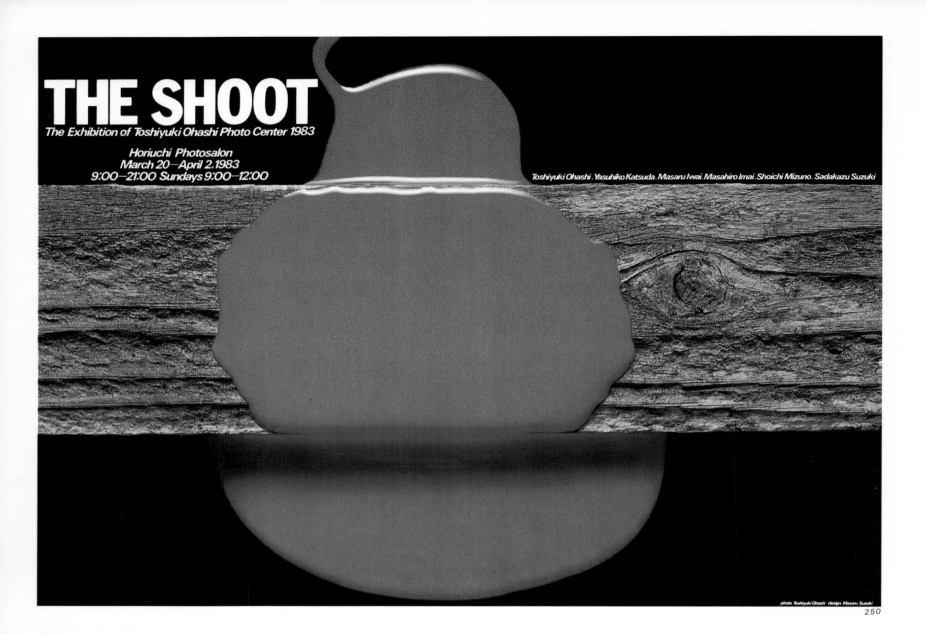

# THE SHOOT
### The Exhibition of Toshiyuki Ohashi Photo Center 1983
**Horiuchi Photosalon**
**March 20—April 2.1983**
**9:00—21:00 Sundays 9:00—12:00**

Toshiyuki Ohashi. Yasuhiko Katsuda. Masaru Iwai. Masahiro Imai. Shoichi Mizuno. Sadakazu Suzuki

photo. Toshiyuki Ohashi   design. Masaru Suzuki

250

200℃以上での強度は、他に類をみません。

251

●250　●poster
photo exhibition

photographer　大橋利行 toshiyuki ohashi
●
art director　大橋利行 toshiyuki ohashi
designer　鈴木勝 masaru suzuki
advertiser　大橋利行フォトセンター
toshiyuki ohashi photo center

●251　●pamphlet
plastic materials

photographer　羽生敏夫 toshio habu

art director　五来達雄 tatsuo gorai
designer　五来達雄 tatsuo gorai
copywriter　小山明好 akiyoshi koyama
production　G.グラフィス g. graphis
advertiser　旭硝子㈱ asahi glasses

251

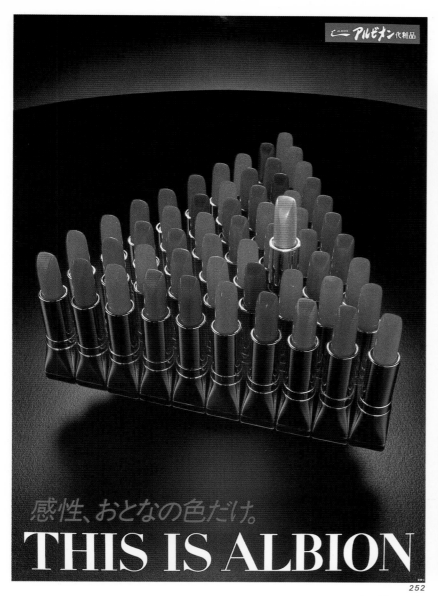

感性、おとなの色だけ。

# THIS IS ALBION

252

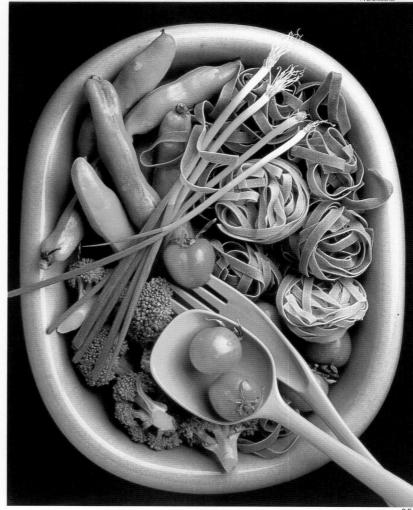

NEW
FUJICHROME 100D
Professional

253

エクタフレックスによる"挑戦"
## ニュークリエーションの世界

昭和57年6月14日(月)〜19日(土)A.M.10:00〜P.M.6:00(最終日はP.M.3:00迄)

新製品エクタフレックス・システムが"生み出すニュークリエーションの世界"にプロ・アマが"挑戦"。
新しい映像のコミュニケーション—エクタフレックス作品展—をお楽しみください。

Kodak film
ナガセフォトサロン

254

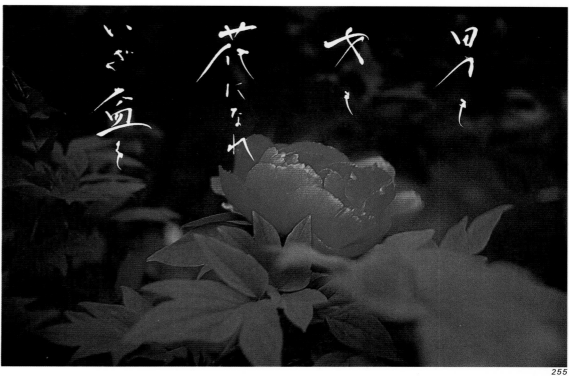

255

| ●252 | ●poster cosmetics | ●253 | ●poster camera film | ●254 | ●direct mail photo exhibition | ●255 | ●direct mail photographer's portfolio |
|---|---|---|---|---|---|---|---|
| photographer | 本宮正幸 masayuki motomiya | photographer | 熊谷晃 akira kumagaya | photographer | 杉木直也 naoya sugiki | photographer | 大谷勝美 katsumi otani |
| art director | 新谷誠悟 seigo shintani | agency | ㈱クリエイティブハウスCA creative house ca | advertiser | 長瀬産業㈱ nagase | art director | 大谷勝美 katsumi otani |
| designer | 新谷誠悟 seigo shintani | production | ㈱クリエイティブハウスCA creative house ca | | | designer | 大谷勝美 katsumi otani |
| copywriter | 渡部清 kiyoshi watanabe | advertiser | 富士写真フィルム㈱ fuji photo film | | | copywriter | 大谷勝美 katsumi otani |
| production | ㈱アルビオン化粧品 albion cosmetics | | | | | advertiser | otani写真館 otani photo studio |
| advertiser | ㈱アルビオン化粧品 albion cosmetics | | | | | | |

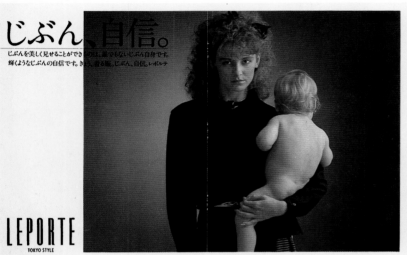

●256 　　●magazine
　　　　　　fashion
photographer　稲越功一 koichi inakoshi
●　　　　　　　●
art director　吉村 明宏 akihiro yoshimura
designer　　　山口誠 makoto yamaguchi
copywriter　　小川清重 kiyoshige ogawa
agency　　　　博報堂 hakuhodo
production　　㈱スタジオ・コム studio com
advertiser　　㈱東京スタイル tokyo style

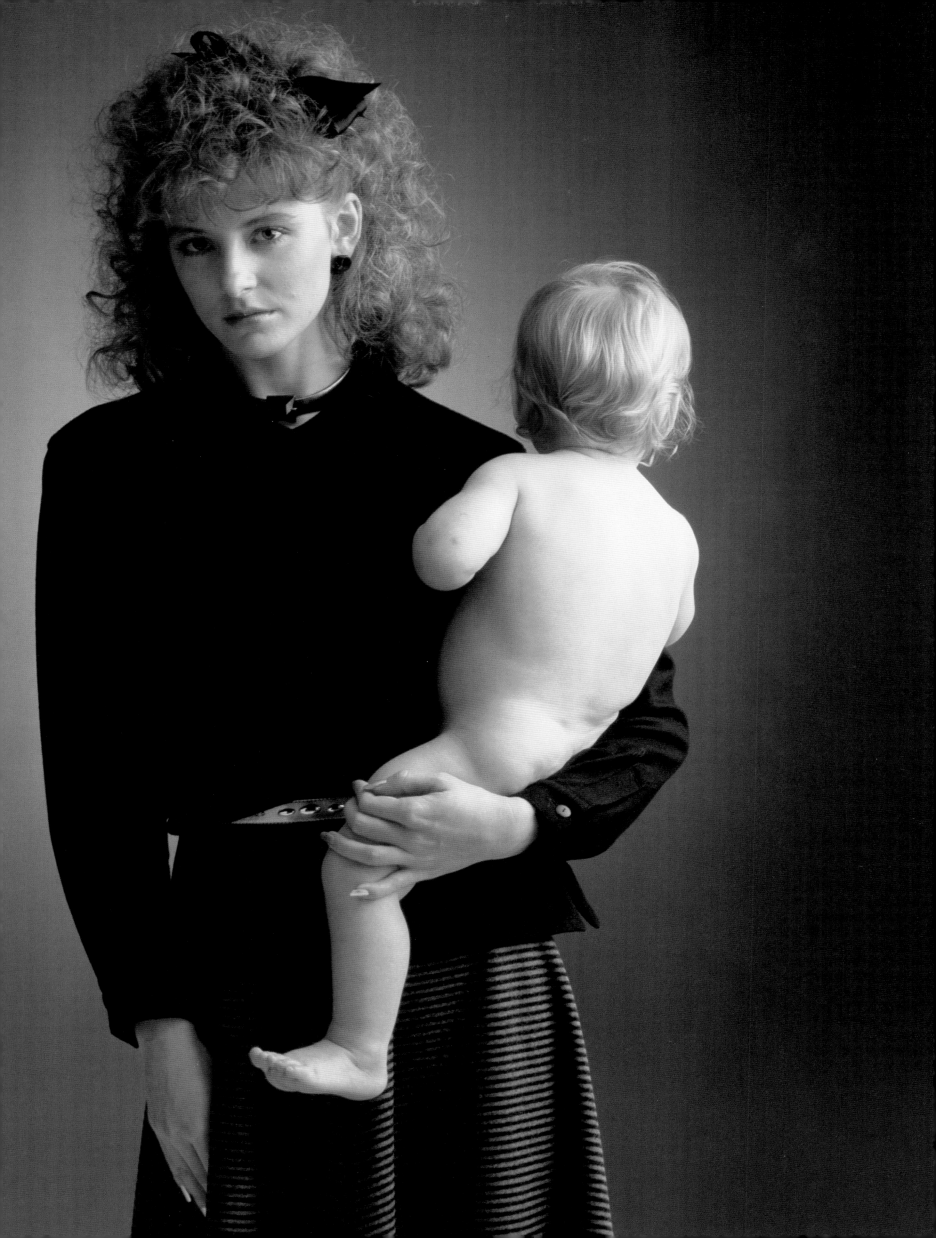

乾いた空気の中で、アダルトの暖かさをもった人は輝いて見える。恋してるな、仕事のってるな…ペリコール

**FASHION HOUSE**
# NARUMIYA

Narumiya Co., Ltd./3-5-6 Kita-aoyama, Minato-ku, Tokyo, Tel.03-404-2261 ● Osaka Branch./1-7 Kyobashi, Higashi-ku, Osaka, Tel.06-943-3241
Hiroshima Branch./1-5-8 Otemachi, Naka-ku, Hiroshima, Tel.082-247-9274 ● Fukuoka Branch./2-10-19 Hakata-ekimae, Hakata-ku, Fukuoka, Tel.092-473-0081

生きていくことは重ねること…仕事を重ね、恋を重ね、あなたは美しくなる。秋、感性も重ねて、ペリコール。

**FASHION HOUSE**
# NARUMIYA

Narumiya Co., Ltd./3-5-6 Kita-aoyama, Minato-ku, Tokyo, Tel.03-404-2261 ● Osaka Branch./1-7 Kyobashi, Higashi-ku, Osaka, Tel.06-943-3241
Hiroshima Branch./1-5-8 Otemachi, Naka-ku, Hiroshima, Tel.082-247-9274 ● Fukuoka Branch./2-10-19 Hakata-ekimae, Hakata-ku, Fukuoka, Tel.092-473-0081

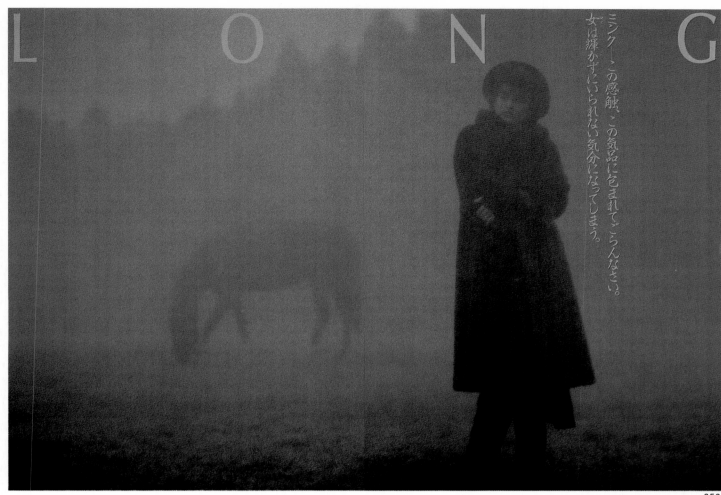

ミンク――この感触、この気品に包まれてごらんなさい。女は輝かずにいられない気分になってしまう。

259

●257·258　●magazine
　　　　　　　fashion

photographer　白鳥真太郎 shintaro shiratori
●
art director　岡田稔 minoru okada
designer　増田泰介 taisuke masuda
copywriter　千葉登美雄 tomio chiba
agency　㈱博報堂 hakuhodo
production　㈱博報堂 hakuhodo
advertiser　ナルミヤ narumiya

●259　●pamphlet
　　　　　cosmetics

photographer　鈴木英雄 hideo suzuki
●
art director　田辺美明 yoshiaki tanabe
designer　田辺美明 yoshiaki tanabe
agency　㈱博報堂 hakuhodo
production　㈱博報堂 hakuhodo
advertiser　㈱ノエビア noevir

●260　●poster
　　　　　department store

photographer　白鳥真太郎 shintaro shiratori
●
art director　和田延二 enji wada
designer　西尾修一 shuichi nishio
copywriter　岩崎孝治 koji iwasaki
agency　㈱博報堂 hakuhodo
production　㈱博報堂 hakuhodo
advertiser　大丸 daimaru dept.

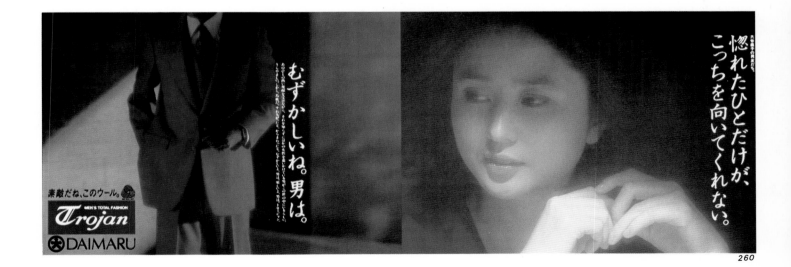

260

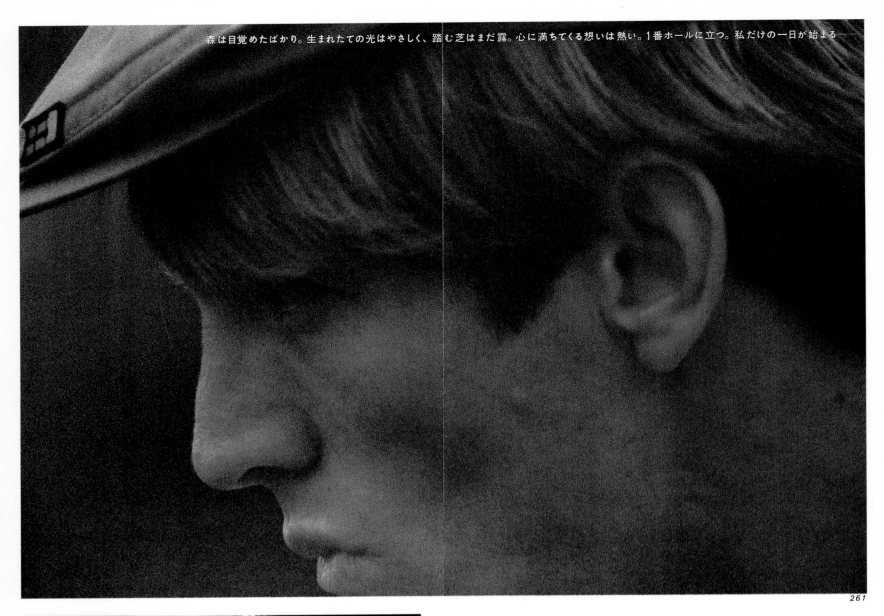

森は目覚めたばかり。生まれたての光はやさしく、踏む芝はまだ露。心に満ちてくる想いは熱い。1番ホールに立つ。私だけの一日が始まる——

261

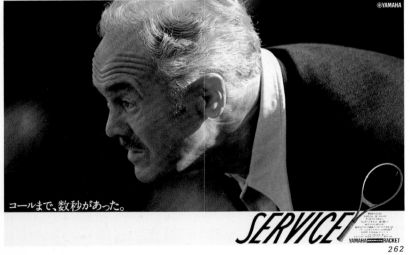

コールまで、数秒があった。

SERVICE

262

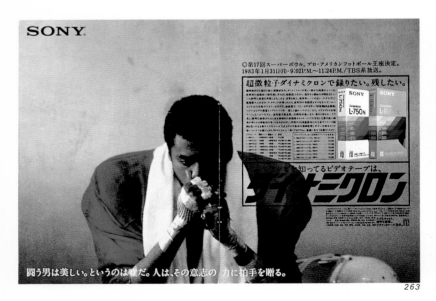

263

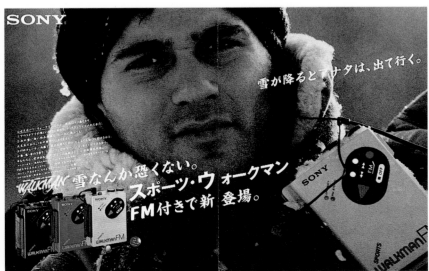

264

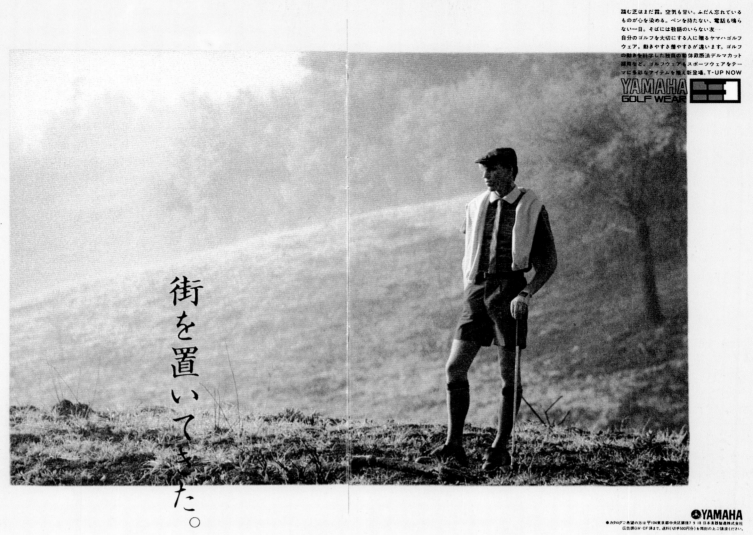

街を置いてきた。

265

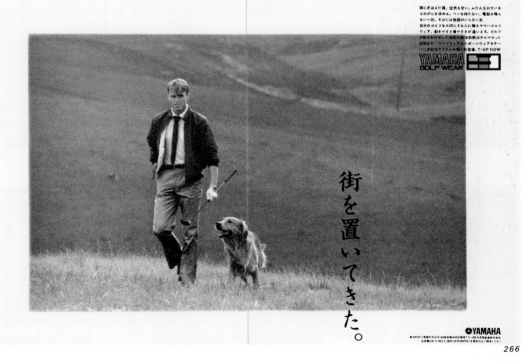

街を置いてきた。

266

●261 ●catalog
●262・265・266 ●magazine
　　　　　　　golf wear
photographer 藤井保 tamotsu fujii
●
creative
director 尾子弘尚 kosho oko
art director 藤田努 tsutomu fujita（261・265・266）
　　　　　　鈴木哲郎 tetsuro suzuki（262）
designer 西脇一成 kazunari nishiwaki（261・265・266）
　　　　　木村容子 yoko kimura（262）
copywriter 紺野久 hisashi konno（261・265・266）
　　　　　　間宮修 osamu mamiya（262）
agency NCSアドバタイジング ncs advertising
production NCSアドバタイジング ncs advertising
advertiser ㈱日本楽器製造 nippon gakki

●263 ●magazine
　　　　　audio equipment
●264 ●magazine
　　　　　videotapes
photographer 藤井保 tamotsu fujii
●
creative
director 仲畑貴志 takashi nakahata
art director 副田高行 takayuki soeda（263）
　　　　　　葛西薫 kaoru kasai（264）
designer 奥脇吉光 yoshimitsu okuwaki（263）
　　　　　葛西薫 kaoru kasai（264）
copywriter 仲畑貴志 takashi nakahata
agency ㈱東急エージェンシーインターナショナル
　　　　tokyu agency international
production 仲畑広告制作所 nakahata company
advertiser ソニー㈱ sony

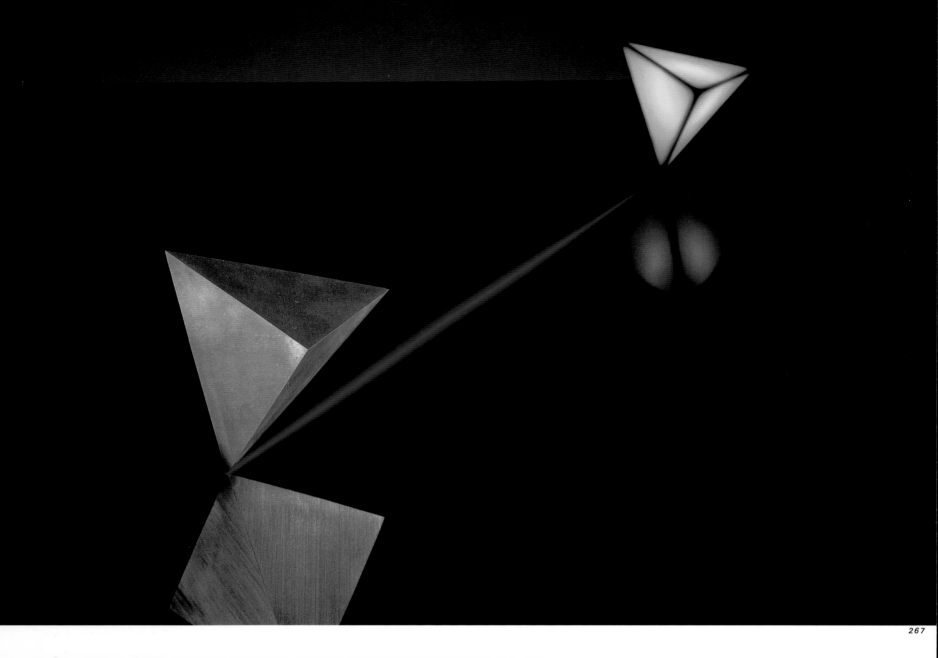

軌 LOCUS
精密計測に奇跡はあり得ない。
すべては計測の意念を考えることから始まり、
数限りない試練を超えるために叡智を注ぐ。
いまそれは確かな軌跡となって現われた。

オプティカル・リフレクティブ・センサ

高分解能の非接触センサ
TO-5のパッケージ内に、発光/受光、光学レンズ系を内蔵、
物体の有無、表面の状態を0.17mmφのスポットで検索、電
気信号に変換します。物体の凹凸、濃淡の検出、マークセ
ンサなどの検出用素子として使用されます。

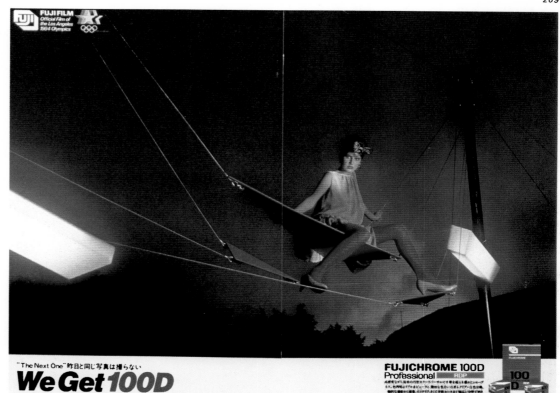

"The Next One" 昨日と同じ写真は撮らない
**We Get 100D**

FUJICHROME 100D
Professional RDP
100 D

「闇の時代」と言われた中世、

人々は

金属を黄金に変える物質「賢者の石」を求めていた。

闇を拓き、無機質な空間に意味を与え、

移りゆく時間の質に変える。

光は、現代の「賢者の石」。

人を照らし、人を包み、人をなごませ、そして

自らの輝きで人を魅了する。

光は人間に、夜というひとつの次元の扉を開く。

●267　●pamphlet
　　　　measuring instruments
photographer　竹崎昭 akira takezaki
●
art director　小平重之 shigeyuki kodahira
designer　遠藤誠一 seiichi endo
copywriter　小平重之 shigeyuki kodahira
production　キティ kitty
　　　　一誠堂印刷 isseido printing
advertiser　㈱東京精密 tokyo seimitsu

●268　●magazine
　　　　camera film
photographer　高井哲朗 tetsuro takai
●
art director　森田純一郎 junichiro morita
designer　森田純一郎 junichiro morita
copywriter　関橋栄作 eisaku sekihashi
agency　J.W.トンプソン j.w.thompson
production　J.W.トンプソン j.w.thompson
advertiser　長瀬産業㈱ nagase

●269　●calendar
　　　　computer components
photographer　佐藤健治 kenji sato
●
art director　加藤昭彦 akihiko kato
designer　信耕純一郎 junichiro shinko
copywriter　作宮邦夫 kunio sakumiya
production　マグブロス㈱ magburosu
advertiser　横河ヒューレット・パッカード㈱
　　　　yokokawa hewlett packard

●270　●magazine
　　　　camera film
photographer　寺島彰由 akiyoshi terashima
●
art director　龍山悠一 yuichi tatsuyama
designer　龍山悠一 yuichi tatsuyama
copywriter　越前昭彦 akihiko koshimae
production　㈱クリエイティブハウスCA
　　　　creative house ca
advertiser　富士写真フィルム㈱
　　　　fuji photo film

●271　●pamphlet
　　　　lighting
photographer　浦賢一 kenichi ura
●
art director　杉本政人 masato sugimoto
designer　寺田忠男 tadao terada
copywriter　宮本昭子 akiko miyamoto
agency　㈱日本SPセンター japan sp center
production　㈱大阪アートディレクターズ
　　　　osaka art directors
advertiser　小泉産業㈱ koizumi sangyo

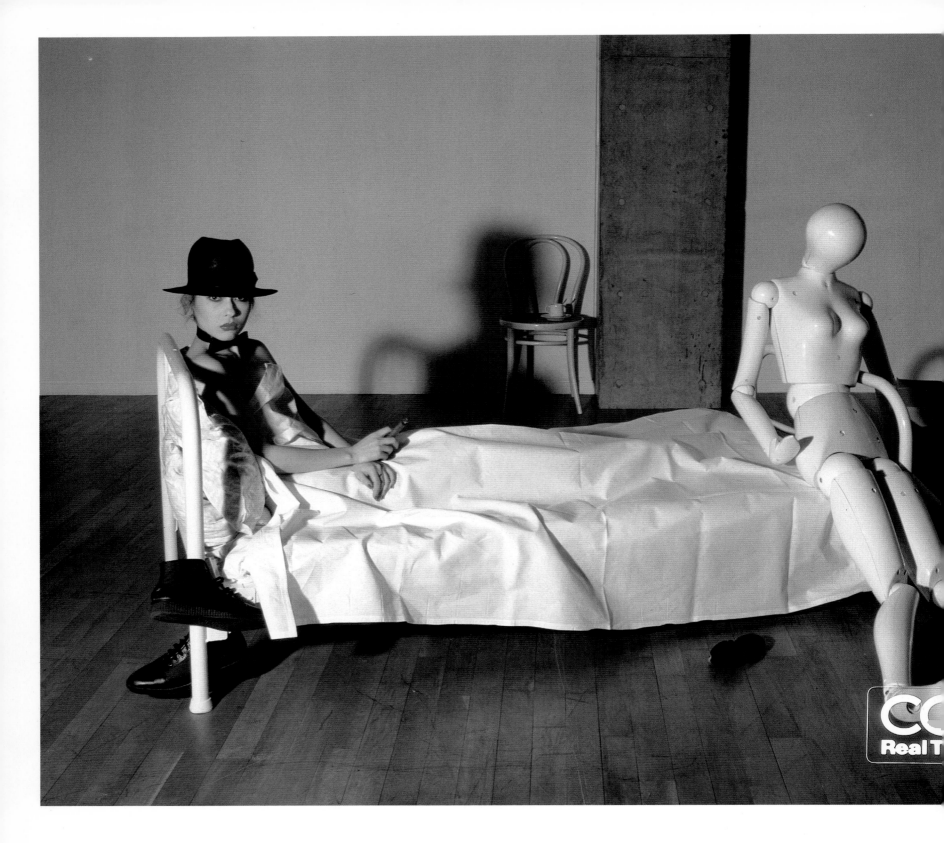

●272-274    ●pamphlet, direct mail
                  cameras
photographer    中村正也 masaya nakamura
●
art director    武井尚武 shobu takei
advertiser    京セラ株ヤシカ事業本部 kyocera

272

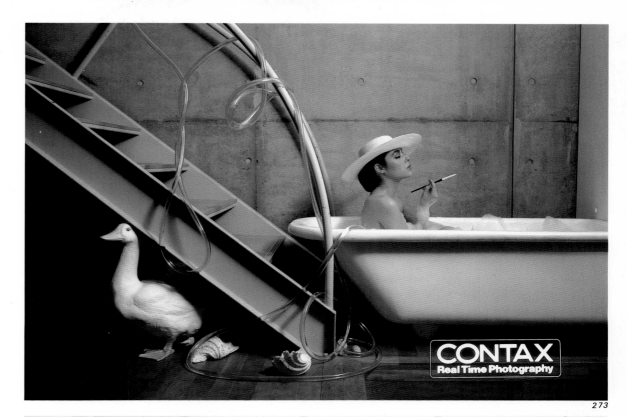

273

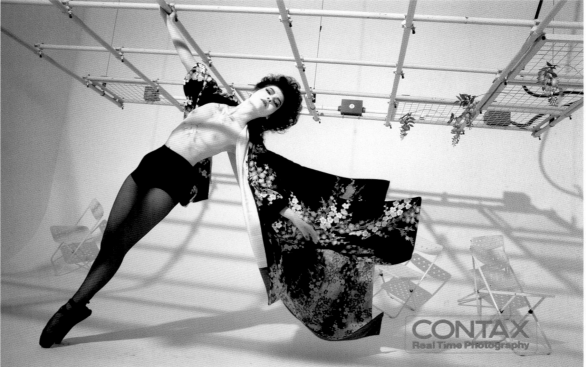

274

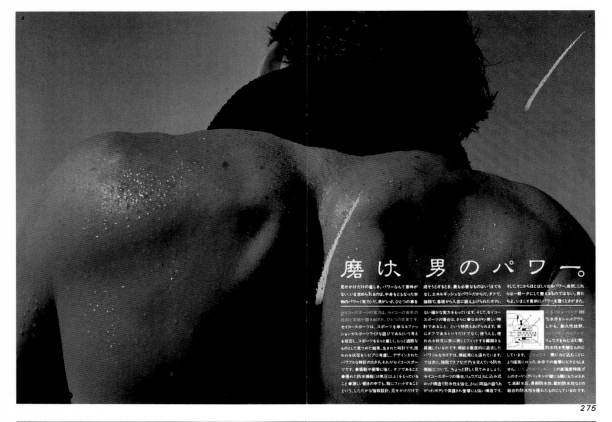

磨け、男のパワー。

275

276

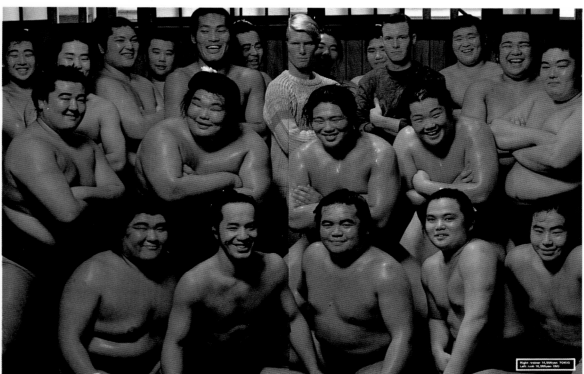

277

●275　　●catalog
　　　　　men's watches

photographer　藤井保 tamotsu fujii
●
creative　　　粟野牧夫 makio awano
director
art director　深山重樹 shigeki miyama
designer　　　辻中進 susumu tsujinaka
copywriter　　園部為幸 tameyuki sonobe
agency　　　　㈱日本デザインセンター
　　　　　　　nippon design center
production　　㈱日本デザインセンター
　　　　　　　nippon design center
advertiser　　㈱服部時計店 k. hattori

●276・277　●magazine
　　　　　　fashion

photographer　坂野豊 yutaka sakano
●
art director　横山修一 shuichi yokoyama
production　　ダイアモンドヘッズ diamond head's
advertiser　　㈱ジュン jun

●278　　●poster
　　　　　audio equipment

photographer　相川喜伸 yoshinobu aikawa
●
art director　葛西薫 kaoru kasai
designer　　　鈴木司 tsukasa suzuki
　　　　　　　西川哲生 tetsuo nishikawa
copywriter　　山之内慎一 shinichi yamanouchi
agency　　　　㈱サン・アド sun-ad
production　　㈱サン・アド sun-ad
advertiser　　ソニー㈱ sony

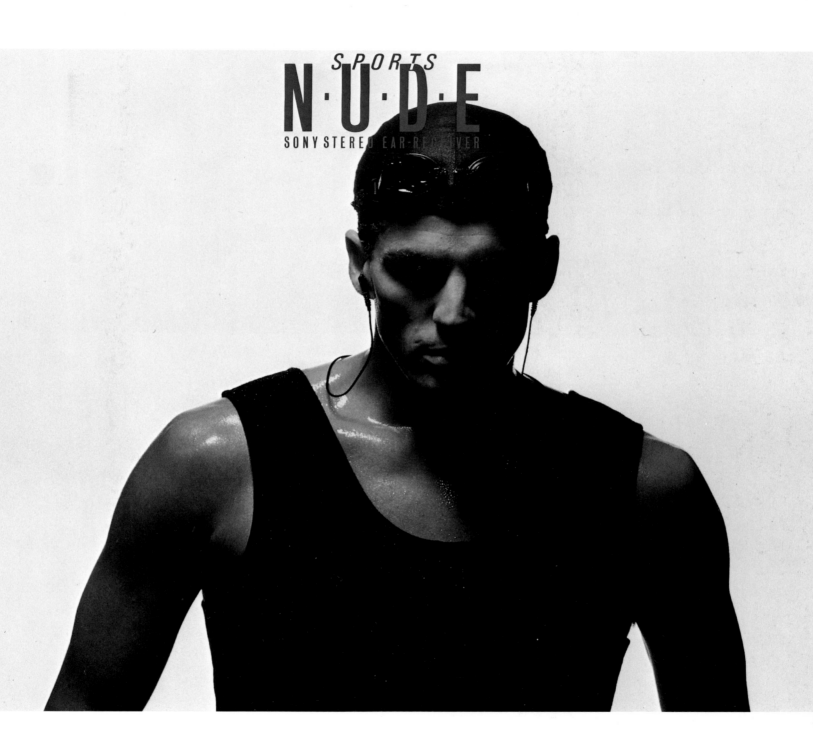

SPORTS
# N·U·D·E
SONY STEREO EAR-RECEIVER

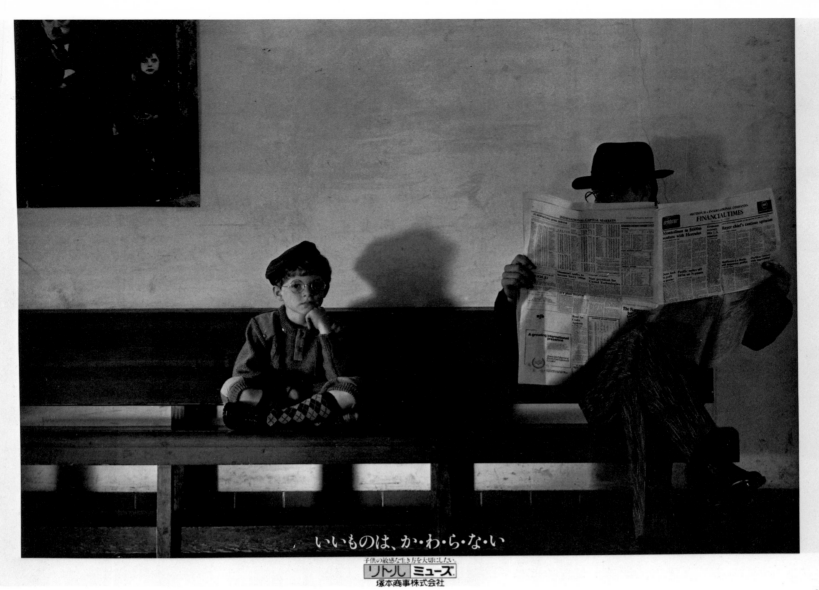

いいものは、か・わ・ら・な・い

子供の敏感な生き方を大切にしたい。
リトル ミューズ
塚本商事株式会社

279

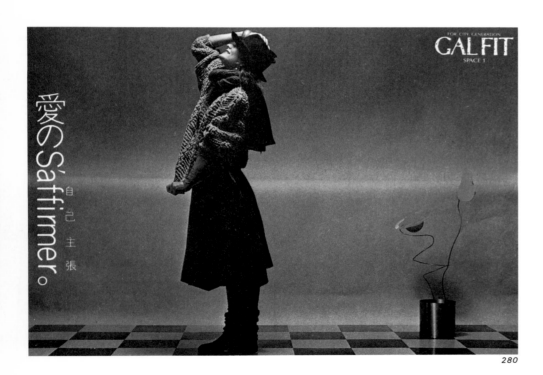

FOR CITY GENERATION
GAL FIT
SPACE 1

愛のSaffirmer。自己主張

280

●279　●poster
　　　　children's shoes

photographer　瀬川博一 hirokazu segawa
●
art director　小室修二 shuji komuro
designer　　　足立朗 akira adachi
copywriter　　笹岡誠 makoto sasaoka
production　　㈱塚本商事 tsukamoto shoji
advertiser　　㈱塚本商事 tsukamoto shoji

●280　●direct mail
　　　　fashion

photographer　森れい子 reiko mori
●
art director　薗部俊美 toshimi sonobe
designer　　　薗部俊美 toshimi sonobe
copywriter　　山川玲子 reiko yamakawa
agency　　　　㈱東急エージェンシー名古屋支社
　　　　　　　tokyu agency, nagoya branch
production　　クリエーティブコーポレーション242
　　　　　　　creative corporation 242
advertiser　　ユニー㈱ uny

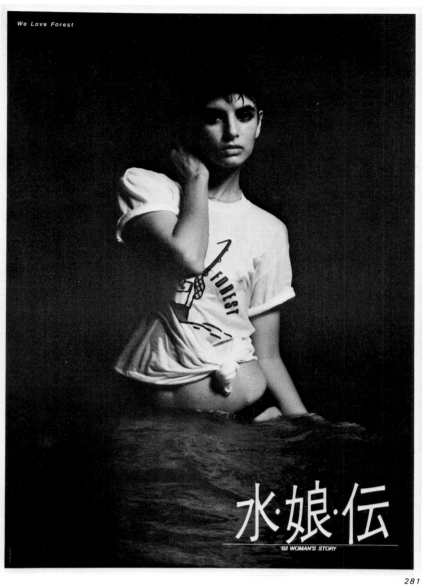

| ●281 | ●poster<br>sportswear | ●282 | ●magazine<br>airline | ●283 | ●poster<br>makeup brushes |
|---|---|---|---|---|---|
| photographer | 伊藤一仁 kazuhito ito | photographer | 根岸広行 hiroyuki negishi | photographer | 藤平守男 morio fujihira |
| ● | | | | | |
| art director | 吉川忠幸 tadayuki furukawa | art director | 白田環 kan hakuta | art director | 竹内亜季良 akira takeuchi |
| designer | 金子寛之 hiroyuki kaneko | designer | 白田環 kan hakuta | designer | 渋谷滋 shigeru shibuya |
| copywriter | 中村澄子 sumiko nakamura | copywriter | 木内登希晴 tokiharu kiuchi | copywriter | 大崎徹人 tetsuto osaki |
| agency | 正美屋 masamiya | agency | ㈱マッキャンエリクソン博報堂<br>maccan erickson hakuhodo | agency | マーケティング・ファイブ<br>marketing five |
| production | ㈱スタジオ・モア studio more | production | ㈱マッキャンエリクソン博報堂<br>maccan erickson hakuhodo | production | エクスレバン xlevan |
| advertiser | t.s. | advertiser | ルフトハンザ lufthansa | advertiser | エトワール海渡 etoir kaito |

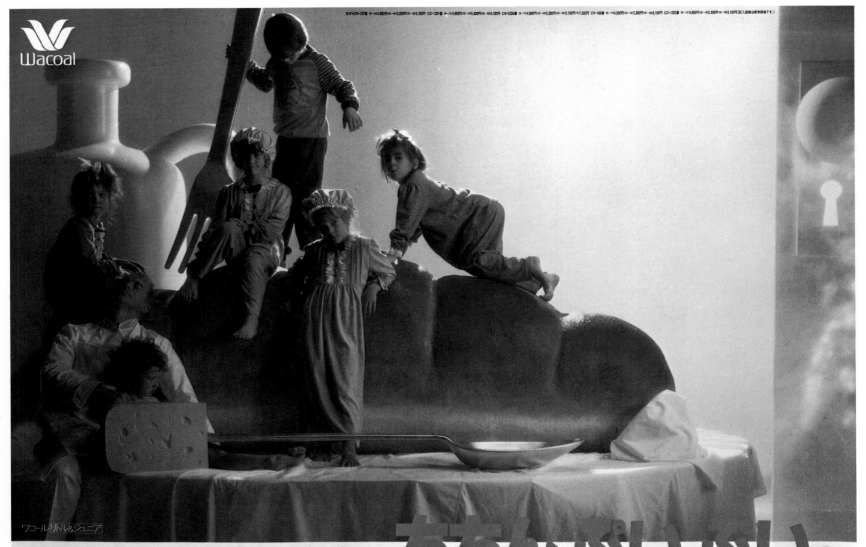

魔法のナイティ、ちちんぷいぷい。

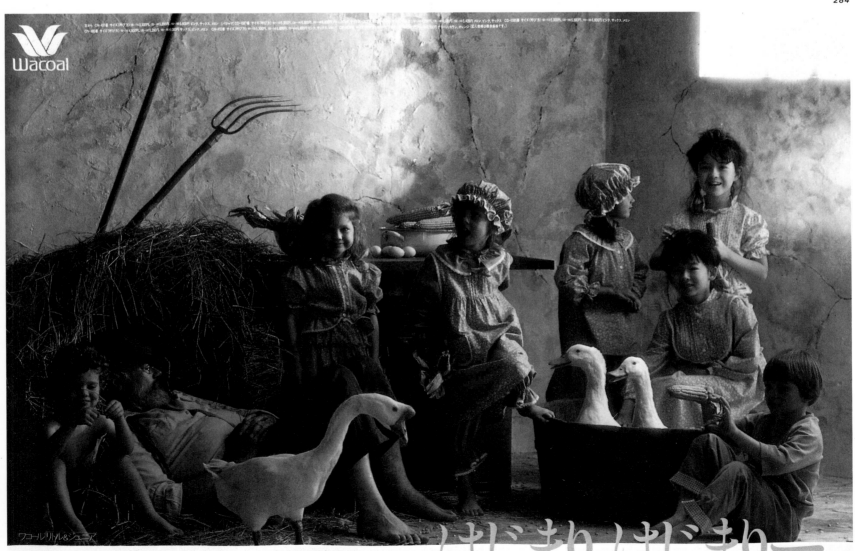

大人たちが目を閉じると子供だけの世界のはじまり、はじまりー。

♥世界の友情物語 「トム・ソーヤの冒険」トウェイン作
たからさがしに、ゆうれいやしきにやってきたトムとハック。「ひゃー、こいつはすごいや！ きんかがあんなにいっぱい…」「しー。インジャン・ジョーにみつかったらたいへんだよ。」ふたりは、にかいにかくれて、ワクワクしながらみていました。

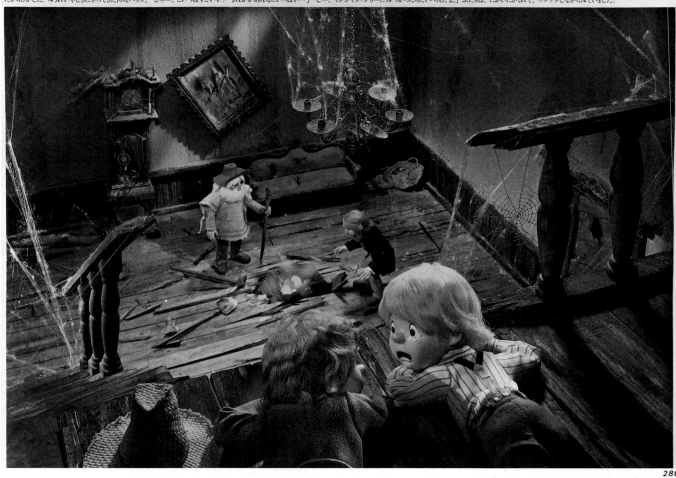

286

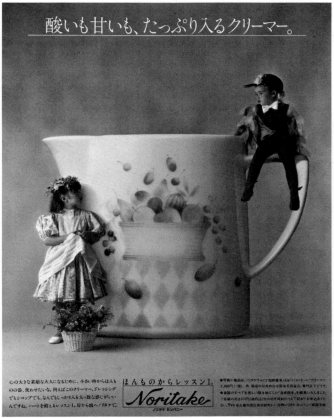

287

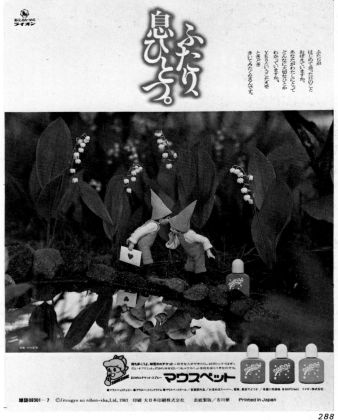

288

| | | | | | | | |
|---|---|---|---|---|---|---|---|
| ●284·285 | ●poster<br>children's pyjamas | ●286 | ●calendar<br>general electronics manufacturing | ●287 | ●magazine<br>chinaware | ●288 | ●magazine<br>breath freshener |
| photographer | 角田正治 masaji tsunoda | photographer | 江川龍生 ryusei egawa | photographer | 白鳥真太郎 shintaro shiratori | photographer | 中村都夢 tomu nakamura |
| art director | 岡晃一 koichi oka | art director | 和田州生 shusei wada | art director | 砂沢正昭 masaaki sunazawa | art director | 直井章朗 akio naoi |
| designer | 大八木雅夫 masao oyagi<br>阿部修久 nobuhisa abe (284) | designer | 明正寺美保子 mihoko myoshoji | designer | 祖父江将浩 masahiro sobue | designer | 桜井一太 kazuta sakurai |
| copywriter | 宮沢えり子 eriko miyazawa | copywriter | 長節子 setsuko cho | | 太田豊 yutaka ota | copywriter | 三浦康浩 yasuhiro miura |
| agency | ㈱ワコール宣伝部<br>wacoal publicity dept. | agency | ㈱ベクトル・アド bektol ad. | copywriter | 蟹瀬令子 reiko kanise | agency | ㈱第一広告社 dai-ichi advertising |
| production | ㈱ワコール宣伝部<br>wacoal publicity dept. | production | ビデオ東京プロダクション<br>video tokyo pro. | agency | ㈱博報堂 hakuhodo | production | ㈱第一広告社 dai-ichi advertising |
| advertiser | ㈱ワコール wacoal | advertiser | 日立家電販売㈱ hitachi | production | ㈱博報堂 hakuhodo | advertiser | ライオン㈱ lion |
| | | | | advertiser | ノリタケ noritake | | |

## 本当です。スニーカーの生　活圏に限界はありません。

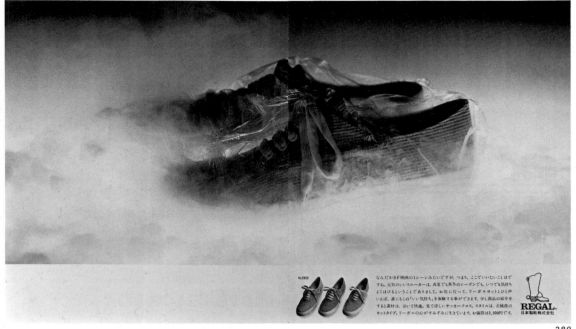

289

## スニーカーは、大好きな短編小説に　似ていると思った。リーガルのグリップ。

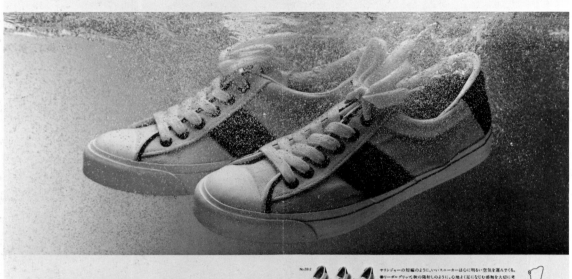

290

## エクセーヌ。をスニーカーにしま　した。リーガルから、新発売。

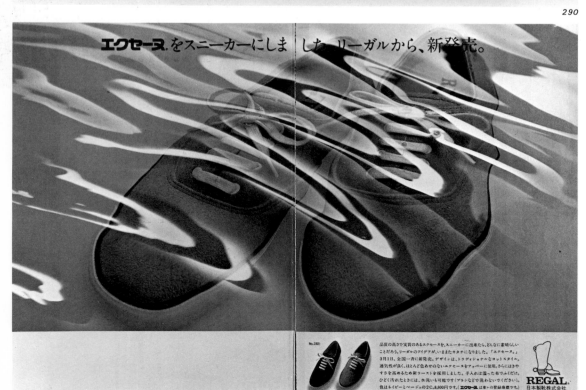

291

292

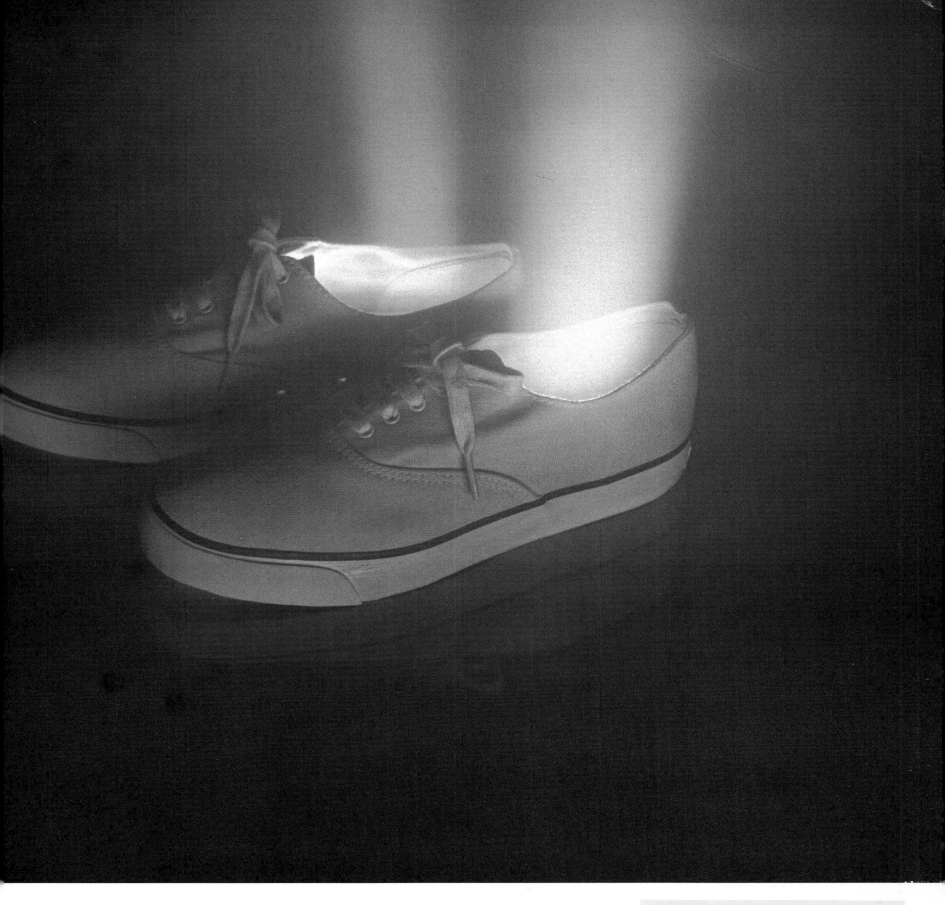

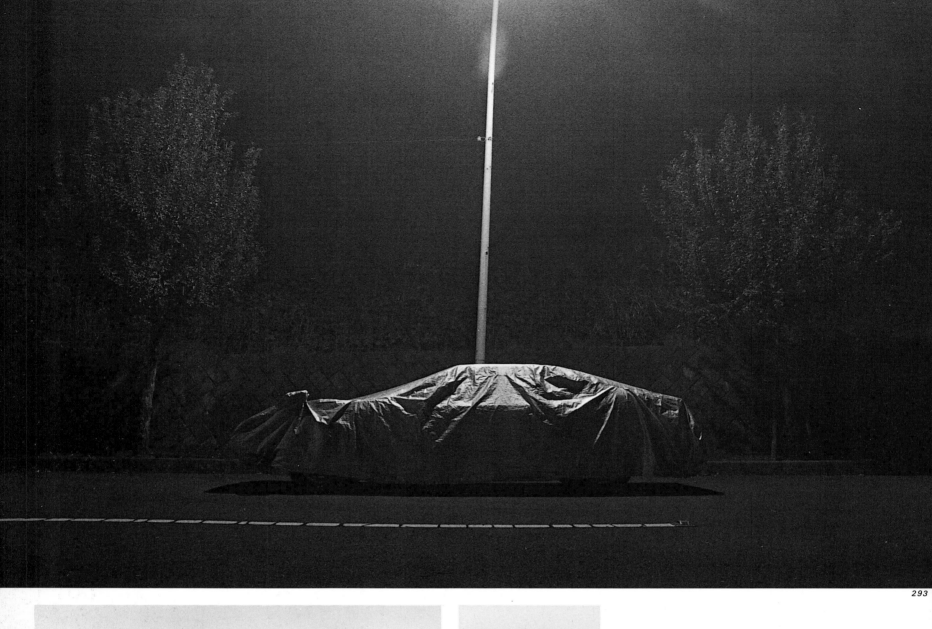

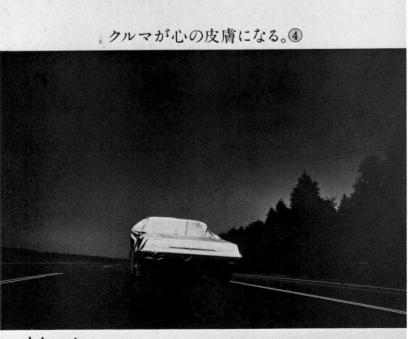

クルマが心の皮膚になる。④

遊次元。 シートを倒す。走り切ったあとに、快感は無重力を漂う。
星空が砕けて、ガラスの窓辺が降りしきる夜。
それでも残る悲しみを、クルマと森はキラキラ囁っているのだろうか。

auto-humanity
TOYOTA

クルマが心の皮膚になる。

微交感。

auto-humanity
TOYOTA

293

●293　　●magazine
　　　　　motorcars
photographer 細川晃 ko hosokawa
●
art director 羽山恵 kei hayama
designer 羽山恵 kei hayama
copywriter 柴田鉄博 tetsuhiro shibata
agency ㈱日本デザインセンター
nippon design center
production ㈱日本デザインセンター
nippon design center
advertiser トヨタ自動車㈱
toyota motor

●294　　●magazine
　　　　　motorcars
photographer 高木松寿 matsutoshi takagi
●
art director 羽山恵 kei hayama
designer 羽山恵 kei hayama
copywriter 柴田鉄博 tetsuhiro shibata
agency ㈱日本デザインセンター
nippon design center
production ㈱日本デザインセンター
nippon design center
advertiser トヨタ自動車㈱
toyota motor

●295　　●catalog
●296　　●poster
　　　　　motorcars
photographer 前田宗夫 muneo maeda
●
art director 白田利夫 toshio hakuta
designer 羽山恵 kei hayama
copywriter 宮崎光 hikaru miyazaki
　　　　　川口孝男 takao kawaguchi
production ㈱日本デザインセンター
nippon design center
advertiser トヨタ自動車㈱
toyota motor

295

ROYAL TWIN-CAM
NEW CROWN

4Door Hardtop Royal Saloon & Royal Saloon G/2.8DOHC & ECT

296

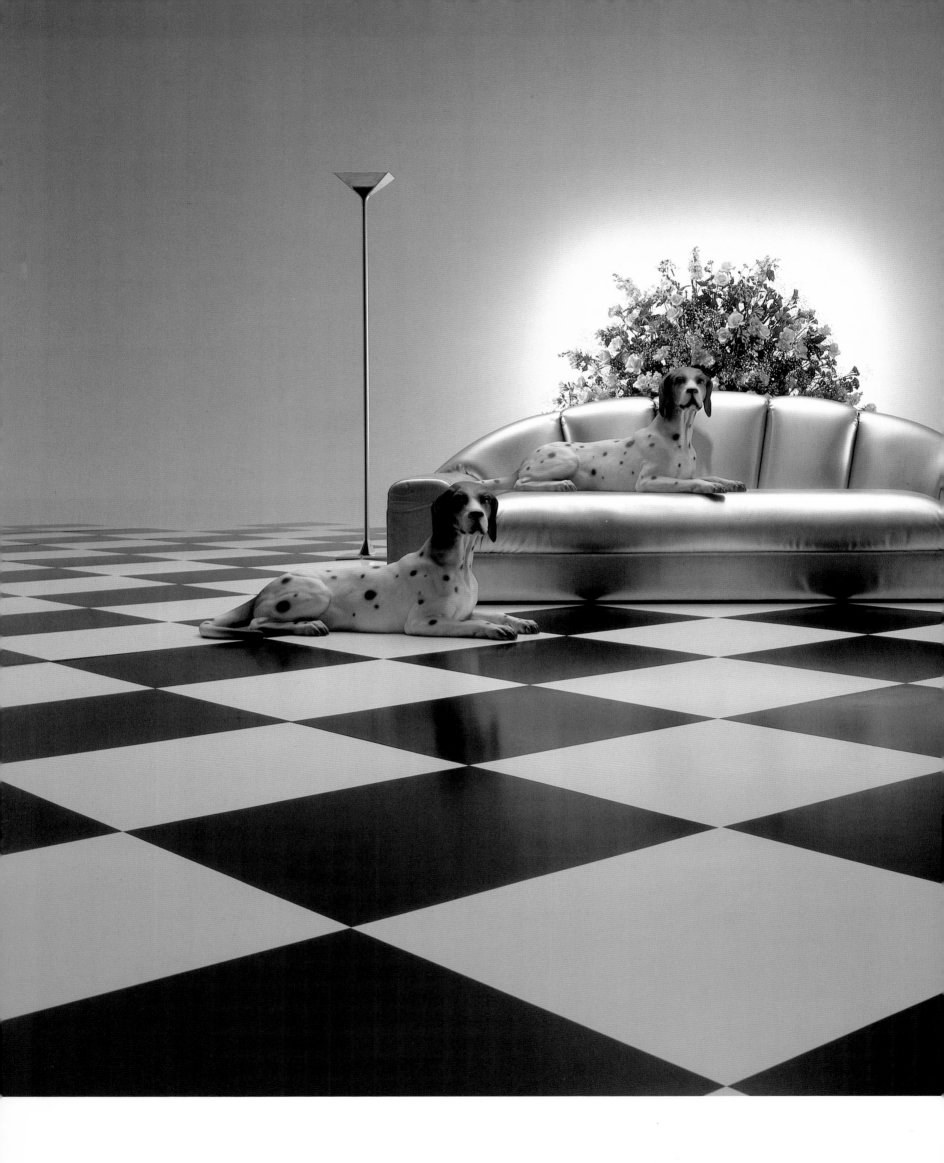

●297・298　●pamphlet
　　　　　　　furniture

| | | |
|---|---|---|
| *photographer* | 加藤勝彦 | katsuhiko kato |
| ● | | |
| *art director* | 伊勢隆思 | takashi ise |
| *designer* | 伊勢隆思 | takashi ise |
| *copywriter* | tcb | |
| *agency* | 東京専商 | tokyo sensho |
| *production* | tcb | |
| *advertiser* | モダンファニチュアーコバヤシ | |
| | modern furniture kobayashi | |

297

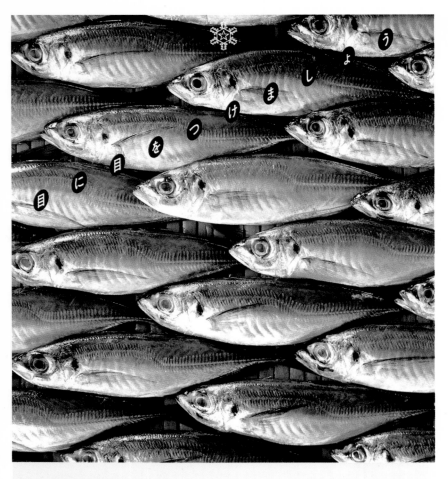

目に目をつけましょう

あじは一年中とれますが、とくに夏が「おいしい」といわれます。目が透き通って盛り上がっていて、えらが鮮紅色の肥ったのを選びましょう。一般的なのは真あじで、10cmほどの小あじ、20〜25cmぐらいの中あじが家庭向きです。買ってきたら、すぐにえらや内臓をとり、海水ぐらいの塩水で、よく洗って置くのをお忘れなく。水気をふきとり塩をまぶします。10分ほどで塩がまわったら、こしょうをし、小麦粉をまぶします。フライパンにバターとサラダ油を半々に熱し、表は強火で色よく焼き、裏返したら火を弱めて、中まで火を通すのがコツです。さらに仕上げにバター。すばらしい風味になります。

雪印バター

夏の贈りものには、雪宝の「ギフト券」がございます

299

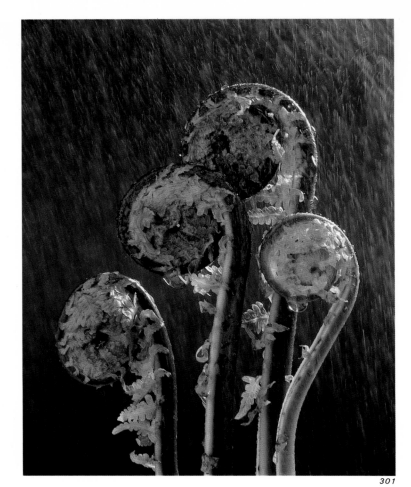

301

本物の味 胡麻の油
北京の冷奴。
嵐山 光三郎

301

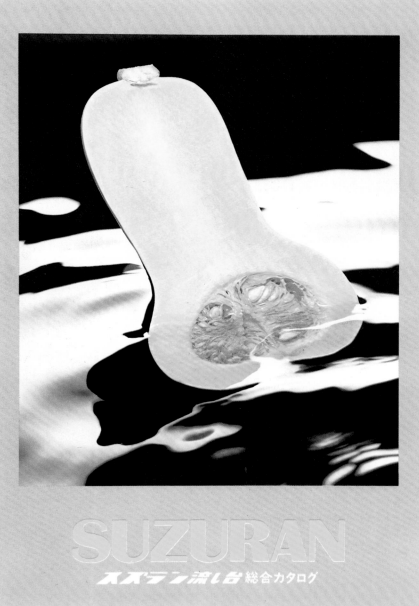

SUZURAN
スズラン流し台 総合カタログ

300

●299　●magazine
　　　　dairy products
photographer 佐藤洋一 yoichi sato
●
art director 向秀男 hideo mukai
designer 向秀男 hideo mukai
　　　　 家中あい ai ienaka
copywriter 向秀男 hideo mukai
production 向デザイン企画室
　　　　 art directors studio mukai & assoc.
advertiser 雪印乳業㈱
　　　　 snow brand milk products

●300　●pamphlet
　　　　sink manufacturer
photographer 鈴木一雄 kazuo suzuki
●
art director 志村耕一 koichi shimura
designer 志村耕一 koichi shimura
production 大日本印刷㈱CDC事業部
　　　　 dai nippon printing
advertiser スズラン流し台
　　　　 suzuran sink

●301　●magazine
　　　　cooking oil
photographer 湯浅明久 akihisa yuasa
●
art director 寺尾正哉 masaya terao
designer 寺尾正哉 masaya terao
copywriter 嵐山光三郎 kozaburo arashiyama
advertiser 竹本油脂㈱ takemoto yushi

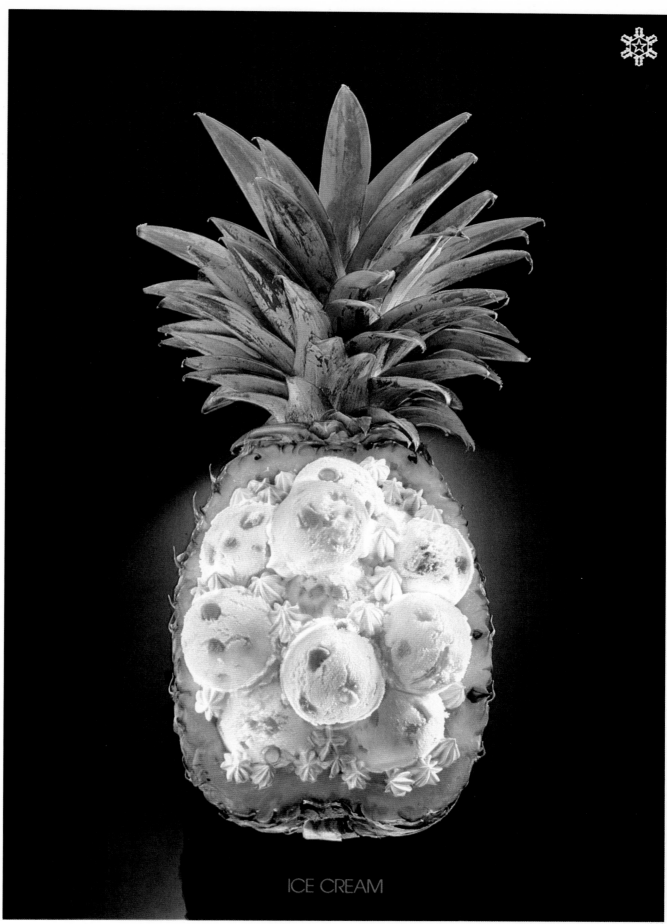

ICE CREAM

●302　　●poster
　　　　　　dairy products

photographer　佐藤洋一 yoichi sato
●　　　　　　　●
art director　布施行造 kozo fuse
designer　　　布施行造 kozo fuse
　　　　　　　家中あい ai ienaka
production　　雪印乳業宣伝部制作課
　　　　　　　snow brand milk products
advertiser　　雪印乳業㈱
　　　　　　　snow brand milk products

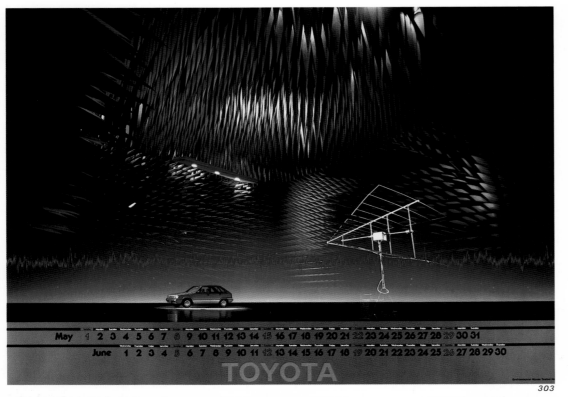

303

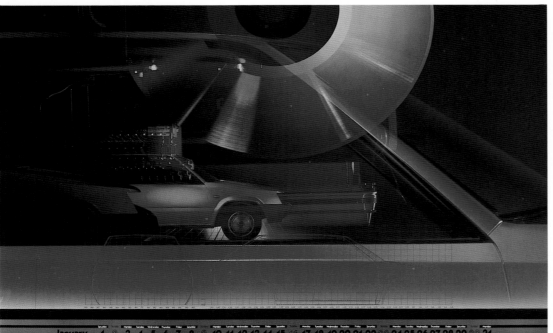

304

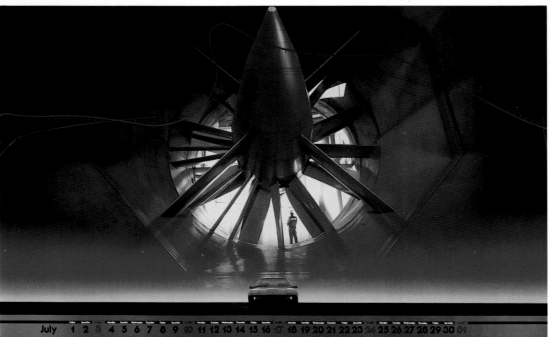

305

1. SUN
JANUARY

2

9

16

23/30

●303-305    ●calender
                 motorcars

photographer  高木松寿 matsutoshi takagi
●
art director  山本洋司 yoji yamamoto
designer      山本洋司 yoji yamamoto
production    ㈱日本デザインセンター
              nippon design center
advertiser    トヨタ自動車㈱ toyota motor

●306・307    ●calendar
                 audio-visual supplies

photographer  早崎治 osamu hayasaki
●
art director  青木東之 motoyuki aoki
designer      佐藤稔 minoru sato
copywriter    河西純一 junichi kasai
agency        ㈱電通 dentsu
production     ㈱電通 dentsu
advertiser    日立マクセル㈱ hitachi maxell

●308        ●magazine
                 camera film

photographer  鳥居正夫 masao torii
●
art director  森田純一郎 junichiro morita
designer      森田純一郎 junichiro morita
copywriter    関橋栄作 eisaku sekihashi
agency        J.W.トンプソン j.w.thompson
production     J.W.トンプソン j.w.thompson
advertiser    長瀬産業㈱ nagase

●309        ●pamphlet
                 kimono school

photographer  永井照人 teruto nagai
●
art director  佐渡正明 masaaki sado
designer      佐渡正明 masaaki sado
advertiser    大原和服専門学園
              ohara wafuku senmon gakuen

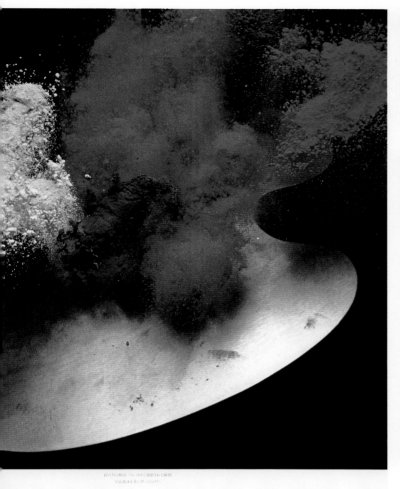

エピタキシャル ビデオテープ **maxell**

| WED | THU | FRI | SAT | ● | SUN | MON | TUE | WED | THU | FRI | SAT | **2** |
|---|---|---|---|---|---|---|---|---|---|---|---|---|
| ● | ● | ● | 1 | | ● | ● | 1 | 2 | 3 | 4 | 5 | FEBRUARY |
| 5 | 6 | 7 | 8 | | 6 | 7 | 8 | 9 | 10 | 11 | 12 | |
| 12 | 13 | 14 | 15 | | 13 | 14 | 15 | 16 | 17 | 18 | 19 | |
| 19 | 20 | 21 | 22 | | 20 | 21 | 22 | 23 | 24 | 25 | 26 | |
| 26 | 27 | 28 | 29 | | 27 | 28 | ● | ● | ● | ● | ● | |

306

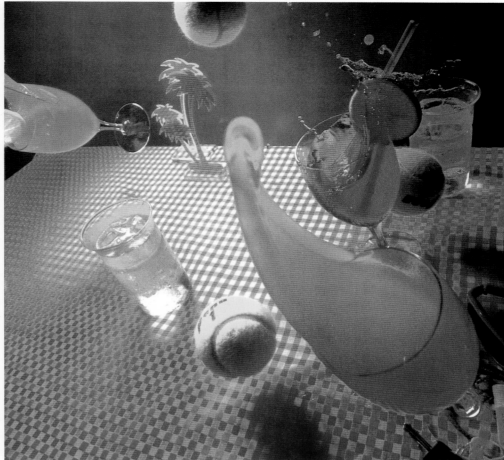

電気・電子機器 **maxell**

| **5** | SUN | MON | TUE | WED | THU | FRI | SAT | ● | SUN | MON | TUE | WED | THU | FRI | SAT | **6** |
|---|---|---|---|---|---|---|---|---|---|---|---|---|---|---|---|---|
| MAY | 1 | 2 | 3 | 4 | 5 | 6 | 7 | | ● | ● | 1 | 2 | 3 | 4 | JUNE |
| | 8 | 9 | 10 | 11 | 12 | 13 | 14 | | 5 | 6 | 7 | 8 | 9 | 10 | 11 | |
| | 15 | 16 | 17 | 18 | 19 | 20 | 21 | | 12 | 13 | 14 | 15 | 16 | 17 | 18 | |
| | 22 | 23 | 24 | 25 | 26 | 27 | 28 | | 19 | 20 | 21 | 22 | 23 | 24 | 25 | |
| | 29 | 30 | 31 | ● | ● | ● | ● | | 26 | 27 | 28 | 29 | 30 | ● | ● | |

307

Photo-illustration

Kodak Ektachrome professional film

308

OHARA

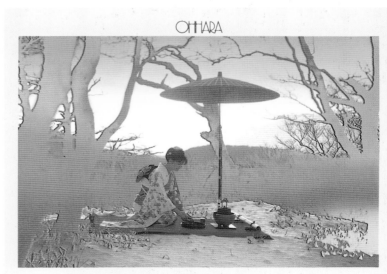

この道は――技術のシルクロード

309

310

●310 　　●calender
　　　　　　　cosmetics
photographer 　新正卓 taku aramasa
●
creative 　　　若林忠明 tadaaki wakabayashi
director
art director 　横内善男 yoshio yokouchi
designer 　　横内善男 yoshio yokouchi
copywriter 　渡部清 kiyoshi watanabe
production 　㈱アルビオン化粧品 albion cosmetics
advertiser 　㈱アルビオン化粧品 albion cosmetics

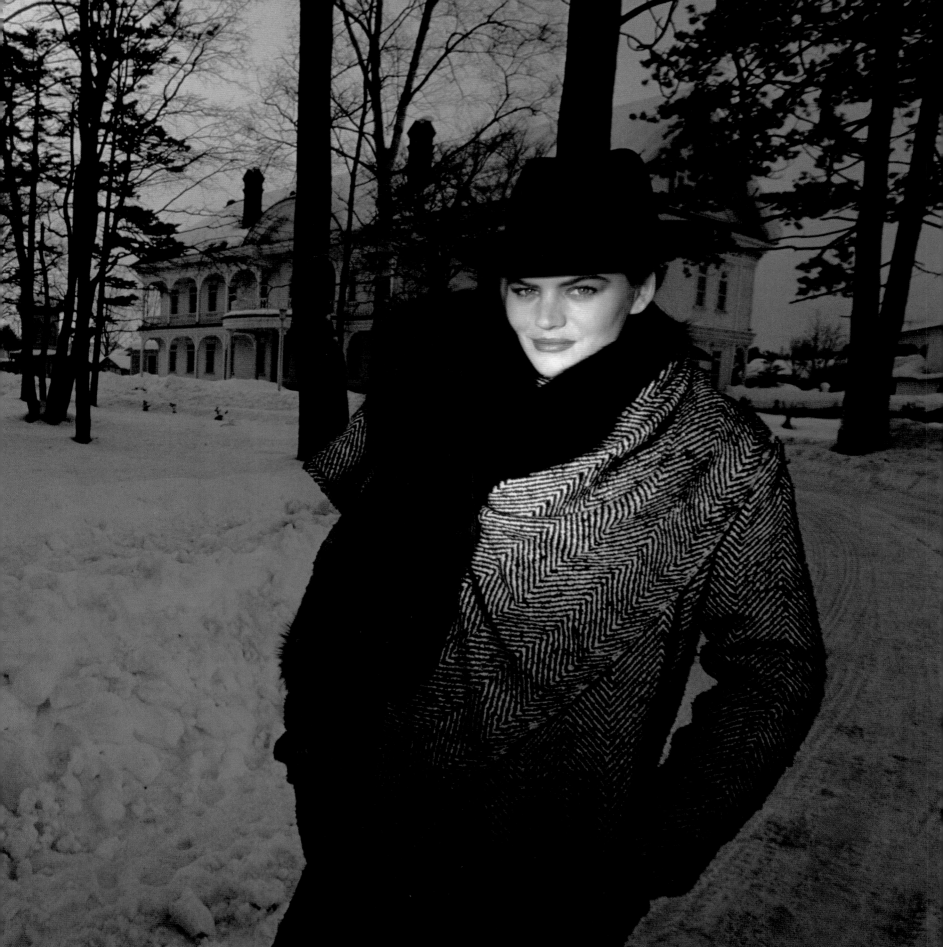

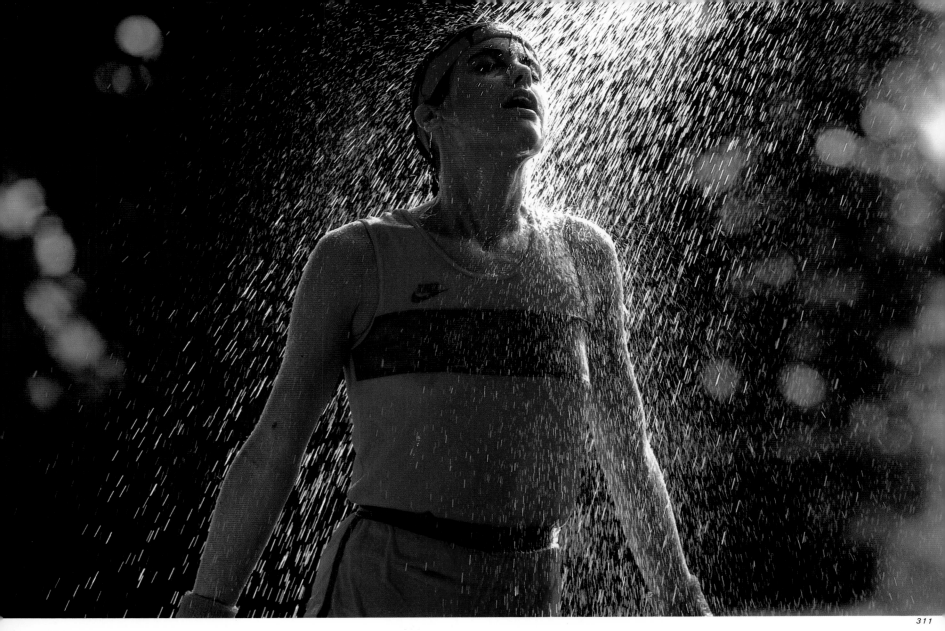

311

312

●311·312　●calendar
　　　　　　　sports shoes

photographer　轟近夫 chikao todoroki
●
art director　稲川浩教 hirokazu inagawa
designer　木本健雄 takeo kimoto
copywriter　野島一裕 kazuhiro nojima
production　マルチコミニュケーションズ
　　　　　　 maruti communications
advertiser　ナイキジャパン nike japan

●313　●poster
　　　　　 department store

photographer　富永民生 minsei tominaga
●
art director　土屋亘 wataru tsuchiya
designer　土屋亘 wataru tsuchiya
copywriter　眞木準 jun maki
agency　㈱博報堂 hakuhodo
production　㈱博報堂 hakuhodo
advertiser　伊勢丹 isetan dept.

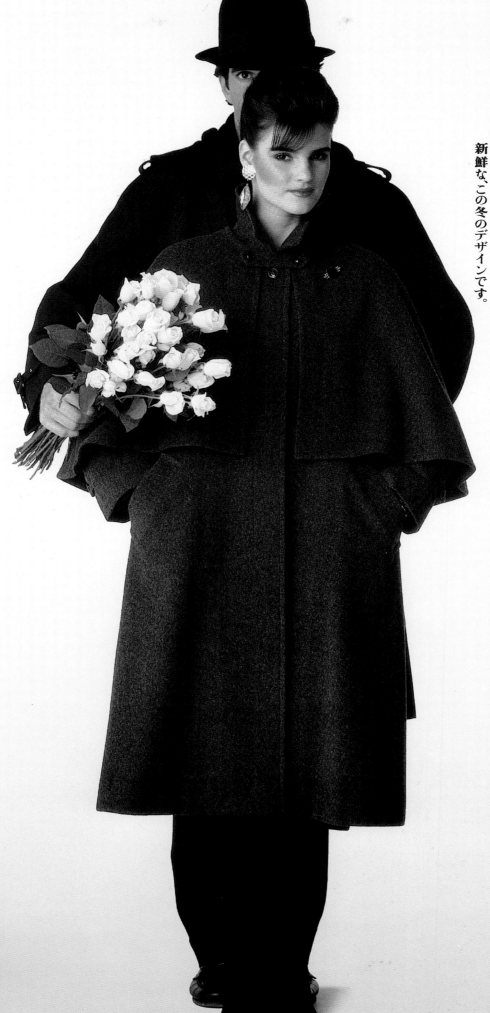

男性が肩を抱く程度の暖かさ。

伊勢丹は、ケープレットコート。
クラシックな女に見えるくらいが
新鮮な、この冬のデザインです。

素敵だね、
このウール。

NEW WOOL 100%

素敵だね、
このコート。

伊勢丹

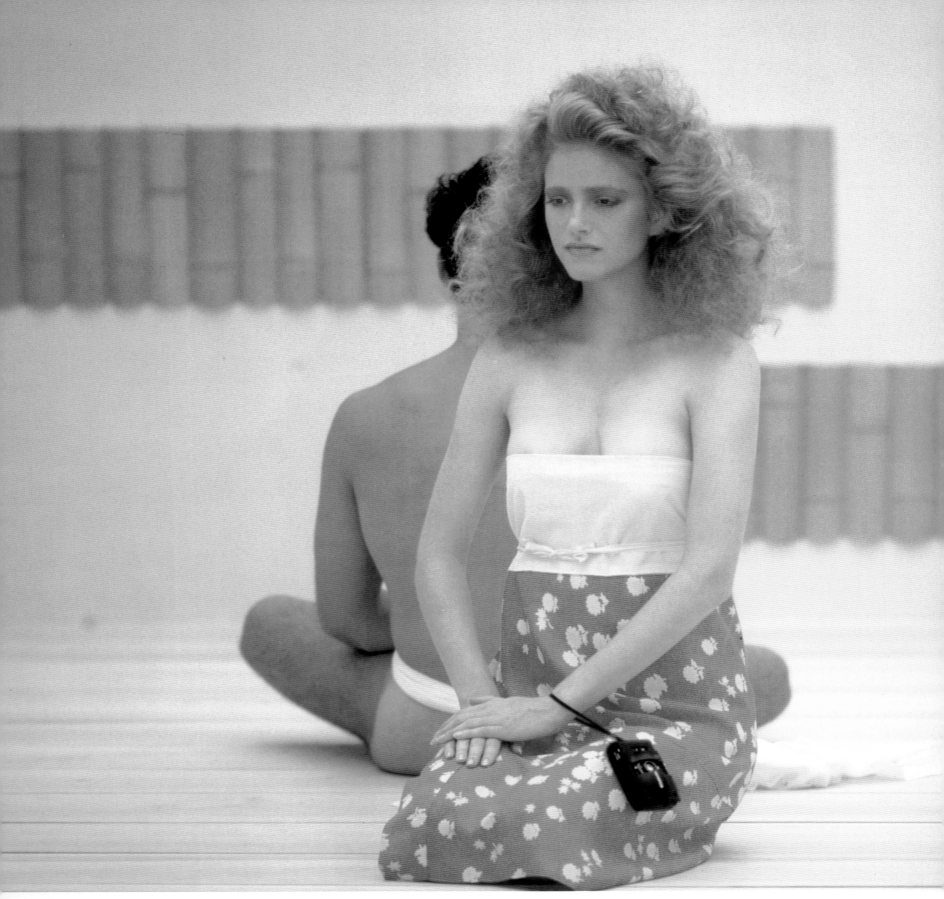

314

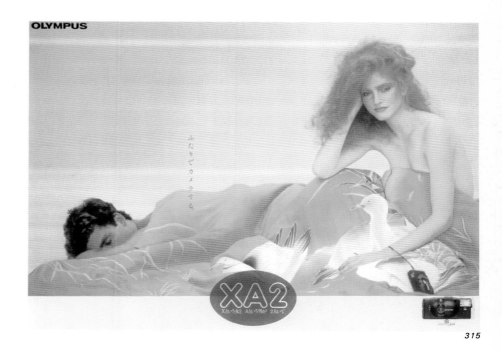

315

●314·315    ●poster
                 cameras

photographer    菅昌也 masaya suga
●
art director    戸田正寿 masatoshi toda
designer        中村卓 taku nakamura
copywriter      土井徳秋 noriaki doi
agency          ㈱博報堂 hakuhodo
production       ㈲戸田事務所 toda design office
advertiser       オリンパス光学工業㈱ olympus

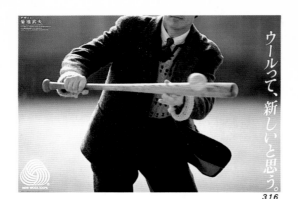

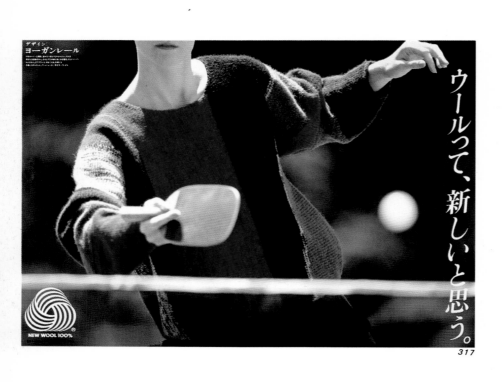

316

●316·317　●poster
　　　　　　 woolen clothing

photographer　菅昌也 masaya suga
●
art director　中島祥文 yoshifumi nakashima
designer　宮本光明 mitsuaki miyamoto
copywriter　西村佳也 yoshinori nishimura
agency　J.W.トンプソン j.w.thompson
production　J.W.トンプソン j.w.thompson
advertiser　国際羊毛事務局
　　　　　 international wool secretariat

318

ASA65で1回、85で1回、100で1回、シャッターを押した。標準ズーム35〜70mmF4。

(チャンス・ハンター)
目撃者 in L.A.

(5秒あれば、12回はシャッターが切れる) OM10 BLACK

319

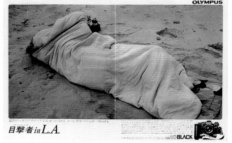

目撃者 in L.A.

OM10 BLACK

318

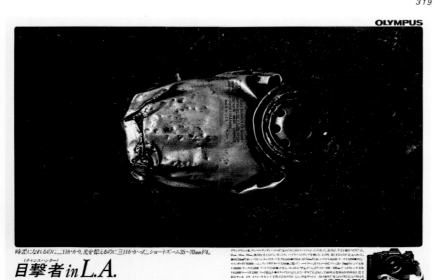

時を止めになれるのに二川かか、光を捉えるのに三川かか。ズ ショートズーム35〜70mmF4。

(チャンス・ハンター)
目撃者 in L.A.

(5秒あれば、12回はシャッターが切れる) OM10 BLACK

320

●318-320　●magazine
　　　　　　　cameras
photographer　影山光久 mitsuhisa kageyama
art director　三浦俊郎 toshiro miura
designer　近藤薫 kaoru kondo
copywriter　影山光久 mitsuhisa kageyama
production　㈱マグナ magna
advertiser　オリンパス光学工業㈱ olympus

●321　●magazine
　　　　mayonnaise
photographer　中川徹 tetsu nakagawa
●
creative　　秋山晶 sho akiyama
　director
art director　細谷巌 gan hosoya
designer　沼尻保美 yasumi numajiri
copywriter　秋山晶 sho akiyama
agency　㈱ライト・パブリシティ light publicity
production　㈱ライト・パブリシティ light publicity
advertiser　キユーピー㈱ q.p.

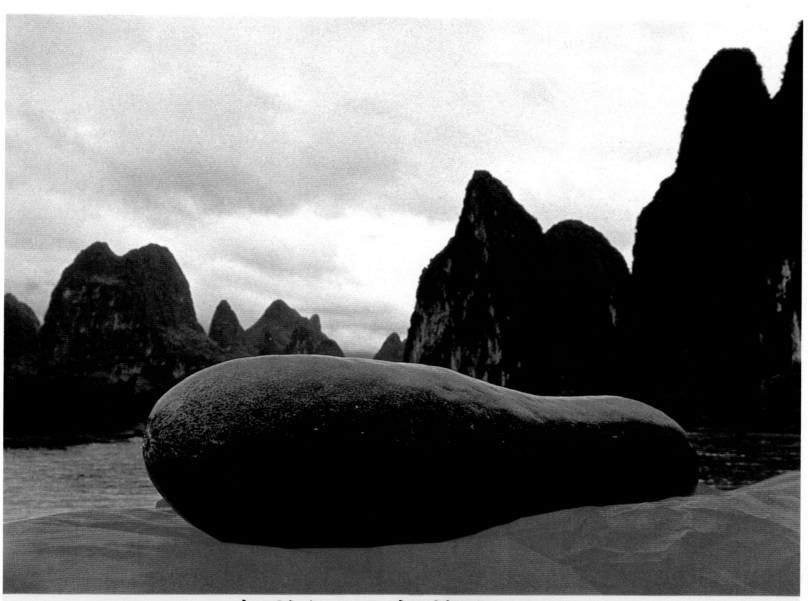

水が人をつくり、人が畑をつくった。

中国、桂林。漓江を舟で下った。かつて海底が隆起して生まれたと言われる山と山の間を水はゆっくりと動いていた。曇り空の午後遅い薄明かりの中で、風景は、そのまま水墨画のように見えた。目をこらすと河のほとりには、ときどき人家があった。人家があると、まもなく畑が目についた。緑の上を、河の風が渡っていた。人がいると、野菜がある。私たちは都会で忘れかけた、この事実に気づいた。爽快な夏だった。

Kodak film
NAGASE Photo Salon
4-3-13 Ginza, Tokyo

一色一成 ● 写真展 "光のメモワール"
昭和58年1月5日㈬〜14日㈮・日曜休館
AM10:00〜PM6:00(最終日PM3:00)
ナガセフォトサロン　TEL.03(567)4567

# Issei Isshiki
## "Mémoire de la Lumière"

●322　●poster
　　　　photo exhibition

photographer　一色一成 issei isshiki
●
art director　東本三郎 saburo tomoto
designer　　　東本三郎 saburo tomoto
advertiser　　一色一成 issei isshiki

●323-325　●poster
　　　　　　photographic book

photographer　久留幸子 sachiko kuru
●
art director　高岡一弥 kazuya takaoka
designer　　　高岡一弥 kazuya takaoka
copywriter　　高橋睦郎 mutsuo takahashi
production　　d.k.
advertiser　　毎日新聞社 mainichi newspapers

千　年・久留幸子写真集

写真・久留幸子　詩・高橋睦郎　構成・高岡一弥　毎日新聞社刊　定価 28,000円　B4判（カラー写真 162 ページ　詩・写真解説 64 ページ　布表紙，外函入り）

323

千　年・久留幸子写真集

写真・久留幸子　詩・高橋睦郎　構成・高岡一弥　毎日新聞社刊　定価 28,000円　B4判（カラー写真 162 ページ　詩・写真解説 64 ページ　布表紙，外函入り）

正当に怒る者は血の潮上げると感じられよ

砂の水平線上，太陽の指低下で。

324

千　年・久留幸子写真集

写真・久留幸子　詩・高橋睦郎　構成・高岡一弥　毎日新聞社刊　定価 28,000円　B4判（カラー写真 162 ページ　詩・写真解説 64 ページ　布表紙，外函入り）

起すとは砂に，あるいは水に起すということだ。

起された王の系譜は華を挙げにとき萌えている。

322

325

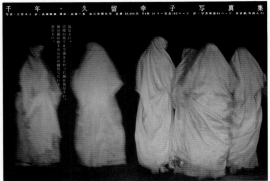

326

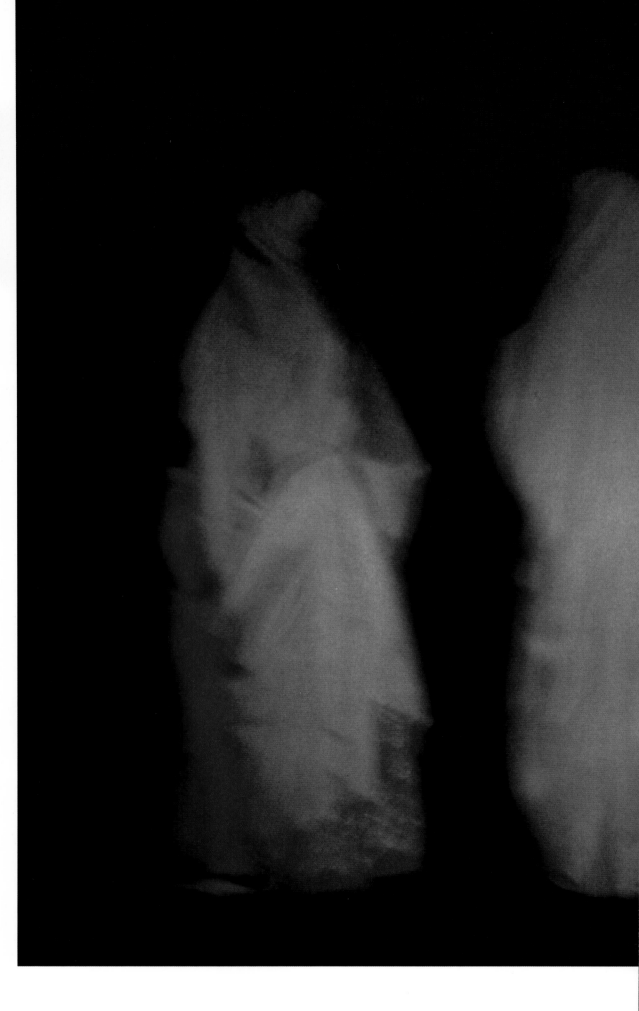

●326        ●poster
            photographic book

photographer    久留幸子 sachiko kuru
●               ●
art director    高岡一弥 kazuya takaoka
designer        高岡一弥 kazuya takaoka
copywriter      高橋睦郎 mutsuo takahashi
production       d.k.
advertiser      毎日新聞社
                mainichi newspapers

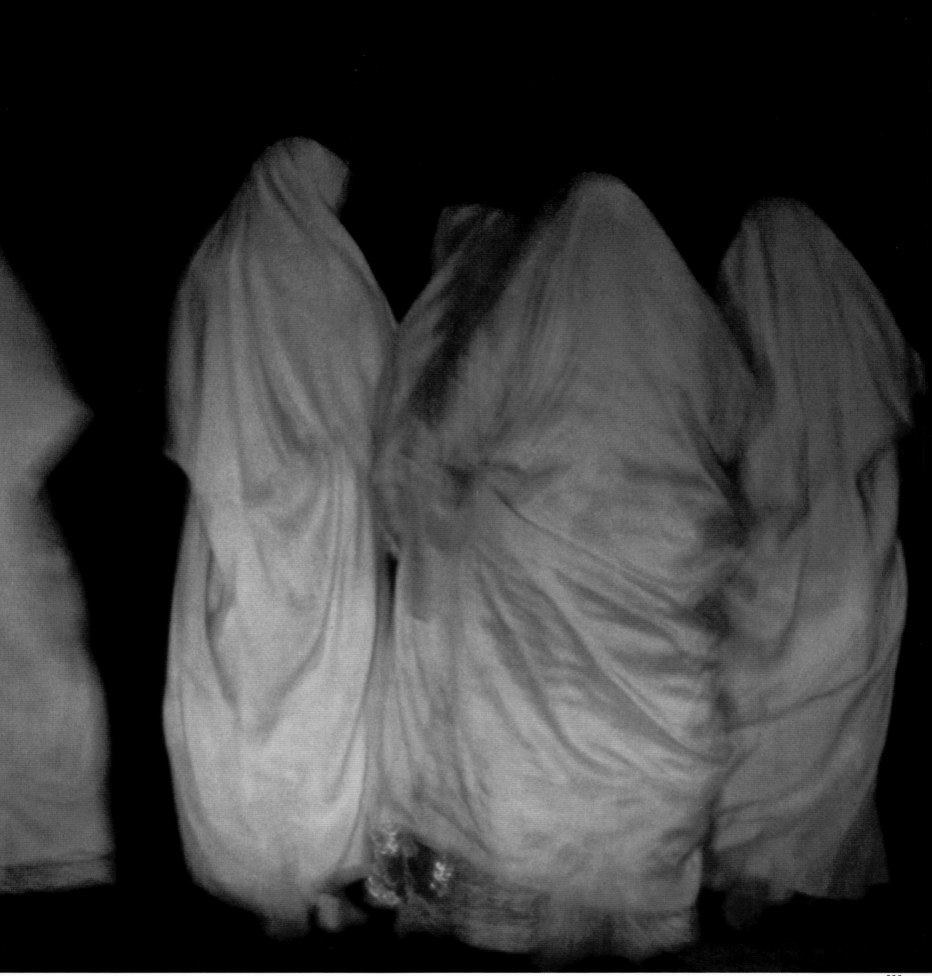

いまは女が醜くなれない時代だと思う。でもきっとそれは、女にとって幸せなことよ。

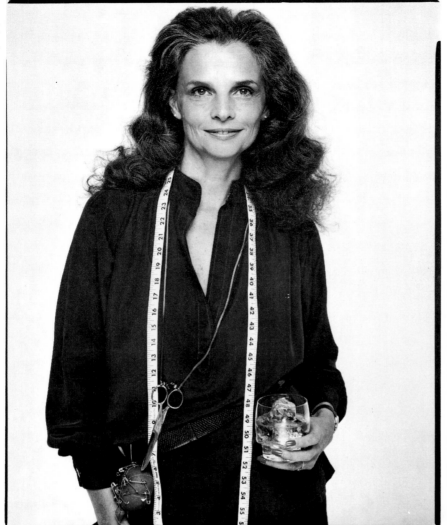

マリア・テレサは私にとって特別な人だ、とアイリスは言った。彼女はとても美しい。顔のシワも、手のシワも、声も、スマイルも、すべてが美しい。あの人を見ていると、美しさは内面から来るものなのだということがよくわかる。歳を重ねて、私もあん存在になりたい…。あなたは自分が好きですかと訊ねた。好きです。生まれてよかったと思う、女に生まれたこともすごく幸せだと思う。男でなくて本当によかった、とも言った。そして笑った。いい笑顔だった。ちょっとグラスを傾けた。とても控え目でいい感じだった。つまり彼女は、いつだって自分らしいのだった。

SUNTORY OLD WHISKY

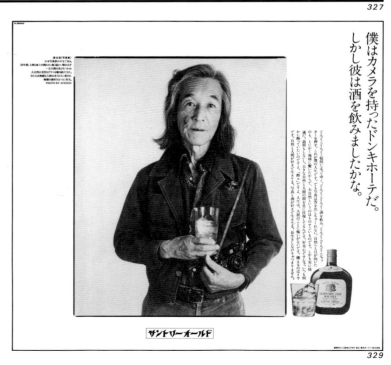

**サントリーオールド**

お酒もとことん。恋もとことん。夢を生きるのって難しいのよね。

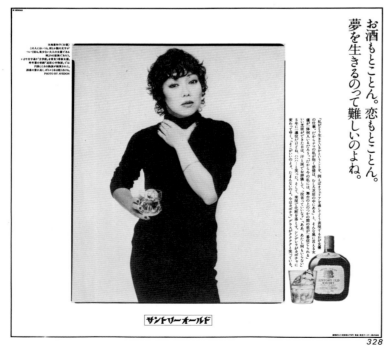

**サントリーオールド**

僕はカメラを持ったドンキホーテだ。しかし彼は酒を飲みましたかな。

**サントリーオールド**

●327-329　　●newspaper
　　　　　　　　whisky

photographer　リチャード・アベドン　richard avedon
●
art director　大道康央　yasuo omichi
designer　　　大道康央　yasuo omichi
copywriter　　西村佳也　yoshinori nishimura
agency　　　　㈱東急エージェンシー　tokyu agency
production　　㈱大道康央デザイン事務所
　　　　　　　yasuo omichi design office
advertiser　　サントリー㈱　suntory

# FUJINON

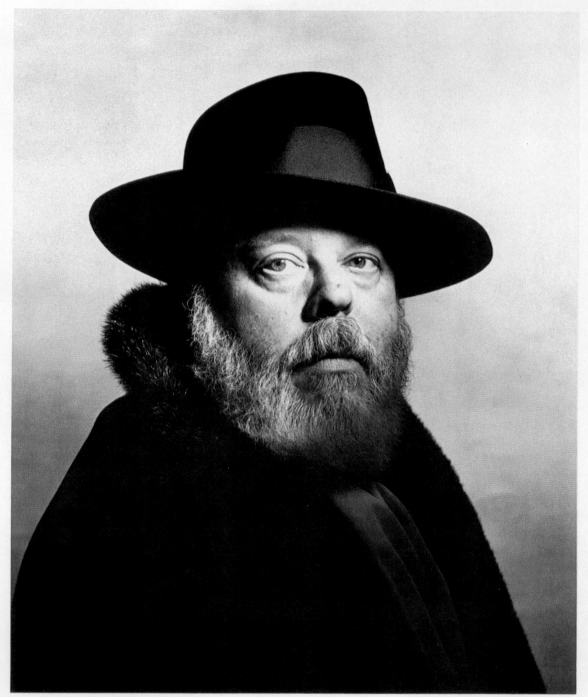

インシリーズ新登場
1:11.5 f400mm 1:12.5 f3mm

アービング・ペンの主題は、つねにソフトでロマンチックだが、彼がレンズに求めるのは、非情なまでの精密さだ。

## *IRVING PENN*

富士写真フイルム株式会社

●330          ●poster
                 camera lenses
photographer   アービング・ペン irving penn
●
art director   山岸亨子 yuko yamagishi
designer       大道康央 yasuo omichi
copywriter     西村佳也 yoshinori nishimura
advertiser     富士写真フイルム㈱ fuji photo film

# INDEPENDENT WORKS

As the APA's membership has increased, so has the range of photographers which it represents. Today, the organization includes not only photographers involved in advertising, but also those who work for magazines and television, or any other media suited to their creative abilities.

This category displays works produced by APA members working in free pursuit of their own interests, as opposed to professional assignments. In their commercial projects, they have had an opportunity to develop extensive knowledge, broadly-based technical skills, and a keen aesthetic sensibility. As they build from a base of such discipline, this category provides a forum to publish work in which they have attempted to create distinctive personal images, or to experiment with new techniques. The accumulation of experience gained through such experimentation contributes a great deal, in turn, to the ambitious creativity of their work as professional advertising photographers.

One obvious trend in this year's selection process—and this trend occurred in both the Independent Works and the Open Division—was the tendency to select series of photos rather than single-sheet photographs. I view this trend as an unfortunate one, for there were relatively few selections that had the impact of the single-sheet advertising photo.

Members submitted 1052 works, of which 132 were selected for inclusion.

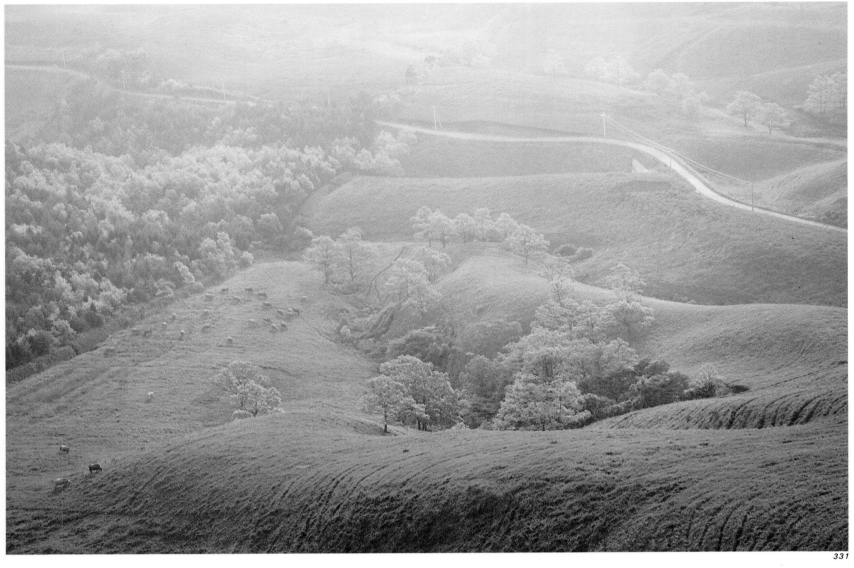

### Silver Award

●331-339

横井隆和 takakazu yokoi

●四季散策

*a stroll through the four seasons*

335

336

337

338

339

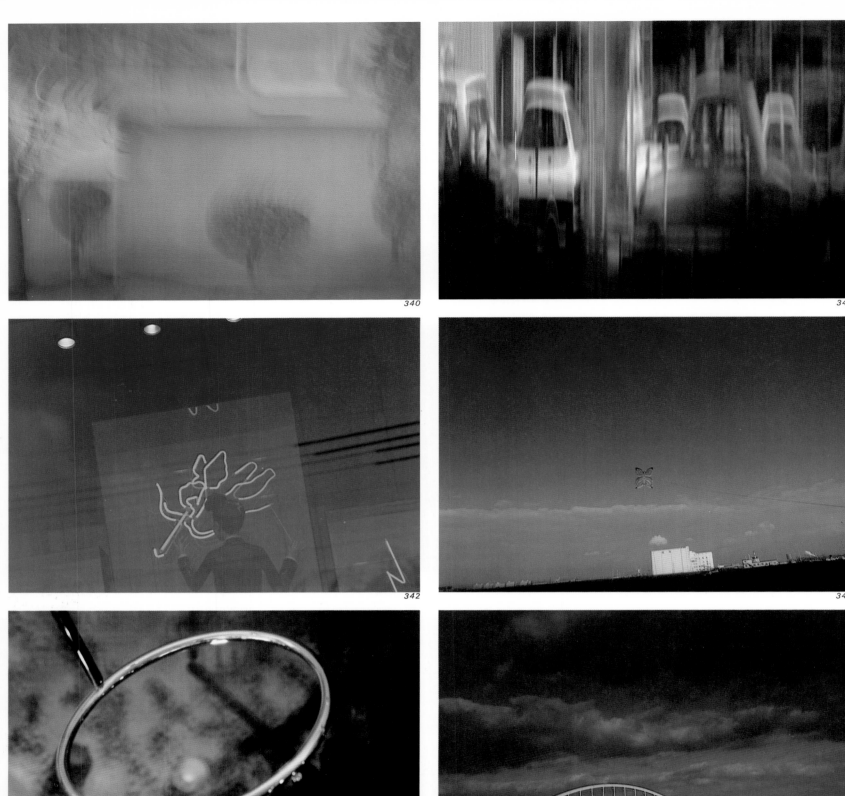

340

341

342

343

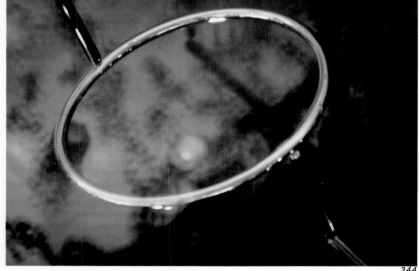

344

345

# *Bronze Prize*

●340-345
美坂竹廣 takehiro misaka
●*one day*

●346-351
大谷勝美 katsumi otani
●遙かなる時 *a long, long time ago*

●352・353
秋山庄太郎 shotaro akiyama
●*country house*

346

347

348

349

350

351

352

353

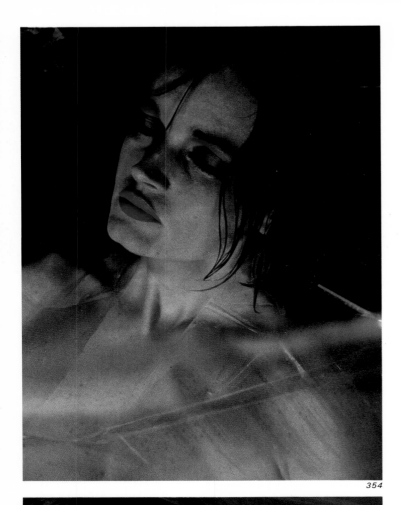

354

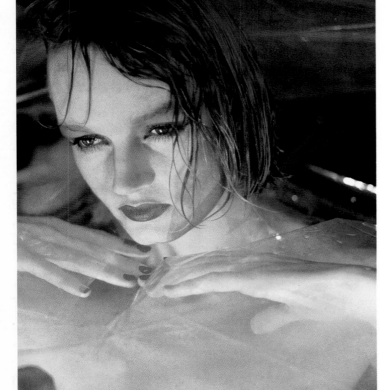

355

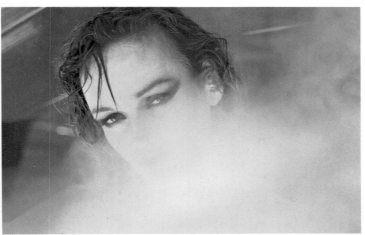

356

357

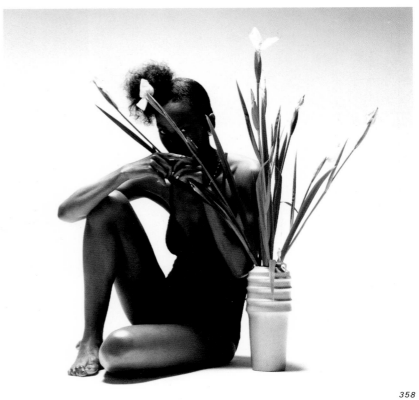

358

●354-356
西巻順一郎 junichiro nishimaki
●sandstorm

●357・358
岸本日出雄 hideo kishimoto
●黒の女 black woman

●359-361
井谷勲 isao itani
●光彩 éclat

●362
喜多荘一郎 soichiro kita
●illumination

●363
塚本章雄 fumio tsukamoto
●邪鬼 an imp

●364
塚本章雄 fumio tsukamoto
●躁鬱 manic depression

359

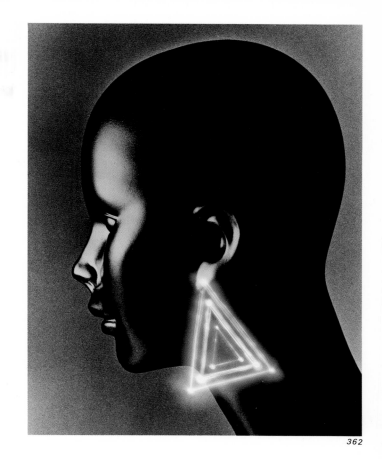

362

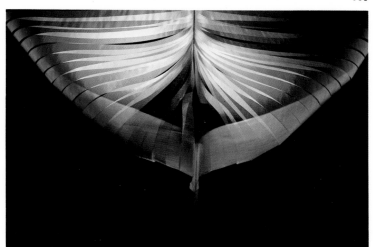

360

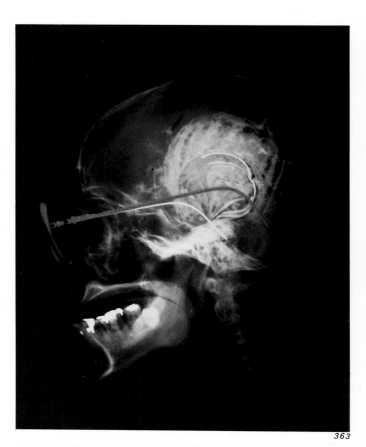

363

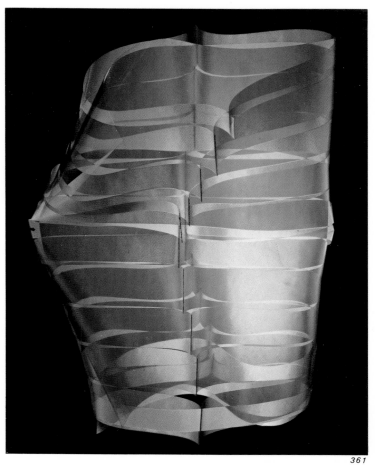

361

364

365

366

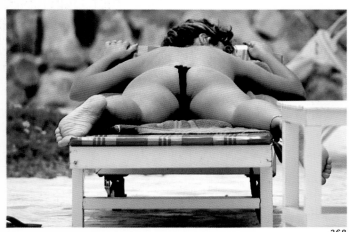

367

368

369

370

371

372

●365-369
望月剛 tsuyoshi mochizuki
●poolside

●370-372
江面俊夫 toshio ezura
●peep

●373・374
白鳥真太郎 shintaro shiratori
●妖 bewitching

●375-378
白鳥真太郎 shintaro shiratori
●スペインにて in spain

373

374

375

376

377

378

382

379

383

380

384

●379-385
福井由二 yoshitsugu fukui
●8月 in morocco *august in morocco*

●386-392
池野徹 toru ikeno
●*dialight*

●393-396
池野徹 toru ikeno
●*pinskin*

●397-400
鶴田義久 yoshihisa tsuruta
●遺言 *last testament*

381

385

397

398

386

393

387

388

394

389

390

395

391

392

396

399

400

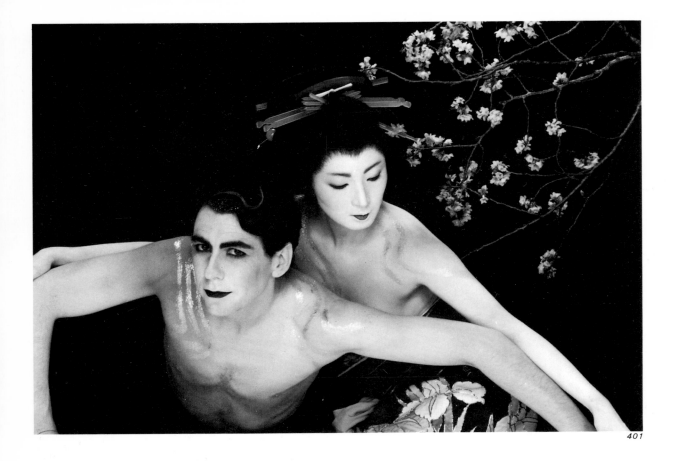

401

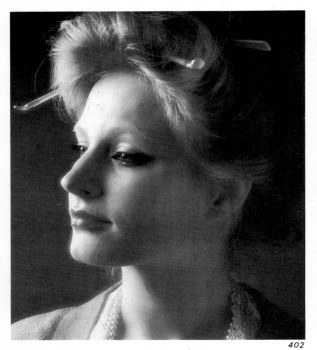

402

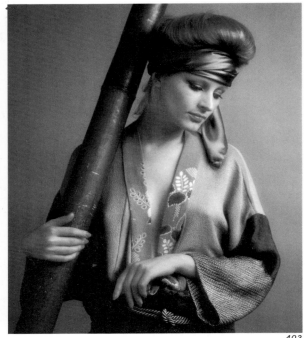

403

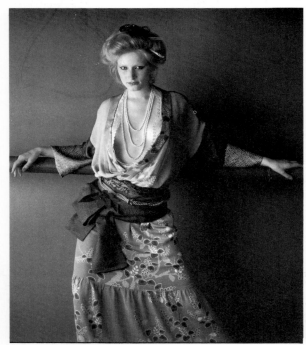

404

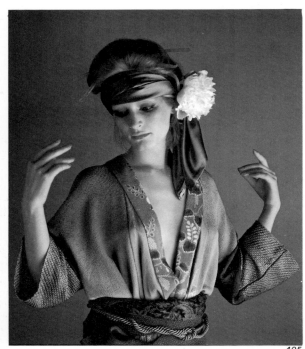

405

●401
藤井秀樹 hideki fujii
●アラン・シャンフォーのレコードジャケット
*record jacket for alain chamfort*

●402-405
中嶋やすとし yasutoshi nakajima
●かぐやひめ *princess kaguya*

●406
兼本延夫 nobuo kanemoto
●浮名草 *promiscuous grasses*

●407-411
角田正治 masaji tsunoda
●アフタヌーン *afternoon*

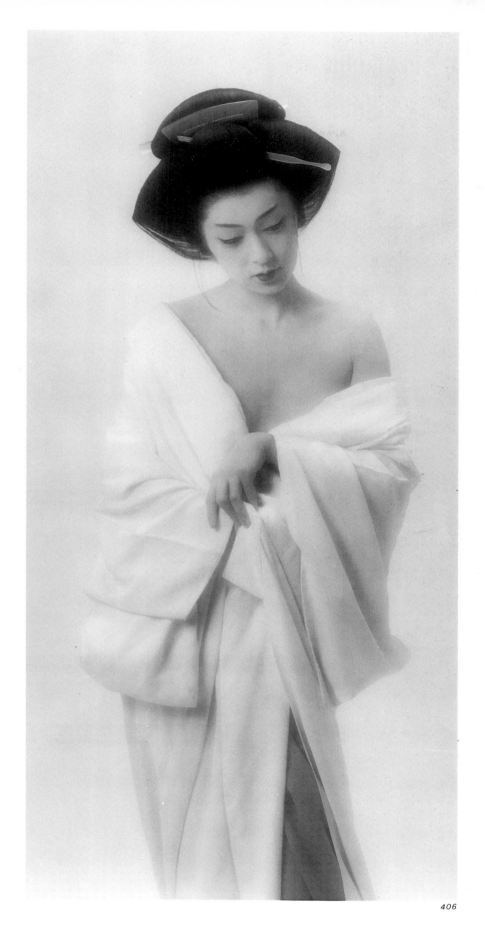

406

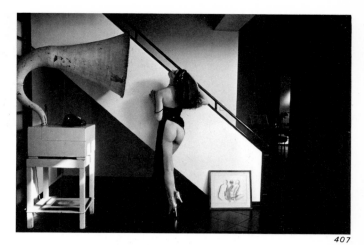

407

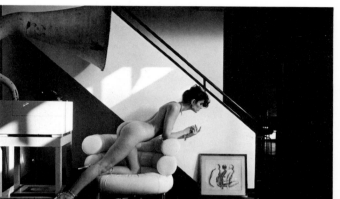

408

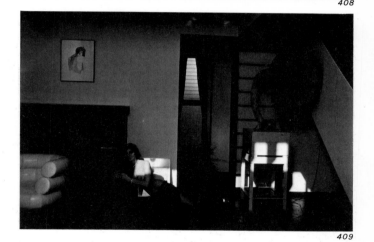

409

410

411

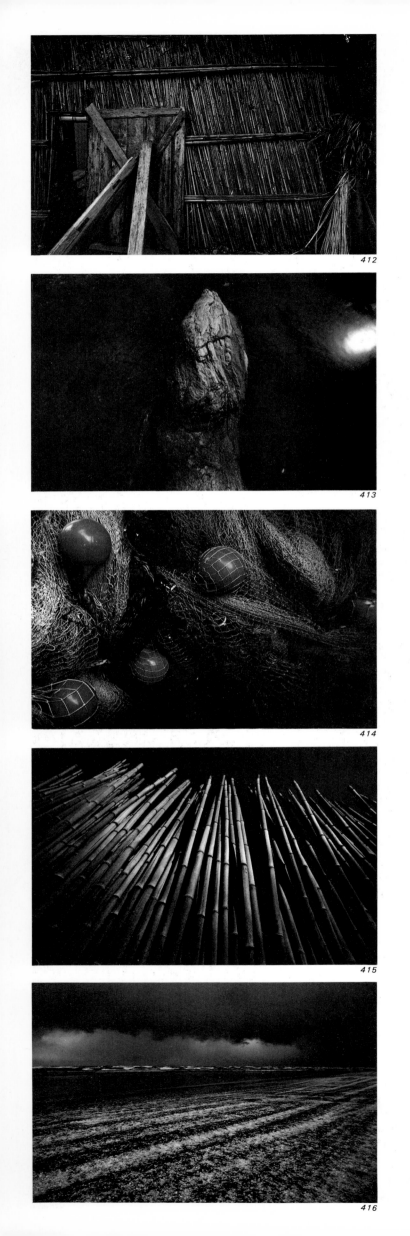

412

413

414

415

416

417

418

419

420

421

422

423

424

425

426

427

●412-416
西岡伸太 shinta nishioka
●能登詩抄 *poems from noto peninsula*

●417-420
福田正市 shoichi fukuda
●インクライン *ink line*

●421-423
芹川明義 akiyoshi serikawa
●火の鳥 *autumn birds*

●424-427
芹川明義 akiyoshi serikawa
●*summer is over*

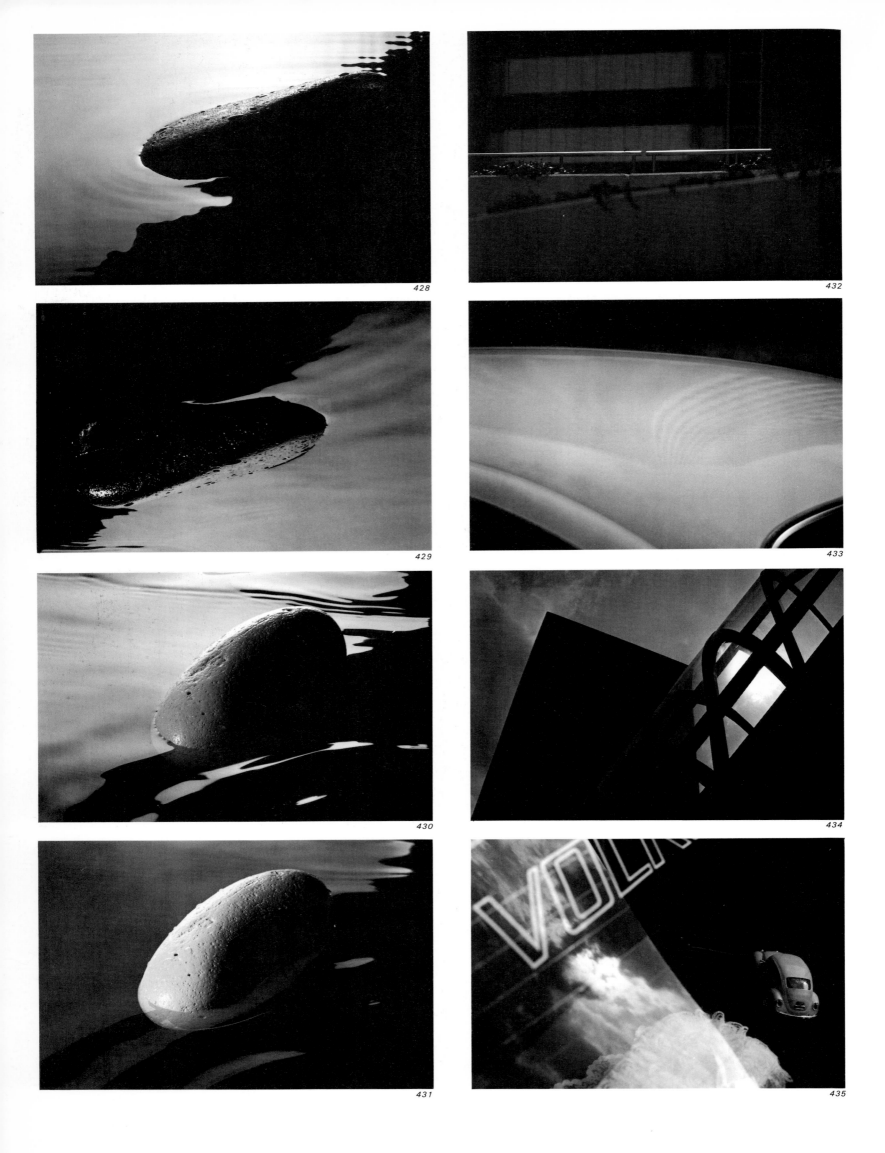

428

432

429

433

430

434

431

435

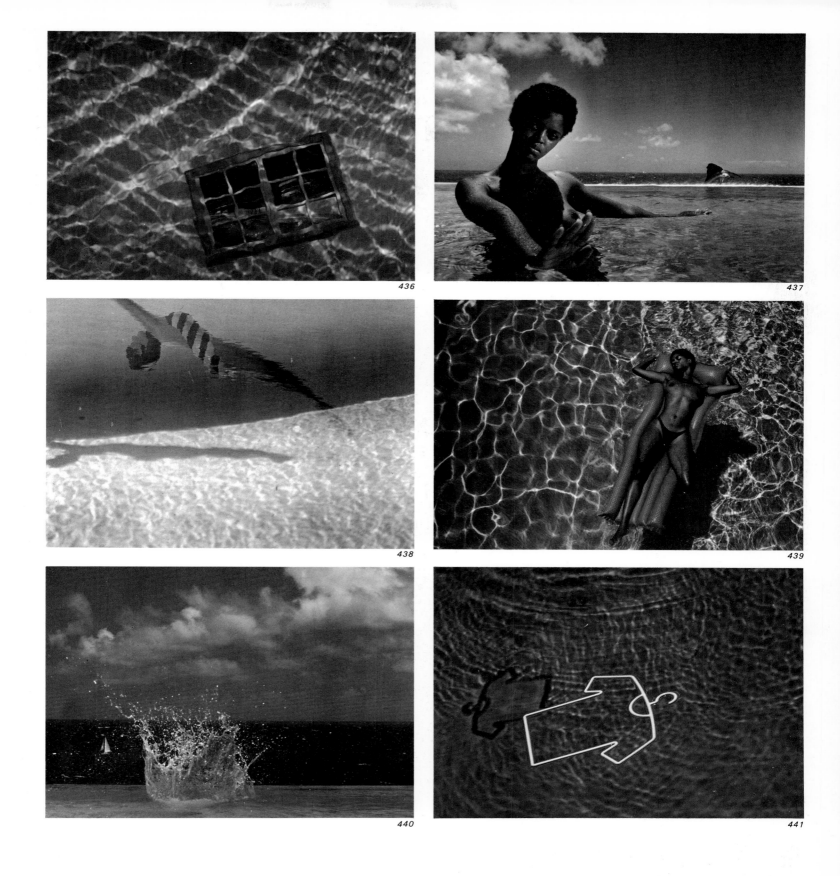

436

437

438

439

440

441

●428-431
鈴木一雄 kazuo suzuki
●ブリーザ breather

●432-435
金崎俊夫 toshio kanasaki
●shining

●436-441
角尾栄治 eiji kakuo
●in the sun

442

443

444

445

446

447

448

449

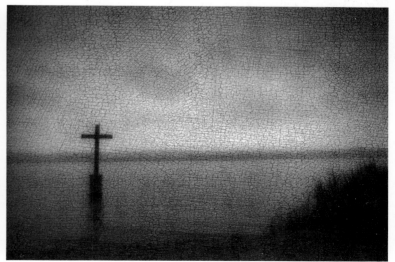

451

●442-444
沖田義治 yoshiharu okita
●yellow

●445・446
小西祐典 yuten konishi
●handmade (A) (B)

●447-451
山根光雄 mitsuo yamane
●悲劇の王、ルートヴィヒ2世のイメージ
the king of tragedy: image of ludwig II

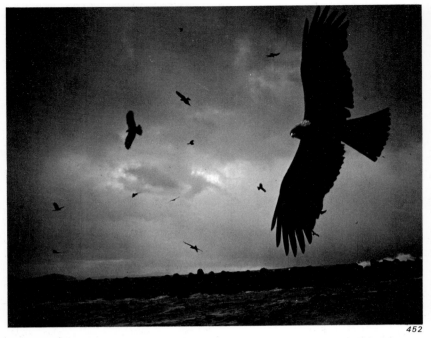

452

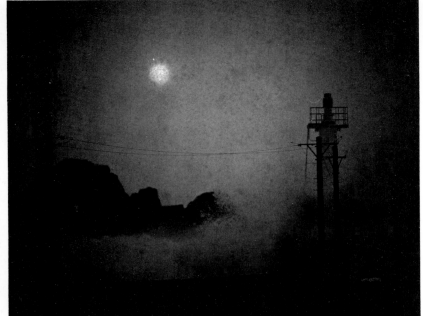

453

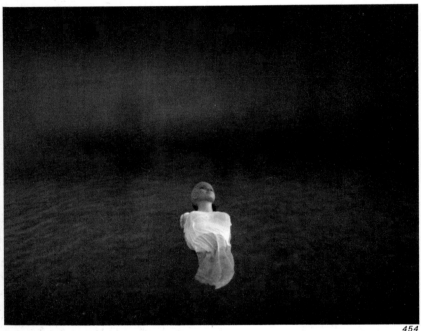

454

455

456

●452
マツシマススム susumu matsushima
●冬の海(A) *winter sea (A)*

●453-455
マツシマススム susumu matsushima
●瘴痾地帯 *malaria belt*

●456
マツシマススム susumu matsushima
●幻の彼方へ *beyond fantasy*

●457
菅井タケオ takeo sugai
●カニ, コンピュータ・グラフィック *crab, computer graphic*

●458-461
奥村公平 kohei okumura
●メーキャップ *makeup*

●462-465
老川良一 ryoichi oikawa
●土と火 *earth and fire*

457

462

458

459

463

460

461

464

465

# OPEN DIVISION

This category is distinguished by the fact that it is open to photographers who are not APA members—including amateurs and students of photography who are hoping to become professional advertising photographers. Each year, a common theme is established for all the categories in the collection, to provide a unifying concept for the photographs. For the 20th APA Exhibition this year, contributions were invited on the theme, ''How Much Faster Can Photographs Run than Words?''

Prizewinning photographs displayed a variety of new directions, and they were outstanding for each photographer's unique approach. This is a reflection of the advent of a period of varied, competing values. The photographs that were awarded prizes in this category reflected the influence of their time, but also displayed unusual individuality.

Perhaps the greatest privilege for the entrant who wins the top APA Prize in this division is introduction to APA members. Such an honor is influential in launching a successful career in professional advertising photography. However, professionals in the advertising, magazine, television, and commercial film worlds take a keen interest in all of the successful entrants in this category. This year 1016 photographers contributed 2767 entries, of which 229 were selected for inclusion.

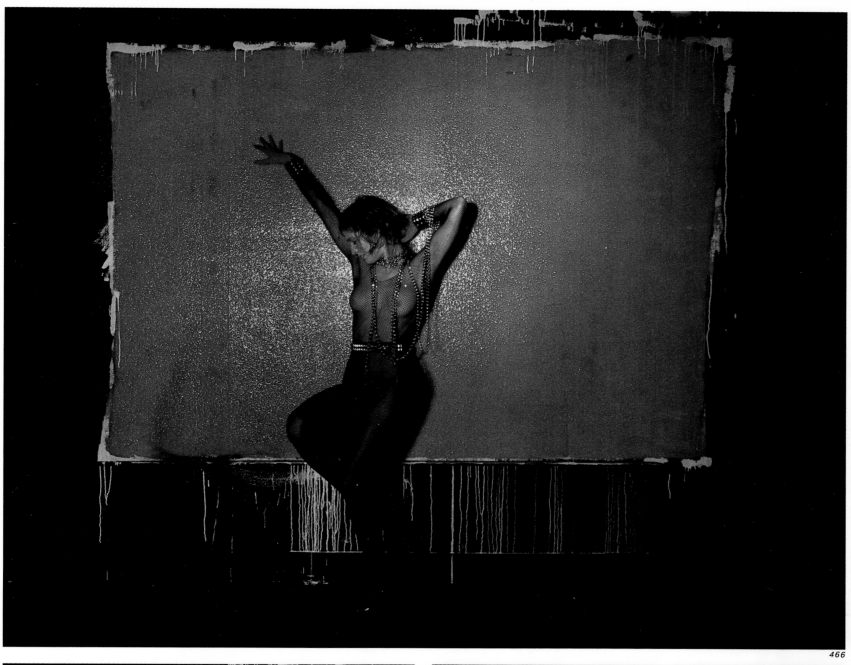

466

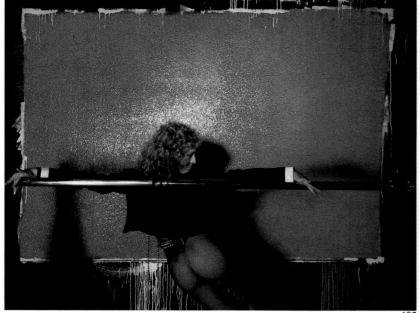

467

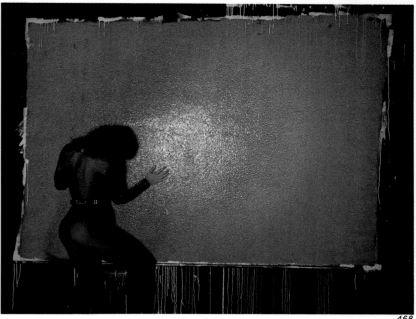

468

**APA Prize**
●466-468
大沢尚芳 hisayoshi osawa
●redden

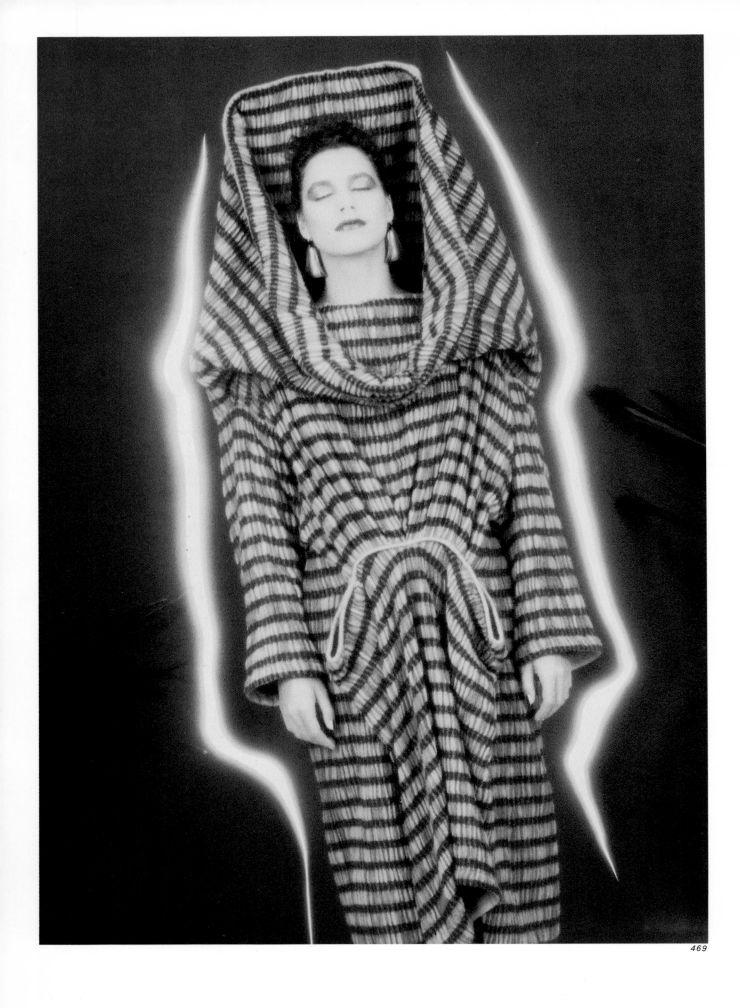

469

Special          Special
●469            ●470-473
鈴木英雄 hideo suzuki    井手貴久 takahisa ide
●zigzag line       ●遠い記憶 distant memory

470

471

472

473

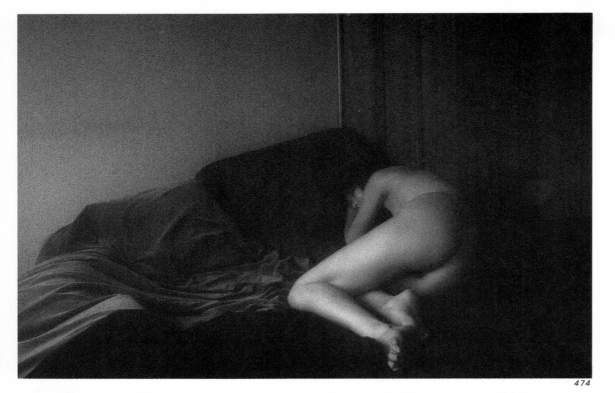

474

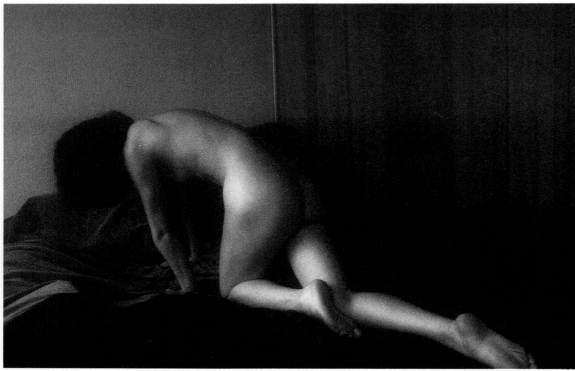

475

478

## *Promotion Prize*

●*474・475*
丸山裕 hiroshi maruyama
●*eve*

●*476・477*
山本保子 yasuko yamamoto
●心象風景 canada, scotland
　*mental images: canada, scotland*

●*478-480*
黒田高司 koji kuroda
●*water in the sky*

476

477

479

480

481

484

482

485

483

486

**Promotion Prize**　**Promotion Prize**
●*481-483*　　　　●*484-486*
柳生博之 hiroyuki yagyu　井上良幸 yoshiyuki inoue
●*landscape*　　　　●思い出 *memory*

487

488

489

490

491

## Kanamaru Award

●487-491
小岩井普志 hiroshi koiwai
●ハートブレイク *heartbreak*

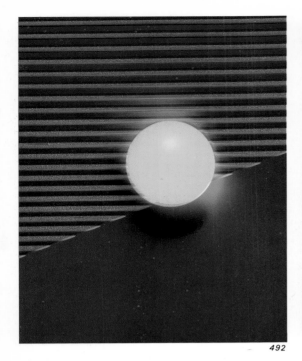

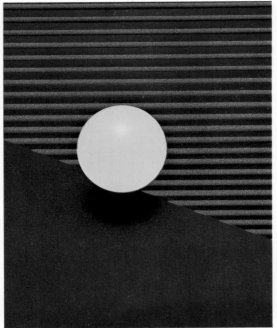

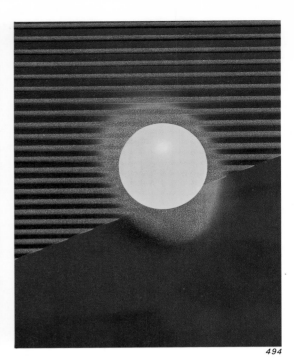

492

493

494

495

497

496

498

●492-494
池田正一 masakazu ikeda
●transformation

●495·496
星野尚彦 naohiko hoshino
●in the dream

●497
上原国弘 kunihiro uehara
●season off

●498
中山健治 kenji nakayama
●黄色いカラス yellow crow

499

500

501

502

503

504

505

506

507

●499-502
町田正男 masao machida
●パラソル parasol

●503
長澤数美 kazumi nagasawa
●a passer-by

●504
酒井孝 takashi sakai
●幻の海「日蝕」 sea of illusion

●505-507
菱沼勝彦 katsuhiko hishinuma
●沐浴 ablutions

508

509

510

511

512

513

514

515

516

517

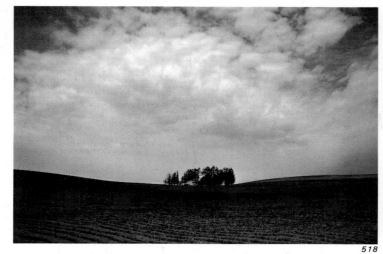

518

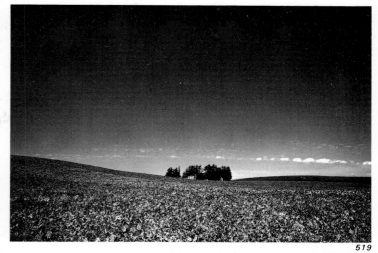

519

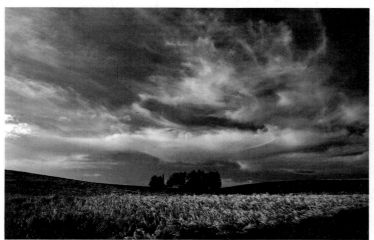

520

521

522

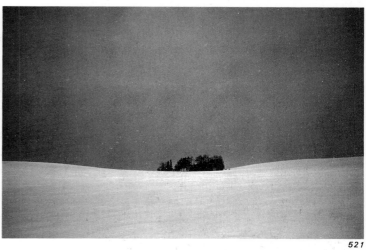

523

524

525

526

527

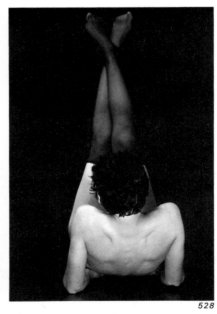

528

529

530

531

●524
下田泰造 taizo shimoda
●無彩艶 *achromatic color*

●525
鈴木英雄 hideo suzuki
●*moment*

●526-531
藤田一咲 issaku fujita
●*nude*

●532・533
矢野間隆 takashi yanoma
●*twelve midnight*

●534-536
徳永三城 mishiro tokunaga
●*doll*

●537-540
寺岡張之助 chonosuke teraoka
●*kim*

537

532

533

538

539

534

535

536

540

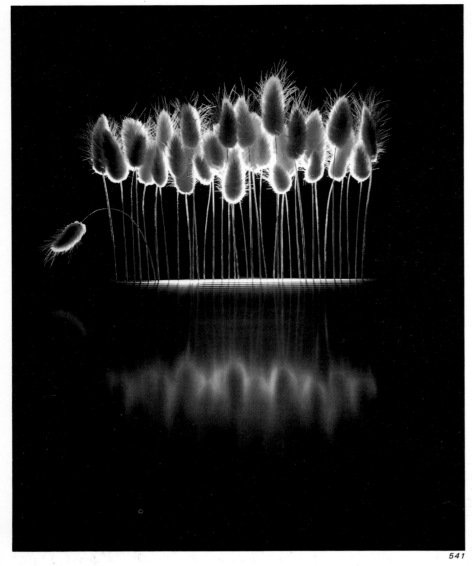

541

543

544

545

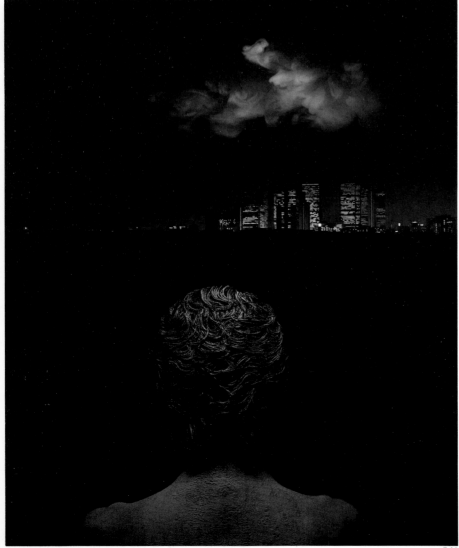

542

546

547

548

549

550

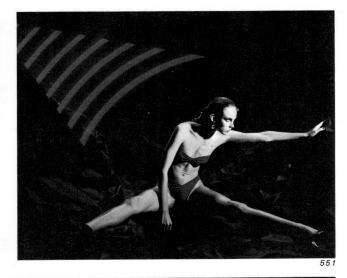

551

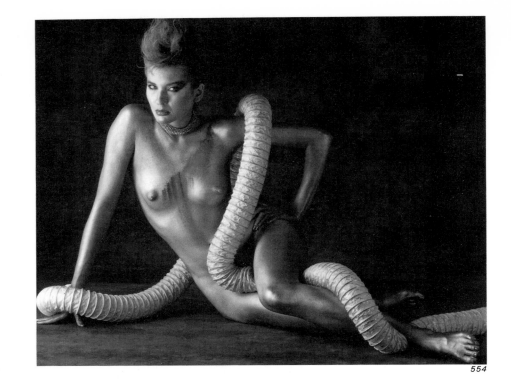

554

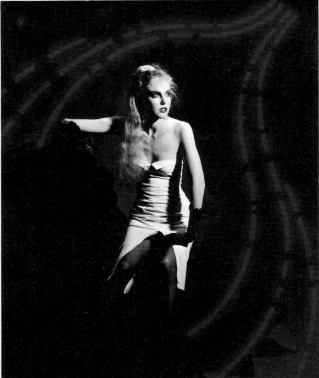

552

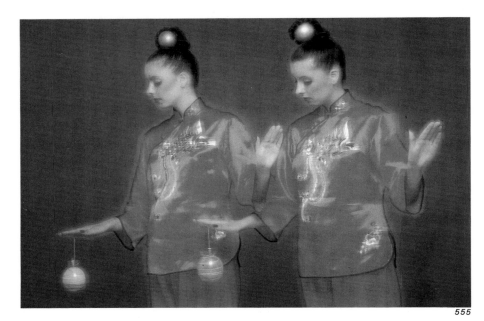

555

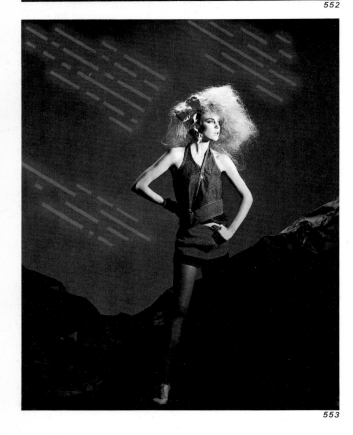

553

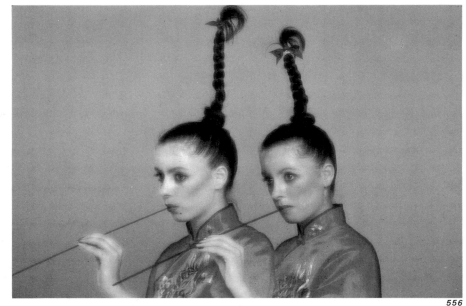

556

●551-553 田井夙虫 tsutomu tai
●beam

●554 河内裕 yutaka kawachi
●noelle plus α

●555・556 永田陽一 yoichi nagata
●シノワズリー・ツイン chinoiserie twins

●557・558 渡辺重史 jushi watanabe
●浮遊間 floating space

●559-561 上杉敬 kei uesugi
●kizashi omen

●562・563 庄嶋与志秀 yoshihide shojima
●秋日 autumn sun

557

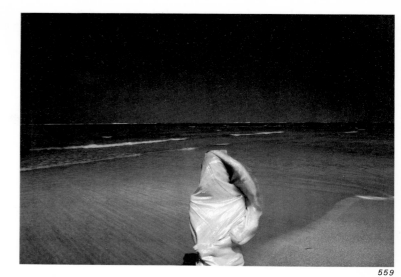

559

558

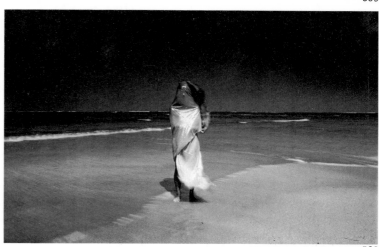

560

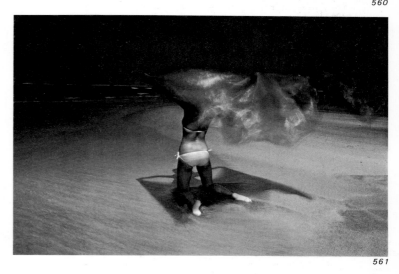

561

562

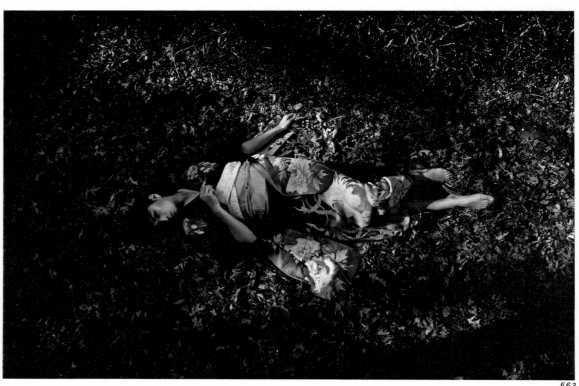

563

564

567

568

565

569

566

570

573

571

574

572

575

576

577

578

579

580

585

581

586

582

587

583

588

584

●580-584
湊忠之 tadayuki minamoto
●one day

●585-588
赤坂哲三 tetsuzo akasaka
●from new caledonia

●589-591
田中裕子 yuko tanaka
●line

●592・593
松田隆 takashi matsuda
●私の遠い国 my faraway country

●594
松下知尚 tomohisa matsushita
●終えて get it over with

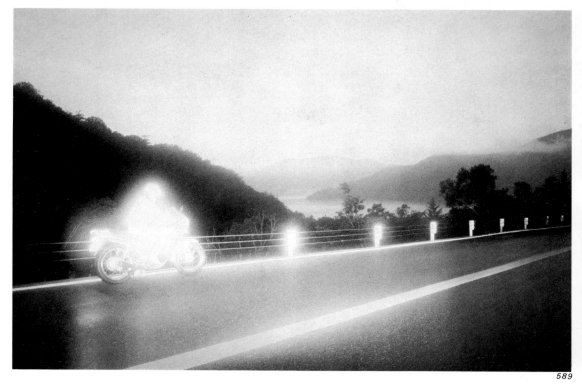

589

590

591

592

593

594

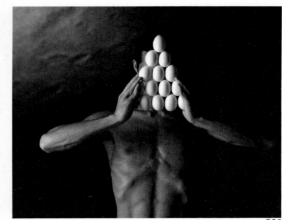

596

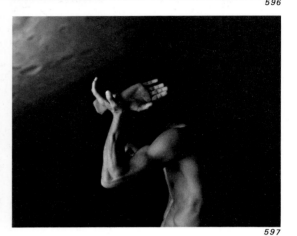

595

597

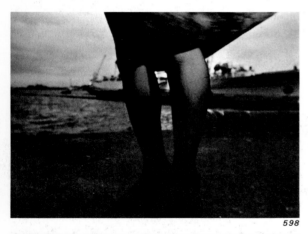

598

599

600

601

602

603

604

605

606

●595-597
秋信悟 satoru akinobu
●おとこ *man*

●598-600
与古田松市 shoichi yokota
●独り事 *soliloquy*

●601
宅間邦博 kunihiro takuma
●*black*

●602-605
阿部修二 shuji abe
●*doll in a dream*

●606-608
飯岡徳司 tokuji iioka
●*midnight ballet*

607

608

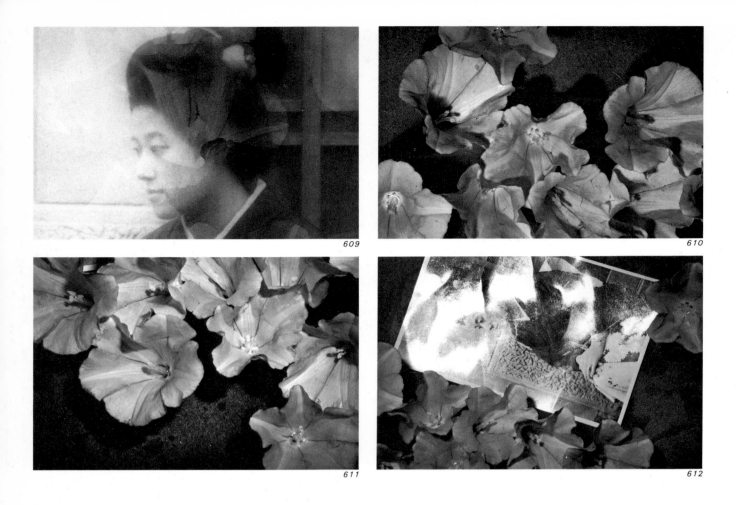

609

610

611

612

613

614

615

616

617

618

●609-612
山下直子 naoko yamashita
●ひるがお bindweed

●613-615
奥田純一 junichi okuda
●終焉 moment of death

●616-618
南浦護 mamoru minamiura
●第一印象 first impression

●619-624
西岡千春 chiharu nishioka
●retention f16

●625-627
石川隆三 ryuzo ishikawa
●rainy night

●628-630
澤野新一朗 shinichiro sawano
●the dark side of the moon

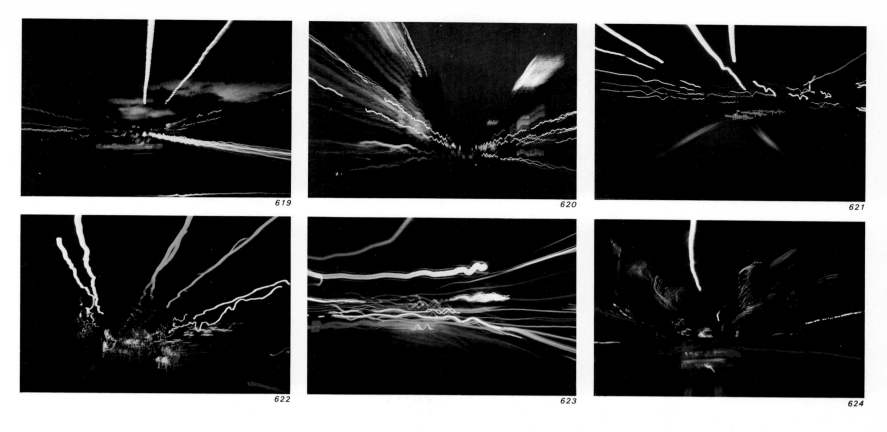

619

620

621

622

623

624

625

626

627

628

629

630

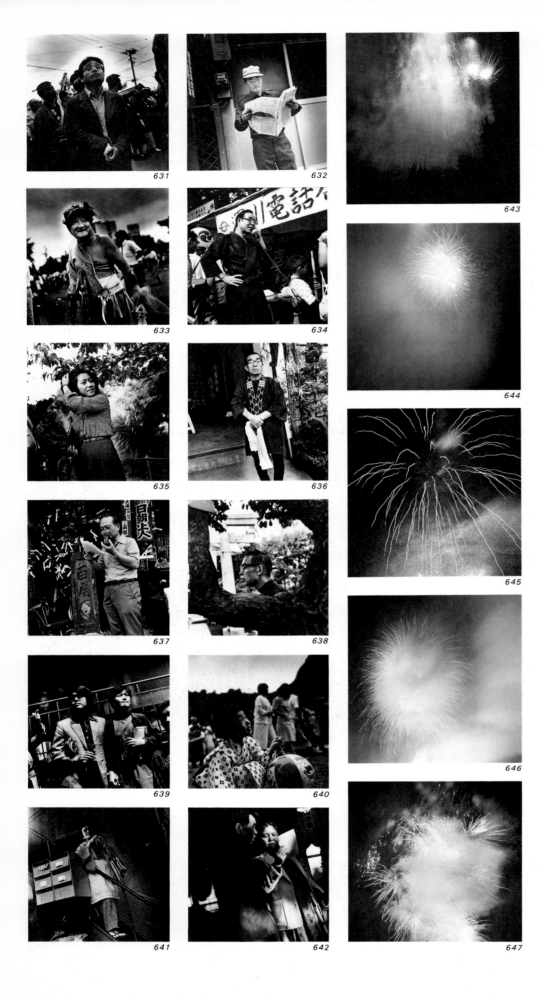

652

653

654

655

656

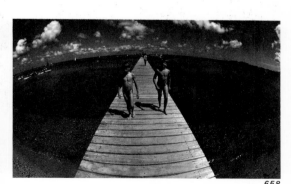

658

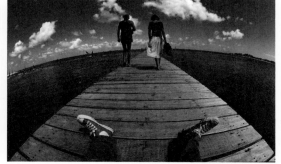

657

659

662

660

661

663

664

665

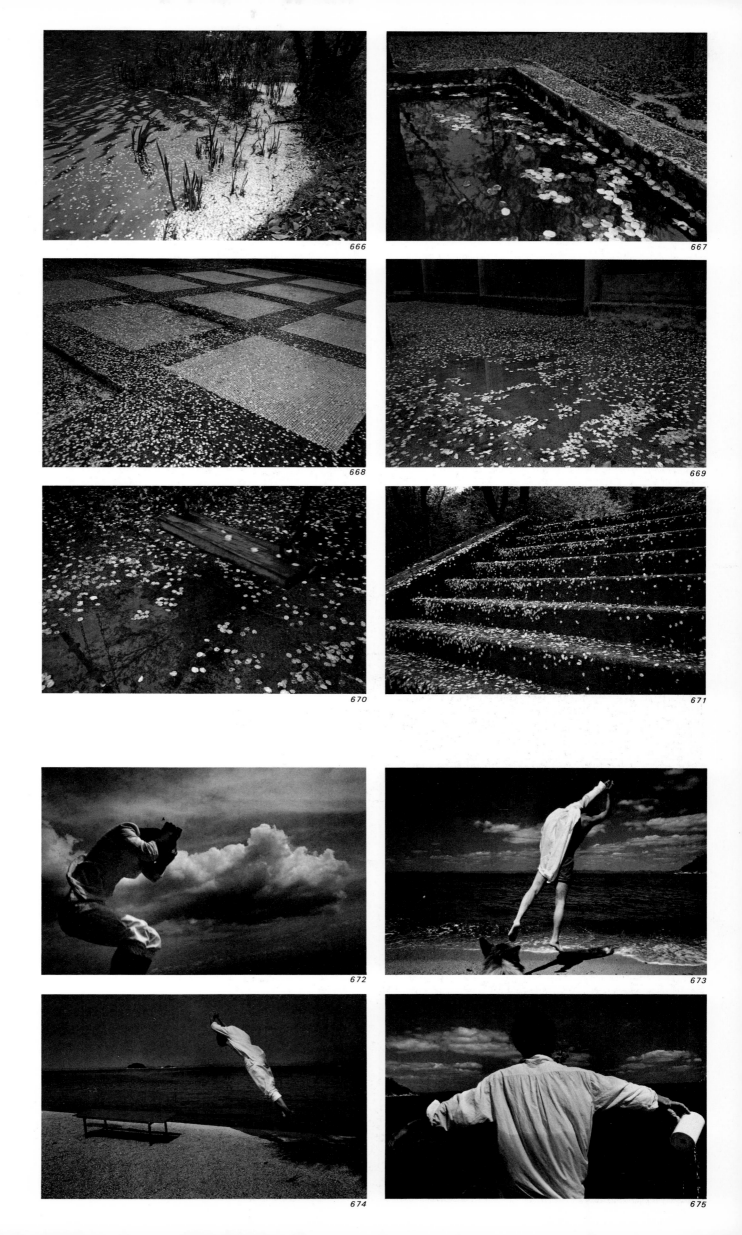

666

667

668

669

670

671

672

673

674

675

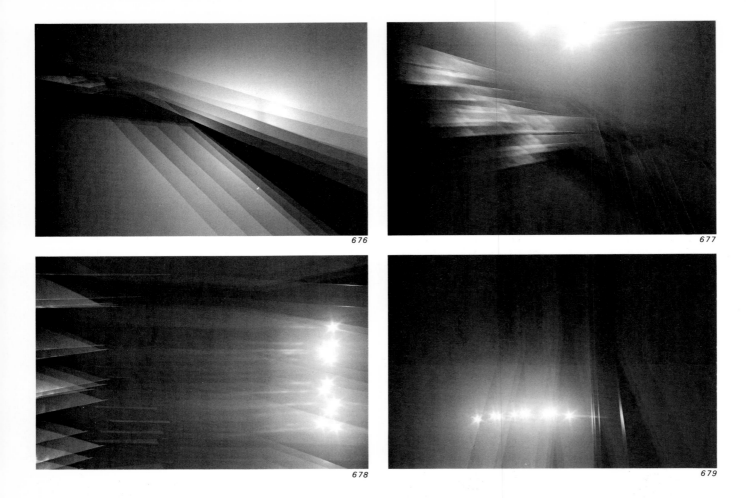

676

677

678

679

680

682

683

681

684

●676-679
古井圭介 keisuke furui
●ice zone

●680・681
奥村正利 masatoshi okumura
●時は生を喰う time eats your life

●682-684
豊田真 makoto toyota
●woman

●685-688
吉田宗義 muneyoshi yoshida
●lips imagination

●689-693
後藤得三 tokuzo goto
●zoo

685

686

687

688

689

690

691

692

693